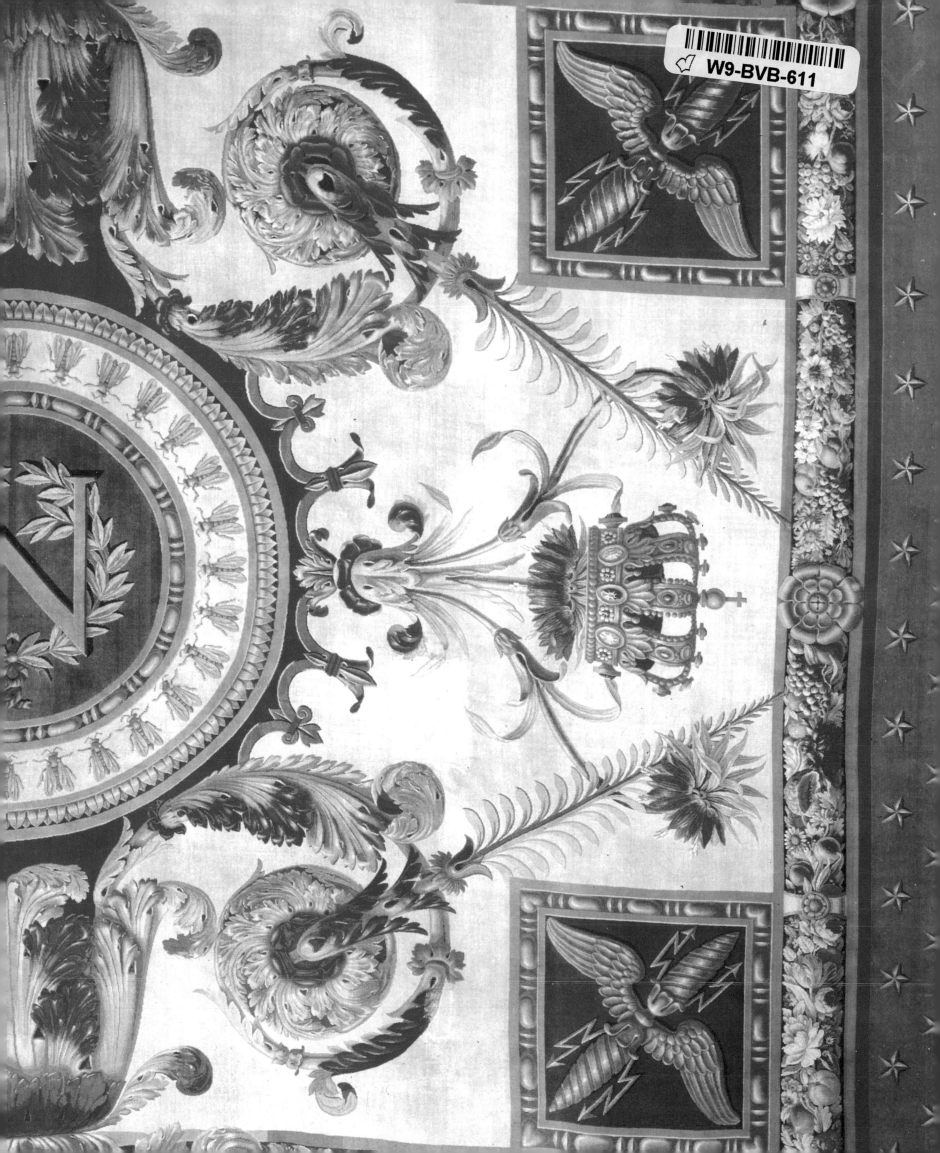

EMPIRE

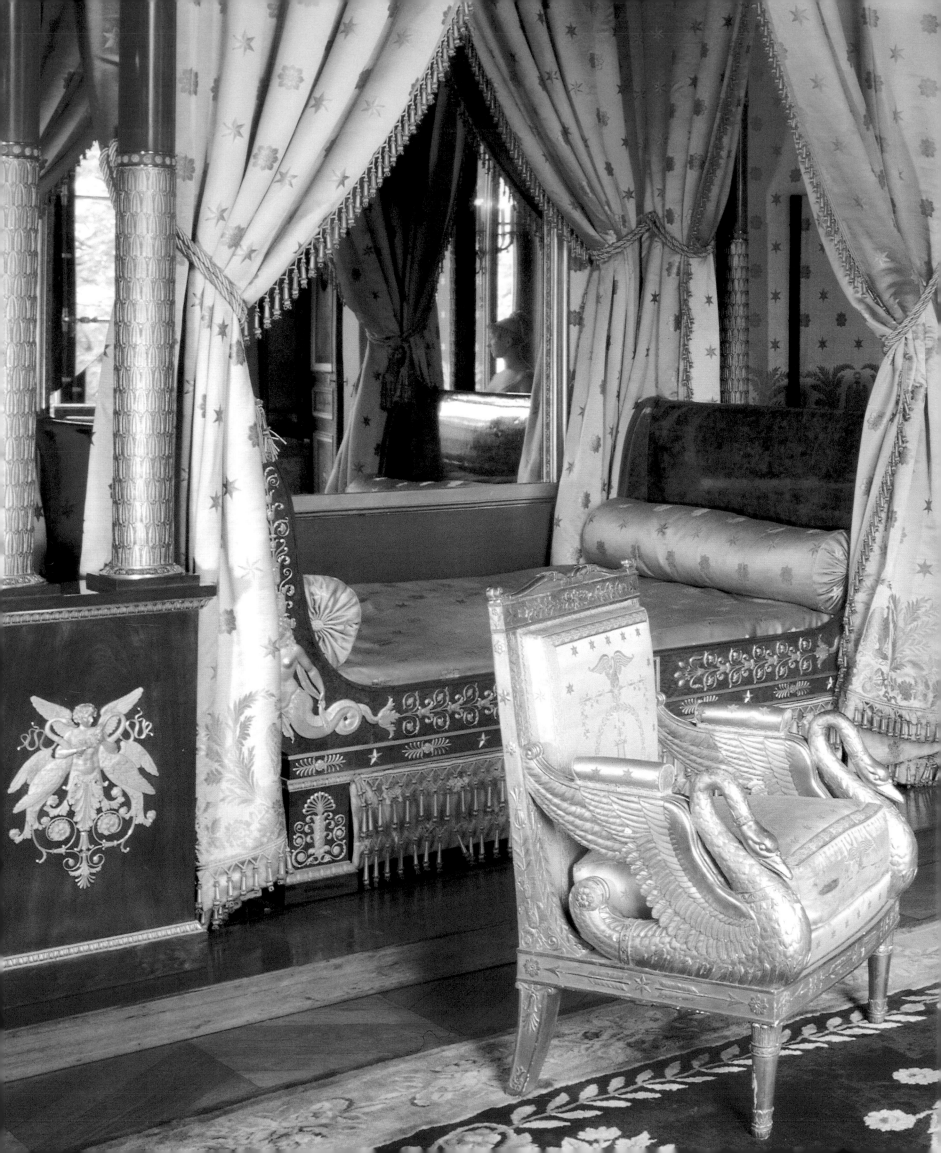

EMPIRE

MADELEINE DESCHAMPS

Special Photography by
Fritz von der Schulenburg

Abbeville Press · Publishers
New York · London

For Damien

FRONT COVER: The library at Malmaison. Decorated in 1800 by Charles Percier (1764–1838) and Pierre-François-Léonard Fontaine (1762–1853) during the Consulat, this room shows many of the features of the Empire style, which developed out of the Consulat style a few years later (see page 49).

BACK COVER: The Guriev Service, commissioned in the early nineteenth century from the St. Petersburg Imperial Porcelain Factory, graces the table in Mon Plaisir, a banqueting pavilion at Peterhof Palace in Russia (see page 154).

ENDPAPERS: Period replica of the carpet in the Throne Room in the Tuileries Palace, 1807–9, Manufacture Impériale de la Savonnerie, wool (see page 149).

FRONTISPIECE: Queen Hortense's bedroom in the Hôtel de Beauharnais, Paris (see page 116).

TITLE PAGE: Kolydan Vase, 1803, Pavlovsk Palace, Russia.

EDITOR: Jacqueline Decter
MANUSCRIPT EDITOR: Amy Handy
DESIGNER: Celia Fuller
PRODUCTION EDITOR: Abigail Asher
PICTURE EDITOR: Laura Straus
PRODUCTION MANAGER: Simone René
CALLIGRAPHER: Anthony Bloch

FIRST EDITION
10 9 8 7 6 5 4 3 2

Library of Congress Cataloging-in-Publication Data
Deschamps, Madeleine, 1945–
 Empire / Madeleine Deschamps ; special photography by Fritz von der Schulenburg.
 p. cm.
Includes index.
ISBN 1-55859-032-3
1. Decoration and ornament—Empire style. I. Title.
NK1372.D47 1994
745'.0944'09034—dc20 94-9021

CONTENTS

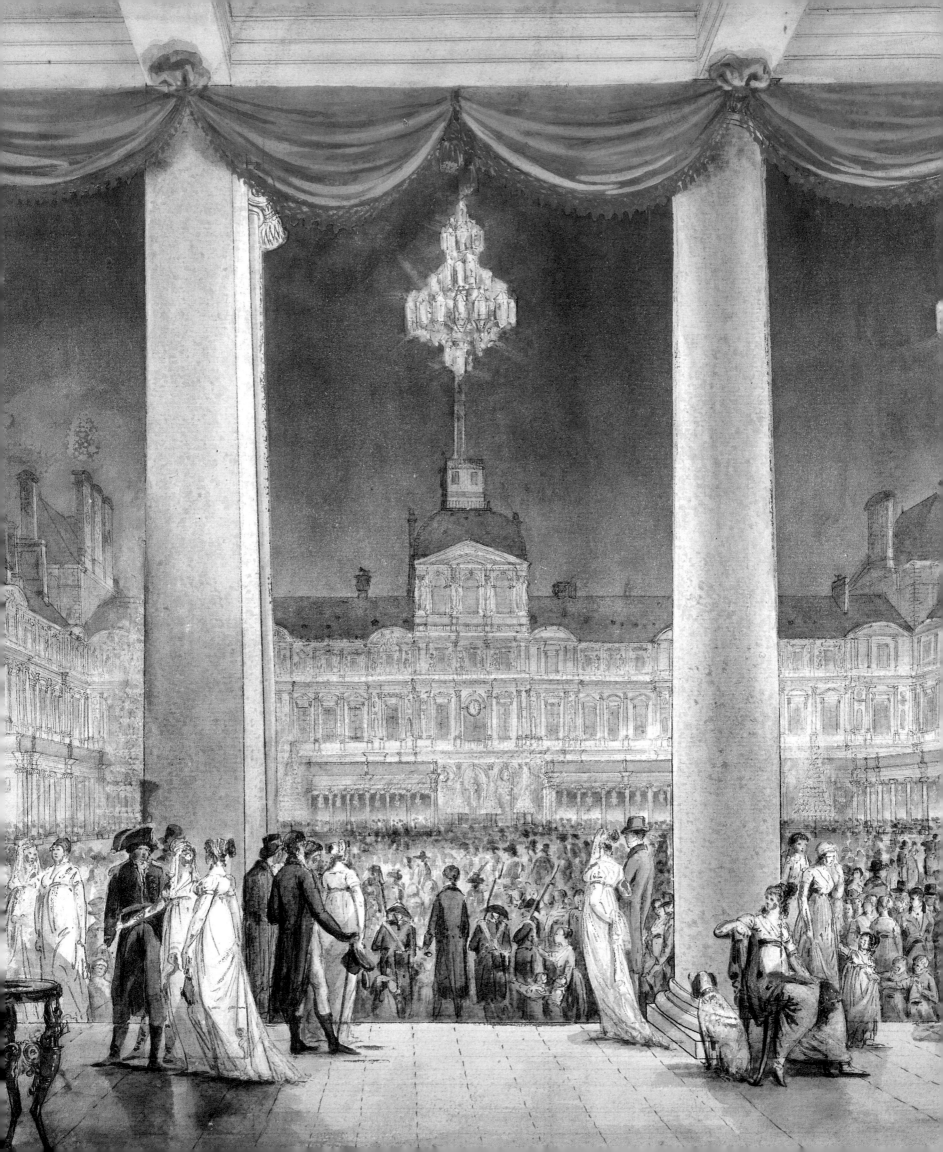

INTRODUCTION

*T*he end of the eighteenth century was a tumultuous and remarkably rich period that laid the foundations of modern times. In the course of the century the philosophy of Enlightenment had opened minds to realities veiled until then, and it had awakened hopes of social and political change in many lands. In France this new consciousness culminated in a major cultural rupture, the Revolution. The fall of the Bastille in 1789 and the death of Louis XVI in 1793 marked the end of a monarchy that had shaped France, its society, and its economy for ten centuries.

Revolutions do not immediately find a language to express the social order they are striving to establish. While their participants want to herald the advent of a new era, they can do so only with inherited words and modes. Hence there was no real break between the styles and art forms that characterized the reign of Louis XVI and those of the Revolution or the subsequent Directoire, Consulat, and Empire. Gradually evolving over the course of these years, the Empire style was a natural development of the neoclassical art born in the preceding decades, which explains why Empire also includes styles that predate the coronation of Napoleon.

The forms and decorative vocabulary of the Empire style began to take shape about 1798, a little before the Consulat, and its spirit slowly changed after the French Empire was established in 1804. Despite a strong connection to its stylistic predecessors, the Empire style was highly influenced by the personality of one man. From the time he was a consul, Napoleon Bonaparte had been pre-occupied with the expansion of the French economy, and this concern drove his desire to dominate European countries and control their trade. Once in power, he also wished to give a grandeur and splendor to his reign, a purpose best served by the arts. Thus the short years of his rule were a period of extraordinary development for arts and crafts in France and in the countries he controlled.

When Napoleon came to power he found a country that had been torn apart by civil war and lay in partial ruin. He also inherited royal residences that had been stripped bare by the Revolution. In his ten years as emperor he not only refurbished palaces and châteaux throughout France and Europe but also gave France one of its most superb collections of decorative arts. To accomplish this he provided massive help to workshops and nascent industries, encouraged and publicized technical inventions, and instituted schools, competitions, and prizes. No one since Louis xiv's minister Jean-Baptiste Colbert had been so concerned with the economic status of France and the international image of its arts and crafts. Just as Napoleon knew how to surround himself with the best political and military counselors, so too did he call some of the best artists in Europe to his service.

The expansion of the French Empire as well as the speed with which prints were distributed and works exported account for the remarkable diffusion of this style—a style that answered the taste for luxury of the new middle classes.

The age of Empire was one of conquering armies and flamboyant cavaliers, progressive legislators and meticulous administrators, refined architects and sophisticated craftsmen. This was a world that admired and followed the masculine models of ancient Rome, a fascination reflected in Empire interiors and furniture. After the Consulat, as the fantasy and delicacy of the eighteenth century waned, court etiquette stiffened, decoration became more dignified and ponderous, and the graceful allegories of early neoclassicism became emblems of the new classes' power and wealth.

PAGE 6: View of the Exposition des Produits de l'Industrie Française in the Cour Carrée of the Louvre *(detail), 1801, artist unknown, watercolor, 16⅞ × 27⅛ in. (43 × 69 cm). MUSÉE CARNAVALET, PARIS*

Although the age of Empire was dominated by men, both politically and aesthetically, the women of the period played an important political and intellectual role, particularly with their influential salons. They also formed a link between the former aristocracy and the new society. Through their commissions they supported the development of French crafts and luxury industries, and theirs was a very different, less formal sensibility. Empress Josephine showed an interest in nature that infused what was an imposing, architectural style with charm and delicacy. And she encouraged a romantic taste for the Middle Ages, a style that was to supplant the Empire.

The Napoleonic era was a heroic and tragic time, as the victories of a remarkable strategist and his formidable army spread French hegemony over most of the Continent. The spectacular expansion of French culture marked the political or social structure and the arts of entire nations. And the collapse of the colossal Empire in 1815 ended an epic that was to inspire endless dreams of glory among the following generations.

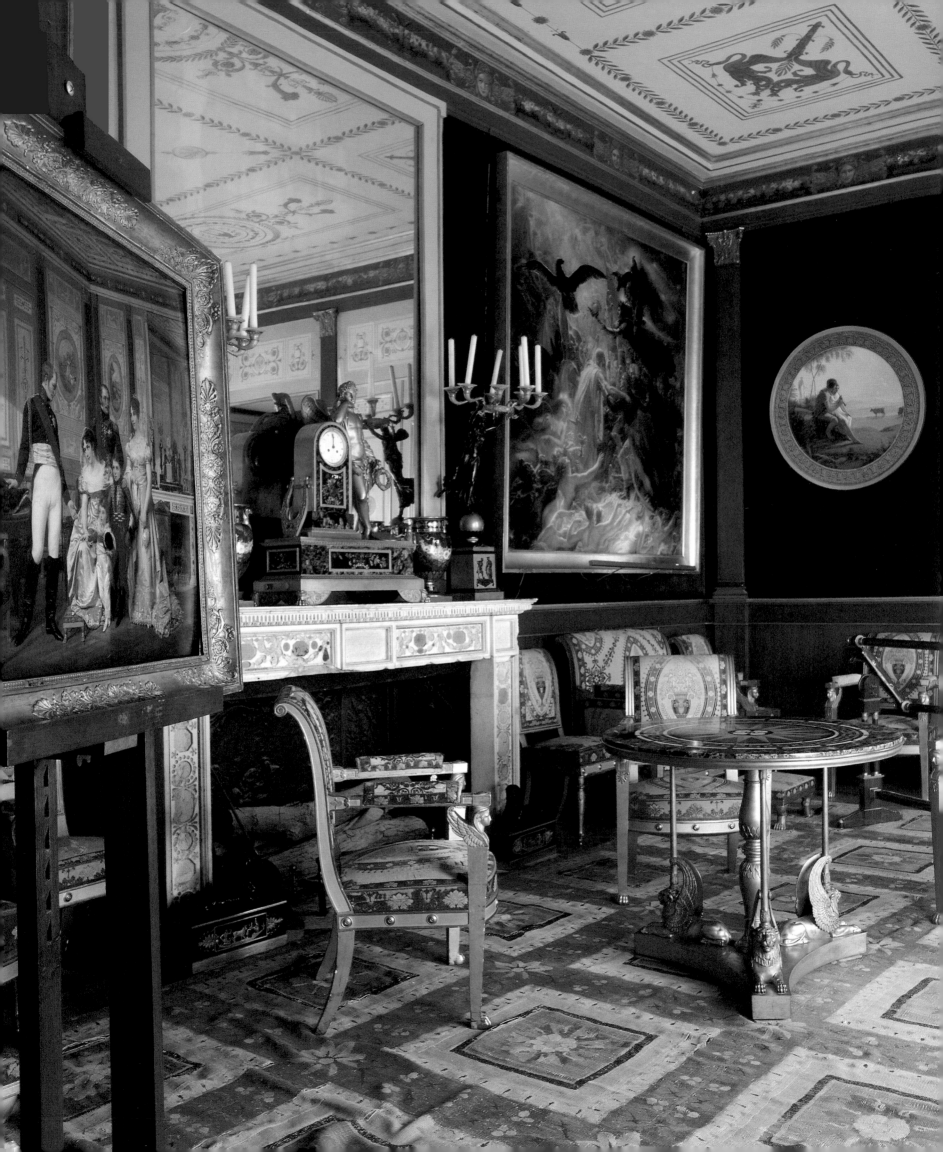

F R O M R E V O L U T I O N T O E M P I R E

T he years of the French Revolution were a period of turmoil and violence, of hope and free thinking, that left a lasting imprint on French society and politics. For centuries kings had reigned over an essentially rural population that lived scattered over a land held by the aristocracy and the church. The people were dazzled by the splendor of a distant court, which they could not understand and which censorship did not allow them to criticize. Only in the last decades had the Enlightenment philosophes cast a new light upon the injustices and the absurdity of a social system that was not cruel but negligent of the value of the individual citizen.

The Revolution began as an outburst of idealism and freedom, but it was soon diverted by revolutionaries intent upon crushing the former rulers as well as their own opponents, and its initial aspirations were perverted by violence, countless executions, and widespread destruction.[1] Between 1789 and 1794 the end of the monarchy, the execution of Louis XVI and Marie-Antoinette, ongoing upheavals, and especially the Terror seemed to have broken down the French political and social system.

By 1794, when the austere and sanguinary Maximilien Robespierre, the Incorruptible, himself went up to the guillotine, the country had been bled white. Overthrowing the ancien régime, it had too quickly negated too many centuries of its past. With no leadership France was fighting foreign powers on all sides, and its economy was in shambles. Over the previous years coups and new regimes had followed in quick succession, changes that were difficult to understand both for the people living through them and for those observing France from abroad. But in 1795 a government headed by five directors was set in place, giving the country a needed, if precarious, sense of order.

THE DIRECTOIRE

France had been in a tempest for six years since the beginning of the Revolution, and although the Directoire was a period of uncertainty, which again witnessed several coups, it began to give the country hope of peace. The cities were becoming slightly more secure. French victories abroad were protecting the borders of the nation as alliances and coalitions of European powers formed to contain the expansion of what appeared to be a crusading, ideological nation. A twenty-six-year-old general, Napoleon Bonaparte, was put in command of France's Army of Italy and won with dazzling speed and panache the battles of Lodi, Castiglione, Bassano, Arcole, and Rivoli, among others. Furthermore, the military and scientific expedition that he led to Egypt in 1798 seemed to open new horizons for France.[2] The cleverly written military reports that Bonaparte sent from the Italian and Egyptian campaigns revived the country's confidence. The French Republic was soon allied with sister republics whose constitutions were modeled on its own: the Batavian (Dutch), Cisalpine (Northern Italian), Ligurian (Genoan), Roman, Helvetian (Swiss), and Parthenopean (Neopolitan) republics, in which the French armies were often hailed as liberators by local opponents of despotic regimes.

But France's financial and economic situation remained disastrous, its fledgling industries barely functioned, and terrible winters and famines had increased the extreme poverty of the lower classes, who had not benefited from the political changes. What had once been a good network of roads built by the

PAGE 10: The Salon at Malmaison. The white and gilded ceiling and door decorations were commissioned by Josephine in 1811. The large painting to the right of the mirror is by Anne-Louis Girodet (1767–1824), 1802; it depicts Ossian opening the heavens to heroes who died for France, including generals Hoche, Marceau, Desaix, and Kléber. François-Honoré-Georges Jacob-Desmalter (1770–1841) designed the seats of sculpted and gilt wood. The gueridon is of gilt bronze. The clock, made of gilt bronze, malachite, and colored stones, is by Pierre-Philippe Thomire (1751–1843) and Bourdier.

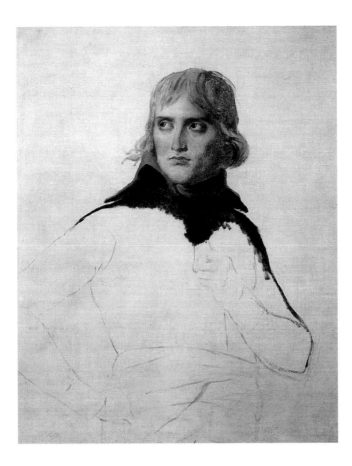

General Bonaparte, *Jacques-Louis David (1748–1825), oil on canvas, 31⅞ × 25⅝ in. (81 × 65 cm).* LOUVRE, PARIS

kings had fallen into pitiful condition, ports and canals were sanded in, and the provinces were infested with highwaymen, vagabonds, and beggars.

After the fall of Robespierre and the end of the Terror, however, the country felt a relief that was manifest in the sudden transformation of social life. Since the early 1790s a nouveau riche class had been forming: businessmen and financiers but also profiteers. The latter had speculated on the devaluation of the *assignats*, the bank notes issued by the revolutionary government on the large sales of grain to the armies, on purchases of colonial goods, and on the innumerable sales of *biens nationaux*, the properties confiscated from the aristocracy and the church. All these were very important transactions in which such speculators as Gabriel-Julien Ouvrard and Simons made huge fortunes.

This new class was a minority in a country that was primarily rural and would remain so during the whole of the Empire period. Yet it set the tone for a society that had within a few short years lost the value system it had relied upon for centuries. France was building a *république bourgeoise* as a new middle class moved to the forefront, reinforced by the strife. They were the deputies, the new civil servants, and the merchants and bankers of large cities. In small towns they comprised a few noblemen of the ancien régime, landlords, and the *notables:* lawyers, notaries, and doctors. The groups of the bourgeoisie that

had been powerful before the Revolution—the landed bourgeoisie and the *bourgeoisie des offices*, who bought their offices—were now being replaced in society by the businessmen.

These newly minted bourgeois felt the need to assert their position. Admittedly, France was still agitated by both partisans and adversaries of the Revolution, who gathered in clubs and wrote profusely in the many pamphlets and gazettes that everyone avidly read and discussed. But increasingly people wanted to display their wealth and enjoy the pleasures of a city life now free of fear. Many travelers were coming to France again, and in their letters and journals they stressed the economic recovery and atmosphere of contentment they noticed with amazement after such terrifying years.[3]

Wall decoration from the Salon Directoire in the Masséna Palace. Musée Masséna, Nice

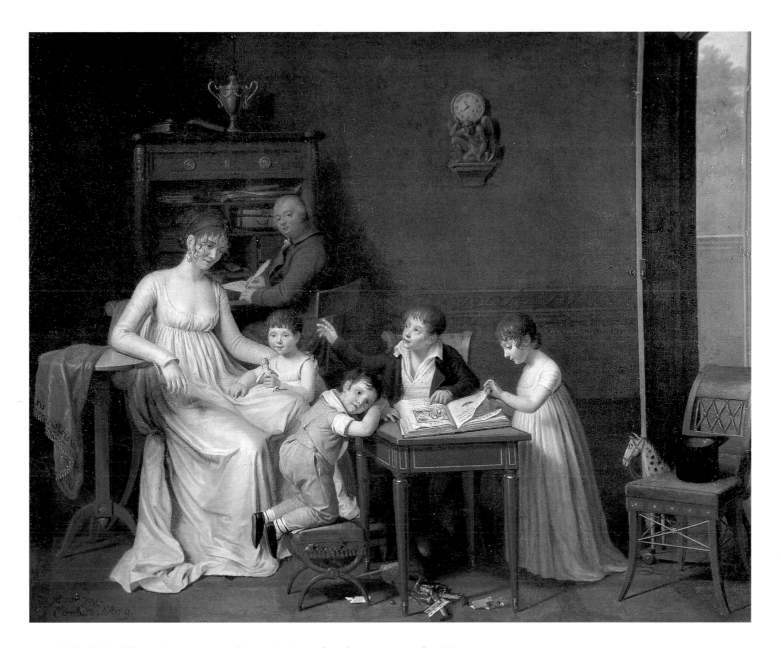

A fashionable society emerged, consisting of such groups as the Musca-
dins, the Incroyables, and the Merveilleuses, who became symbols of the time
although they were but a gilded fringe of the young and wealthy.[4] The Mus-
cadins were counterrevolutionaries in Lyons and Paris who behaved affectedly
and dressed eccentrically, often imitating English styles and wearing tight-
fitting eighteenth-century breeches as opposed to the Revolutionary *pantalons*
(trousers). They stood in marked contrast to the stern politicians of the time,
who had banished the color and fantasy so characteristic of eighteenth-century
apparel in favor of black, which was symbolic of republican virtue and civic
purity. Fashionable youth throughout France rejected this austere revolutionary
mentality as well as the garb. The Incroyables, who succeeded the Muscadins,
dressed even more outrageously, sporting "incredibly" high collars and frock

Family Portrait, *1800–1801,*
Joseph-Marcellin Combette, oil on canvas,
23⅝ × 28¾ in. (60 × 73 cm). Musée des
Beaux-Arts, Tours

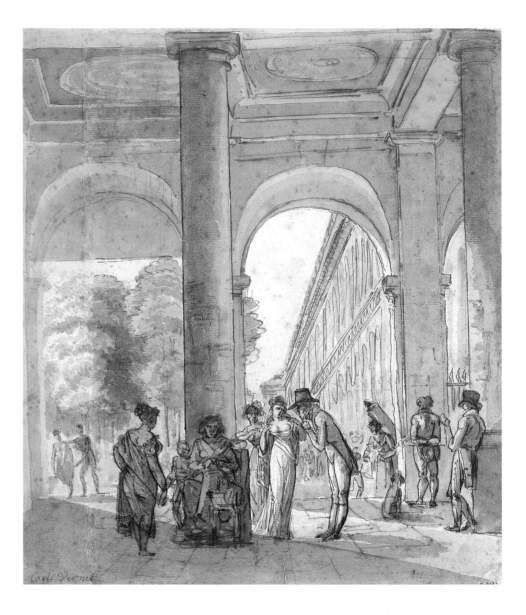

The Palais Royal in 1810, *Carle Vernet (1758–1835), drawing, pen, India ink, gray and brown wash over pencil, 12 1/8 × 10 3/8 in. (30.7 × 26.2 cm). Musée Carnavalet, Paris*

coats that trailed on the ground and speaking with a lisp—the latest chic. The Incroyables escorted women known as Merveilleuses, who draped themselves lightly in gauzes that left their bosoms and arms bare and hid very little else. They threw their long ample skirts over their arms and wore elaborate hats and turbans.

These extravagant young people would meet in the gardens of the Palais Royal to show off their sartorial inventions, read the newspapers, and discuss the countless posters that announced political events, theater performances, or balls. They also gathered in the cafés and famous restaurants under the arcades, and they met in parks all around town, where the whole population of Paris seemed to congregate. Foreigners were astonished by the animation and gaiety of the many gardens that were now accessible to the public. Some of them were on the

grounds of noblemen who had been guillotined: most in vogue were the gardens of Tivoli and those of Mousseaux (the future Parc Monceau), which had been the famous *jardin pittoresque* of the duc de Chartres, Philippe Egalité, cousin of Louis XVI. The Jardin d'Idalie, in a former aristocratic mansion, the Hôtel Marbeuf, had groves and grottoes to stroll through, as did the Jardin de Mousseaux. Just outside Paris was the Champs Elysées. A little farther west in the Bois de Boulogne were Longchamp, where one went to flaunt one's fast cabriolet or phaeton, and Bagatelle, the former property of Louis XVI's brother, the comte d'Artois, who was living in exile in England.

Public entertainments staged in the parks drew large and varied audiences from all classes of society. Since 1789, the revolutionary fetes had been a means of social cohesion for a government that could offer few amenities. Now parks and gardens were filled with theater performances, concerts, competitions, games, fireworks, and the "aerostatic ascensions" of balloons. At the Jardin de Mousseaux one could also watch pantomimes such as *Les Sauvages du Missouri* or *L'Attaque des Illinois par les Français.*

Meeting in the parks and at lavish parties throughout Paris, the most trend-setting Merveilleuses included the wives and mistresses of prominent businessmen and politicians. Madame Hamelin, who was married to an associate of

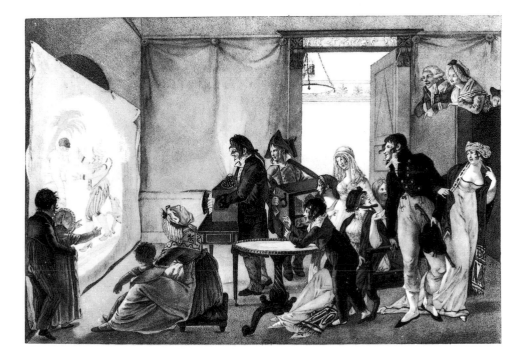

The Magic Lantern, *artist unknown, print.*
BIBLIOTHÈQUE NATIONALE, CABINET DES ESTAMPES, PARIS

In this depiction of a popular form of entertainment, the interior decor, the furniture, and the dress of the spectators are all typical of the transitional styles in the years following the Revolution.

*Mythological frieze from the Bonapartes'
hôtel on the rue Chantereine.* CHÂTEAU DE
MALMAISON, PARIS

Collot, a supplier to the armies, was known for dressing in particularly revealing
attire. Madame Tallien, who had divorced the politician Jean-Lambert Tallien,
became the mistress of the director Paul Barras, and later formed a liaison with
Gabriel-Julien Ouvrard, gave lavish parties in the Luxembourg Palace, where the
Directoire was seated. She would attract crowds when she drove through Paris
in her red carriage, dressed in nothing but a very low-cut and high-waisted white
muslin dress *à la romaine* and covered with jewels. And when Barras happened
to receive some goods from India, she launched the fashion for cashmere and
turbans. But Madame Tallien was not entirely frivolous; she was interested in
the arts and was said to have initiated the preference for the pianoforte over the
harpsichord and to have encouraged the revival of the Manufacture de Sèvres,
which had greatly suffered from the Revolution. Among the most fashionable,
too, was Josephine de Beauharnais, the young and pretty widow of an aristo-
crat who had been guillotined. She herself had been very close to death when
imprisoned in the Couvent des Carmes, and she had seen many of her friends
taken away around her, but she was now intent on enjoying herself and leading
a financially secure existence.

The lust for life among those who had survived prompted a tremendous
hunger for pleasure and luxury. The taste for festivities, especially dancing, was
greater than ever. During the Directoire there were six hundred *bals* in Paris from
which to choose, and the waltz was the latest fashion. Innumerable concerts and

operas, public or private, were attended by all social classes. In this blithe atmosphere intellectual and aesthetic interests that might have remained the province of a small group of connoisseurs became real fads. Such was the case with the interest in classical antiquity, which had appeared a few decades earlier and now became universal, particularly in the realm of fashion.

The Revolution not only granted women the right to divorce, it also liberated their bodies from the obligatory corsets and bodices. Even during the monarchy, when court formality had permitted it, Queen Marie-Antoinette had liked to abandon her highly ornate grand attire and wear thin but quite modest muslin dresses. Now women discarded any tight or heavy clothing, were free in their behavior and movements, and dressed according to the latest trends, which meant *à l'antique*. Their dresses were *à la Flore*, *à la Minerve*, *à la Galatée*, their chemises *à la prêtresse*, their belts *à la victoire*, and they did their hair up

A Pastoral Ball in the Tivoli Gardens, *Paris, artist unknown, print.* MUSÉE CARNAVALET, CABINET DES ESTAMPES, PARIS

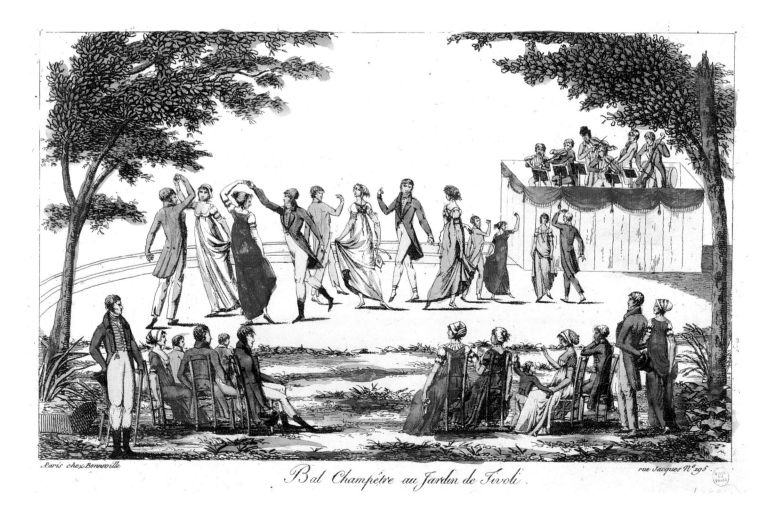

Bal Champêtre au Jardin de Tivoli.

Plate from Pierre de La Mésangère's (1761–1831) influential publication Collection de meubles et objets de goût. BIBLIOTHÈQUE DES ARTS DÉCORATIFS, PARIS

à la grecque or *à la Titus.* They also entertained *à l'antique:* Elisabeth Vigée-Lebrun, who was famous for her lovely portraits of women and children, especially of Marie-Antoinette and her children, would invite her guests to lie on beds and drink Samos wine in Greek cups while music was being played on a lyre.

A Taste for Antiquity

Long before the Empire style epitomized this new taste, neoclassicism had
enthralled historians, artists, and connoisseurs throughout Europe. The redis-
covery of the ruins of Pompeii and Herculaneum in the middle of the eighteenth
century had fascinated Europeans, who were suddenly confronted with a
complete civilization where only fragments had been known before. Since the
Renaissance antiquity had been a powerful influence on French classical art,
particularly during the reign of Louis xiv, but the new discoveries forced a
reevaluation of its full character. The civilization now unearthed was not only
that of the stately monuments and statues everyone knew but also that of
Mediterranean porticoes, atriums, and gardens, fine furniture, and friezes
of running nymphs.

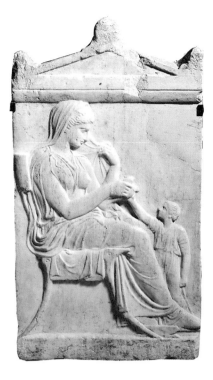

 As early as 1749 Madame de Pompadour had sent her brother, the marquis
de Vandières, on a journey to Italy with the architect Jacques-Germain Soufflot
and the artist Charles-Nicolas Cochin. She thus manifested a very modern
curiosity at a time when rocaille (the French version of baroque) reigned over
the arts. During the same period the comte de Caylus's remarkable collection
of antiques, as well as his writings and etchings, became widely influential. They
revealed many monuments and treasures previously unknown to students and
other devotees of classical antiquity.[5] In the early 1780s Marie-Antoinette,
who followed the arts closely, fostered the taste for neoclassicism in Louis xvi
furniture and decor. For her Laiterie (dairy) in the gardens of the château de
Rambouillet, she commissioned furniture in 1787 that was to be very important:
the chairs were designed by Hubert Robert, the famous painter of ruins, and
executed by the *menuisier* Georges Jacob in imitation of models from antiquity.
With scrolled and latticed backs such as those seen on antique sculpture, they
were made of solid mahogany, a wood that would be increasingly employed; their
back legs were *en sabre* or *à l'étrusque* (turned outward), a shape that would like-
wise become characteristic of Directoire, Consulat, and Empire seats.

 The painter Jacques-Louis David was a true scholar of antiquity and played
a leading role in the propagation of the new style. During his studies in Rome
he had copied many a Roman monument and decorative detail, and he knew the

furniture depicted on tombs and vases. Back in Paris in 1784 he designed, and Georges Jacob executed, furniture to be used in his studio as props for his paintings—historical painting being the noble genre of the time.[6]

Inspiration was drawn from antiquity with more fantasy than accuracy until the 1790s. Artists working in Italy rarely had direct access to the excavations in Campania, which were jealously protected by the king of Naples. So they studied all available sources—Roman arches and temples, Greek vases, Etruscan tombs, private collections—without knowing the exact origin of their models (which explains why many shapes were indiscriminately named *à la grecque* or *à l'étrusque*).[7] By the end of the century Italy was attracting

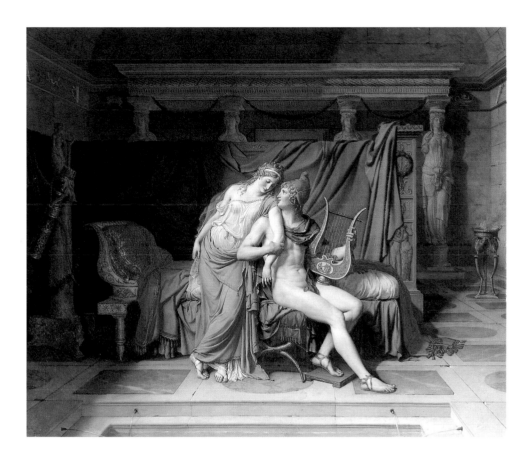

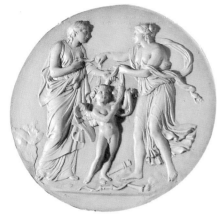

international architects, sculptors, painters, and *ornemanistes* (sculptors or painters of ornaments) who spent months and even years filling their sketch-books with classical columns and caryatids, eagles and putti, anthemion and acanthus leaves. In the midst of these appeared ornaments from the Italian Renaissance, a period that was beginning to intrigue artists who rediscovered it in Rome and Florence.[8]

 To revolutionaries smitten with social equality and ideological purity, emblems and decorative motifs borrowed from the times of the Roman Republic seemed appropriate. Neoclassicism, with its simple and rather strict lines, its sober grays and delicately hued monochromes, stood in total contrast to the earlier rocaille style, which reminded them of the fallen aristocracy. Hence fasces, pikes, and Phrygian bonnets appeared, sculpted or painted on beds (*lits patriotiques!*), around mirrors, and on ceramics destined for civic-minded citizens.

 The Revolution, however, marked no break in style; it merely accentuated certain neoclassical traits that had appeared during the reign of Louis XVI and

LEFT: Paris and Helen, 1788, Jacques-Louis David (1748–1825), oil on canvas, 57½ × 71¼ in. (146 × 181 cm). LOUVRE, PARIS

This painting was commissioned by the comte d'Artois, the future Charles X; it was shown in the 1789 Salon and was seized from his collections during the Revolution.

RIGHT: A stucco relief in the Hôtel Gouthière, Paris.

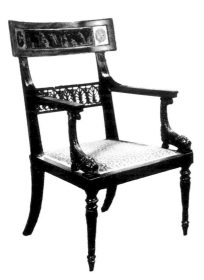

Etruscan-style armchair, Georges Jacob (1739–1814). Musée Marmottan, Paris

The paper frieze featuring an antique motif was glued onto the curved board.

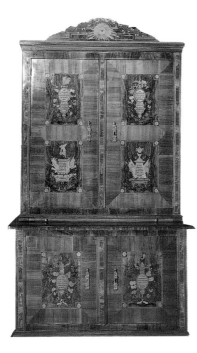

Armoire in two parts with marquetry panels, late eighteenth century, artist unknown, mahogany, indigenous woods, and bronze mounts. Musée Carnavalet, Paris

The marquetry depicts revolutionary motifs.

that would probably have evolved into styles close to those of the Directoire and Empire had political regimes been different. Parallel developments occurred in England, for instance, during the Georgian period. But these traits were seized upon and enhanced by France's consecutive regimes, for they corresponded directly to their political needs.

CRAFTS DURING THE DIRECTOIRE

Nevertheless, the Revolution did have important consequences in the arts, for when the ancien régime was abolished so were many institutions and guilds whose regulations were thought to be constraining. The old and powerful Académie Royale de Peinture et de Sculpture disappeared in 1793. The Corporations, Jurandes, and Maîtrises had been abolished two years earlier by the Le Chapelier law. Some of them dating back to the Middle Ages, these guilds had for centuries strictly controlled the crafts, furniture making in particular. The artisans of wood were divided into *menuisiers* (joiners who made furniture out of solid wood), *ébénistes* (cabinetmakers who could use veneers and marquetry), *tabletiers* (who made smaller objects), and so on. When the guilds disappeared, so did the protection they offered: the strict system of masters and apprentices was broken up, leaving the poorer workers officially on their own. Nevertheless, many remained with their employers as before and often still lived with them in the flats above and behind the shops.

But the protection of the buyer disappeared too: no longer was the guild's stamp of approval burnt into the wood of the furniture with a branding iron. Many claimed that the remarkable quality of French furniture fell forever. This might have been true in some instances, and more so as the decades passed, but in the late eighteenth and early nineteenth centuries standards remained consistently high. Many of the artisans who were active in the 1790s and even under the Empire had worked for the Crown and the society of the ancien régime, and their know-how was unchanged. Well-known *ébénistes* like the Boulard family, Jean-Baptiste Séné, Joseph Stockel, and Adam Weisweiler, many of whom had supplied the king's palaces, continued to work during the Directoire. And so did

Jean-Démosthène Dugourc, Bernard Molitor, and Jean-Guillaume Beneman, who would go on creating innovative work during the Empire.

Moreover, the abolition of the guilds offered new opportunities to men of talent. Georges Jacob had been an extremely gifted *menuisier*, but now he was allowed to do more than a joiner's work and became the best cabinetmaker of his time. Martin-Guillaume Biennais, who had been but a *tabletier* making cases and objects inlaid with metal or ivory, became an outstanding goldsmith.

Notwithstanding the craft of these artisans, the postrevolutionary years were lean. If quality did decline in certain cases, the cause was political and economic, for after the Revolution commerce plummeted and the war prevented a free flow of merchandise, making good materials scarce. When production did start anew, the need for large quantities of goods did not always permit the same attention to perfection. But most important, the traditional clientele—the court and the aristocracy—had vanished, and at least in the first years the new middle class was in no mood to think of furnishing homes. Those of modest or uncultured extraction were quite happy to move straight into the requisitioned homes of the former upper classes. Besides, so large were the collections of the Crown

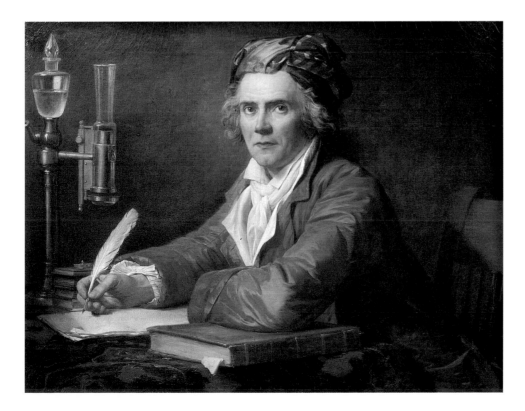

Portrait of Doctor Alphonse Leroy, *1783*, *Jacques-Louis David (1748–1825), oil on canvas, 28⅜ × 35⅞ in. (72 × 91 cm).* *MUSÉE FABRE, MONTPELLIER, FRANCE* *An Argand lamp stands on the doctor's desk.*

and the aristocracy, which were being dispersed and sold off far below their value at countless auctions, that new furniture was hardly needed. Director Barras, for instance, had the best furniture, porcelain, and silverware from the former royal collections brought to his apartments in the Luxembourg.

When they did order new furnishings, these new clients were often less concerned with quality than with an ostentatious display of their recent fortune. In 1795 the young architect Pierre-François-Léonard Fontaine noted in his journal that bankers and suppliers now dared to show the wealth they had acquired,

The Game of Draughts, *c. 1803, Louis-Léopold Boilly (1761–1845), oil on wood.* GALERIE CAILLEUX, PARIS

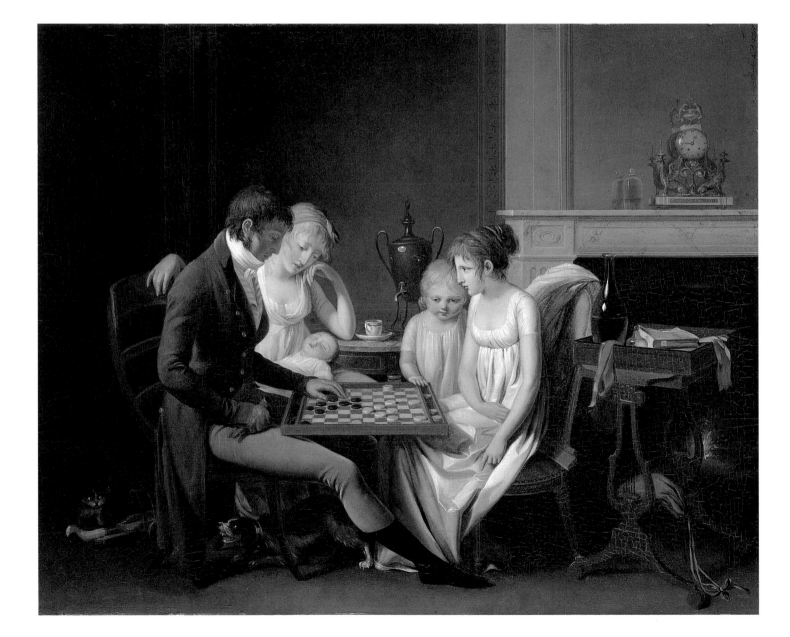

and among the first clients whom he and his partner Charles Percier had were financiers and the speculator Gabriel-Julien Ouvrard.

Despite frequent use of modest materials, Directoire furniture could nevertheless be quite delightful. The great variety of pieces that the eighteenth century had produced was reduced during these years, and shapes and details were simplified. Because exotic timbers were not available, wood was often painted. But the Directoire style retained a grace inherited from the Louis XVI style, and its very simplicity gave it an air of distinction. Case furniture was square and far less decorated than pieces made ten years earlier, and marquetry was rare. Beds were still Louis XVI in spirit, with delicate fluted columns and pediments over the ends. Seats had scrolled backs (*dossiers à crosse*), back legs curved slightly backward for greater stability, and armrests often supported by slender columns as in the time of Louis XVI. The top rails of chairs, like the tops of beds, were decorated with neoclassical tureens (*soupières*) or lozenges, two common Directoire motifs. The feet of beds and case furniture were usually in the shape of tops or spiraled. A die, square or on its point, striped or sometimes including a stylized rosette, joined the chair legs to the seat rail.

The new elite wanted to give dinners and dances in handsome surroundings. The likes of the director Barras or the unscrupulous Ouvrard were relatively

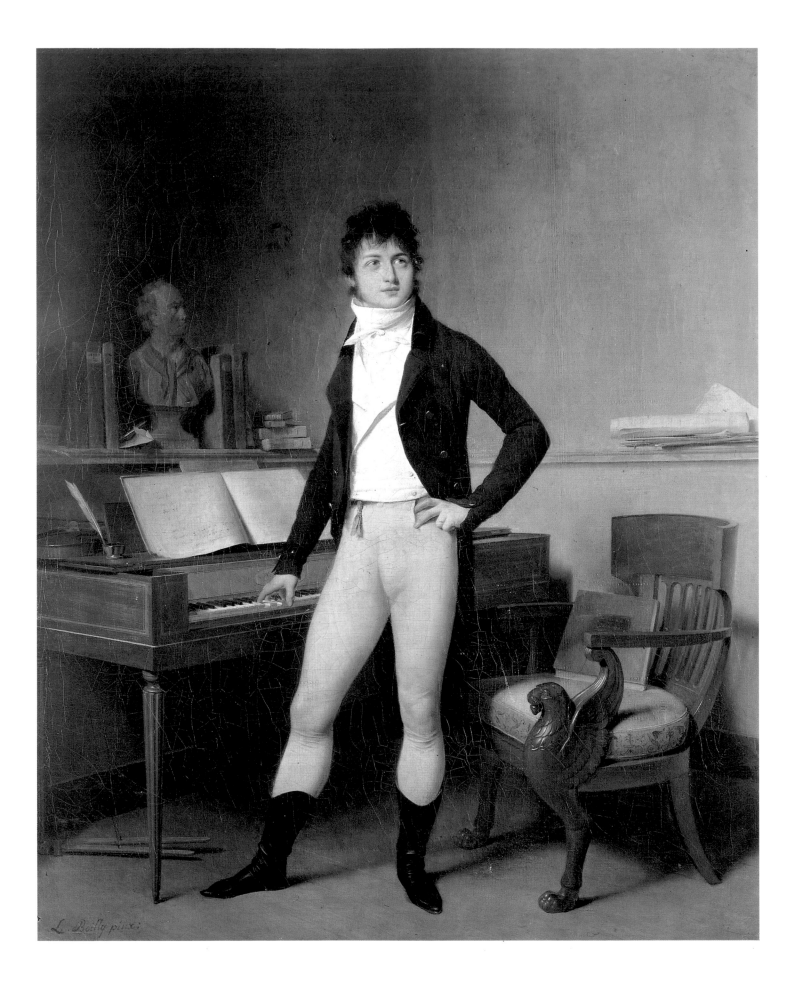

ignorant of these matters, but they were surrounded by women who were quite aware of the latest innovations in the arts and knowledgeable enough to commission the finest furnishings. The role of women would be similar in later years, when the wives of the marshals of the Empire often came from the nobility or the upper middle class and had more refined tastes than their husbands.

Among the women who had a far-reaching influence were Josephine Bonaparte and Juliette Récamier. Before the widowed Josephine de Beauharnais married Napoleon Bonaparte in 1796, she had taken up residence on the rue Chantereine in Paris, near the Chaussée d'Antin. While her husband was campaigning in Italy (upon his return the street was renamed rue de la Victoire in his honor), she had her house redecorated and furnished by the frères Jacob (the Jacob brothers).[9] Having inherited their father's workshop and designs, these skillful craftsmen created a perfect link with earlier neoclassicism and became two of the best *ébénistes* of the Consulat.

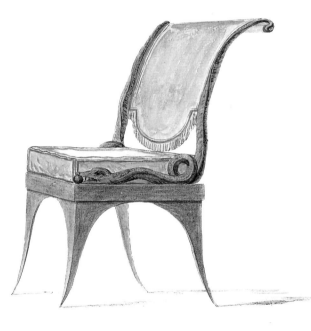

VOYAGE DANS LA BASSE ET LA HAUTE EGYPTE

Despite a few publications in the course of the eighteenth century, Egypt remained a mysterious land. But in 1798, hoping to weaken England's power in the Orient,

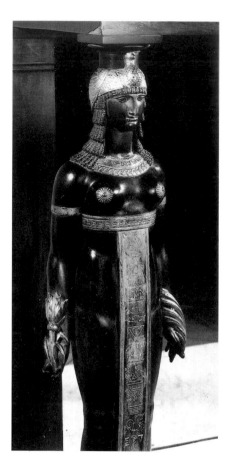

This Egyptian-style caryatid supports a mahogany console. The sculpted wood is painted "antique green" and gilded.
Musée Marmottan, Paris

perhaps cut off its trade route to India, and open France's own route east, the Directoire sent General Bonaparte across the Mediterranean Sea toward Egypt. Commanding France's most valorous generals—Louis-Alexandre Berthier, Louis-Charles Desaix, Andoche Junot, Jean-Baptiste Kléber, Jean Lannes, and Joachim Murat—he stood at the head of 54,000 soldiers and sailors who discovered only shortly before landing that they were heading for Egypt. Within a few days they won several battles with astounding speed, including the much-publicized Bataille des Pyramides, news of which would resound throughout France. Only a few days later, however, Admiral Horatio Nelson attacked the French fleet in Aboukir and virtually destroyed it. This did not stop Bonaparte from conquering Egypt and, at great cost to his army, which was decimated by the plague, venturing as far as Syria. But three years later Egypt was lost to the English.

Nevertheless the Egyptian campaign left a lasting imprint on both France and Egypt. In France Bonaparte's successes helped restore national confidence, and in Egypt he immediately began organizing the country and its administration, shaping a public service system as he would do in each land he conquered. Even in the short year he spent there and in only three years of French rule, Bonaparte's policies began to pull Egypt out of the Middle Ages.

Moreover, Bonaparte had brought with him from France a hundred scientists, mathematicians, astronomers, engineers, geographers, and doctors, who returned to France with invaluable information on both ancient and modern Egypt. Among them were some of the great scientists of the time: Claude Berthollet, Gaspard Monge, and Etienne-Geoffroy Saint-Hilaire. And in their midst was Dominique-Vivant Denon, a future *baron d'Empire* straight out of the eighteenth century, a diplomat and artist whom Bonaparte had considered too old (at fifty) for such a hazardous expedition. But thanks to his charm and vast culture—and to Josephine's recommendation—Denon became an extraordinary witness to the rediscovery of the monuments of Egypt. He left Cairo to explore the country and spent months sketching temples and landscapes, sometimes under difficult conditions. When he came back to Cairo in 1799 he showed his drawings to Bonaparte, who immediately appointed more than 150 scientists to measure and draw all the monuments that Denon had seen and to pursue the research. Already in August 1798, only a week after entering Cairo, Bonaparte had founded the Institut d'Egypte, which was to study all aspects of Egyptian civilization—

mineralogy, zoology, botany, medicine, architecture, crafts. It was the first institution to undertake the study of Egypt in depth, and it still exists today.

After returning to Paris Denon published his spectacular *Voyage dans la Basse et la Haute Egypte* (1802), which fascinated the whole of Europe. Then from 1809 to 1822 the monumental *Description de l'Egypte* was published by the Commission des Sciences et des Arts de l'Armée d'Orient, which Bonaparte had appointed. Its nine volumes of text and eleven very large volumes of plates, along with Denon's publication, laid the foundations of a scientific Egyptology. These studies inspired Jean-François Champollion as well as many other scholars; in 1822 Champollion would discover the secrets of hieroglyphics in the Rosetta Stone.

Egyptian obelisks, pyramids, and some random decorative elements had influenced the arts in earlier centuries. But only after the expedition to Egypt did artists use these motifs in a more deliberate manner in both architecture and the decorative arts. The Retour d'Egypte style was secondary to that of Rome and Greece, yet it lasted far beyond the years of the Consulat.

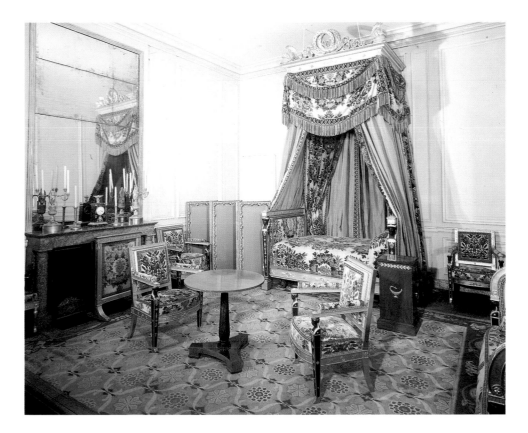

Napoleon's bedroom at the château de Fontainebleau. The bed, of bronzed and gilded wood and featuring Egyptian figures, is attributed to the frères Jacob, as are the seats. The canopy, 1804–10, sofa, table, and night table are all by François-Honoré-Georges Jacob-Desmalter (1770–1841). The velvet upholstery was woven by the frères Grand, 1811–13. The carpet is by Bellanger, 1810; the andirons, by Pierre-Philippe Thomire (1751–1843), 1810; and the objets d'art were a present from Charles IV, king of Spain.

The expedition enhanced an interest that had appeared in Rome in the 1760s when Giambattista Piranesi decorated the Caffè degl'Inglesi in a so-called Egyptian style. In France Marie-Antoinette had encouraged this fashion at Versailles and Fontainebleau, and during these years Georges Jacob, David Roentgen, and Jean-Baptiste Séné had made furniture featuring sphinxes and Egyptian heads. Now Egypt became a true vogue. Masonic lodges were decorated in the Egyptian style; when *The Magic Flute* was performed in Vienna in 1791 it was given an Egyptian set, and in 1801 it was performed at the Paris Opéra in an uncommon version entitled *Les Mystères d'Isis*. Napoleon's cooks even made cakes in the shape of Egyptian temples and pyramids to interest him in food, for he never paid much attention to what he ate.

In the work of Jean-Guillaume Beneman, the frères Jacob, Bernard Molitor, and even Adam Weisweiler, Egyptian busts and heads turned into very sculptural arm stumps on chairs and couches or corner posts on desks, sometimes prolonged in sheaths to the floor, and chair legs took the shape of animal hocks. Human or lion heads wearing the *klaft*, the pharaonic headdress, were used as

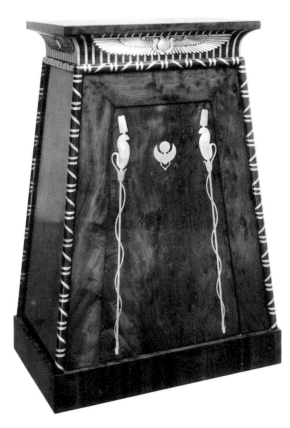

Coin cabinet, 1809–19, by François-Honoré-Georges Jacob-Desmalter (1770–1841) after a design by Charles Percier, with mounts by Martin-Guillaume Biennais (1764–1843), mahogany, silver inlay, and silver mounts, 35½ × 19¾ × 14¾ in. (90.2 × 50.2 × 37.5 cm). THE METROPOLITAN MUSEUM OF ART, NEW YORK; BEQUEST OF COLLIS P. HUNTINGTON, 1926

Part of a set of furniture decorated with Egyptian motifs and figures commissioned by Dominique-Vivant Denon.

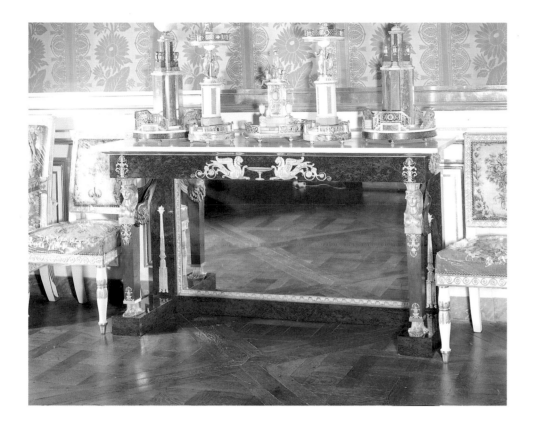

Console attributed to Martin-Eloy Lignereux (1752–1809), Adam Weisweiler (1744–1820), and Pierre-Philippe Thomire (1751–1843), from General Moreau's collection, yew. CHÂTEAU DE FONTAINEBLEAU

column capitals decorating the front of commodes, consoles, and secretaires. These heads, busts, and hocks could be in dark patinated wood to imitate bronze or in patinated or gilded bronze. Some pieces were quite original, such as the furniture that Denon designed for himself, including a bed and armchairs executed by François-Honoré-Georges Jacob-Desmalter and a coin cabinet by Martin-Guillaume Biennais. Percier and Fontaine, despite their inclination toward neoclassicism, appreciated Egyptian themes but stressed that they should be used sparingly. However, some *ébénistes* specialized in furniture *à l'égyptienne*, including Pierre-Benoît Marcion's workshop and shop, which was named Aux Egyptiens. Jean-Jacques Lequeu and Martin-Eloy Lignereux also showed interest in Egypt, as did to an even greater extent the famous bronze makers Pierre Gouthière and Pierre-Philippe Thomire in their candelabra and bronze mounts. In interior architecture chimneypieces, too, were designed *à l'égyptienne*. In England the fascination with Egypt was just as strong, as evidenced by the writings and works of Rudolph Ackermann, George Smith, and especially Thomas Hope, who visited Egypt himself in 1799.[10]

Decorative elements were usually borrowed from the late dynasties, which

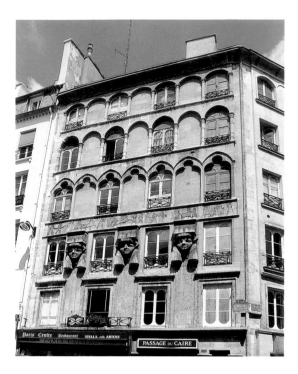

Heads of the Egyptian goddess Hathor adorn the façade of this building on the place du Caire, Paris.

seemed closer to the art of ancient Greece, less esoteric, and easier to imitate. This may explain why Egypt as reflected in the work of Consulat and Empire designers or as seen through the eyes of Thomas Hope was not always refined: the sometimes awkward motifs were modeled on ponderous statuary rather than on Egyptian tomb paintings.

In the realm of architecture a few Parisian structures randomly quoted Egyptian themes. Several streets were given Egyptian names: rue du Caire, rue d'Aboukir, rue Damiette. On the place du Caire the façade of one building, decorated in 1799, features heads of the goddess Hathor on one floor, Gothic-style windows (a rare instance in those years), and an Egyptian-style cornice topping the whole—evidence again of the eclectic way in which archaeological references were used. The splendid Hôtel de Beauharnais, renovated by Napoleon's stepson Eugène, was given an Egyptian porch built in 1807 by Nicolas Bataille and a wide cornice with a winged disk resting on columns in the shape of palm trees.

In 1806 Napoleon ordered fifteen fountains to be built in Paris—indispensable amenities at a time when the distribution of water in the capital was disastrously inadequate. Six of these fountains were inspired by Egypt, among them the fountain at the place du Châtelet by Bralle and the Fontaine du Fellah on the rue de Sèvres by Bralle and Pierre-Nicolas Beauvallet. The model for the latter was not actually Egyptian, as was frequently the case, but rather a Roman statue inspired by Egypt—the *Antinoüs* at Hadrian's Villa, which had been brought back by Bonaparte among the spoils of war from the Italian campaign. Beauvallet also made two copies of it for the porch of the Hôtel de Beauharnais.[11] The Fontaine du Fellah provides another instance of the contradictions fostered by archaeological quoting; the slave carrying jugs of water happens to be wearing a pharaonic headdress.

Egypt also became an inspiration for wall decoration, as in the Egyptian room painted in the Villa San Martino on the island of Elba during Napoleon's exile from 1814 to 1815. Egyptian motifs were found on wallpapers and textiles, too, for instance in the toile de Jouy "Les Monuments d'Egypte."

Another design stemming from Bonaparte's Italian and Egyptian campaigns that became quite popular during the Consulat and Empire was the military tent. In the 1770s the comte d'Artois had decorated the *cabinet turc* in

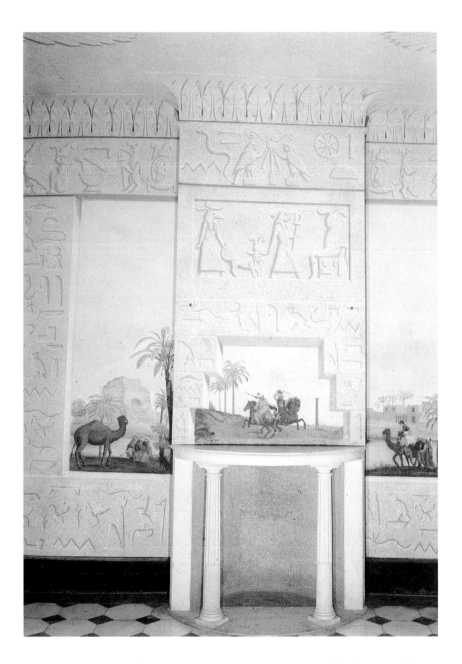

his Palais du Temple in this manner, a very rare instance for the time;[12] now it became more frequent. Inexpensive and easy to set up, a tent transformed a room in an attractive manner and matched the restrained lines of neoclassical furniture. Among the first to use it were Charles Percier and Pierre-François-Léonard Fontaine, who set up a tentlike structure as an entrance to Malmaison. They also tented the Council Room in a blue-and-white striped material. The doors were adorned with trophies after drawings by Percier and were surrounded with pikes and fasces. A most delightful later example of a tented room was

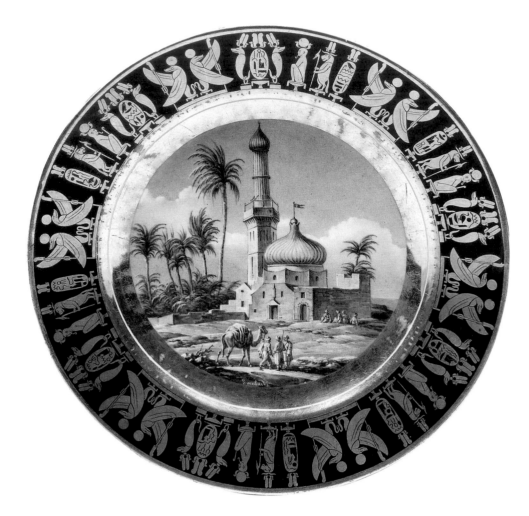

Vue d'une mosquée près de Rosette, *1811, painted by Jacques-François-Joseph Swebach (1769–1823) and gilded by Micaud, plate from a* service égyptien, *Sèvres porcelain. APSLEY HOUSE, THE WELLINGTON MUSEUM, LONDON*

Hortense de Beauharnais's boudoir on the rue Cerruti; the festoons, however, indicated Hortense's growing taste for the Gothic.

But the most beautiful ensemble of works created in the aftermath of the Egyptian expedition came from the Manufacture de Sèvres. Many outstanding sets of tableware were made at the instigation of Denon with motifs and scenes scrupulously copied from his prints. Several *services égyptiens*, *cabarets* (coffee and tea sets), and spectacular *surtouts* (centerpieces) were made, all decorated with charming views of Egypt, temples, ruins, contemporary scenes, assemblies of men, or harems.[13] The borders (*marlis*) Sèvres usually employed were dark blue adorned with gold hieroglyphs. Some of these magnificent sets were given as diplomatic gifts by Napoleon.[14] A remarkable *service égyptien* created by Denon for Sèvres was given to Tsar Alexander I after the peace treaty of Tilsit in 1807. Accompanying it was a spectacular centerpiece in biscuit designed by

the architect J. B. Lepère, who had been to Egypt with the military expedition. More than six meters long, this piece depicted the temples of Philae, Edfu, and Dendur, as well as the colossal Memnon statues, obelisks, and rows of rams.

In addition to its influence on French culture the Egyptian campaign had other consequences of equal importance, though less easy to define and thus overlooked. Not only was it the first campaign in which Bonaparte had sole command with almost no link to France, it was also the first time he had the opportunity to reign over a foreign, distant land and, despite the lootings and killings, to shape a country for modern times. His aim was to bring contemporary civilization to Egypt at a time when the philosophy of Enlightenment severely criticized colonizing for purely economic reasons, as the English did in India. His administrative and scientific work in Egypt satisfied a taste for order, rationality, and progress that he would continue to implement in the other countries he conquered.

Furthermore, as he had done during the Italian campaign, he made great use of the military press. Bonaparte's reports were remarkably informative while serving to shape his public image. This very modern sense of publicity, however, would soon turn into a dictatorial control of the press and of all writings.

Finally, the Egyptian campaign opened up an unknown world, the legendary Orient. Even though some charming works still showed the Near East in a fanciful light, such as the operas *Le Calife de Bagdad* (1800) by François-Adrien Boieldieu and *Semiramis* (1802) by Charles Catel, this was no longer the literary Persia that baron de Montesquieu had invented in his witty *Persian Letters* (1721). This was an Orient of power and mystery, to which such artists as Alexandre-Gabriel Decamps, Eugène Delacroix, Eugène Fromentin, and many Orientalists would be drawn in search of mythical and colorful civilizations.

TWO RESIDENCES IN THE TIME OF THE CONSULAT

During Bonaparte's year in Egypt political instability had increased, but France was faring somewhat better economically. Industrial production of iron, steel, and cotton was slowly improving, and in September 1798 a large exhibition of

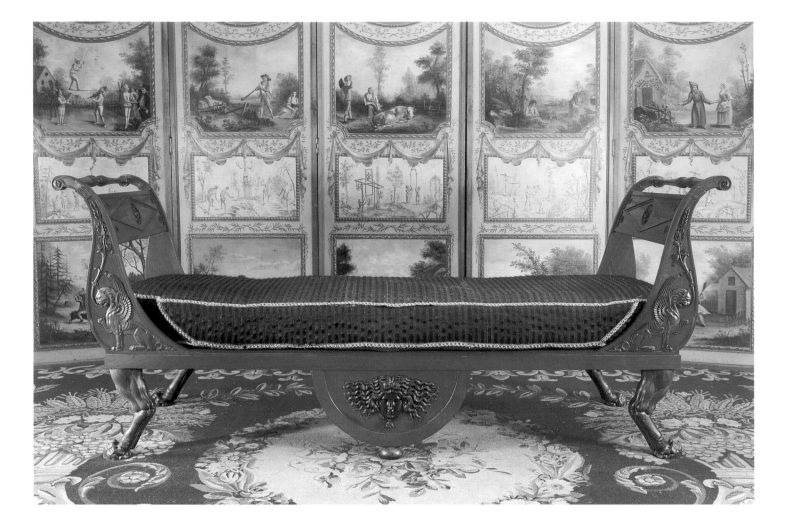

Daybed by Bernard Molitor (1755–1833), mahogany, with sculpted griffins and lion's paw feet. GALERIE BERNARD STEINITZ, PARIS

Maria Letizia Bonaparte, Napoleon's mother, was portrayed lying on a similar bed in a painting now in the Musée Marmottan.

the best products of French industry was successfully held on the Champ de Mars. Among the exhibits were decorative items such as clocks, wallpapers, porcelains, and crystal, which attracted the attention of the rising middle class; the new bourgeoisie was settling into new homes and wanted to discover the latest fashions in decoration.

From the Revolution through the early years of the nineteenth century almost no building was undertaken in France. The eighteenth century had seen the creation of some of the finest architecture of all times—country châteaux and city mansions in which the new society now lived. And no one could afford to build new homes. Architects who had been active before the Revolution were now without clients. Some of them left France and worked for foreign courts and cities, like Joseph Ramée, who built the theater and stock exchange of Hamburg; Salins de Montfort, who worked in Frankfurt and Würzburg; and Joseph-François Mangin, who appears to have become city surveyor of New York. Others turned to teaching, while still others, such as Claude-Nicolas Ledoux, who was incarcerated, and the visionary Etienne-Louis Boullée, wrote

theoretical texts or drafted projects that would never be built. Some, such as Charles Normand, became engravers, and some were hired as engineers or topographers for Napoleon's campaigns.

But the Paris *hôtels*, or mansions, had suffered severely during the Revolution, and some even lost their purpose for many years.[15] (They were inhabited by many families at a time, or used as shops or workshops.) As late as 1797, for instance, the *Petites Affiches* published the fact that the Hôtel Carnavalet was for sale, advertising it as "grand and superb," with sculptures and a large vegetable garden, and suggesting that it would suit any sort of manufacture or commerce. In fact the whole aristocratic neighborhood of the Marais was to see many of its beautiful hôtels auctioned off, while others remained in ruins for almost two centuries. As a consequence of the lack of building and of the disrepair of many residences, some architects became decorators despite themselves and excelled at it.

In spite of the generally distressing state of many Parisian hôtels, some were refurbished with extraordinary style and care. One of the most influential was done under the aegis of Juliette Récamier, who was twenty-one years old when she moved into the hôtel that her husband, a successful banker, had bought. It was situated on the rue du Mont Blanc in the Chaussée d'Antin, a fashionable neighborhood of financiers and businessmen that had developed shortly before the Revolution and now had fine hôtels and a few new houses surrounded by spacious gardens.[16]

The decoration of the Hôtel Récamier was begun in the last months of 1798, about a year before the coup that initiated the Consulat. But it was so innovative and so characteristic of the future Consulat and early Empire styles that it could not be considered Directoire. The hôtel was not especially large, evidence of a change in tastes. The bourgeoisie, though not opposed to spending money, did not like to waste it on such extravagant *folies* (pleasure houses) as those of the ancien régime princes. In this mansion the sense of luxury stemmed not from its size but from the novelty of the decoration and the extreme care that was taken in the choice of materials and colors.

Juliette Récamier was the most celebrated beauty of the late eighteenth century; indeed, as far away as Russia people knew about her and tried to see her when they came to Paris. She was a young woman of great refinement who

Consulat armchair by the frères Jacob, mahogany inlaid with ebony and pewter. MUSÉE MARMOTTAN, PARIS

The straight armrests end in lion's heads.

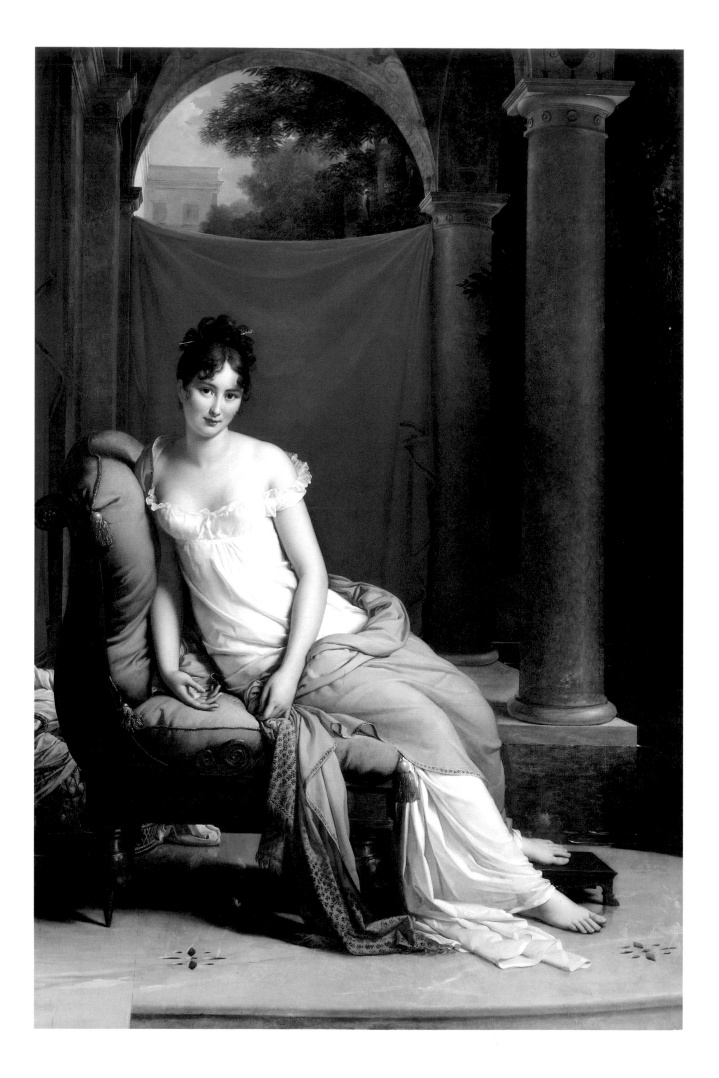

dressed in the fashionable muslins and light cashmere shawls of the time, but she was especially known for her artistic and literary tastes and for the sensitivity and kindness she showed to everyone. Madame Récamier was also particularly discerning in choosing for her home a style of decoration that was the epitome of what would become the Consulat style, anticipating most of the traits of Empire.

The courtyard one entered from the street was profusely adorned with bushes and flowers and brightly lit at night with candelabra; the same taste for flowers, which would become a widespread fashion, was evident inside the house as well. The vestibule, paved with white marble, opened onto the reception rooms: to the right two drawing rooms led to Madame Récamier's bedroom, and to the left was a dining room, still quite a rarity in those days. (For centuries a table, often on trestles, was brought into the most appropriate room whenever one wished to dine, and only now was a special room for this purpose beginning to appear.) Beyond the dining room were a boudoir and a ballroom. All of these were public rooms.

The size of the hôtel and of the rooms was also a sign of a nascent sense of intimacy, if not yet privacy, an idea that originated in England and would transform the home in the course of the next century. In the eighteenth century, behind the stately *appartement de parade*, which was designed for receiving visitors, was an *appartement de commodité*, the simply furnished rooms where the family lived. Slowly, however, private life would become more important, and the decor of bedrooms as well as of smaller salons would grow much more distinctive. But in the Hôtel Récamier the attraction was in seeing the main rooms, which were decorated in the very latest fashion (no records were left of the private rooms). Visitors who came to Paris from the provinces or from abroad had often already read descriptions of this interior in the journals of French, English, or German travelers, and they tried to be invited to the cosmopolitan receptions the Récamiers gave. In her memoirs the comtesse de Boigne recalled that one could meet not only dignitaries and marshals of the Empire, prominent financiers, and many foreigners, but also members of the former nobility who refused Napoleon's invitations but wished to be seen at these sophisticated evenings.

The Hôtel Récamier was enlarged and decorated by the architect Louis Berthault, a student of Charles Percier who built and decorated a number of mansions in and around Paris, designed many gardens, and would later be in charge of the château de Compiègne.[17] The most attractive room to all visitors

was Juliette Récamier's bedroom. The high ceilings, tall mirrors, wood panels, and chimneypiece were all *à l'antique*. The whole room was framed with an architrave of purple granite and encircled by a frieze. Its purple walls were ornamented with mahogany pilasters that had alabaster bases and white and gilded capitals and were entirely decorated with arabesques. The doors were of mahogany embellished with panels of lighter wood, gilded moldings, and Greek frets; on the central panel a graceful figure of Fortune stood on a globe—a figure that would be endlessly reproduced.

The furniture, designed by Berthault and made by the frères Jacob, was also *à l'antique*, its volumes simple, even stark compared to designs from the time of Louis XVI. The solid mahogany bed, which was the highlight of the house, was in the shape of a boat (*en bateau*), its straight sides turned slightly outward at the top and joined by a large garland. It was placed on a dais and flanked by a night table and a jardiniere in the form of pedestals. The bed was sumptuously decorated with sculpted bronze swans and gilt-bronze mounts. It was one of the first beds decorated in this manner and became immensely influential, its swans and allegorical motifs of night copied by innumerable furniture makers.

Also by the frères Jacob was the mahogany seating: armchairs, a stool, and Madame Récamier's famous chaise longue.[18] These seats were decorated in a way that would soon disappear, with contrasting parts of lemon wood and pati-

Madame Récamier's bedroom, plate from Krafft and Ransonnette, Plans, coupes et élévations des plus belles maisons. . . . BIBLIOTHÈQUE DES ARTS DÉCORATIFS, PARIS

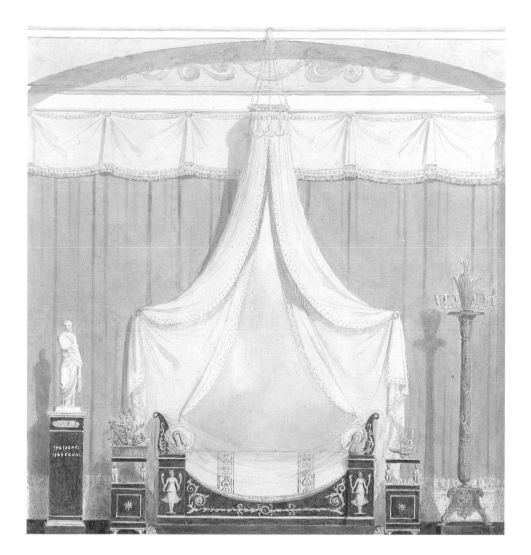

The Bedroom of Madame Récamier, *Sir Robert Smirke (1781–1867), drawing.* ROYAL INSTITUTE OF BRITISH ARCHITECTS, LONDON

nated wood. Several pieces of furniture were adorned with neoclassical ormolu (*or moulu*, ground gold, in French) motifs of great quality, which were also found in the mural decoration of the house.

Counterbalancing the austerity of its design, which Madame Récamier was sometimes said to lament, the bedroom was softened by an abundance of fabric, a lavish expenditure in difficult times. Muslins embroidered with gold and violet silks were draped around the windows and mirrors and in the niche. The bed, which was backed by a very large mirror, especially delighted one German visitor, who described it as surrounded by a cloud of muslin like a white vapor.

Another room that attracted attention was Madame Récamier's bathroom, which was entirely covered with tall mirrors and a green *gros de Tours*, a rich and textured silk. In a niche the seat of a large red leather sofa lifted to reveal a bathtub.

In 1799 Bonaparte hastily left Egypt, arrived back in Paris, and—with Emmanuel-Joseph Sieyès, Roger Ducos, and his brother Lucien, who was minister of interior

—overthrew the Directoire in the coup d'etat of 18 Brumaire (November 9). Bonaparte, Sieyès, and Ducos then established the Consulat, which marked the beginning of a new economic and political stability. Despite the initial hopes the Directoire had inspired, France's political, social, and economic situation had remained confused during its rule. The government had been unable to overcome the dissatisfaction, lack of direction, and weak political vision that had followed the end of the Terror, but Bonaparte seemed to be capable of unifying the country. Wreathed in the glory of his Italian campaign and the still mythical Egyptian expedition, the ambitious general thus became premier consul.

In the course of 1799 Josephine Bonaparte had bought the château de Malmaison near Paris, and after Bonaparte's ascension to the position of consul it was enlarged and decorated by Percier and Fontaine. These two young architects had already worked for Pauline Bonaparte, the premier consul's sister, at her château de Montgobert, and Josephine knew the Hôtel Chauvelin, which they had decorated on the rue Chantereine, where she lived. Their work, like that of Berthault at the Hôtel Récamier, was of the finest quality. In fact Malmaison was the most refined example of interior decoration of the Consulat period and a model for many years to come. Its influence was all the greater since many foreigners saw it when they came to this pretty country château. Malmaison saw the constant activity of government meetings, official and private receptions, concerts, balls, boating parties, and hunts. Around Bonaparte's intense work schedule Josephine created an entertaining and easy court life.

A tent-shaped veranda constructed of blue-and-white striped twill adorned with red fringe provided the entrance to Malmaison. This tent was not only in the tradition of the temporary architecture erected in eighteenth-century gardens but also a fashionable shape in these times of military campaigns. It was very simply furnished, as antechambers usually were, with four large benches upholstered in red and a large, round lantern. The veranda opened onto an elegant vestibule, which had a black-and-white marble floor and stuccoed columns, pilasters, and walls decorated with sword and wreath motifs. The delicate colors of the stucco were inspired by Pompeian paintings: the pilasters and the bases of the columns imitated granite, the walls were of a pale yellow, and the doors appear to have been of a light green. A few sculptures and marble copies of classical busts adorned the vestibule. But most striking to visitors were the

The main salon at Malmaison. The half-moon mahogany pier table by François-Honoré-Georges Jacob-Desmalter (1770–1841) is ornamented with patinated bronze chimeras. On its Italian marble top is a British porcelain vase, offered by the prince of Prussia to architect Pierre-François-Léonard Fontaine (1762–1853) in 1818. The mahogany and lemon wood pianoforte was delivered by the Erard brothers in 1809 to King Louis of Holland.

incessant songs of exotic birds from America, Africa, and Brazil that Josephine kept in eight aviaries. Entering the château, one immediately became aware of Josephine's extraordinary interest in plants and animals yet unknown in Europe.

For the vestibule, as for the other ground-floor rooms that had no fireplace, Percier and Fontaine devised an ingenious system: the rooms were heated by hot air sent up from a stove in the basement. All the public rooms contained numerous mahogany chairs of a simple and pleasing design, with four saber legs and often upholstered in black horsehair. The armchairs in the main salon were made about 1800 by the frères Jacob, as was most of the Consulat furniture in Malmaison, and their armrests were supported by gilded Egyptian heads. The matching chairs had splats made of bronze swans and top rails inlaid with ebony and pewter. These seats were upholstered in a blue silk velvet with gold braid.

The music room at Malmaison. The sofa is by the frères Jacob.

OPPOSITE: The dining room at Malmaison was decorated by Charles Percier (1764–1838) and Pierre-François-Léonard Fontaine (1762–1853) in 1800. The mural paintings are by Louis Lafitte. The mahogany chairs, inlaid with ebony and pewter, are by the frères Jacob. They were bought by Caroline and Joachim Murat for the Elysée Palace in 1805.

In the music gallery the columns and pilasters as well as the furniture were of mahogany, again by the frères Jacob, who most probably also had all the bronze mounts made in their own workshops. Many music and theater performances were given here until a small theater was built in 1802. Actors from the Théâtre Français and such famous names as Louise Contat, Mademoiselle Georges, and François-Joseph Talma appeared, but less formal performances were also given by the whole Bonaparte family, by generals and prefects who surrounded the premier consul, and by their wives and daughters. Ambassadors, high-ranking officials, and friends would come from Paris for these lively plays, after which ice cream and other refreshments were served.

The dining room was another example of the elegant simplicity of Malmaison, a château where the many references to antiquity were never cold or stiff. This room had a marble floor similar to that of the vestibule and a marble fountain, a new trend for dining rooms. As elsewhere in the house, the wall decoration was particularly handsome, with graceful Pompeian dancers painted on large stucco panels by Louis Lafitte, who might also have painted the ceiling

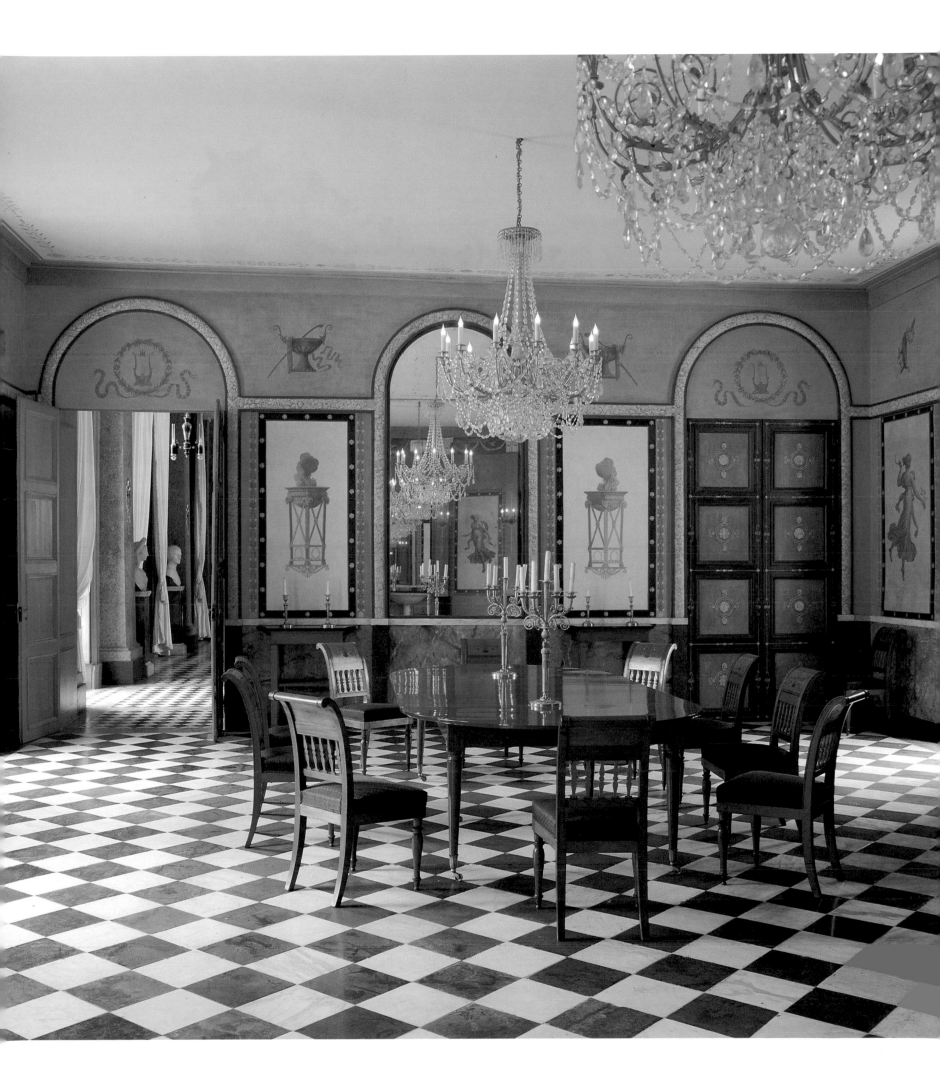

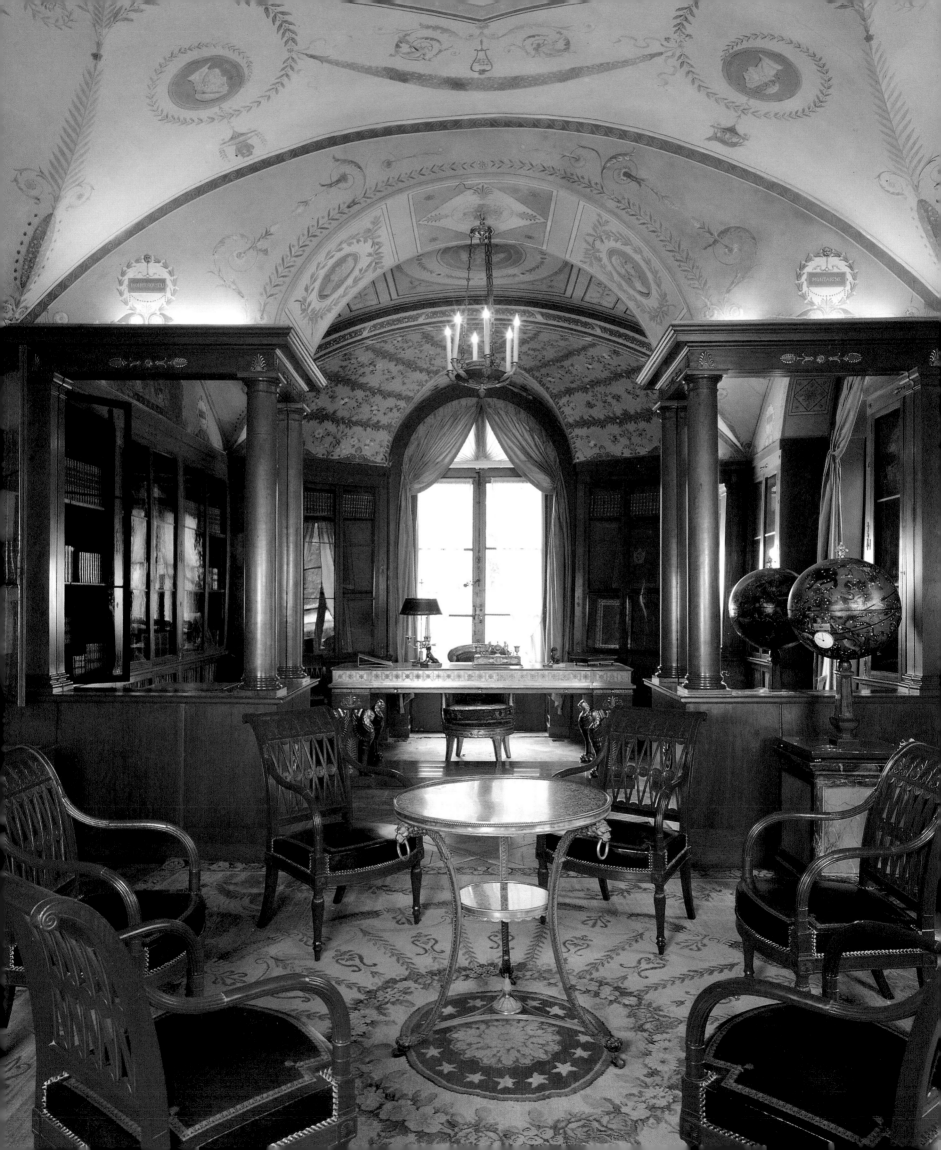

of the library. That handsome vaulted room, installed by Percier and Fontaine, was entirely lined with mahogany bookcases ordered from the frères Jacob.

To avoid interrupting Bonaparte's work, Percier and Fontaine had to decorate the Council Room in just ten days, so here again they hung the room in tent-like fashion. It was furnished with seats by the frères Jacob and with a secretaire and an armoire by their father, Georges Jacob, that were more in the Directoire style and had been brought from the Bonaparte hôtel on the rue de la Victoire.

Malmaison was the focus of a brilliant social life, but the premier consul also enjoyed simple family pleasures. Picnics and outdoor games delighted everyone, and many an evening was spent reading or playing backgammon or cards.

The century was thus coming to an end and styles were slowly evolving. The Directoire style had been a slightly starker neoclassical heir to the Louis XVI

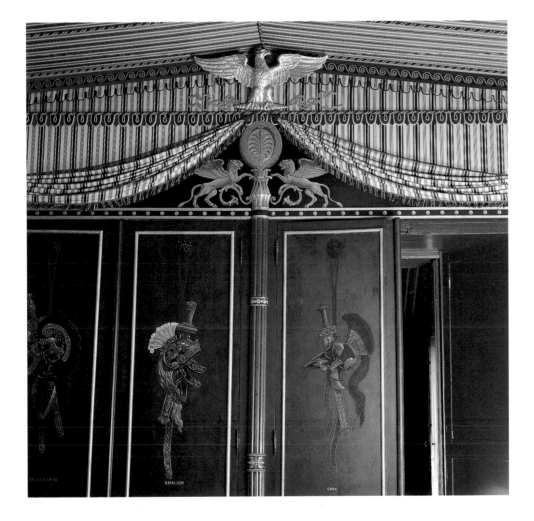

The Council Room at Malmaison (detail). In the wake of the Italian and Egyptian campaigns, tented rooms such as this one, designed by Charles Percier (1764–1838) and Pierre-François-Léonard Fontaine (1762–1853), became popular. The doors are ornamented with trophies of weapons after sketches by Percier.

OPPOSITE: Bonaparte's library at Malmaison, decorated in 1800 by Charles Percier (1764–1838) and Pierre-François-Léonard Fontaine (1762–1853). The wood paneling, bookcases, and desk are by the frères Jacob. The Aubusson carpet used to be in the Tuileries Palace.

Room in the shape of a tent for Malmaison, by Charles Percier (1764–1838) and Pierre-François-Léonard Fontaine (1762–1853), a plate from a copy of their Recueil de décorations intérieures . . . *that belonged to Martin-Guillaume Biennais and was watercolored by B. Schlick.* MUSÉE DES ARTS DÉCORATIFS, PARIS

style. Now, in the short period from about 1798 to the first years of Napoleon's reign as emperor, the Consulat style brought new fantasy and richness to the impoverished decorative arts. In the Hôtel Récamier, at Malmaison, and in the Hôtel de Bourrienne (which belonged to Bonaparte's secretary and was decorated by Etienne-Chérubin Leconte), new shapes and new motifs appeared that would become some of the most familiar of the Empire style.

In its main features the Consulat style did not differ greatly from the Directoire. A taste for smaller rooms and boudoirs, for Pompeian colors and wall decoration, persisted, and many allegorical figures and motifs of *athéniennes* (classical tripods) adorned panels and doors. A taste for dainty pieces of furniture such as gueridons (small tables), jardinieres, and worktables was also common to both, as was the use of mahogany. Furniture became richer as prosperity increased. Delicate inlays of pewter, ebony, and ivory characterized the best seats by the frères Jacob, whose partnership lasted from 1796 to 1803. Many of their most interesting works were seats; as in Directoire the backs were turned slightly outward and continued in one supple line into saber feet. In their later works, the linear Directoire motifs of lozenges, *soupières*, or striped squares and rectangles were replaced by more sculptural elements. These were still drawn from antiquity, whether masks, bronze or pewter stars studding the mahogany, or delicate flowers lining the beautiful silks and muslins commissioned by Josephine from the Lyons silk weavers.

But during the Consulat classical and Egyptian figures and animals became more prominent. The swans on Madame Récamier's bed were widely imitated.

Consulat or early Empire wall decoration in the Hôtel de Brancas et Laplace, Paris, photograph reproduced in Les Vieux Hôtels de Paris, *1934. BIBLIOTHÈQUE NATIONALE, PARIS*

Many seats and tables had legs in the shape of animal hocks. Caryatids, chimeras, griffins, and Egyptian heads increasingly appeared as three-dimensional front posts on case furniture. Made of gilded or patinated bronze or of "bronzed" wood, these same motifs were remarkably carved arm stumps in the work of Bernard Molitor and the frères Jacob.

These latter elements were still full of grace during the Consulat years, but as the Empire settled in they became more rich and ponderous. Little by little figures and animals would almost vanish, giving way to thick and stylized floral motifs, acanthus leaves, cornucopias, heavy branches of ivy and vine, and crowns and garlands of laurel and oak leaves.

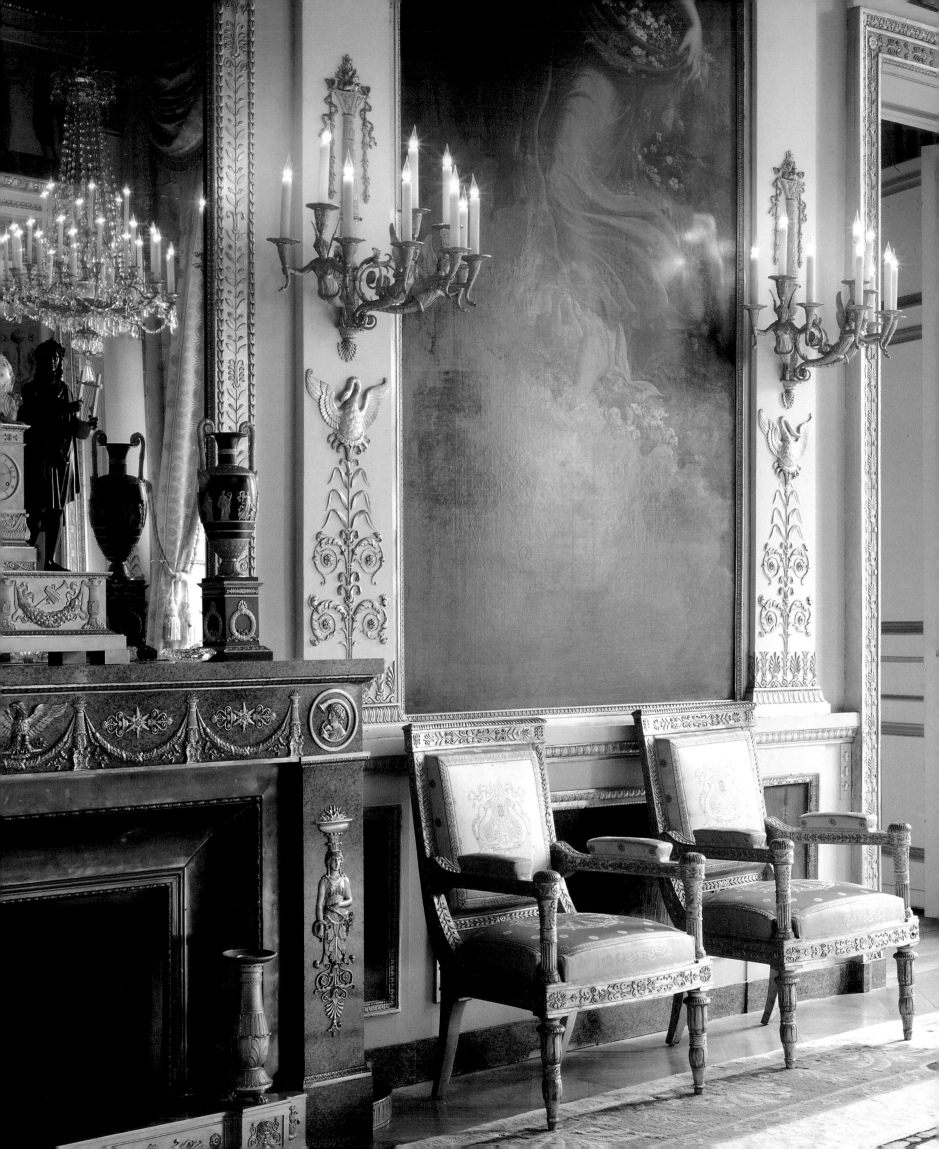

THE NAPOLEONIC EMPIRE

*I*n fast succession Bonaparte became premier consul in 1799, consul-for-life in 1802, and emperor in 1804. Thus twelve years after the monarchy was abolished and Louis XVI was guillotined, Napoleon was named emperor of the French "by the grace of God and the constitutions of the Republic." A national plebiscite approved this action by a very large margin: France longed for a guide, legislator, and maker of peace.

The country wanted peace, having been at war since 1792. But since 1796 Bonaparte had won victories over the European coalition and had signed peace treaties with Austria and England. He had also restored peace within France, signing an armistice with the still very active royalists. Of great importance, too, he had agreed upon a concordat with the pope, settling relations that had been badly strained and a major source of social tension since the Revolution. After revolutionary anticlericalism a revival of Christian faith was manifest in France, which Napoleon realized could be useful to his political plans. At the same time, however, he maintained the equality and freedom of worship recently gained by Protestants and Jews. He now wanted to give France a new direction.

Mahogany column with Napoleon's coat of arms in gilt bronze by Pierre-Philippe Thomire (1751–1843). One of a pair, these decorative columns were used to hold billiard cues. Thomire also made bronze eagles that were mounted on standards and became insignia for each regiment of Napoleon's army.
GALERIE BERNARD STEINITZ, PARIS

PAGE 52: Salon of the Four Seasons, Hôtel de Beauharnais, Paris. The paintings of the four seasons were formerly attributed to Pierre-Paul Prud'hon, but now more realistically to Anne-Louis Girodet (1767–1824), who painted works on the same theme for the Platinum Study in the Casa del Labrador in Aranjuez, Spain, 1802–3, and later for the empress's bedroom in the château de Compiègne. On the green granite chimneypiece is a clock by Revel, its bronze work attributed to Pierre-Philippe Thomire (1751–1843).

Despite his swift rise to power Napoleon was quite aware that he had to legitimize the Empire he had established. The sumptuous pageantry of the coronation ceremony and the style and symbols he chose thus became crucial to the image he wished to impose upon the world. He wanted to institute a hereditary monarchy modeled on the Carolingian empire. On a symbolic level this involved having himself crowned by the pope, just as Charlemagne had been in the year 800; his crown was said to resemble the medieval emperor's, and he chose as an emblem the bees found on Merovingian jewels. Part of Napoleon's attraction to the Carolingian empire lay in its claim to have descended from the Roman Empire, for he, too, wished to link his own empire to Roman antiquity. Another emblem he adopted was the imperial eagle, which was of Roman origin.

The majesty and grandeur of Rome were to become Napoleon's model. In private life he was a very simple man, as many people remarked, but where the state was concerned he had a taste for magnificence and theatricality. A first public manifestation of this taste came with the fetes and military ceremonies he ordered. These were staged by Jacques-Louis David, who had organized the Revolutionary fetes and had been commissioned to design civic costumes and uniforms for the Republic. David, along with the painter Jean-Baptiste Isabey and the architects Percier and Fontaine (who had designed sets for the Paris Opéra in the 1790s), also planned the coronation, an extraordinary ceremony held in Notre Dame and admired even by Napoleon's detractors. Isabey was responsible for designing the costumes, and David later depicted the event.

Napoleon's idea of order was naturally that of a general who attached importance to distinctions and knew that people are flattered by honors. In his grand plan to restore order in France he was intent on giving the country a new social hierarchy, so all public institutions and administrations were organized in a strictly centralized system around national councils, ministries, civil services, and departmental prefectures. Honorific distinctions carrying great social significance were also instituted, among them the Legion of Honor, which he created in 1802, and the Arms of Honor. These awards were not given out freely but were bestowed on men who had been heroic in battle or were skillful diplomats, administrators, or businessmen. Napoleon knew that his regime had to rely essentially on such members of the middle class, a bourgeoisie that had grown since the Revolution and supported his policies because it owed its wealth to the

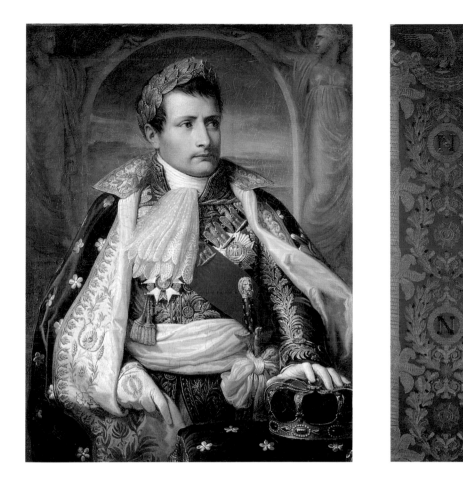

new economic order. His hierarchical system opened the path of social success to these "men of talents," as he liked to call them.

Because he came from a noble but poor family and had risen to power so rapidly, Napoleon always felt the need to be acknowledged by his social betters. He had married the graceful and attractive Josephine because he was very much in love with her—she was one of the most elegant women of her time, and Bonaparte was impressed by her manners and her worldliness—but also because she was part of the fashionable Directoire society. She had been the mistress of director Barras, she knew everyone of note, and she had many friends among the aristocracy, some of whom she had met in prison during the Terror.

Napoleon made a great effort to unify a country that had been severely torn by civil war, and both he and Josephine strove to bring together the old and the new France. Josephine, in fact, was the one who first started inviting members of the former aristocracy to Malmaison and the Tuileries, and Napoleon soon encouraged the return of the émigrés, including some exiled aristocrats who resumed quiet lives in the Faubourg Saint-Germain and others who obtained prominent civil and military appointments. But the former nobility scorned the new society and for quite a while refused to come to the new court. Napoleon

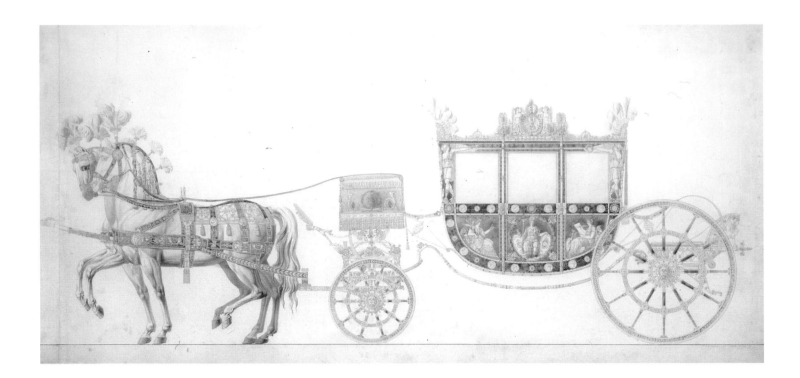

Design for the Emperor's Carriage,
*c. 1804, Charles Percier (1764–1838)
and Pierre-François-Léonard Fontaine
(1762–1853), watercolor.* COLLECTION
HERMÈS, PARIS

persisted in building up court life, however, surrounding his throne with digni-
taries and finally founding the Nobility of the Empire in 1808. France's aristoc-
racy dated back to the Middle Ages, and Napoleon's institution of a nobility of
his own creation at first seemed ludicrous to the former one. But he was right in
seeing it as a link between the two societies, which he wanted to reconcile. And
despite their initial haughtiness, part of the old nobility did slowly accept the
new. France once again had princes and counts who partook in the pomp of the
monarchy, although they did not have any of the financial and legal privileges
of the ancien régime's nobility.

COURT AND FASHION

Napoleon, whose main residence was the Tuileries, re-created a veritable court
around himself during the early years of the Empire. The emperor's household
included a grand chaplain, a grand marshal of the palace, many chamberlains,
and masters of ceremony (the councillor comte de Ségur brought all his knowl-
edge of the king's court to this new one). A protocol was established that became
stricter as the years went by and influenced both the life and the furnishing of
the palaces.

 Napoleon was not a socialite: indeed he spent very little time at the balls,
presentations, and festivities that he ordered, and preferred reading books or

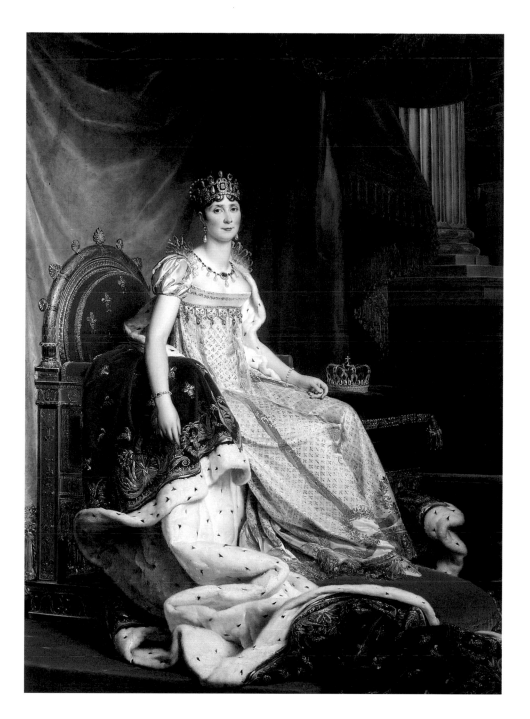

Empress Josephine in Her Coronation
Dress, *1807–8, François, baron Gérard
(1770–1837), oil on canvas, 84⅝ × 63 in.
(215 × 160 cm).* MUSÉE NAPOLÉON
IER À FONTAINEBLEAU

*Josephine's cloak was made by the Leroy and
Rimbaud company; her diadem, by Bernard
Armand Marguerite (active 1804–15).
The throne was made by François-Honoré-
Georges Jacob-Desmalter (1770–1841) for
the château de Saint-Cloud, after designs by
Percier and Fontaine.*

seeing the famous actor Talma at the Comédie Française to such frivolous, but
in his eyes necessary, events. The comtesse de Boigne recalls in her memoirs
how astonished she was by the little time Napoleon spent with his guests. When
he did take time, however, he was courteous and above all incredibly perspica-
cious—"Il savait tout," said the duchesse d'Abrantès.

Josephine played an important role in the shaping of the new court. She
had been born in the West Indies, and her languid Creole behavior provided a
mellow transition from the flighty Directoire society to a restrained court life.
Once a Merveilleuse, she had become a genteel hostess at Malmaison and had

given dignity to a young society. She soon introduced the idea of *bon genre* (gentility) to the court, and the light apparel of the Directoire gave way to more formal wear. Dresses retained the main features of neoclassical Directoire fashion and, with slight differences, became absolutely characteristic of the Empire: a high waist, a long, supple skirt, a low-cut neckline, and small, usually puffed sleeves. Despite Napoleon's conservative taste Josephine could not give up her predilection for muslins, plain or embroidered, for the feminine tulles, gauzes,

Portrait of a Lady in Elegant Dress, *c. 1810, Henri-François Mulard (1769– 1850), oil on canvas, 39 × 31 ¾ in. (99.1 × 80.7 cm).* PRIVATE COLLECTION

Portrait of Pauline Bonaparte, *Jean-François Bosio (1764–1827).* *GALERIE DIDIER AARON, PARIS*

Jean-François Bosio, brother of the sculptor François-Joseph Bosio and a student of David, was one of the most fashionable portrait painters of his time. Pauline is shown here with what appears to be a version of Cupid and Psyche *by Antonio Canova (1757–1822), who received many commissions from the Bonaparte family.*

and crepes that she and her friends had brought into vogue, or for the sumptuous cashmere shawls that she draped in all ways.[1] But necklines and transparencies during these years grew a little more modest in deference to Napoleon, who also ruled that only French fabrics be used in order to support the textile industry.

Fashion at court was a sign of the evolution of the Napoleonic regime; after so many years of changing fancy, dress became codified as court life became more sumptuous and formal. Just as Josephine's taste influenced French and other European women's fashions, Napoleon's set the style for men. In court ceremonies men did not sport the dark *redingote* (from the English "riding coat") that they ordinarily wore. Instead, if they were not in military or civil uniform they were to wear the *habit à la française*, a ceremonial court costume that

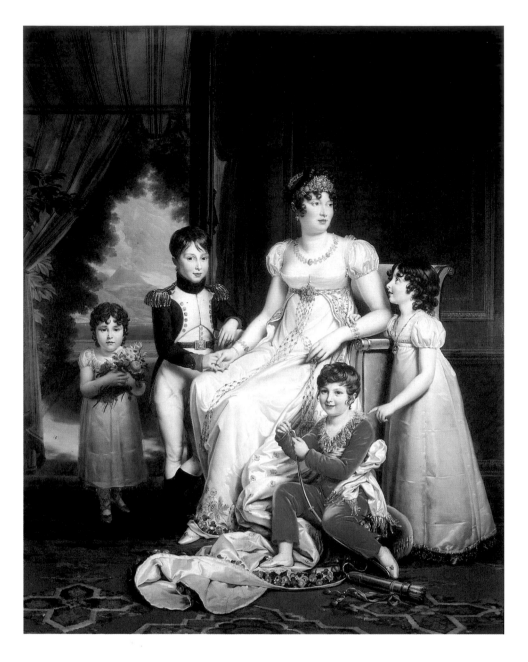

Caroline, Queen of Naples, and Her Children, *1808, François, baron Gérard (1770–1837). Château de Fontainebleau*

recalled the pomp of Versailles and was composed of coat, mantle, waistcoat, breeches, and stockings. The *habit* was made of rich silks and velvets, marvelously embroidered, as were the court dresses and trains that women wore on such occasions. Whereas lace had been the luxury of the former aristocracy, embroidery was that of the new society. This art was encouraged by Napoleon, who had the imperial bees and neoclassical palmettes and frets introduced into the wonderful floral vocabulary of the embroiderers.

The master of the lavish Empire fashion for women was Josephine's couturier, the ambitious and outrageously expensive Louis-Hippolyte Leroy. Napoleon was constantly irritated by the huge bills that came from Leroy, but the couturier dressed everyone with a name from Rome to The Hague—

Josephine's daughter, Hortense de Beauharnais, the duchess of Wellington, and the queens of Spain, Bavaria, and Sweden were among his clients.

Josephine also had a passion for jewels, and she owned splendid stones and pearls of the most extraordinary color and quality. She set the fashion for very elaborate jewelry, which was particularly highlighted by the low neckline and simple shape of the Empire dress. Josephine, Marie-Louise (Napoleon's second wife), and Napoleon's sisters owned parures, matching sets comprised of a diadem, a comb, a bandeau worn on the forehead, a necklace, bracelets, earrings, and a belt. The jeweler to both empresses, Etienne Nitot, made Marie-Louise's wedding parure as well as Napoleon's coronation crown and a tiara given by Napoleon to the pope. Among the most exquisite pieces of Empire jewelry were cameos in the antique manner, of which Josephine, Napoleon's sister Caroline, and Napoleon himself were especially fond.

In all classes of society, women followed the fashions set by Josephine. From the discreetly dressed Parisienne to the respectable provincial bourgeoise and the more heavily clad wives and daughters of wealthy peasants, all were aware of Parisian fashions through the many imaginative magazines that flourished after the Revolution: *Le Journal des dames, Le Journal des modes et des nouveautés, La Correspondance des dames, La Revue du suprême bon ton, L'Elégance parisienne, Le Messager des dames ou le portefeuille des amours.* . . . The most famous of these was *Le Journal des dames et des modes*, which Pierre de La Mésangère took

Gold parure with carnelians and pearls.
MUSÉE DES ARTS DÉCORATIFS, PARIS

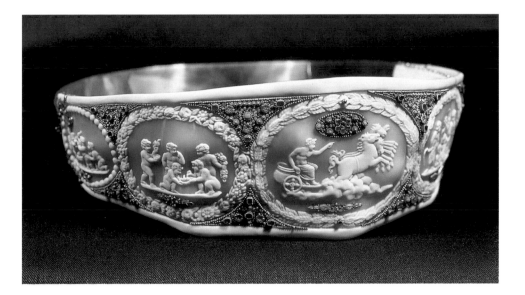

Empress Josephine's cameo diadem, artist unknown, shell, gold, pearls, and precious and semiprecious stones, 2⅝ × 6¾ × 7⅞ in. (6.7 × 17 × 20 cm). MUSÉE MASSÉNA, NICE

This diadem was carved from a single shell and was given to Empress Josephine by Joachim Murat.

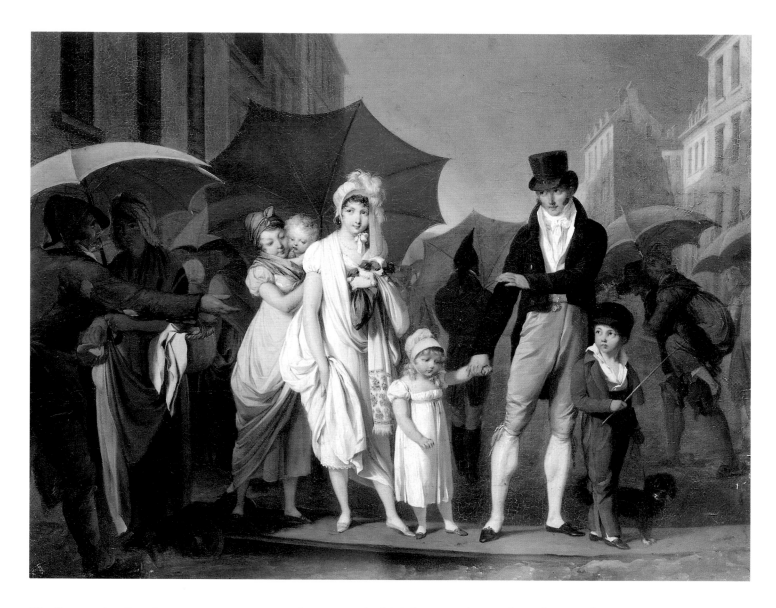

The Shower, *1811, Louis-Léopold Boilly (1761–1845), oil on canvas, 12⅝ × 15¾ in. (32 × 40 cm). LOUVRE, PARIS*
Large umbrellas, muslin dresses, a cashmere shawl, a reticule, and light, pointed shoes are all indications of a fashionable family.

OPPOSITE: Josephine and her Entourage at Lake Garda, *1805–6, Hippolyte Lecomte, oil on canvas, 43¾ × 75⅝ in. (111 × 192 cm). MUSÉE NATIONAL DU CHÂTEAU DE VERSAILLES In 1796 Josephine and her entourage were joining General Bonaparte in Italy, when they were caught in a barrage of enemy fire.*

over in 1799 and which became almost the only one after he absorbed most of the other magazines. La Mésangère's publication was imitated in many countries and helped diffuse French fashion. The international impact of French dress was heightened further by Josephine and the wives of high-ranking dignitaries and military men who often traveled with their husbands to various parts of the Empire with trunks full of dresses, which were much admired in European courts and cities.

Josephine gave life at court an atmosphere of ease and grace that grew more difficult to maintain as Napoleon's rule started to become more imperious about 1806. Etiquette became stiffer, imperatives in decoration became stricter, and

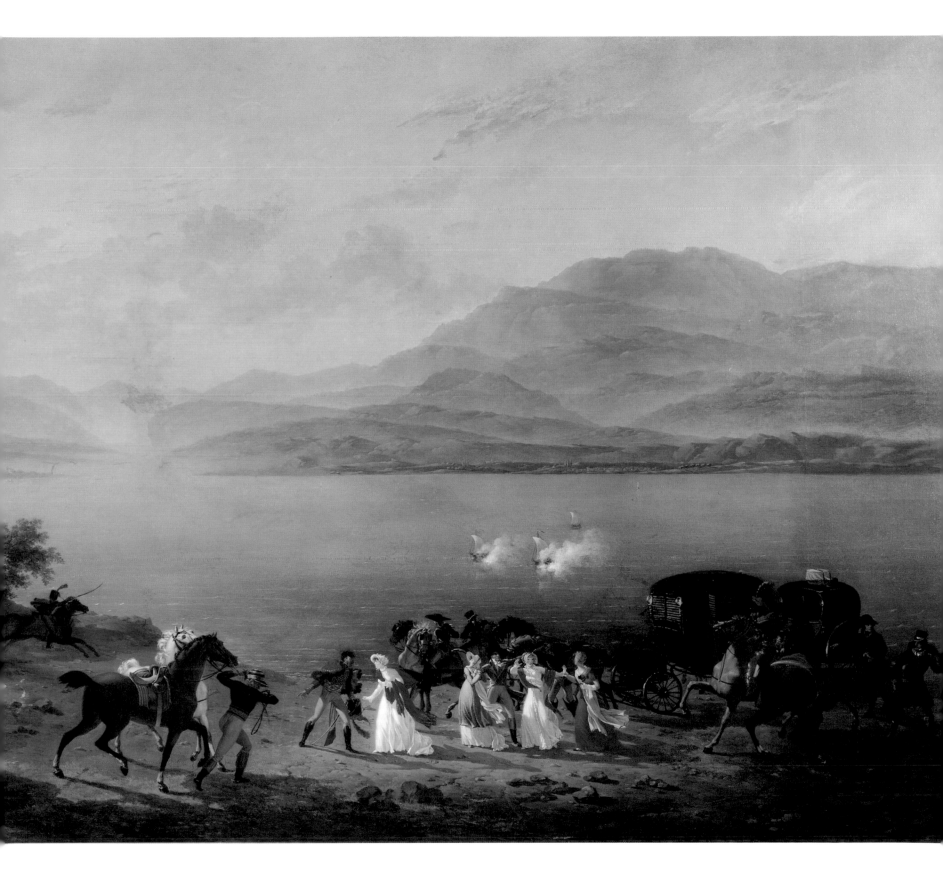

women lost the freedom they had gained in the Revolution. This change showed in fashion, which covered more and more of women's bodies. Their hair alone remained natural, and wigs never came back into style. But most important, women were increasingly looked upon as wives and mothers, primarily by Napoleon himself. The civil code he instituted in 1804 was in many ways a remarkable system of laws; it reflected the liberal evolution of society and was the origin of modern law in France and several other European countries. But it strengthened the husband's authority within the family and enforced a return to prerevolutionary days in regard to women.

As the Empire grew, one concern dominated Napoleon's mind: Josephine

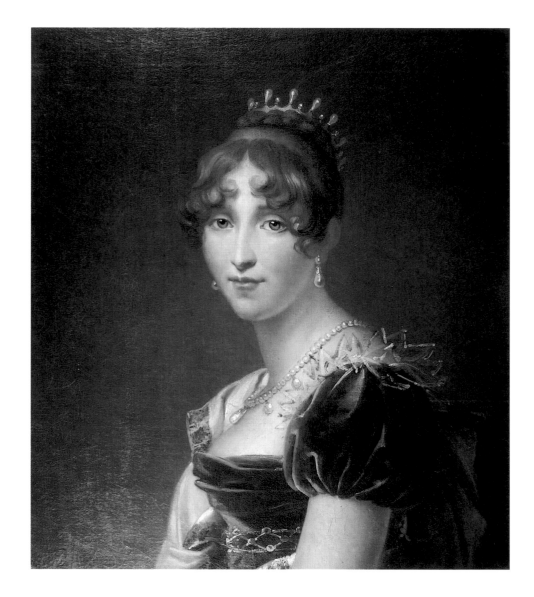

Hortense de Beauharnais, *François, baron Gérard (1770–1837), oil on canvas, 34½ × 30 in. (87.6 × 76.2 cm).* ASH LAWN–HIGHLAND MUSEUM, CHARLOTTESVILLE, VIRGINIA

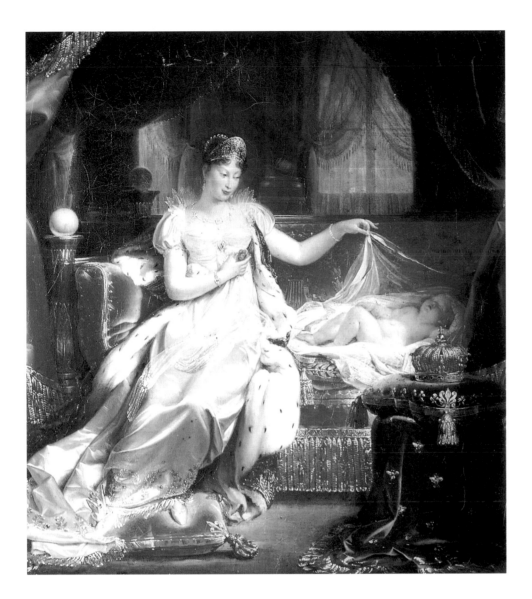

Empress Marie-Louise and the King of Rome, *Joseph Franque (1774–1833), oil on canvas, 20½ × 17¾ in. (52 × 45 cm).MUSÉE NATIONAL DU CHÂTEAU DE VERSAILLES*

This painting was first exhibited at the 1812 Salon.

could bear him no heir. Numerous treatments had had no effect. After long hesitations and consultations he reluctantly, and to Josephine's great despair, repudiated her in 1809, when she retired to her beloved Malmaison.

The next year Napoleon married a Habsburg archduchess, the daughter of his longtime enemy Francis I of Austria, who had been forced to renounce his crown as Holy Roman Emperor. The eighteen-year-old Marie-Louise was too young to influence court life. Described as "a fine slip of a girl" by the comtesse de Boigne, fresh even if a bit too rosy, she seemed insensitive to all things, including the attention bestowed upon her and the lavish presents she was given. Later, however, she willingly acknowledged that Napoleon

was extremely kind to her and that she was not unhappy during her years as empress. In 1811 she gave birth to a son, whom she neglected but who was Napoleon's pride. Everyone who saw him with his son was touched by his extreme tenderness toward the boy and by the attention he paid to his education. Napoleon was generally very interested in educational matters—at least for boys and young men—and he developed the French school and university system.

URBANISM AND ARCHITECTURE

Few rulers have been more concerned with urbanism and architecture than Napoleon. He commissioned innumerable projects, restored most of the royal palaces of the ancien régime, and all through his reign bought castles and hôtels, which he renovated and gave to members of his family. He knew he would be acknowledged and remembered by the splendor of his buildings: "Men are only as great as the monuments they leave behind," he remarked in 1804.[2] He also understood that a vast program of civic improvement was required.

Napoleon was known to prefer engineers to architects, whom he distrusted and accused of ruining the state. A former artillery officer, he had an engineer's mentality and favored military and civil engineers, particularly those who came from the Ecole Polytechnique, opened under the Directoire, and from the Ecole des Ponts et Chaussées, the famous school of civil engineering. The military architecture that Napoleon built throughout Europe constituted a formidable network of fortresses, arsenals, naval dockyards, and maritime forts, comparable to that built by Vauban for Louis XIV. The array of French military structures extended from the Atlantic Ocean to the Rhine, from the mouth of the Elbe to the Apennines. He also built a vast network of roads, which permitted fast transportation within the Empire.

Napoleon had great plans for the cities of the Empire, but because his reign was so short and because the wars he waged were so costly, very few were carried out. In 1798, when he was but a general, he had said, as if in a dream, "If I were the ruler of France, I would want to make Paris not only the most beautiful city

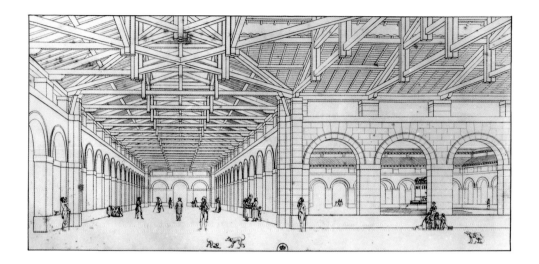

The New Saint-Germain Market, *1816,*
by Jean-Baptiste Blondel and Adrien-Louis
Lusson, print by the Devilliers brothers.
BIBLIOTHÈQUE NATIONALE, PARIS

A vast and rigorously designed structure, the
Marché Saint-Germain was influenced by
Jean-Nicolas-Louis Durand's theories.

in the world, that the world has even known, but the most beautiful city that could ever be."[3]

But Napoleon was a realist, and he knew that aesthetic idealism was not the only reason to undertake important building projects. Equally important were political motives: when he launched major projects of public utility, giving work to more than 25,000 people, it was to keep social unrest and food shortages at bay, as well as to compensate for the toll that his wars and the Continental Blockade were taking.

In Paris insufficient water and poor public sanitation were serious problems. Foreigners were always dismayed by the filth and stench that marred such an otherwise remarkable city. The city's water supply was scarce and unhealthy, coming from a few springs but also pumped from the Seine. To improve the situation Napoleon had important works undertaken to divert waters and bring them to the center of Paris, where he erected fountains. He further organized city life by ordering that houses be numbered, that slaughterhouses and markets such as Jean-Baptiste Blondel's Marché Saint-Germain be built, that streets and canals be cut, and that bridges be constructed: the Pont d'Iéna, the Pont de la Cité, the Pont des Arts, the Pont d'Austerlitz. He had cemeteries designed on the edge of town, including the Montmartre and Montparnasse cemeteries and the Père Lachaise by Alexandre-Théodore Brongniart. The emperor encouraged new building techniques such as the use of iron for the Pont des Arts by S. Becquey de Beaupré, for the dome of the grain market by François-Joseph Bélanger (the architect of Bagatelle), and for the structure of the ceiling of the Grand Salon in

Arc de Triomphe du Carrousel,
*Pierre-François-Léonard Fontaine
(1762–1853), drawing, reproduced in
the* Journal des monuments de Paris
sent to the emperor of Russia, 1809.
BIBLIOTHÈQUE NATIONALE, PARIS

*This view of the Arc de Triomphe du
Carrousel looks toward the entry façade
of the Tuileries Palace.*

*Dessert plate from the Service des Quartiers
Généraux, 1808–9, Sèvres porcelain, scenery
painted by Nicolas-Antoine Lebel, figures
by Jacques-François-Joseph Swebach
(1769–1823).* COURTESY SOUVENIR
NAPOLÉONIEN, PARIS

*The Tuileries Palace and the rue de Rivoli
are depicted on this plate.*

the Louvre. He followed all these projects personally, even from distant cities or battlefields, demanding detailed reports and appointing his own inspectors.[4]

When Napoleon began his efforts Paris was still very much a medieval city where building had gone on somewhat haphazardly over the centuries in a number of neighborhoods. Despite magnificent architecture and even city planning by Louis XIV and Louis XV, unsafe slums remained at the very door of the Louvre and Tuileries palaces. Bonaparte had been made quite aware of this when he suffered an assassination attempt on Christmas Eve 1800: as he and Josephine were on their way to the Opéra to listen to Haydn's *Creation* a bomb exploded next to their carriage on the rue Saint-Nicaise, one of the narrow streets between the two palaces. As a result, the old neighborhoods in this area and around the Tuileries gardens were cleared, and long-delayed projects of the former kings to link the two palaces were revived. Percier and Fontaine erected the Arc de Triomphe du Carrousel (modeled after the arch of Septimus Severus in Rome), opened the rue de Rivoli from the Concorde to the Louvre (it would be length-

ened in the time of Napoleon III), and completed the plan by establishing two perpendicular streets, rue de Castiglione and rue des Pyramides. The overall design and the elegant and modernized Palladian façades gave a new sense of space and dignity to the center of Paris.

The scale of Napoleonic buildings was monumental. As his architect Fontaine said, "The emperor was loath to find beauty anywhere else than in grandeur; he could not conceive that one might separate these two traits one from the other."[5] And the space in which the buildings were set was equally monumental. Blocks were demolished around Notre Dame and the Louvre so that the two structures would stand out. Similarly, new buildings were set in vast open areas to enhance their importance. This was all the more striking since most important buildings were constructed in the antique style and were imposing in their own right. La Madeleine, which was initially conceived as a Temple of Glory, was modeled by Barthélémy Vignon after the Parthenon in 1806. The Bourse, or stock exchange, built in 1808 by Alexandre-Théodore Brongniart, was isolated in the center of a square with a sixty-six-column Corinthian peristyle. And the Arc de Triomphe de l'Etoile, begun by Jean-François Chalgrin in 1806, was planned as the western entrance to Paris on the top of a hill.[6] Many minor commemorative monuments were also erected in the provinces and abroad.

Architecture was the only art of the Empire that was significantly influenced

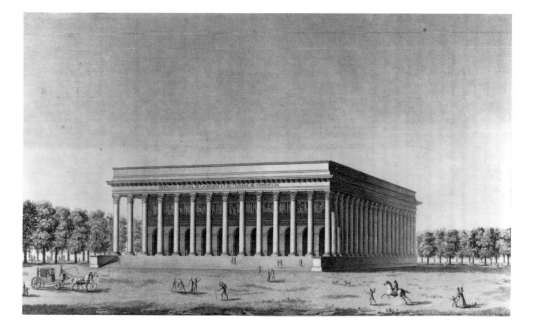

View of the Imperial Palace of the Bourse, *1814, Jacques-Louis Le Cerf, print.* BIBLIOTHÈQUE NATIONALE, CABINET DES ESTAMPES, PARIS

The Bourse, or stock exchange, was built in 1808 by Alexandre-Théodore Brongniart.

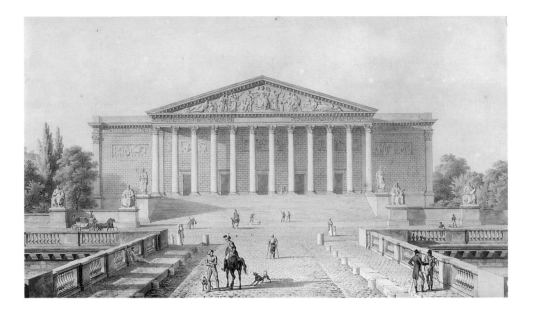

Project for a new pediment for the National Assembly, 1815, Alexandre-Evariste Fragonard (1780–1850), print. *Bibliothèque de l'Assemblée Nationale, Paris*

Rue des Colonnes, Paris. Note the primitive Doric-style columns, which were thought to be typically antique in the years right after the Revolution.

by Greece; the decorative arts drew more strongly on Rome and Pompeii. In fact, in the years following the Revolution architecture was influenced by the very early style of the temples of Paestum. This primitive Doric style was copied as typically antique until more refined examples were studied. In Paris a very small street, rue des Colonnes, was built with columns in this primitive style.[7] Many of the city's public buildings were renovated in a neoclassical mode: the Senate within the Luxembourg Palace was restored by Chalgrin; the Bourbon Palace was given a new façade by Bernard Poyet; the Collège des Quatre Nations, which became the home of the Institut de France in 1805, was refurbished by Antoine Vaudoyer.

Despite the many designs Napoleon commissioned and the few that were actually carried out, the capital was not really transformed during his reign, and no distinct urban plan emerged. Within France the only true imperial city planning was implemented in two little towns in Vendée, a royalist and rebellious province south of Brittany that needed attention: Pontivy and La Roche-sur-Yon were given a rational modern layout and architecture for their public buildings. Napoleon visited the provinces frequently, for he always wanted to know of the state of the country firsthand, and his visits were of consequence for the local administrations. He often redistributed buildings of public interest, as in Toulouse, where after his visit in 1808 major urban work was undertaken that would be pursued throughout the nineteenth century.

During the Empire there were not only builders but also theoreticians and teachers. The most influential of these was Jean-Nicolas-Louis Durand, who had

studied and worked with Etienne-Louis Boullée and who taught for forty years at the prestigious Ecole Polytechnique. His lectures were published between 1802 and 1805, strongly marking the vigorous and sober neoclassicism of the time. The writings of the archaeologist Quatremère de Quincy also encouraged architects and artists to imitate classical antiquity.

Several architects had important roles in rich and active provincial cities. Louis Combes, an engineer of civil buildings and a teacher, imposed a neoclassical clarity on the public structures of Bordeaux. Mathurin Crucy, a student of Boullée and a classmate of David at the Académie de France in Rome, gave Nantes remarkable neoclassical public and private architecture. Many others worked abroad in the Napoleonic states.

PERCIER AND FONTAINE

Charles Percier and Pierre-François-Léonard Fontaine—the two architects Napoleon learned to trust—became the official architects of his grand schemes.[8] The architecture of the Empire was said to be one of projects rather than completed achievements, and Percier and Fontaine did outline many new buildings or transformations of existing palaces that could not be finished, or even begun, before the fall of Napoleon. The most ambitious of these projects was the Palais du Roi de Rome, a colossal palace that Napoleon wanted to build on the hill of Chaillot (the present Trocadéro) for the son he adored and had named king of Rome.[9]

Because many more buildings were renovated than constructed, Percier and Fontaine were much more important as decorators. From the time of the Consulat they were responsible for the expansion, renovation, and especially the decoration of the state palaces. After Malmaison they renovated the antiquated Tuileries, the court's main residence, building a grand staircase, a chapel, and a theater. They restored the Louvre, which was in part a museum and was also used by the emperor for receptions and official ceremonies. They were also in charge of the restoration and decoration of most of the other imperial residences— the châteaux of Saint-Cloud, Fontainebleau, Compiègne, Rambouillet, Le Raincy, Eu. So extensive was their influence that they were compared to Charles Le Brun, who wasall-powerful in the arts in the time of Louis XIV.

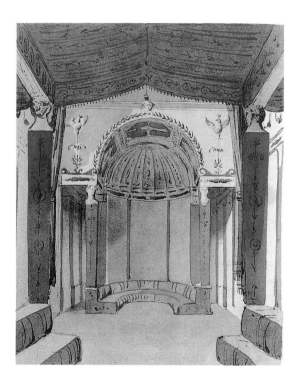

Room with an Alcove, *Charles Percier (1764–1838), watercolor.* BIBLIOTHÈQUE NATIONALE, PARIS

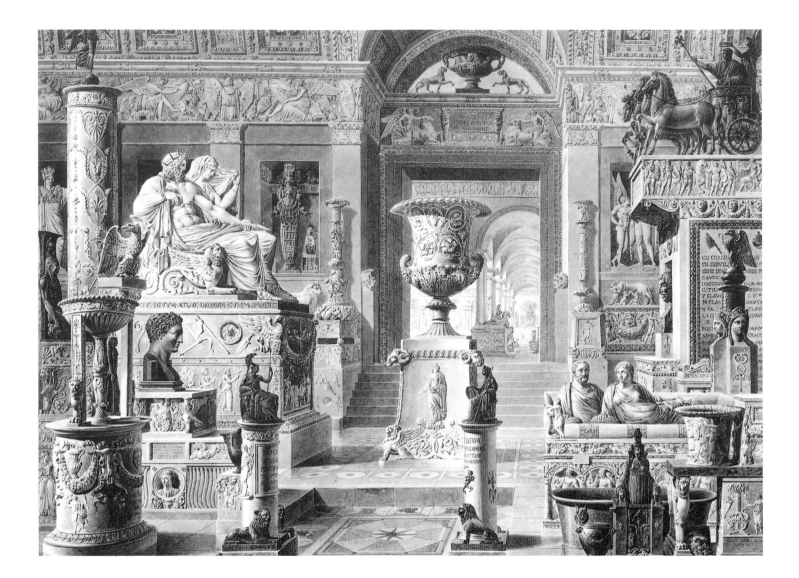

Project for the Interior of a Museum,
*Charles Percier (1764–1838), shown at the
1796 Salon, drawing, black ink, gray wash,
18¼ × 23 in. (46.5 × 58.5 cm).* MUSÉE
VIVENEL, COMPIÈGNE, FRANCE

*This little-known drawing provides an
important early indication of Percier's
decorative vocabulary, which borrowed from
Greek, Roman, Etruscan, and Egyptian
antiquity. Two years later, with the
publication of Percier and Fontaine's* Palais,
maisons et autres édifices modernes
dessinés à Rome, *this vocabulary began to
become widely known.*

Percier and Fontaine both had vast archaeological grounding. After their
studies in the architect Antoine Peyre's school, where they met, they spent sev-
eral years in Rome: Percier had won the Grand Prix de Rome, allowing him to
reside and study at the Académie de France in Rome, and Fontaine had joined
him there. They brought back extremely precise drawings and published many
of them,[10] intending them as a source of inspiration not only for their own future
works but also for the work of countless architects and decorators. Under Percier
and Fontaine's influence classical antiquity was quoted much more rigorously
than it had been in the eighteenth century, when it was above all a repertory of
decorative motifs. Fantasy and Pompeian charm gave way to archaeological pre-
cision. Fontaine had also spent some time in England, where he apparently
became friends with Robert Adam and Thomas Hope and well acquainted with
the contemporary arts. This explains why some ideas were common to the deco-
rative arts on both sides of the Channel at about the same time.

The association of Percier and Fontaine was to be unique. Fontaine, the more worldly and business-minded architect, was granted the honors, while Percier, the artist of the team, drafted interiors, furniture, and objects.[11] Indeed an important feature of their work, though not an innovation, was the overall unity they gave their compositions: elements of architecture, wall decoration, wood paneling, furniture, and objets d'art were all conceived together for a particular place.

From their years in Rome they had retained a taste for colossal orders and stark geometric forms that was quite in keeping with Napoleon's requirements. Their interior architecture was majestic and cold, as in their Salle des Maréchaux in the Tuileries, which evidently resembled the Erechtheum. Also inspired by antiquity, and by the Renaissance interpretation of it, were the architectural elements they used in their ceilings and cornices and the strict symmetry of their tall, rectangular wall panels, doors, pilasters, and columns.

Their immensely influential *Recueil de décorations intérieures comprenant tout ce qui a rapport à l'ameublement* was published in the form of plates from 1801

Lantern with caryatids, after a 1798 drawing by Charles Percier (1764–1838), black patinated bronze and silvered bronze, a rare juxtaposition. GALERIE DIDIER AARON, PARIS

The Bedroom and Studio of Citizen I., Charles Percier (1764–1838) and Pierre-François-Léonard Fontaine (1762–1853), plate from Recueil de décorations intérieures . . . , BIBLIOTHÈQUE DES ARTS DÉCORATIFS, PARIS

onward and as a completed book in 1812.[12] The plates were all the more interesting because most were not just proposals but real interiors produced for clients. The *Recueil* was as bountiful a source for craftsmen, *ébénistes*, bronze makers, and goldsmiths as it was for decorators and *tapissiers* (upholsterers), both in France and throughout Europe. No other publication was as seminal in the first decade of the century, fostering many other pattern books in all languages. Fontaine, and especially Percier through his teachings, shaped a whole generation of architects, including Henri-Alphonse Guy de Gisors, Louis-Hippolyte Lebas, Achille Leclerc, Jean-Baptiste Lesueur, and Louis Visconti.

Among the main *ornemanistes* who also provided patterns for decorators and upholsterers was Jean-Démosthène Dugourc; his long and prolific career spanned the time of Louis XVI to that of Louis XVIII. He not only drew many patterns himself for furniture and silks but was also in charge of entire ensembles like the ones he conceived for the Spanish court. Another important *ornemaniste* was François Grognard, who worked for the Garde-Meuble Impérial[13] and for

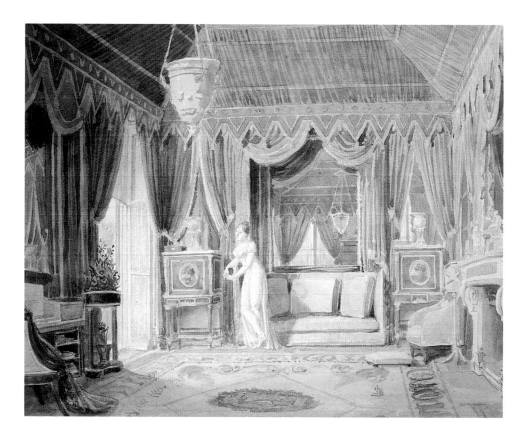

Queen Hortense's Boudoir, *1811, Auguste Garneray (1785–1824), watercolor.* COLLECTION OLIVIER LE FUEL, PARIS

The two pieces of furniture flanking the sofa are Louis XVI. The walls are covered with mirrors. The jardiniere is now at Malmaison. The large lantern is of alabaster.

the duke and duchess of Alba. Pierre-Nicolas Beauvallet and Charles Normand's *Fragmens d'ornemens dans le style antique* and many other publications popularized the style that was to become Empire. Some focused on motifs drawn from antiquity; others suggested furniture designs; still others—like La Mésangère's *Collection de meubles et objets de goût* and d'Hallevent and Osmont's *Cahiers de dessins pour le décor des appartements de Paris*—offered inventive ways of using materials to *tapissiers* and their clients. Like the fashion magazines, they showed charming examples of smaller and more feminine pieces of furniture—dressing tables, small gueridons (pedestal tables), *athéniennes* (tripods), jardinieres (plant stands), and sewing tables.

Pierre de La Mésangère played a particularly important role in spreading the Empire style. A former priest and professor of philosophy, he became a journalist after the Revolution and in 1797 became director of the *Journal des dames et des modes*. In 1802 he began publishing the *Collection de meubles et objets de goût*, which continued until 1835, four years after his death. Both these publications were immensely influential and imitated all over Europe. The *Collection*'s several hundred plates were pleasant, full of fantasy, and very detailed, providing a more bourgeois and less intimidating version of Empire. Other pattern books included Duguers de Montrosier's *Recueil* (1806) and Santi and Madame Soyer's plates, which in 1828 were still spreading the Empire style throughout Europe.

PALACE FURNISHINGS

The most sumptuous interior decorations were commissioned by Napoleon. Yet he was not extravagant: even with a wealth of residences at his disposal he refused to build, rebuild, and enlarge palaces as his various architects encouraged him to do. Most of the structures had been stripped of their furnishings by the Revolution and were in sad disrepair; hence Empire was more an art of the interior than of building.

Magnificent decors were created for the palaces, for the numerous hôtels and châteaux he bought, and for those he ordered his marshals and high-ranking officials to decorate for themselves as representatives of the French state and its crafts. Because of their superb quality, many of the official interiors remained

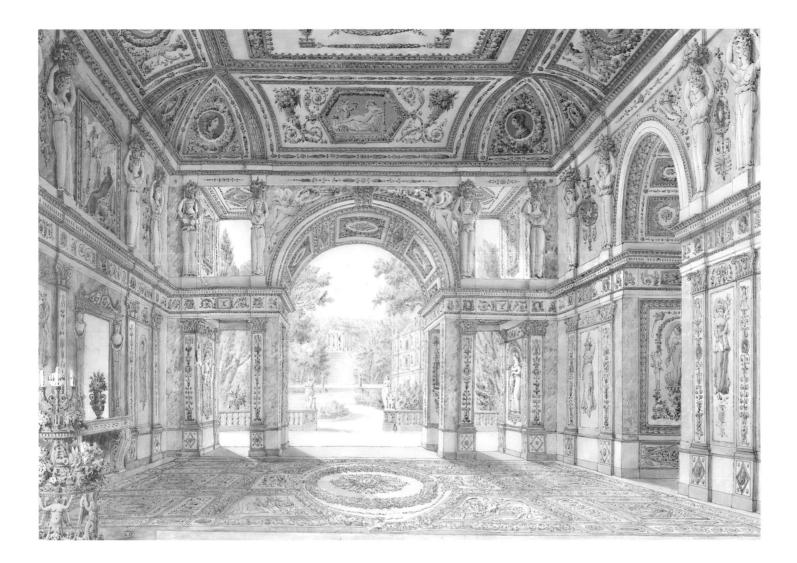

virtually unchanged by the kings who succeeded Napoleon. Two prestigious imperial residences outside Paris—the château de Fontainebleau and the château de Compiègne—have survived wars and monarchs and preserved most of their Empire decoration and furniture. But the château de Saint-Cloud was destroyed during the war of 1870, as was the Tuileries Palace during the upheavals of the Commune in 1871; the Louvre was converted into a museum, and most private hôtels were transformed by successive owners.

Percier and Fontaine were the great orchestrators of these decorations, especially after 1801 when they became the official architects of the government. Napoleon had appreciated their talent and efficiency at Malmaison; they had designed the project swiftly, organized and supervised the work diligently, and employed the best artisans of their time.[14] But the little château soon became too small, and Napoleon decided to settle in another residence not far from Paris, the château de Saint-Cloud, which Percier and Fontaine renovated in 1802.

Napoleon never wanted to live in Versailles, which he found too symbolic

Portico of a Palace Opening onto a Park, 1810, Louis de La Hamayde de Saint-Ange (1780–1831), drawing. MUSÉE DES ARTS DÉCORATIFS, PARIS

of the French monarchy. But he had the château restored, repairing the damage done by the revolutionary riots in which most of its furniture was lost. He had the Grand Trianon renovated for his mother, who found it insufficiently regal and spent little time there. In the back of the Trianon, Napoleon had a very small, pretty apartment decorated for himself with furniture by François-Honoré-Georges Jacob-Desmalter. The apartment opened onto a little enclosed garden; Napoleon favored small rooms with direct access to the outdoors, which he loved. Not far from Paris, he also had the château de Rambouillet renovated.

Napoleon was particularly fond of Fontainebleau. There, he said, he felt the passage of time, describing it in the *Memorial de Sainte-Hélène* as "la vraie demeure des Rois, la maison des siècles" (the true residence of kings, the home of centuries). Respectful as he usually was of former monuments, he transformed it only partially, renovating apartments on the ground floor and first floor of the wing Louis XV had built. The royal bedroom, which had become the Salon de l'Empereur in 1804, was transformed into a Throne Room in 1808, with furniture made by Jacob-Desmalter after drawings by Percier and Fontaine. But the seventeenth- and eighteenth-century decor remained unchanged. In Fontainebleau, too, Napoleon commissioned for himself a rather modest apartment

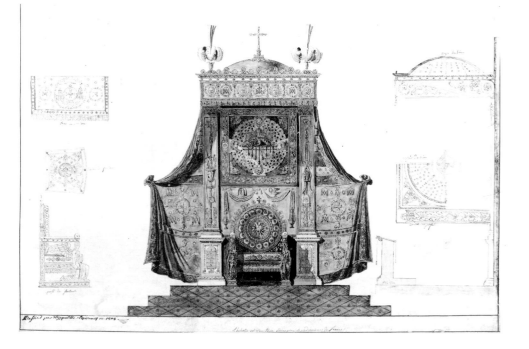

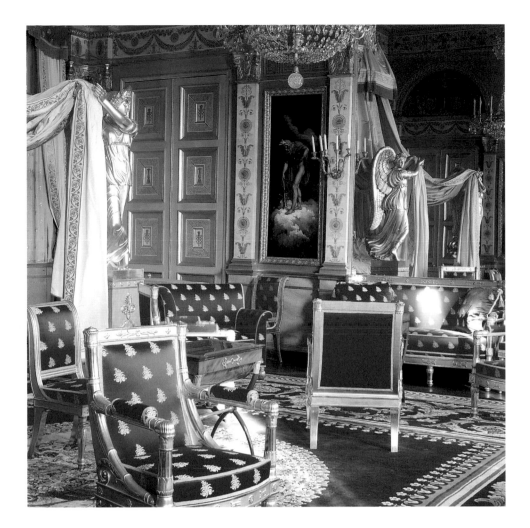

The empress's bedroom, château de Compiègne, decorated in 1808–9. The painted wall decoration is by the firm of Dubois and Redouté. The paintings are by Anne-Louis Girodet (1767–1824), 1814, who reprised works he had created for King Charles IV's Platinum Study in the Casa del Labrador, Aranjuez, Spain. The tapissier Darrac provided the rich textiles for the bed, which is by François-Honoré-Georges Jacob-Desmalter (1770–1841); its angels might have been Louis Berthault's idea. The rest of the furniture is also by Jacob-Desmalter. The chandelier is from the Mont-Cenis crystal works. The sconces are by Feuchère. The Aubusson carpet, delivered in 1811, has been rewoven.

overlooking a quiet garden, while the empress's rooms and the official rooms were grandly decorated.

At Compiègne, however, Napoleon undertook more radical transformations, which were planned by Percier and Fontaine and supervised by Berthault in 1807. Some rooms kept their ancien régime decor, but the empress's apartments, the library, and the emperor's bedroom were entirely redecorated. The renovation had just been completed in 1810 when Marie-Louise arrived from Austria; Napoleon brought his bride to the château.

Among the residences of the imperial family was the Hôtel de Beauharnais in Paris.[15] Eugène de Beauharnais, Josephine's son, had bought the Hôtel de Torcy, built by Boffrand, and ordered renovations. But when Napoleon appointed him viceroy of Italy in 1805 Eugène left his mother in charge of the renovation—hardly a wise choice, considering how extravagant Josephine was known to be. Napoleon, who loved his stepson dearly, was nevertheless irritated by the enormous sums spent, and he confiscated from Eugène what is undoubtedly one of the most beautiful and refined Empire ensembles, both in its decoration and in its furnishings.

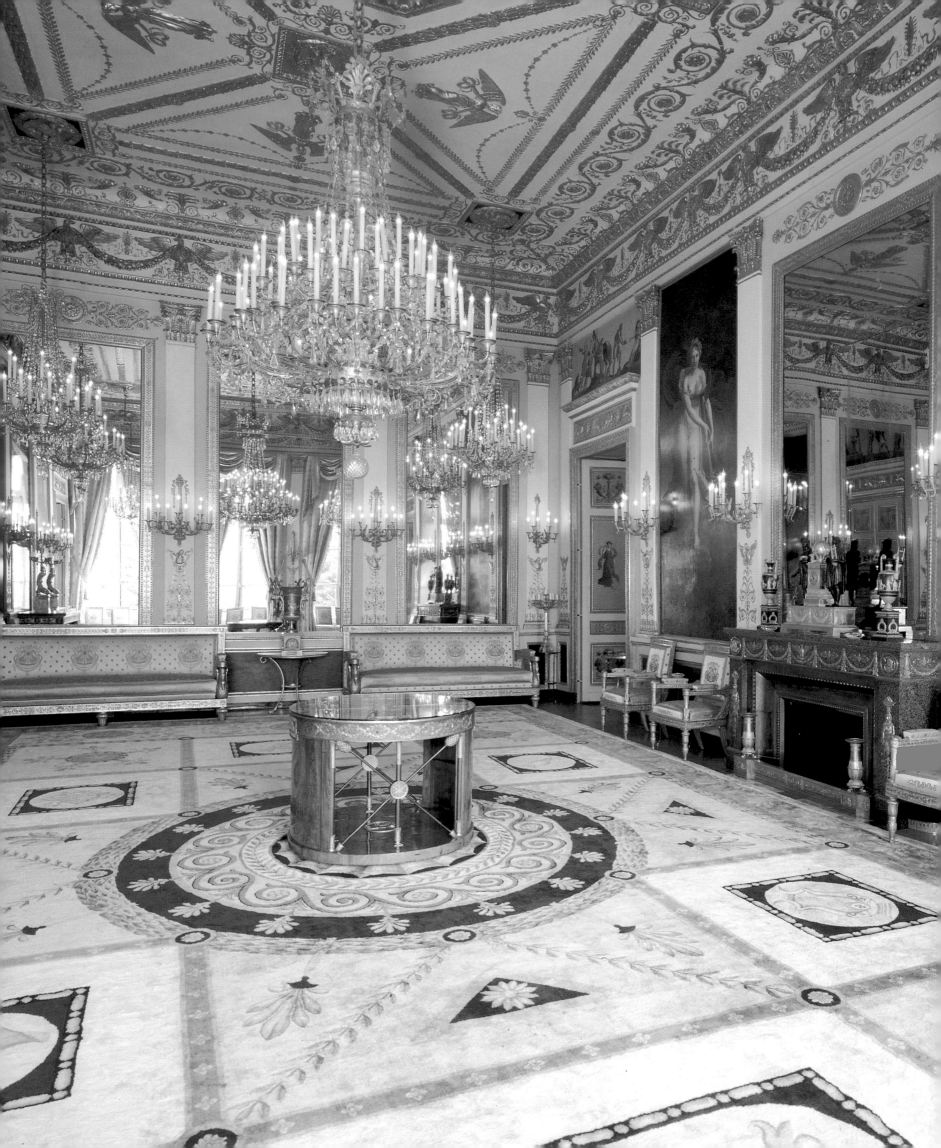

The Elysée was another historical palace, the former property of Madame de Pompadour. Napoleon gave it to Joachim Murat, his sister Caroline's husband, took it back when he named Murat king of Naples, and let Josephine live in it for a while after their divorce.[16] It was refurbished by Barthélémy Vignon and Jean-Thomas Thibault and was beautifully furnished (the Silver Salon was of particular refinement). A very fine staircase with a bronze banister was commissioned by Murat.[17]

Napoleon had arranged for the marriage of his sister Pauline to one of his officers, Leclerc, and had sent them to Santo Domingo, where Leclerc died. Pauline returned to France bereft, but she had a most lively temperament and soon recovered her joie de vivre. In 1803 she bought the splendid Hôtel de Charost on the rue du Faubourg Saint-Honoré (now the British Embassy) and had it decorated in the latest style by Fontaine. The ceilings were adorned with garlands and rosettes; sphinxes, vases, and scrolls appeared above the doors; the rooms were sumptuously hung with brightly colored Lyons silks; and large numbers of gilded seats were introduced, some attributed to Pierre-Benoît Marcion.

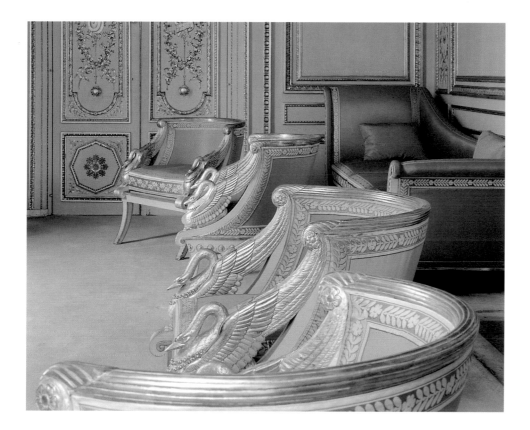

The Silver Salon in the Elysée Palace, commissioned by Caroline Murat, who lived in the Elysée until her husband was named king of Naples in 1808. The silver-painted furniture is by François-Honoré-Georges Jacob-Desmalter (1770–1841).

OPPOSITE: Salon of the Four Seasons in the Hôtel de Beauharnais, one of the most sumptuous Empire interiors. The Savonnerie carpet was rewoven following the original design. The seats are by Pierre-Antoine Bellangé (1758–1827).

Pauline's bedroom featured a canopied bed of gilded carved wood with four Egyptian caryatids. Chandeliers, candelabra, and clocks were of the highest quality. Pauline's way of life was a bit too flighty for Napoleon, who married her off again, this time to Prince Camille Borghese. But she refused to live in Italy and returned to Paris, where she gave splendid receptions in her hôtel. She was to prove the kindest and most grateful of Napoleon's relatives, visiting him on Elba and helping him financially.

GARDENS

As cities were redesigned, public gardens, which had been severely damaged by the revolutionary riots, were restored. The Jardin des Tuileries, the Jardin du Luxembourg, and the Jardin des Plantes were redesigned or slightly enlarged, their walls pulled down and replaced with railings. During the early years especially they were places of public festivities as they had been during the Directoire, with releases of balloons and fireworks displays by the Ruggieri family. The Jardin des Tuileries was especially animated; after the Revolution

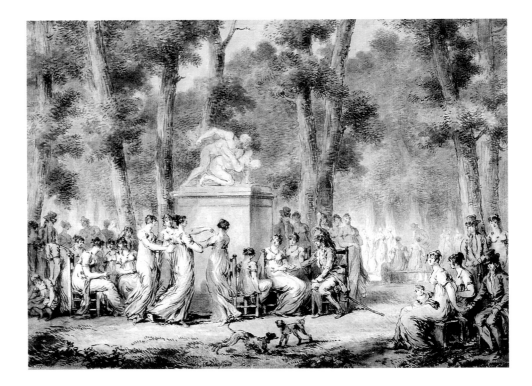

The Terrace in the Tuileries Garden, 1807–8, Jean-Pierre Norblin de la Gourdaine (1745–1830), drawing, pen, ink, and bister wash, 13¾ × 16⅞ in. (35 × 43 cm). MUSÉE CARNAVALET, PARIS

it was even called the first reopened salon. Officers in elaborate uniforms, women in the latest fashions, and children with their hoops formed a colorful crowd. Here too the members of the imperial family could be seen; they could not walk in the gardens or even come close to a window of the Tuileries Palace without attracting a crowd.

Château gardens also received attention, and their transformation was characterized by two main traits: the importance of trees in the general layout and a growing interest in new and exotic varieties of plants and flowers. The last decades had witnessed a rising taste for the *jardin à l'anglaise*, the naturalistically landscaped garden that replaced the formal *jardin à la française*. Now a new fashion in landscaped gardens was sweeping Europe, and the eighteenth-century vogue for gazebos and pyramids was giving way to a fashion for botanics. This trend owed much to the work of the English landscape gardener Humphrey Repton, who stressed color effects in composing a landscape and paid great attention to the play of light and shade.

But not everyone appreciated the new style. One of the reasons Napoleon liked Fontainebleau, for instance, was that it fulfilled his need to be close to nature. He was irritated by the new fashion that was conquering France: "How

silly," he told Fontaine, "to spend fortunes on creating little lakes, little rocks, little rivers. . . . These are but bankers' whims; my *jardin à l'anglaise* is the forest of Fontainebleau and I want no other!"[18]

A very successful garden designer was the architect Louis Berthault, who was called upon to restore *jardins à la française* as well as to transform many gardens according to the new fashion.[19] When Berthault became architect of the château de Compiègne, he turned the garden into a vast *parc à l'anglaise*: seventy thousand trees were delivered to Compiègne by the imperial nurseries directed by Gabriel Thouin in the Jardin des Plantes.

Berthault's most personal creation was the park he designed for Josephine at Malmaison. Josephine's first choices had been the Englishman Howatson, who had worked on Bagatelle, and the Frenchman J. M. Morel, but she did not like the projects they submitted. Then she discovered in Berthault a landscape gardener who understood the atmosphere she wished to create and the love for plants and flowers she had developed in her youth in the West Indies. Vases, statues, and a Temple de l'Amour by Alexandre Lenoir did not detract from the extraordinary variety of plants that Josephine and Berthault imported from all over the world and installed in the fifty-meter-long hothouse built by Thibault and Vignon. With its tall trees, winding paths, and meandering river, the park of Malmaison was an ideal setting for the many boating parties, outdoor lunches,

A Visit to the Hothouse at Malmaison, *c. 1822–23, Auguste Garneray (1785–1824), watercolor, 6¼ × 9½ in. (16 × 24 cm).* CHÂTEAU DE MALMAISON

OPPOSITE: Empress Josephine, *1805, Pierre-Paul Prud'hon (1758–1823), oil on canvas, 96⅛ × 70½ in. (244 × 179 cm).* LOUVRE, PARIS

In this painting Josephine is portrayed in the gardens of Malmaison.

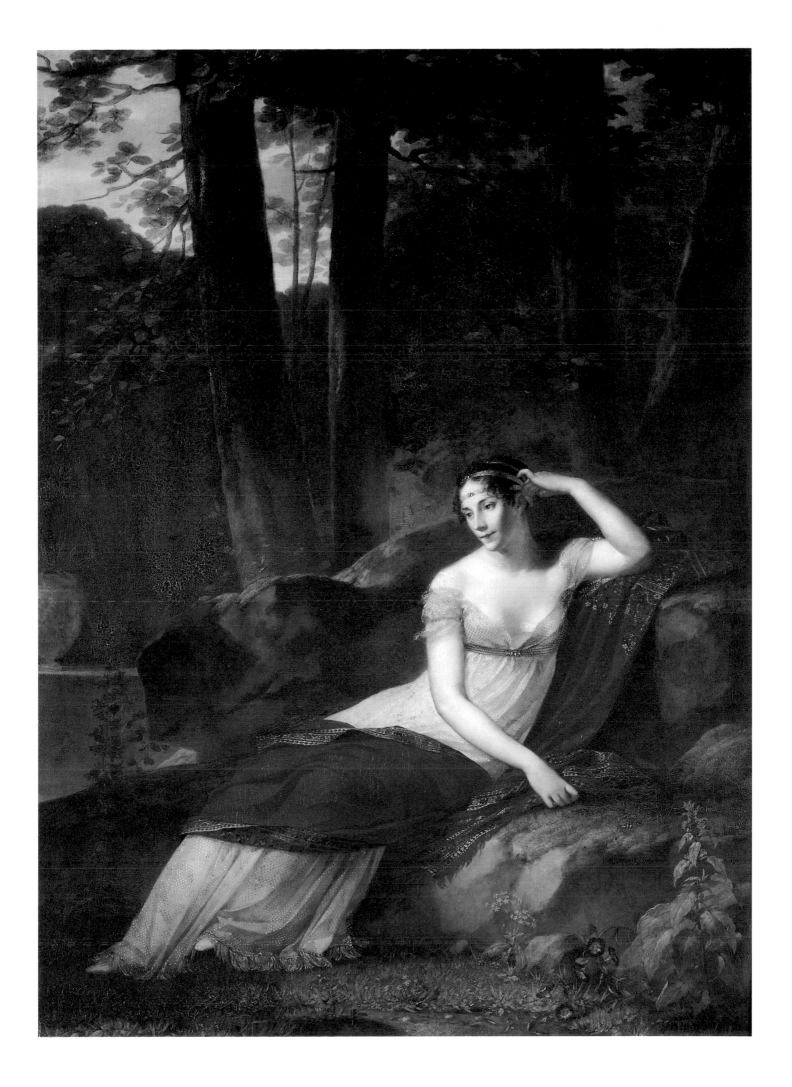

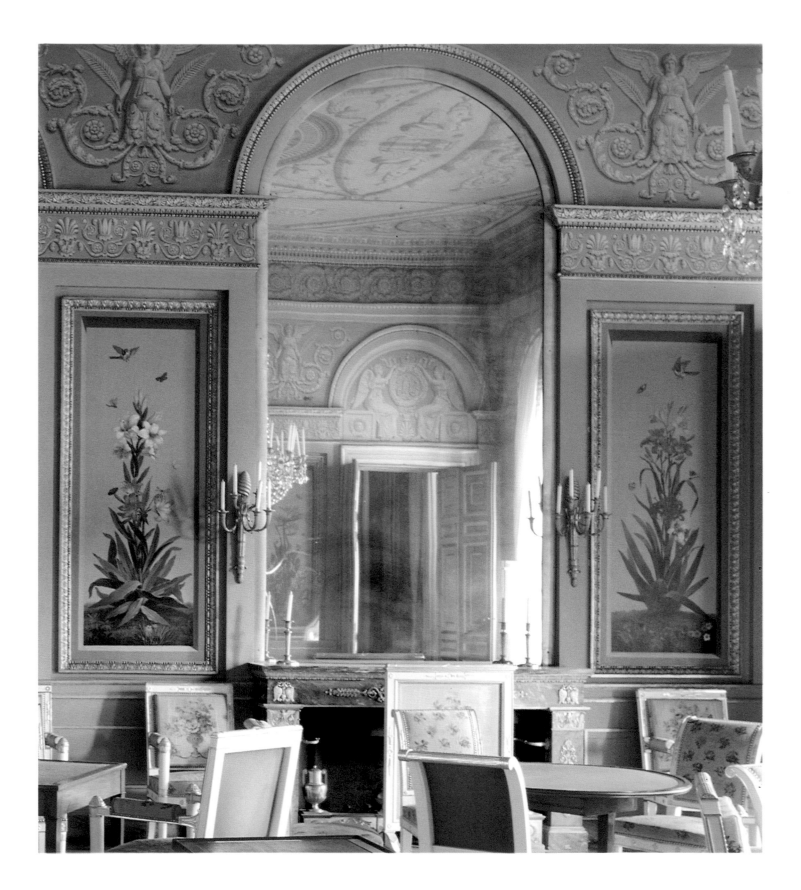

and open-air games Josephine liked to organize for her numerous guests, whether diplomats, ministers, scientists, or artists.

Malmaison and the Jardin des Plantes played an important role in botanics in those years because Josephine corresponded and exchanged plants and seeds with scientists and horticulturists as far away as the United States, South America, and Russia. Hundreds of trees and plants—including cedars of Lebanon, gingkos, magnolias, camelias, hydrangeas, dahlias, and some 250 varieties of roses—formed the exceptional collection of Malmaison.

"It is a joy for me," Josephine said in 1804, "to see foreign plants multiply in our gardens. . . . In ten years time I want every French department to own a collection of precious plants initially grown in our nurseries."[20]

Josephine's botanical tastes had an impact not only on the plants that began to adorn public gardens but also on interior decoration and textile design. At her request, renowned botanical artist Pierre-Joseph Redouté painted splendid watercolors of her flowers, which were published in 1803–4. The Manufacture de Sèvres bought some of his works and often used them to decorate later services.

PRIVATE ARCHITECTURE

Beautiful hôtels had been built just before the Revolution by such architects as Alexandre-Théodore Brongniart and François-Joseph Bélanger, and they continued to inspire architects when their plans were published by Krafft and Ransonnette in 1801.[21] But by about 1800 architecture was no longer destined for princes, nor did it express the dreams of visionary architects.

In the decade following the Revolution ideologues had yielded to shrewd businessmen. Architects who had survived the lean years now had a very different clientele. They had precise programs to fulfill for investors who were building to rent in the districts of the Chaussée d'Antin, the Faubourg Poissonnière, or the Plaine Monceau. Whole ensembles were sometimes commissioned, such as the Cité du Retiro or the Cour Batave.

The official state-commissioned architecture had little stylistic influence on these blocks of flats, which were built in a subdued, well-proportioned Palladian

OPPOSITE: Empress Marie-Louise's Second Salon, later called the Salon of Flowers, château de Compiègne. The wall decoration is by the Dubois and Redouté firm, 1809–15. The large floral panels were directly inspired by Pierre-Joseph Redouté's (1759–1840) famous paintings. The furniture is by François-Honoré-Georges Jacob-Desmalter (1770–1841).

Plate from Krafft and Ransonnette's Plans, coupes et élévations des plus belles maisons et des hôtels construits à Paris et dans les environs. *BIBLIOTHÈQUE DES ARTS DÉCORATIFS, PARIS*

These drawings depict the house of Citizen Ollivier, architect, rue Pépinière, Faubourg Honoré, built in 1799.

style inherited from prerevolutionary architects. Their tall, simple façades of stone or crisp plaster facing had almost no detailing and might be adorned with a few niches and statues; their imposing doorways were sometimes framed by winged victories. They were inhabited by people of varied social strata, depending on the neighborhood. There might be a shop on the ground floor with the shopkeeper's home in the back. The first floor was generally lived in by a well-to-do family, and the wealth of the occupants decreased as one rose floor by floor to the garrets.

Many cities in the provinces also developed a handsome private architecture. Well-known architects built for both public and private clients and created harmonious city centers. In Lyons, in Bordeaux, in the prosperous cities of the north, like Lille, and west, like Nantes, neoclassical buildings rose. Rarer were the mansions built in the countryside such as Louis Combes's splendid Palladian château Margaux, which he built in the middle of the famed vineyards near Bordeaux.

A most pleasing feature of Empire architecture was the way boutique façades were decorated with inventive colors and decorative motifs, both elegant and whimsical, unconstrained by any of the principles of grandeur that guided the official architecture. The same freedom was found in another urban feature,

Directoire building, 4 rue d'Aboukir, Paris. In the last years of the eighteenth century, many such simple buildings were erected as apartment houses. With its arcade and its niches, this one is particularly elegant.

Façade of Debauve & Gallais, a chocolate company founded on the rue des Saints-Pères in Paris in 1800. The design of the shop is attributed to Charles Percier (1764–1838) and Pierre-François-Léonard Fontaine (1762–1853).

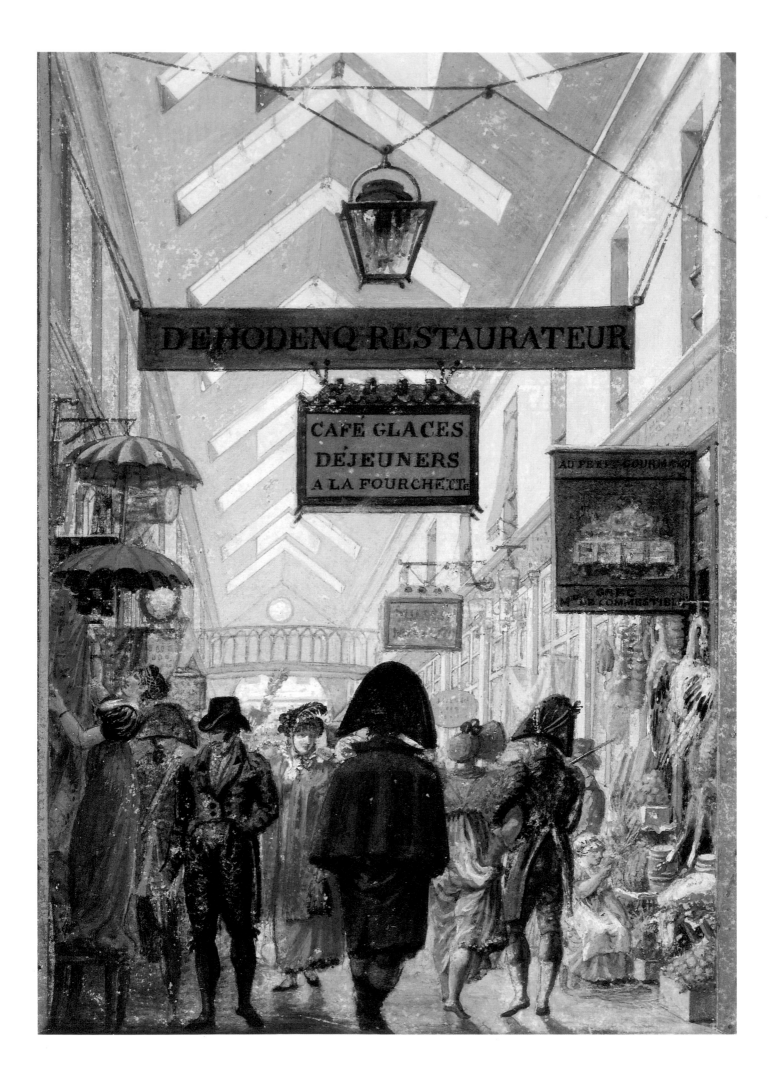

the *passages.* In these years, when real estate speculation was rising at the same time as commerce, private developers took advantage of the space between blocks, covering it to form galleries where luxury boutiques opened. These *passages* were well decorated and attracted lively crowds.

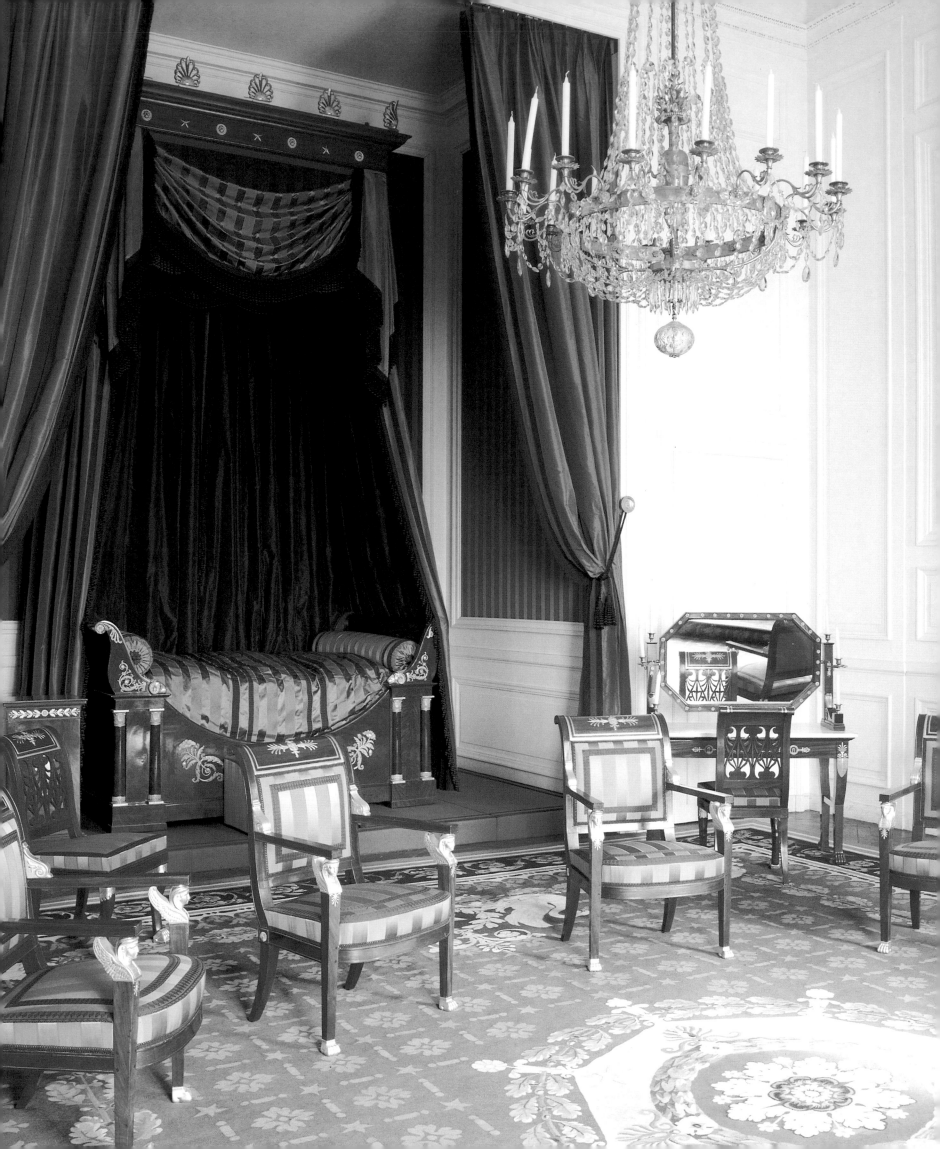

FURNITURE

Napoleon's grand vision for France was territorial and military, encompassing whole nations and monarchies. But it was also pragmatic; he was always concerned with economic and industrial matters, even if the wars he waged often contradicted his plans for the French economy. One of his concerns from the time he was a consul was the development of French industry, which still lagged quite far behind the English. And between 1800 and 1815 France did indeed develop its industry, even though it lost its commercial rank because of the Continental Blockade[1] and hostilities.

Napoleon stimulated discoveries; he created the Société d'Encouragement pour l'Industrie Nouvelle in 1801, as well as numerous competitions and prizes for inventors of machines. He promoted and helped publicize these inventions, gave loans to industry, and created schools. He also lent his support to the Expositions des Produits de l'Industrie Française. Much of this was, in the first years, carried out by the excellent minister of the interior he had chosen, Jean-Antoine Chaptal.

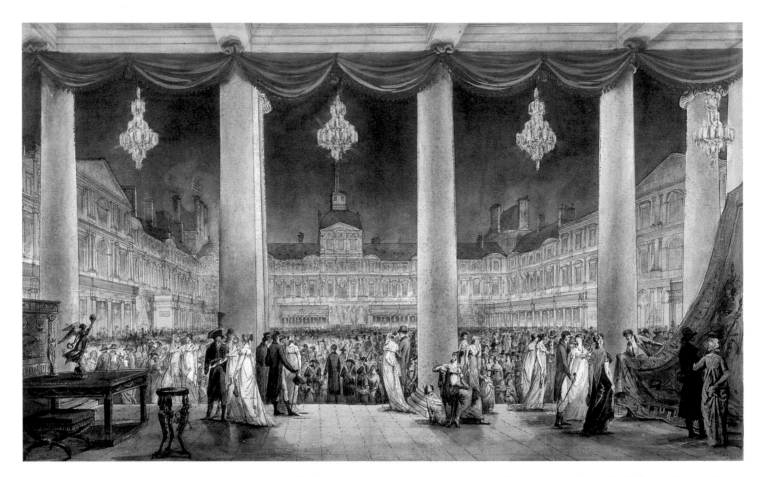

View of the Exposition des Produits de
l'Industrie Française in the Cour Carrée
of the Louvre, *1801, artist unknown,
watercolor, 16⅞ × 27⅛ in. (43 × 69 cm).*
MUSÉE CARNAVALET, PARIS

*PAGE 92: Large bedroom in the Double
Apartment of Princes, château de Compiègne.
With its purple and fawn gorgoran-silk
upholstery, purple trimmings and contrasting
golden yellow silk window curtains (not seen),
this room is one of the boldest creations of the
Empire period. The partially gilded mahogany
seats with claw feet and armrests supported
by winged figures are by François-Honoré-
Georges Jacob-Desmalter (1770–1841),
1808. The chandelier was commissioned
from Valentin.*

Such encouragement was necessary because at the end of the eighteenth
century France was essentially a rural country in which—until the end of the
ancien régime—the aristocracy had taken pride of place. Just before the Revolu-
tion, in the southern city of Toulouse for instance, the nobility, one percent of
the population, owned two-thirds of the city's wealth.[2] The aristocracy invested
in land, and the other social groups imitated it: as soon as a Toulousain had some
money he bought a piece of land, a vineyard, a meadow, or a house. But he almost
never invested in industry. Notwithstanding the slow rise of capitalism, land
ownership remained the main basis of wealth and social status during the Empire.[3]

Napoleon encouraged many industrial sectors but gave special attention
to the most glamorous, those that would best pursue and promote the historical
tradition of French arts and crafts: the manufacturing of cottons, silks, furniture,
bronzes, and porcelain. And he had very precise requirements in the fields of
fashion and decoration. So it was that the Empire style followed so closely the
will of one man.

PATRONS AND ARTISANS

Napoleon's personal taste, together with the authority of Percier and Fontaine, played a greater role than would have been the case before. In earlier times the taste of the ruling class did not depend entirely on that of the king. It had been shaped by generations of collecting and commissioning, and by close contacts with artists and craftsmen. Now, for the first time, a good part of the new bourgeoisie was aware of its lack of cultural references and was often relieved to be given a social and artistic model to follow. This may explain why the names of the same well-known craftsmen appeared so often.

As in architecture and interior decoration, furniture commissions from the emperor and the court were to determine the style not only of the whole of France but of a great part of Europe. French cabinetmaking had been in demand throughout the Continent for decades, and its supremacy was unrivaled. The practice of looking toward France remained, despite the nationalistic feeling that arose in countries occupied by France.

Traditionally, most of the commissions for palaces were given through the Garde-Meuble Royal, a very old institution that had been reorganized in 1663 by Louis XIV's minister Jean-Baptiste Colbert to commission, restore, and distribute the furniture of the Crown. During the Revolution many palaces and châteaux were emptied of their furniture, which was either stolen or burned. Furthermore, in 1793 the revolutionary government ordered the sale of the sumptuous royal furniture in the Trianons and the châteaux of Versailles, Saint-Cloud, Marly, Fontainebleau, and Compiègne. (Fortunately, some of the furniture was used to furnish the Luxembourg Palace when the Directoire moved there.) Napoleon renewed the royal tradition, and from then on the Garde-Meuble Impérial played a very efficient role.

Some eighteenth-century families of craftsmen were still active; indeed, marriage and inheritance formed true dynasties that were able to resume work on an even larger scale than before the Revolution while maintaining a superb level of quality.[4] They were not a genuine industry, and not until the 1820s and 1830s would machinery permit mass production. But in 1803 the frères Jacob owned sixteen different workshops (including those for joining, turning,

L'Ebéniste, *artist unknown, engraving.*
BIBLIOTHÈQUE NATIONALE, PARIS

sculpting, inlaying, molding, and gilding), and during the Empire Jacob-Desmalter employed over 330 people. Similar dynasties existed among the bronze makers, and some were in the business for four consecutive generations. They worked in close collaboration with the cabinetmakers and had equally large workshops; Feuchère employed 150 workmen and Galle declared 400, as did Denière et Matelin. In 1807 Paris had more than 10,000 workers in the field of furniture.

Jacob-Desmalter was by far the *ébéniste* most in demand. But many others worked for the Garde-Meuble as well as for private clients: Antoine-Thibaut Baudoin, Pierre-Antoine Bellangé, Martin-Guillaume Biennais, Benoît-François Boulard, Pierre-Gaston Brion, Charles-Joseph Lemarchand, Simon-Nicolas Mansion, Pierre-Benoît Marcion, Bernard Molitor, Duguers de Montrosier, Jean-Baptiste Séné, and Adam Weisweiler all made remarkable pieces. The craftsmen of lesser renown worked for a clientele of *notables*,[5] for the civil servants of the new Napoleonic administration, or for members of the military.

French cabinetmakers and bronze makers were thus particularly prosperous until about 1806, when Napoleon's international policy brought dramatic reversals of fortune to many of the workshops. The blockade made it impossible to

Empire bedroom furnished for Napoleon and Josephine's visit in 1808, château de Serrant, Saint-Georges-sur-Loire. Napoleon had been invited by the count and countess de Serrant, she a lady-in-waiting to Empress Josephine, who was their daughter's godmother. When Napoleon learned about the serious French defeat in Bailén, Spain, on his way back from Vendée, he decided to shorten his stay at the château. The desk appears to bear the stamp of P. Marcion, the bed and seats are by François-Honoré-Georges Jacob-Desmalter (1770–1841), and the lights are by Pierre-Philippe Thomire (1751–1843). The carpet is an Aubusson.

import such materials as exotic woods and cottons and, at a time when many of them sold a great part of their work abroad, prevented French craftsmen from exporting overseas. Jacob-Desmalter, for instance, exported one-third of his production. Napoleon tried to remedy these disastrous consequences with large loans; as early as 1807 Jacob-Desmalter and Pierre-Philippe Thomire, among others, received large sums of money from the state, which they were supposed to repay by 1809.

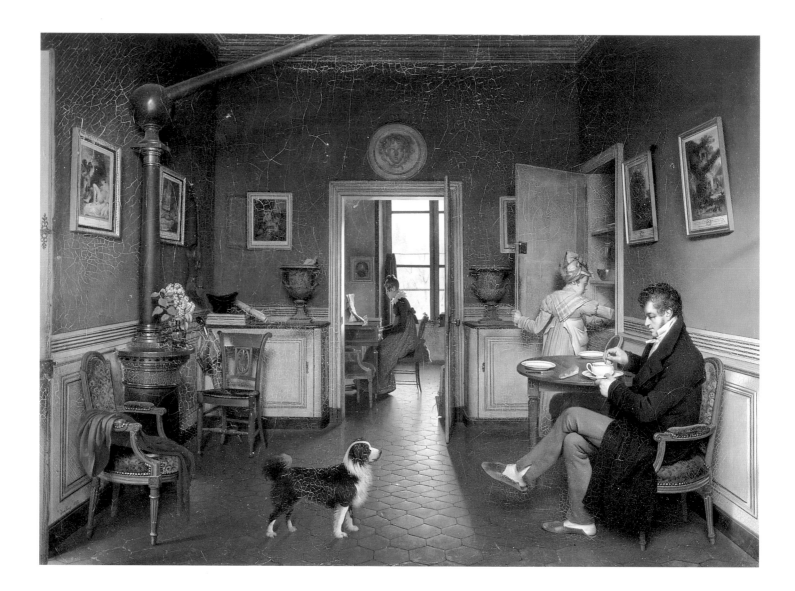

Interior of a Dining Room in Paris,
1816, Martin Drolling, oil on canvas.
PRIVATE COLLECTION

In 1811 and 1812 another crisis arose: the wars were taking their toll on French wealth, the state had less money to spend on luxurious furnishings, and Napoleon imposed restrictions on imperial commissions. The craftsmen had been unable to repay their loans, and the state took or bought part of their production. With the crisis deepening and many workshops going bankrupt, Napoleon gave out yet more commissions. Interestingly, these were given not only to the well-known ateliers but also to craftsmen of lesser skill who had lost their clientele faster than the better ones. They could not afford expensive materials and were thus asked to make pieces destined for less luxurious rooms in the palaces.

WOOD AND
THE LIFE OF A STYLE

During the eighteenth century exotic woods had been used for the most refined marquetries: kingwood, tulipwood, rosewood, amaranth, and satinwood were among the most frequent. Mahogany was seen only very occasionally, as when Madame de Pompadour bought six solid mahogany commodes for her château de Crécy in 1753. The Chippendale style had made mahogany fashionable in England, and it was used in solid *menuisier* furniture by Georges Jacob for the chairs he made for Jacques-Louis David and Marie-Antoinette.[6]

Mahogany came from the Malabar Coast of India, from Santo Domingo, or from Cayenne. Thanks to faster and easier transportation and to new sawing techniques, it could be used widely as veneer in fine sheets only three or four millimeters thick. Since its fine surface and color required little work, the need for moldings soon disappeared. The thin sheets were assembled with great precision, and cabinetmakers also knew how best to take advantage of the veins or

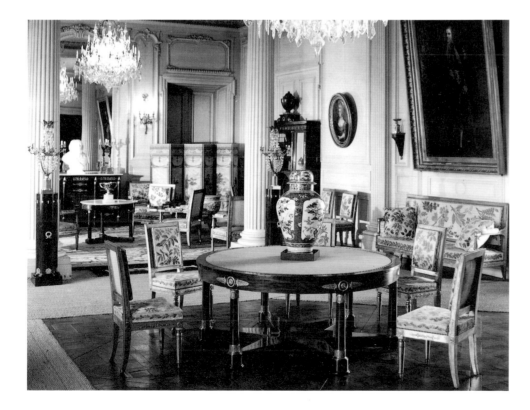

Large drawing room, château de Valençay. The furniture is in the Empire style. The large round table was originally used during the Congress of Vienna (1814–15).

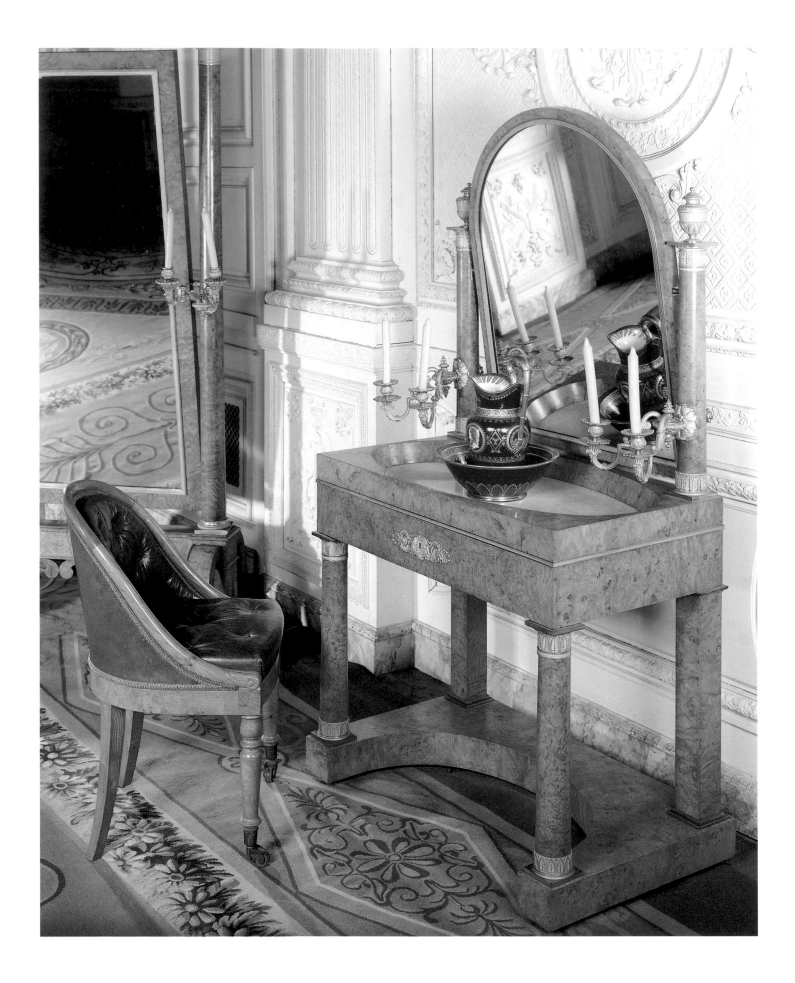

the marks of the different varieties of mahogany, such as crotch, mottle, rope, or fiddleback. Nevertheless, this wood remained a luxury found only in the best interiors. A darker, redder mahogany was considered less desirable and was used in pieces of lesser quality. Sculpted mahogany was one of the most attractive features of Consulat furniture and was used in Empire pieces for claw feet, animal-headed armrests, or small round tables.

In 1806 the Continental Blockade forced cabinetmakers to turn to indigenous woods, which until then had been little used for good furniture. Walnut, beech, pear, ash, and elm were now employed even for prestigious commissions. Two very fine elm cradles were made for the king of Rome, one by Jacob-Desmalter for Saint-Cloud, the other by Thomire and Duterme for the Tuileries.[7] For the empress's bedroom in the Grand Trianon, Baudoin made a pretty ash dressing table. Poplar was used for simpler pieces. A number of *ébénistes* showed pieces of figured elm and other local woods, which were highly appreciated in the Expositions des Produits de l'Industrie Française. Baudon-Goubaut from Châteauroux and Charles-Marin Burette thus received commissions from the Garde-Meuble, while François-Ignace Papst was recognized for having shown "a magnificent and valuable *bureau à cylindre*" in indigenous wood.[8]

Political circumstances after 1810 caused a decline in the quality—or at least in the beauty—of Empire furniture. In the time of Marie-Louise, when the style had become more ponderous, many palaces were furnished with consoles and chairs of cheaper woods painted white and studded with gilded motifs in low relief, or painted light gray with their structure outlined in white.

ORNAMENTS

Motifs drawn from antiquity had been used in French decoration since the Renaissance, when Francis I brought Italian art and artists to France. In the time of Louis XIV acanthus leaves, grotesques, and masks were prominent design elements. In this sense antiquity was not as new to France as it perhaps was to northern Europe or to England, where Robert Adam's and Thomas Hope's taste for antiquity was so influential in the decorative arts. During the Directoire caryatids, griffins, lions, vases, and geometric motifs such as lozenges, striped

OPPOSITE: The empress's toilette, bought in 1809 from furniture dealer Antoine-Thibaut Baudoin (1759–1814), ash with gilt-bronze mounts. MUSÉE NATIONAL DU CHÂTEAU DE VERSAILLES, GRAND TRIANON

This dressing table was commissioned for the empress's bedroom, 1809. The candlesticks, by Pierre-Philippe Thomire (1751–1843), were added in 1837.

squares, frets, ova, rosettes, and pearls were to be found in architecture, furniture, bronzes, and textiles; to this the Consulat added Egyptian elements.

Most of the Directoire and Consulat motifs remained under Napoleon (except the lozenges and striped squares), but they became more solid. Military emblems in the form of helmets, swords, lances, arrows, oak and laurel wreaths, imperial *N*s, and eagles appeared frequently, as did lyres, palmettes, bees, and stars. During the Empire many stiffer motifs were drawn from the Roman vocabulary: heavy foliage, cornucopias, amphoras, chariots. As the years went by, from 1795 to 1815, classical references assumed quite a different feeling: graces became victories, winged sphinxes turned into stilted swans, arabesques changed to thick volutes, and delicately fluted columns on furniture became heavy balusters.

Furniture had always been adorned in some manner, whether with inlays, sculpture, bronze mounts, or marquetry, which reached its highest perfection during the eighteenth century. During the Consulat delicate inlays of ebony, pewter, and occasionally ivory were set in dark wood, such as mahogany, or in light lemon wood.[9] The technique disappeared between 1805 and 1815 and reappeared during the Restoration, in contrasting combinations of light and dark woods.

Bronze mounts were finely crafted in rather low relief, with chiseling that alternated shiny and matte parts to create beautiful effects of light and texture. They followed a gilding technique long admired by European collectors, the *dorure au mercure* or ormolu. But they were not very varied and were often conventionally set in the center of a commode door, on drawers, or on seat rails. As they became widespread they were simplified and were frequently made of brass rather than gilt bronze.

S O C I A L L I F E A N D T H E S A L O N S

The Empire was a period of grand entertainments. Even during the wars Paris was alive with feasts and dinners and balls. Indeed, Napoleon sent instructions from the battlefields that the ladies of the court *must* enjoy themselves, to keep the French confident. His sister Pauline and his stepdaughter Hortense needed no encouragement, nor did many of his ministers.

Top of a neo-Gothic ebony and gilded-wood gueridon, c. 1817–20, decorated with eleven drawings constituting Life in the Château de Pontchartrain, *1815, Jean-Baptiste Isabey (1767–1855).* GALERIE DIDIER AARON, PARIS

Isabey often spent time at the château of Aimée-Carvillon Destillères, future comtesse d'Osmond. His own bedroom is depicted in the center of the tabletop, surrounded by charming scenes of the château and its park.

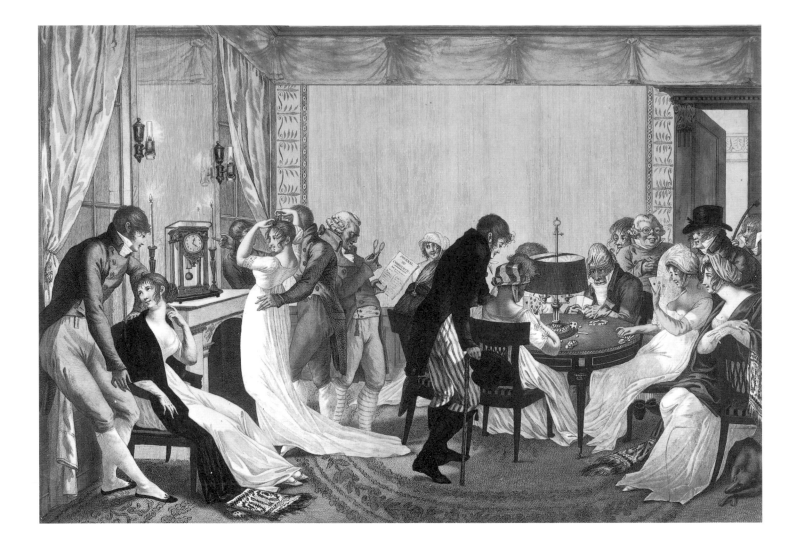

An Evening Playing Cards, c. 1805,
Jean-François Bosio (1764–1827), colored
print from an album published by the Journal
des dames. BIBLIOTHÈQUE NATIONALE,
CABINET DES ESTAMPES, PARIS

The frieze below the ceiling, the silk drapes
bordered with woven trimmings, the Argand
lamps on either side of the mirror, and the
shaded candlestand on the table are all typical
features of an Empire interior.

Middle-class life was also becoming more comfortable. The many genre
scenes showing families in their daily occupations are delightful and informative.
Louis Boilly scored his first successes with prints during the Revolution, at a
time when so much was told through this medium. He became just as successful
as a genre painter, as did Martin Drolling; both artists depicted bourgeois life
and interiors in a straightforward manner with a candid and intimate quality.

People still went to the theater and to concerts often, but after the Revolu-
tion they were happy to resume normal family lives, and many were the evenings
quietly spent with children and friends, reading aloud or staging little plays.
Napoleon enjoyed such family gatherings on Sunday evenings.

In France intellectual life has always been closely linked to social life. *Salon*
referred both to the drawing room in which elegant afternoon or evening events
took place and to the people they brought together. Some salons were far more
interesting and fashionable than others, and many famous works were first read
by their authors at these gatherings before being published.

The running of salons was a typically feminine activity, though some men with intellectual or artistic positions ran them, too (men also met in *cercles*, especially toward the end of the Empire). The salon of the painter François Gérard, for instance, was one of the centers of artistic life in Paris; there, during the Empire and later, one could meet famous actors like François-Joseph Talma, Mademoiselle Mars, or Mademoiselle Georges, scientists like Baron Georges Cuvier, composers like Maria Luigi Cherubini, Giacomo Meyerbeer, or Gioacchino Rossini, writers like Germaine de Staël, and of course many artists, including Percier and Fontaine, Jean-Baptiste Isabey, Jean-Auguste-Dominique Ingres, the Vernets, and even John James Audubon. Nevertheless the salons most in vogue, and probably the most influential, were those of women.

After the comparative freedom of the Directoire, women were increasingly confined to the home. Napoleon did institute schools for young ladies to develop fine skills in painting, music, and dance,[10] but women were given no higher education. Yet they were often highly cultured, and they perpetuated the very French tradition of the salons.

The first salon to reopen after the Revolution was that of Germaine de Staël. It became a major meeting place for the political opposition to the premier consul, though this did not prevent Bonaparte's brothers and ministers from going there: everyone knew they would meet important politicians, from émigrés and aristocrats to members of the new class. The premier consul realized how strong Madame de Staël's power was, both through her insights and connections and through her writings (*Delphine*, 1802, defended many political, religious, and social ideas that he rejected, including the right of women to divorce). Their relations were very tense, and she was exiled from Paris for several years. But she re-created a similar group of opponents at her property of Coppet, by Lake Léman.

Napoleon was almost as harsh with the delightful Juliette Récamier. Although she professed no political preferences, so attractive were her company and her conversation and so gifted was she in bringing people together that she was constantly surrounded by writers and politicians of completely opposing views, who could meet at her salon and talk with no partisan intentions. When the Récamiers lost their fortune and had to sell their hôtel, Madame Récamier was followed to her modest flat at the Abbaye-aux-Bois by her admirers, among whom François-René de Chateaubriand was the most assiduous.[11]

Mantel clock, c. 1805–10, attributed to André-Antoine Ravrio (1759–1814), gilt bronze. COURTESY OF COOPER-HEWITT, NATIONAL DESIGN MUSEUM, SMITHSONIAN INSTITUTION–ART RESOURCE, NEW YORK; GIFT OF THE ESTATE OF CARL M. LOEB

The painter Elisabeth Vigée-Lebrun also had a salon, as did Constance de Salm, Madame de Genlis, Madame de Pastoret, and numerous other ladies from the prerevolutionary aristocracy, whose Faubourg Saint-Germain salons were quite exclusive.[12] Many women had *un jour*, a particular day on which they opened their home to friends and acquaintances.

Needless to say, only women of some means could enjoy such pleasures. In most classes of society women were allowed less freedom as the years passed, and their life during the Empire was difficult; hundreds of thousands of them tragically lost their husbands and sons in the devastating imperial wars.[13]

SEATING

Seating was naturally dependent on the formal quality of the new social life. In the eighteenth century more relaxed gatherings had allowed for many small pieces of furniture and seats. Napoleon wished to renew the pomp of the ancien régime, and his strict etiquette, added to the evolution of styles in the latter part of the eighteenth century, is one of the reasons for the stiffness of Empire furniture: it was very linear, as if it had come straight out of a blueprint, and was meant to be seen frontally by people formally seated. At court ceremonies and political gatherings only the emperor, the empress, and the emperor's mother were seated in armchairs. A few important dignitaries were given chairs; everyone else sat on stools or stood, though an exception was made for pregnant women of the emperor's family, who were permitted to sit on chairs. This was the rule in all official palaces; however, when the empress's Grand Salon in the Tuileries was furnished in 1808, many more chairs and armchairs were brought in, probably another example of Josephine's less formal attitude toward court life.

Larger sofas and armchairs were known as *meubles meublants* (furnishing pieces), as opposed to *chaises volantes* (movable—literally, flying—chairs), which one could bring close to a table or fireplace, where the mistress of the house often entertained her guests. Seats were conceived as ensembles comprising armchairs, chairs, sofas, and stools. For the palaces the Garde-Meuble Impérial gave orders either to the *tapissiers* or directly to furniture makers. For the more stately rooms gilded wood was the rule, and seats painted white with their

OPPOSITE: The Blue Salon, château de Compiègne. Marie-Louise's smaller and less formal drawing room is characteristic of the taste for vivid colors during the Empire. It was decorated by the Dubois and Redouté firm, 1813–14. The furniture is by François-Honoré-Georges Jacob-Desmalter (1770 1841); the sconces, by Claude Galle; and the clock, by Bailly. In the niche is an 1806 statue by Charles-Antoine Callamard (1769–1821).

sculpted parts gilded were also considered proper. The custom of using gilt
wood was practiced even in wealthy homes, as in the sitting room of the general
Jean-Victor Moreau, who owned a very good set of gilded seats by the frères
Jacob. For less imposing surroundings mahogany was the best wood. And local
woods, plain or painted, were common in simpler rooms like vestibules and for
everyday use. Furniture painted with floral motifs was rare in France but was
appreciated in England and especially in the United States, where patterns
were full of fantasy.

Directoire armchairs were made of simple woods and delicately decorated:
a rosette set in a striped square or a lozenge formed a link between the seat rail
and the arm stump. A palmette or a shell often adorned the top of the armrest
where it merged into the back post. As for side chairs, their carved backs were
evidently influenced by George Hepplewhite and Thomas Sheraton. Their top
rails were often turned and separate from the frame or carved to form a hollow
handle so that one could seize the chair easily.

Consulat seats were the most creative. The back of some early pieces was
a splat supporting a horizontal and curved board decorated with delicate scenes

drawn from Greek vases or reliefs that were either painted on the wood or on a sheet of paper glued to the wood. Similar chairs could also be found in England.

The most attractive feature of Consulat seats was the arm stump, which the frères Jacob or Bernard Molitor sculpted into sphinxes, griffins, lions, or eagles. The armrests themselves could be carved in the shape of "elephant trunks" (smooth or fluted curves), as in the armchairs the frères Jacob made for Hugues-Bernard Maret, the secretary-general of the consuls. A few years later, in the armchairs Jacob-Desmalter made for Fontainebleau in 1808, these curves became down-scrolled (*accotoirs à rouleaux*).

Armchairs were also made with front legs and arm stumps that formed one continuous line, but they were usually separated at the seat rail by a carved motif. The front legs were fluted, tapered, turned, or *en jarret* (in the shape of animal hocks), or they might be shaped like flat balusters, a characteristic of the much heavier and imposing armchairs and sofas that furnished official buildings.

As the Empire progressed, seats took on a weighty grandeur that was accentuated by gilding and white or pale gray matte paint. The woodwork thickened, and the legs were set on heavy claw feet. The backs were no longer

Armchair (detail), arm stump in the shape of a griffin, by Bernard Molitor (1755–1833), mahogany. Musée Marmottan, Paris

Two projects for armchairs, by Pierre-Antoine Bellangé (1758–1827), print. The Metropolitan Museum of Art, New York; The Elisha Whittelsey Collection

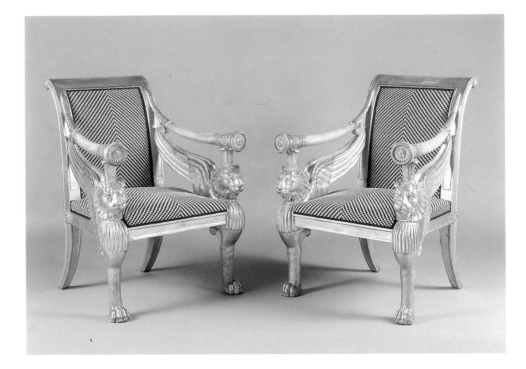

*Armchairs of Assyrian inspiration, c. 1800,
after a drawing by architect Bernard Poyet,
gilt wood. GALERIE ARIANE DANDOIS, PARIS*

*A similar armchair in the Musée des Arts
Décoratifs belonged to the president of
the Assembly.*

Gilt-wood seat, one of a salon *(set of seats)
upholstered in hand-painted silk velvet
depicting Italian monuments and sites.
GALERIE RIVE DROITE, PARIS*

The decoration of this salon *was commissioned
in 1812 from the Delaneuville firm to com-
memorate the birth of Napoleon's son, the king
of Rome. A similar* salon, *commissioned by the
Senate from the same firm, is now in the
château de Fontainebleau.*

scrolled but square and straight, sometimes topped with a pediment: they were made for people who were meant to sit in an upright, dignified position.

Nevertheless a very graceful shape remained, that of the *fauteuil gondole*, a low armchair that enveloped the body. Percier and Fontaine designed and published some with and without swans, which the frères Jacob executed.[14]

One could have slip seats (*à châssis*), in which the seat proper was removable, making it easier to cover. Seats were upholstered in vivid colors, and some exceptional examples were covered with luxurious Beauvais tapestries or tapestries made by the court ladies. They were more frequently upholstered in silk or silk velvets of deep reds and greens, and also of rather garish yellows and purples. Arm pads were prominent, and backs and seats were well padded too.

Dining room chairs could be grand, such as the sixty mahogany chairs with red morocco seats in Pauline Borghese's hôtel. Sometimes a board, rounded at the top, came down in gentle volutes, as in the handsome chairs made for General Moreau's dining room. Simpler chairs, like cane dining room chairs, had amusing patterns, such as those suggested by La Mésangère. They often kept the early montgolfier, lyre, escutcheon, or palm patterns as well as the openwork inherited from England.

Stools were similar to those of the previous century, taking the shape of an ✕, sometimes with arched legs on claw feet, or the shape of crossed swords, their legs featuring the most common Empire patterns. Upholstered with velvets and fringes and tassels, they were used in palaces as well as in bourgeois interiors.

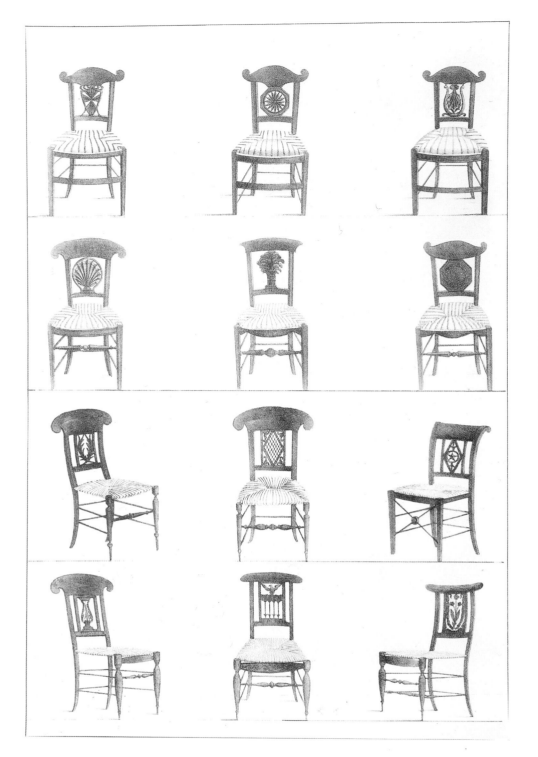

ABOVE: *Stool, attributed to François-Honoré-Georges Jacob-Desmalter (1770–1841), sculpted and gilt wood, covered in Beauvais tapestry.* MUSÉE NATIONAL DU CHÂTEAU DE VERSAILLES, GRAND TRIANON

Twenty-four of these stools were delivered to the Trianon by the tapissier *Darrac in 1810. The tapestry features a rare example of the Napoleonic bee motif, which was usually removed during the Restoration.*

LEFT: *Empire chairs, 1805–6, plate from Pierre de La Mésangère's (1761–1831)* Collection de meubles et objets de goût. BIBLIOTHÈQUE DES ARTS DÉCORATIFS, PARIS

The frères Jacob made some interesting desk armchairs (*fauteuils de bureau*). Often covered with leather, they were round and could swivel, and had an easy air about them. A similar style was the armchair derived from the Roman curule chair with its arched legs.[15]

In the eighteenth century sofas were rounded and comfortable, although they became more rectilinear during Louis XVI's reign. At the time of the Revolution relaxed forms no longer seemed appropriate to a society that feigned

austerity. Chaises longues were necessarily simple, as evidenced by the famous one upon which Juliette Récamier reclines in the portrait by Jacques-Louis David. Perhaps this stiffness was one of the reasons she was displeased with the painting, which remained unfinished, and turned instead to François Gérard for an exquisite portrait; the chair was hardly more comfortable, but the setting was certainly more becoming.[16] *Lits de repos* by Bernard Molitor were the most striking, with their elegant lines and highly sculptured feet and sides.

During the Empire sofas once again became plush. Luxuriously upholstered in tapestry or silk, they were set on either side of the fireplace. The smaller *pommier*, or *paumier*, had a rather square look, with one end lower than the other. The similar *meridienne* was more graceful, with its asymmetrical back and scrolled ends.[17]

The empress's bathroom, château de Fontainebleau. A bathtub is concealed in the sofa. The armchairs and fauteuils gondoles are by François-Honoré-Georges Jacob-Desmalter (1770–1841). The Savonnerie-style carpet is by Bellanger, 1809. The psyché and dressing table are by Pierre-Philippe Thomire (1751–1843), 1809. The chandelier is by Chaumont, 1809.

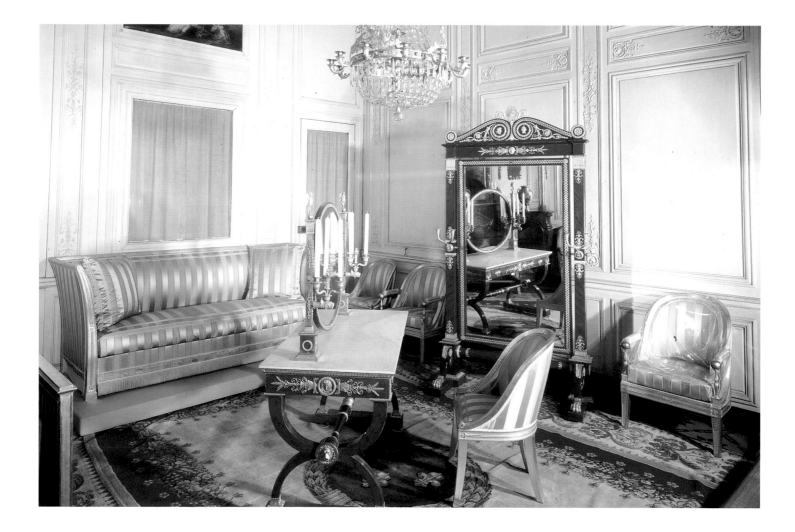

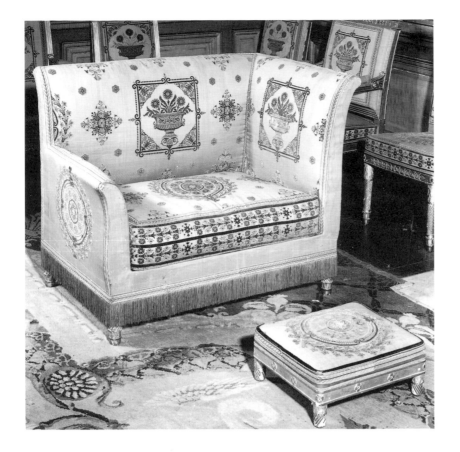

Pommier *by Pierre-Gaston Brion
(1767–after 1841), sculpted and gilt wood
covered in green velvet, in the emperor's
Small Apartment, furnished in 1810, at
the château de Fontainebleau.*

Thanks to the thousands of chairs made for palaces and private homes, in the workshop of Jacob-Desmalter especially, as well as in those of Lemarchand, Lignereux, Louis, and Marcion, furniture making virtually became an industry during those years.

B E D S

One room that was visited almost as much as the drawing room in sophisticated interiors was the bedroom. At court a century earlier, *le grand lever*—an audience with Louis xiv after he rose from bed in the morning—was an event to which every courtier wished to be invited. And a long-standing French tradition allowed women to receive guests in their bedrooms for conversation or literary gatherings. This accounts for the very formal setting of the famous bedrooms by Berthault for Madame Récamier and by Percier and Fontaine for the wives of General Moreau and Isabey.

Beds were certainly among the most creative pieces of Empire furniture. The Revolution had brought its civic symbols to the Louis xvi bed, which became a short-lived *lit patriotique*. Bonaparte's bed in his hôtel on rue Chantereine is an

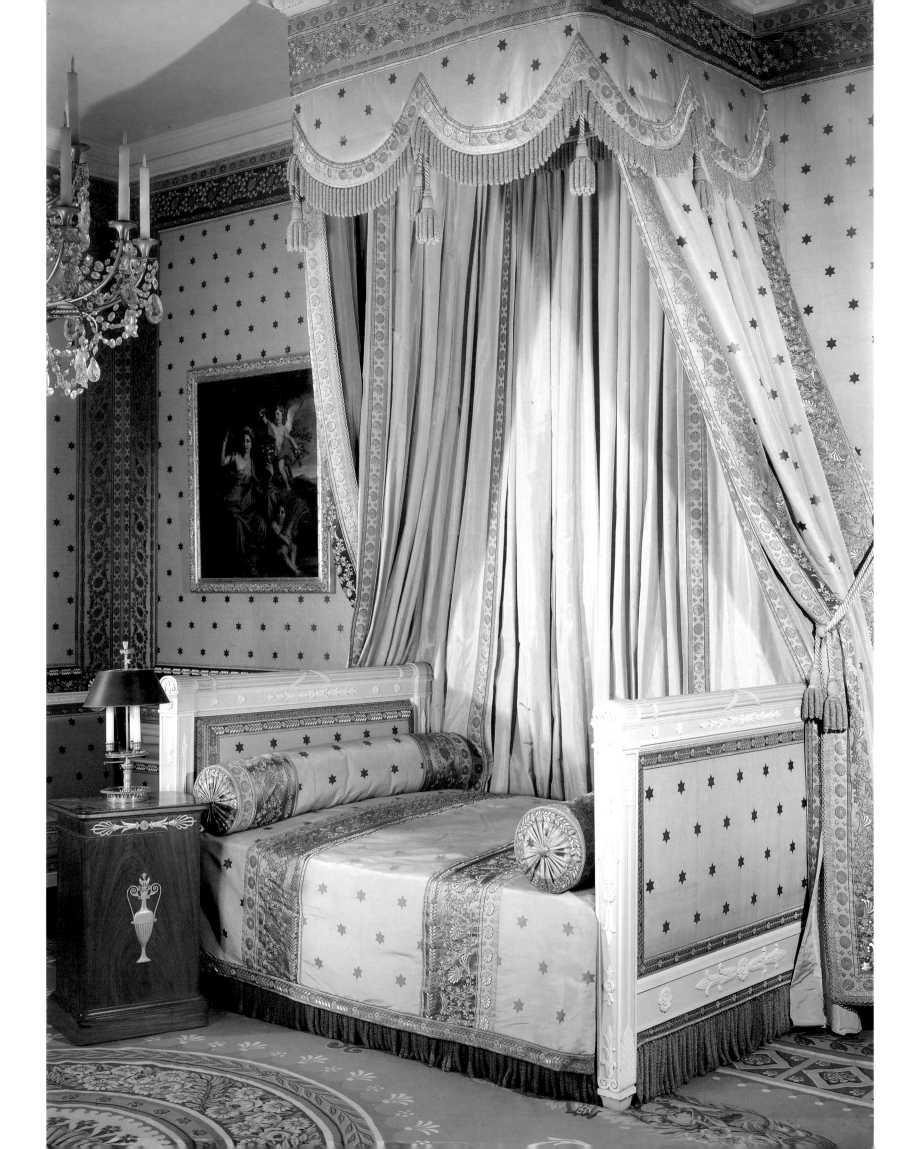

example. Directoire beds were very simple: their sides were often topped with low pediments, the front posts were fluted columns, and the customary geometric motifs were carved in low relief.

The Empire *lit droit*, the straight bed, was similarly conceived but usually made of mahogany rather than of painted wood. Placed lengthwise to the wall, its front posts were sometimes *égyptiennes en gaine* (female Egyptian terms). The *lit en chaire à prêcher* was also similar, but had straight posts (the back ones taller than the front) topped with male or female heads or small vases of patinated bronze, as on the bed now seen in Bonaparte's bedroom at Malmaison. In simpler versions the heads and vases were made of wood, painted black or dark green.[18] An even more basic type is Napoleon's bed in the Grand Trianon. Painted a light bluish gray and white, it was made by Jacob-Desmalter. Squarer beds *en tombeau* were inspired by antiquity too, and the Egyptian goddess Isis was carved into Denon's most unusual bed.

The most successful Empire bed was *en bateau*; its prototype was probably Madame Récamier's bed.[19] Its bottom plank might be curved and sculpted into a large garland of corn ears held by a ribbon, or it could be straight with only the ends of the bed scrolled. These spectacular mahogany beds were placed on a dais or on square plinth feet, and the more luxurious pieces featured heavily sculpted wood. When Josephine redecorated her bedroom at Malmaison in 1812 after she had been repudiated, she felt the need to stress her status despite her unfortunate position: her bed by Jacob-Desmalter is of particular pomp, ornamented with swans and a crown.

Prestigious beds were adorned with bronze mounts of the highest quality. There were military symbols, such as the helmets and arms on the bed of General Berthier in his château de Grosbois. There were also mythological motifs, winged figures, chariots, wreaths, or poppies and torches as symbols of sleep and night.

But the bed, sumptuous in itself, was not a simple piece of *menuiserie*. Theatrically raised above the floor and placed in front of a large mirror, it was often crowned by a canopy from which hung curtains of muslin and heavy silk. These were the creations of the *tapissier*, who supplied the meters and meters of textiles needed to complete the decor.[20] On either side of the bed were *somnos*, night tables in the shape of classical pedestals or steles, decorated with bronze mounts.

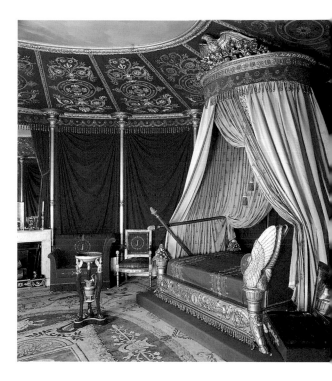

ABOVE: Josephine's bedroom at Malmaison as redecorated by Louis Berthault in 1812. The bed, by François-Honoré-Georges Jacob-Desmalter (1770–1841), may have been designed by Berthault, who had created Juliette Récamier's bed with its sculpted bronze swans in 1798 and had just designed Empress Marie-Louise's bed in Compiègne with a similar gilded-wood crown. The Savonnerie-style carpet is from the Beauvais factory. Josephine usually slept in another, simpler bedroom.

OPPOSITE: Napoleon's bedroom in the Grand Trianon was furnished in 1809–10 by the tapissier Darrac. The "lemon wood" moiré fabric, brocaded with lilac and silver silk, was woven by the Lyons manufacturer Camille Pernon. The bed and seats are by Jacob-Desmalter, as is the night table, delivered in 1810.

FOLLOWING PAGE: Queen Hortense's bedroom in the Hôtel de Beauharnais. The mahogany alcove and bed are by Jacob-Desmalter. The armchairs are attributed to him as well; the swans recall those designed by Percier and Fontaine for Josephine's boudoir at Saint-Cloud (see page 78). The Savonnerie carpet was rewoven.

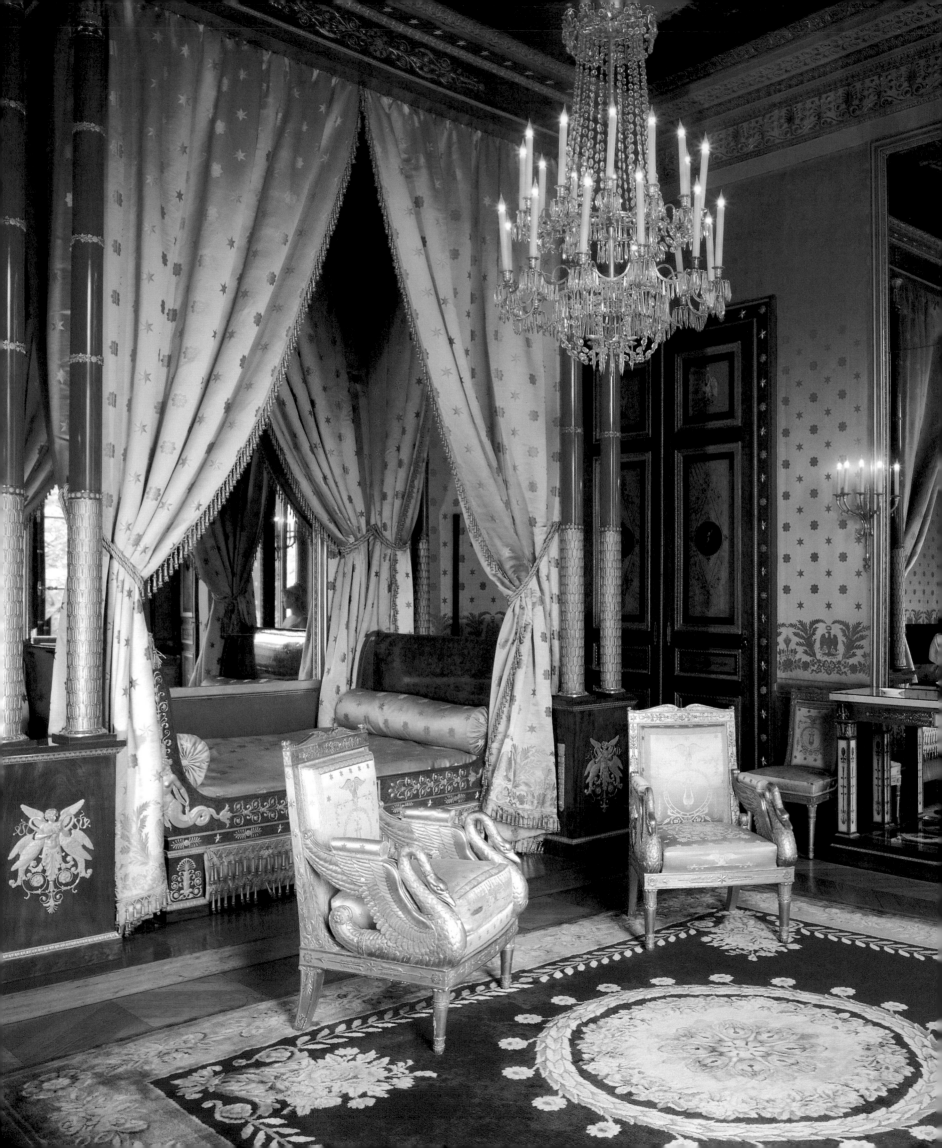

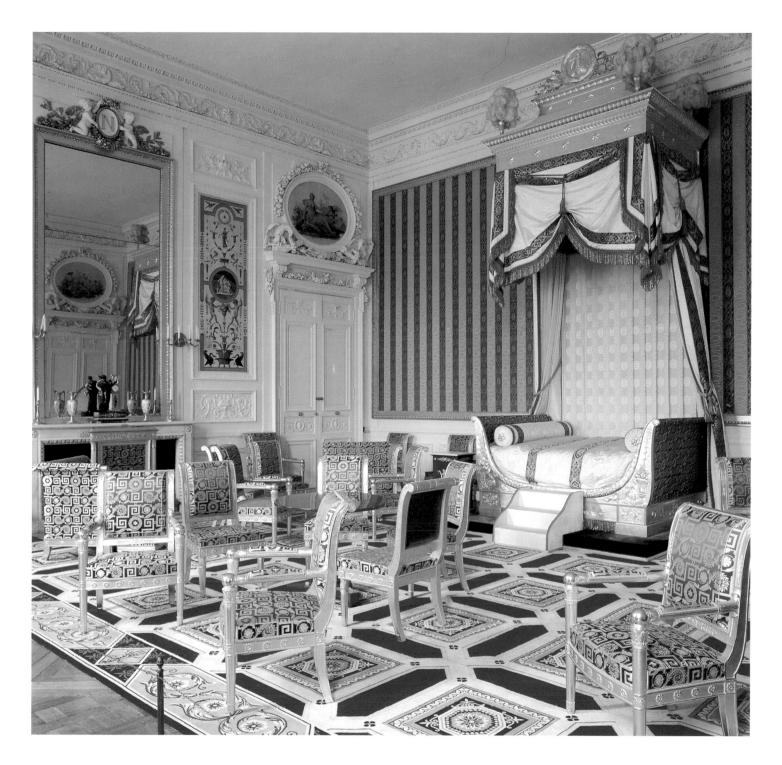

Napoleon's main residence was the Tuileries, but often at the end of a day he would suddenly decide to sleep in the Elysée, in Malmaison, or in Saint-Cloud, or to spend a few days in one of the châteaux outside Paris. To enable him to work as efficiently as possible, he liked his interiors arranged in a similar manner in all his residences. So he did make use of the many bedrooms furbished for him, even though he worked long hours and needed but a few hours sleep.

The king of Rome's bedroom at the château de Compiègne. The Pompeian-style wall panels are by the Dubois and Redouté firm. All of the furniture was made by Pierre-Benoît Marcion (1769–1840), 1808. The fabrics used throughout the room are particularly sumptuous. The lights are by Galle.

"Turkish" commode by François-Honoré-Georges Jacob-Desmalter (1770–1841), who sold it in 1810 to the château de Fontainebleau. Similar motifs adorn a console by the frères Jacob and a night table in the Royal Palace in Naples.

If Empire chairs and beds were of great originality and diversity, commodes and secretaires followed eighteenth-century shapes, although they were more architectural and massive.

Commodes were used as cupboards in virtually all rooms—in the antechamber, the sitting room, and the dining room when there was one, as well as in the study and the bedroom. The Louis XVI commode had lost the curves of its rich baroque antecedents, but it was still a masterpiece of *ébénisterie*. During the Directoire the marquetry disappeared, though some inlays remained, as in a commode by the frères Jacob at Fontainebleau. Standing on top-shaped feet, the commode might have columns at each end. The bails were rectangular; the escutcheons, elongated lozenges.

Posed on a wide base or on claw feet, the Empire commode was square and frontal. It had three drawers, with a fourth one included in the apron. The ring pulls were often held by lion heads. The term *meuble d'appui* (literally, "to lean on") applied both to *commodes à l'anglaise*, the drawers of which were hidden behind two doors (a shape that had been one of Jean-François Leleu's specialties), and to two-door cabinets. These *meubles d'appui* were more sophisticated, and their doors offered large panels on which to display mythological scenes in bronze, such as Venuses or deities in chariots drawn by butterflies. Several handsome ones were made by the Jacob family. Both types of commodes were flanked by columns with capitals, or by female Egyptian terms. These sculptural ornaments were of wood painted green (*à l'antique*) or gilded, and in better pieces they were of gilded bronze. Very heavy ebony cabinets adorned with thick bronze mounts were made for the Grand Cabinet de l'Empereur in the Grand Trianon.

The same format and decoration were applied to *secrétaires à abattant*, drop-front writing desks with bronze figures, friezes, and keyhole escutcheons in the shape of lyres, rosettes, flowers, or leaves. Indeed, commodes and secretaires were often made as pairs. As a rule, the inside of a secretaire was of a lighter-colored wood than the outside.

The *bonheur du jour* was a small writing cabinet set up on a table or console with front legs in the form of caryatids, monopod lions, or columns. Of similar

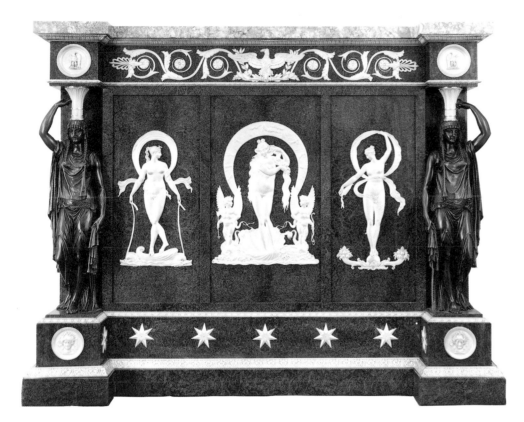

Commode by the frères Jacob, amboyna with bronze mounts and a griotte (red-and-brown-spotted) marble top. VICTORIA AND ALBERT MUSEUM, LONDON

construction were some jewel cabinets (*serre-bijoux*), such as the colossal one made in 1807 by Jacob-Desmalter for Josephine after designs by Pierre-Paul Prud'hon and Percier and Fontaine and the smaller ones that belonged to Marie-Louise.[21] A small *bonheur du jour* and a *serre-bijoux* of eighteenth-century grace by Adam Weisweiler belonged to Hortense de Beauharnais, and can be seen in her boudoir.

Chiffoniers, tall chests of drawers, were also called *semainiers* because they had seven or eight drawers, one for each day of the week. They, too, were adorned like commodes and secretaires.

Bookcases were of simple design. Some were smaller pieces of furniture with glass doors.[22] Others were as tall as the room itself, such as the bookshelves in Napoleon's study in Compiègne. Napoleon read a great deal and decreed that every book that was published be bought for his various libraries, particularly those in Malmaison and the Tuileries. These libraries were central to his way of working, and he always took books with him on his campaigns. He also had prestigious volumes bound in leather.[23]

Consoles (pier tables) were narrow tables meant to be placed against a wall between two windows or opposite a chimneypiece, but they were closer to case

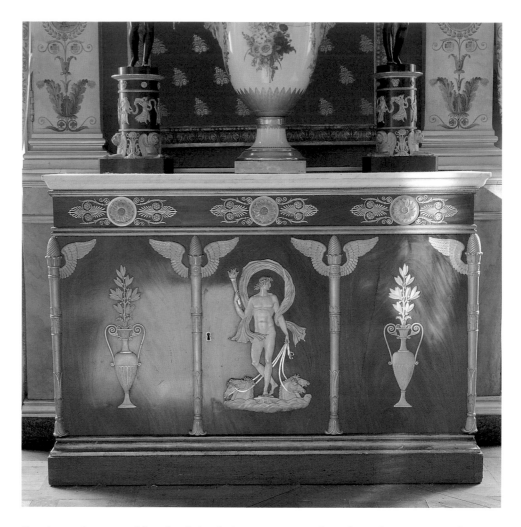

Commode, 1810, by François-Honoré-Georges Jacob-Desmalter (1770–1841), mahogany, with a bronze relief of Apollo.

Jacob-Desmalter made this commode for the empress's bedroom at the château de Compiègne.

furniture than to tables, both in their structure and in their decoration. They were sometimes of a graceful half-moon shape, resting on columns or caryatids.[24] Like commodes, secretaires, and *bonheurs du jour,* they attracted all the classical fauna of sphinxes, griffins, and lions and were adorned with friezes or simple stars. Only the front legs were decorated, though all four legs usually rested on a large base, and there was often a mirror in the back to reflect the carpet in the middle of the room. Consoles and commodes had marble tops of high quality: black or gray, slate blue, blue, sea green, dark green porphyry, purple brown with lilac spots, and white for simpler pieces.

Consoles were used as side tables but more frequently as decorative pieces in reception rooms to display porcelain vases, bronze statuettes, candlesticks and candelabra, or collections of antiques, such as Josephine's at Malmaison. They were often found in pairs and like secretaires might be made to match the rest

of the furniture. From a design standpoint consoles are of particular interest since their simple basic shape did not change over the years, but their manner of decoration reflected quite faithfully the evolution of the Napoleonic style, from the light and inlaid Directoire examples to the graceful Consulat and early Empire mythological formulas to the late Empire versions, which were more frequently made of local woods, often painted light gray, with simple moldings or decorations painted white, as in the Grand Trianon. Although they were part of architecture rather than furniture, chimneypieces were quite similar to consoles, both in shape and decoration.

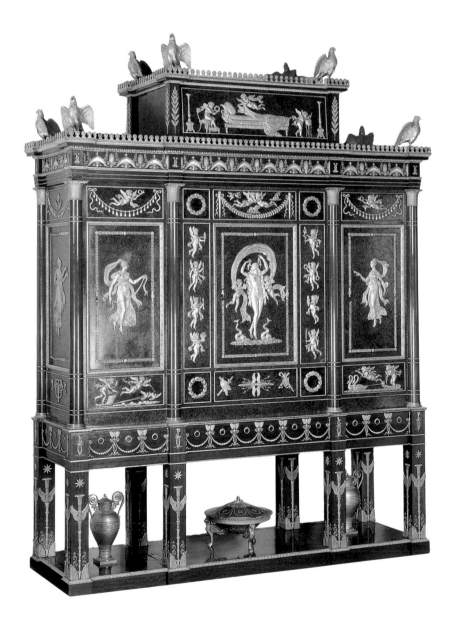

Jewel cabinet, 1809, by François-Honoré-Georges Jacob-Desmalter (1770–1841), yew and amaranth, with bronze mounts and inlays of mother-of-pearl. LOUVRE, PARIS

This massive jewel cabinet was commissioned for Josephine, but it later became Marie-Louise's.

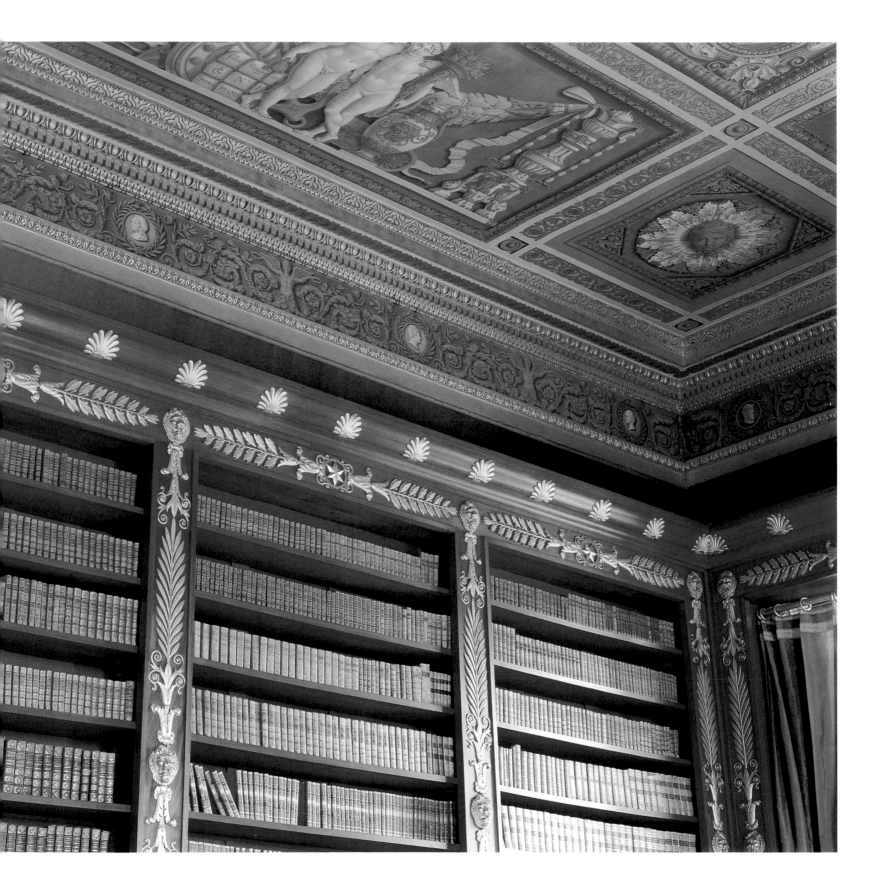

The chimneypiece in the Rose Salon in the Hôtel de Beauharnais is ornamented with Italian mosaics.

OPPOSITE: Napoleon's library at the château de Compiègne (detail). The painted frieze and ceiling decoration are by the Dubois and Redouté firm, 1810.

Half-moon pier table, c. 1800, by the frères Jacob, mahogany inlaid with ebony and pewter, with female term figures characteristic of the Consulat. CHÂTEAU DE FONTAINEBLEAU

Originally in the château de Saint-Cloud, this pier table was brought to Fontainebleau in 1804.

TABLES AND DESKS

Large tables were a rarity in eighteenth-century France and remained so during the Empire, since the dining room was as yet uncommon. Even at the informal ladies' lunches Josephine held every day in her Tuileries apartments (Napoleon had a very quick lunch on his own), the table might still be set in a boudoir. Only in the most official apartments were dining tables found; noticeably influenced by English models, they were usually round, drop-leaf tables with turned legs. The frères Jacob made one of walnut for Bonaparte's hôtel on rue Chantereine in 1797; the one in General Moreau's hôtel on rue d'Anjou is also attributed to them. Jacob-Desmalter made a handsome table for Compiègne in 1811; even though it was very long and designed specially for this

Card table by Martin-Guillaume Biennais (1764–1843), mahogany and ivory. MUSÉE NATIONAL DU CHÂTEAU DE PAU, FRANCE

dining room, it could be entirely dismantled to enable the room to be used for other purposes.

In the eighteenth century many small tables offered elaborate displays of marquetry, but during the Empire they were of mahogany, adorned with bronze fittings and mounts. Graceful card tables, for instance, were found in many interiors; Martin-Guillaume Biennais and Bernard-François Vaugeois were known for tables containing all sorts of games and accessories. In her memoirs Madame de Lamartine recalls how in the evening her husband and she would have a game of chess while their children played or learned some of Jean de La Fontaine's fables.

Pretty *tables à ouvrage* for needlework, embroidery, and tapestry work were common too, made of simple fruitwoods or of more precious woods with bronze mounts for the palaces. The duchesse d'Abrantès tells how Josephine sometimes received her guests while seated in front of her *table à ouvrage.*

Dainty tables were made for watercolorists. Several members of the imperial family were keen artists: Hortense painted, Josephine traveled to the Alps with the painter Turpin de Crissé,[25] and Marie-Louise studied with Prud'hon and Isabey. Another table of this type was the *table à la Tronchin,* an architect's table, the top of which could be raised so that one could work standing up.

Lovely dressing tables—*toilettes*—appeared. No longer the simple Louis XVI model with a three-part top that lifted into a mirror, they seem to have developed from the toilet boxes Biennais made as a *tabletier:* a mirror was held between two delicate columns on a simple consolelike table. Often made to accompany the *toilette* was the *psyché,* a spectacular cheval glass luxuriously sculpted and adorned with bronzes. It had appeared at the end of the eighteenth century but was typically Empire; Prud'hon designed beautiful ones.

The most frequently used table was the gueridon, a round or polygonal table supported by a central leg or by three or four simple columns set on a concave-sided base. These tables were influenced by the tripods found in excavations or were copied from models seen on Etruscan vases. During the Consulat the slender legs were very arched and sported eagle heads at the top and claw feet at the bottom. Gueridons could also be supported by classical or Egyptian caryatids, sphinxes, and monopod or winged lions made of gilded or patinated bronze or of patinated wood. When there were several supports the open space between them was often decorated, as it had been in the Louis XVI style, with

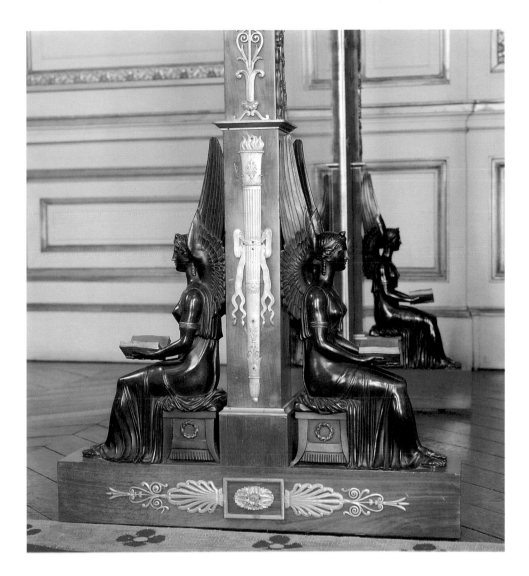

Psyché *in Pauline Borghese's bedroom at
the Hôtel de Charost, Paris. The quality
of this mirror suggests the involvement
of Pierre-François-Léonard Fontaine
(1762–1853), Pierre-Philippe Thomire
(1751–1843), and François-Honoré-Georges
Jacob-Desmalter (1770–1841).*

a vase or a *cassolette*, a delicate antique tureen. The tabletop was of marble, or
very rarely of porcelain, as was the base in a few exceptional pieces made by the
Manufacture de Sèvres: the Table des Maréchaux designed by Percier with
portraits by Isabey and bronzes after Thomire, at Malmaison;[26] the Table des
Saisons at Fontainebleau; and the Table des Châteaux Impériaux.[27] The gueridon
gradually grew to become a table around which several members of a family
could gather. In her memoirs Hortense de Beauharnais claims to have been the
first to place in the center of the drawing room a table around which everyone
could work or keep busy all evening as one did in the country.

Closer to tables than to secretaires were the large *bureaux plats* (flat desks),
which in those years were the most common. *Bureaux à cylindre* (roll-top desks),

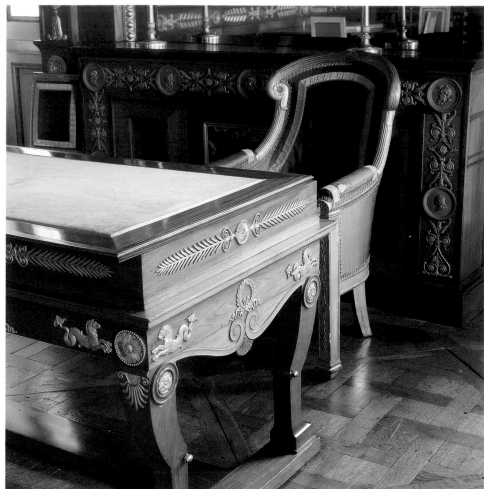

Napoleon's bureau mécanique *in his library at the château de Compiègne. The mechanical system of this large, solid mahogany desk was, it seems, invented by the emperor himself. The bookshelves and all the furniture in the room are by François-Honoré-Georges Jacob-Desmalter (1770–1841), 1808–10. There were up to six mahogany tables and four desks; Napoleon's habit of dictating several letters at a time was famous.*

which had been so fashionable and sophisticated during the reigns of Louis xv and Louis xvi, were less in demand.[28] The large flat desks found in palaces and ministries were useful for spreading out imperial documents. A massive carved mahogany desk of this type, raised on eight seated, winged lions and closely modeled on Roman furniture, was made by Pierre-Antoine Bellangé about 1810.[29] More refined are the *bureaux mécaniques* that Napoleon had designed specifically for laying out large military maps,[30] or the ones that belonged to Charles-Maurice de Talleyrand and Jean-Jacques Cambacérès. Whether for public or private use, these desks had remarkably rich bronze mounts. An unusual piece was the small desk in the shape of a triumphal arch and heavily decorated with caryatids that was made for Josephine by the frères Jacob in 1797, when she was living on rue Chantereine.[31]

Notwithstanding the luxurious furniture created for the palaces and the plush style developed in bourgeois interiors throughout France, the Empire style in furnishings was not as widespread among poorer classes as were sartorial fashions.

France remained a rural country where habits changed slowly, interiors were sparsely furnished, and fabrics were rare outside the upper and middle classes. In the countryside one usually found box beds. Benches were used more frequently than armchairs, and many still doubled as trunks, as in the Middle Ages. The traditional armoire, a major piece of the dowry ceremoniously presented by the bride's father, was used to store all the linen of which the young woman was so proud. Neither this imposing armoire nor the more recent and important-looking buffet, or sideboard, could be replaced by refined case furniture. For many years country furniture continued to be made in the Louis xv style, with its reassuring volumes and sinuous lines. When it did begin to change, the decoration evolved faster than the general structure: the shapes remained Louis xv, while a few decorative motifs—fluted elements, pearls, ribbons, and birds—were Louis xvi, with many regional differences. But the Empire style had almost no impact on country furniture; the scrolled bed, for instance, required a skill that village craftsmen could not develop. Even in the city, many modest flats had no separate kitchen, and the main room had one table, with chairs lined up against the wall.

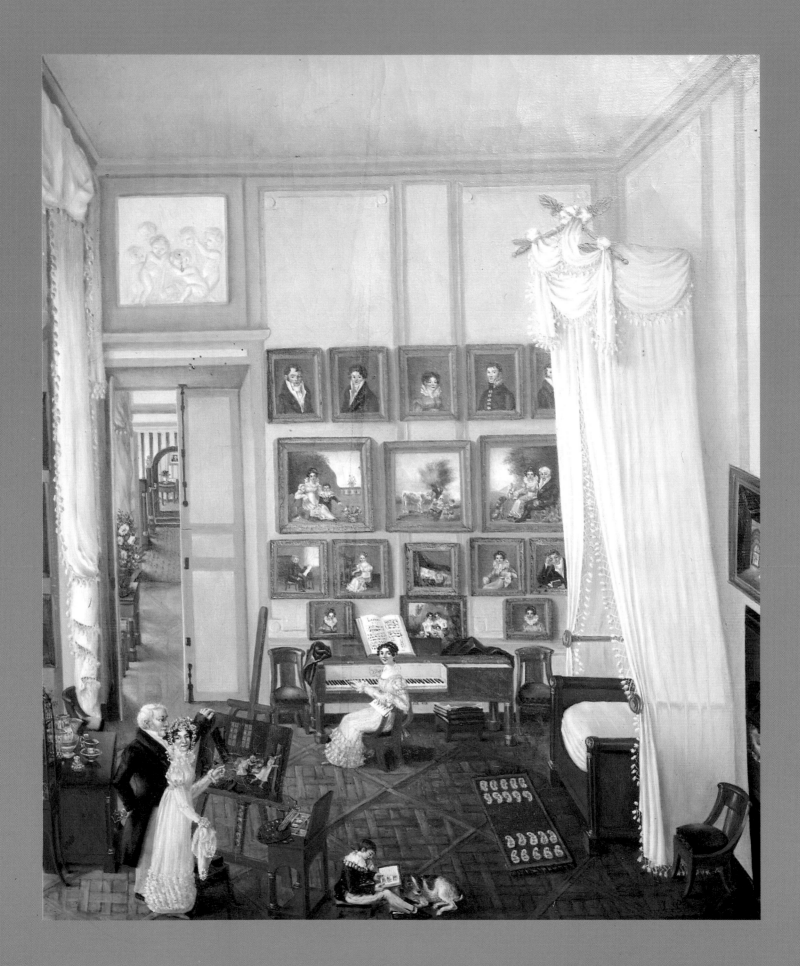

INTERIOR DECORATION

Empire was a masculine style, conceived and designed after Roman models. With the advent of an empire of administrators and soldiers at the turn of the century, the fanciful mood of the eighteenth century vanished, ushering in a style of grandeur and prestige.

During the ancien régime, too, etiquette and royal ceremonies gave rhythm and pomp to court life. Yet the furnishings of the eighteenth century also testified to a less formal life of games and music and amorous encounters. Numerous little tables and light chairs could be moved around for a game of cards or for chamber music. Dainty writing tables suggested many a love letter or poem. And the marquetry and porcelain plaques on the furniture had pastoral and lyrical tones.

But the tradition of the cultured amateur who was familiar with the civilizations of the past and enjoyed the refined pleasures of life would not survive the Revolution and the Directoire. Even after 1815, when the former ruling class returned, industry, commerce, and politics would become the business of men, and life would not be enjoyed with the same insouciant elegance.

The setting of Empire was monumental. Even the *ornemanistes* presented their motifs and their projects in severe black-and-white drawings, influenced as Percier and Fontaine had been by English illustrator and sculptor John Flaxman's linear purity; these drawings were later disseminated in the form of prints, most often without shade or color. Nevertheless, major elements of interior decoration remained free from the geometric austerity of official furniture. Wall decoration differed little from its eighteenth-century antecedents. Loose furnishings were so abundant that they gave a room a sense of plushness.

The role of women in decoration was significant and would increase with La Mésangère's publications and with their many imitations or equivalents, as in Italy and Germany. Despite the sarcasms directed at some women for their lack of distinction, the wives of the dignitaries of the Empire gave new life to the luxury industry through their commissions, purchases, dinners, and balls. Craftsmen complained that business slackened dramatically when the wives of dignitaries and high-ranking military men followed their husbands and left Paris for several months at a time, in the wake of the emperor: "No sooner had her Majesty the Empress come back to Paris than everything changed."[1]

WALLS

In palaces and in the best private homes rooms were lined with large flat panels of wood framed by pilasters or moldings, in the manner advocated by Percier and Fontaine and by Krafft and Ransonnette. The panels were usually painted with arabesques, a familiar motif in earlier French decoration that had gained great lightness from the influence of Pompeian frescoes; in midcentury Charles-Louis Clérisseau, Robert Adam, and François Boucher played an important role in spreading such motifs, which were also found in wallpapers.

During the Directoire wall decoration was not very different from the Louis XVI style. It was delicately *à l'antique*, with grotesques and palmettes running in friezes around rooms and in frames. This Pompeian decoration was peopled with female deities dancing amid floral garlands and wreaths. Trophies, arabesques, vine branches, flowers, masks, garlands, and medallions appeared in cheerful colors. Backgrounds were muted, in what was believed to be Etruscan

browns for the panels, with violets and fawn for the upholstery. Lozenges and palmettes gave a geometric rhythm to the whole.

During the Empire the decoration of panels changed little. In luxurious interiors mahogany panels and doors were adorned in the center, or included panels of light-colored wood inlaid with silver fillets. Beautiful mythological figures appeared in bright colors, as in the Hôtel de Beauharnais. The cornices, the friezes running below these, and the smaller decorative panels were of white or blue-gray stucco.

Interior architectural elements were most striking in the official rooms designed by Percier and Fontaine, and were also found in rooms where stone or marble dominated, such as vestibules and bathrooms. Bourgeois homes featured numerous varieties of stucco ornaments in relief, which could be either designed by an architect or ordered from catalogs like those of the Manufacture de Joseph

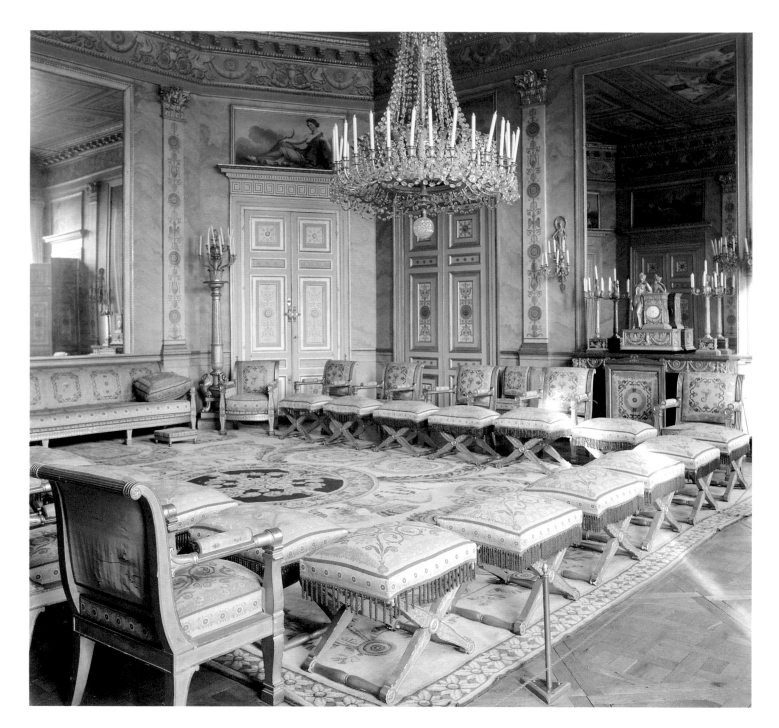

The empress's Third Salon at the château de Compiègne was decorated by the Dubois and Redouté firm in 1809. The seats, made by Jacob-Desmalter, are covered in a gold-and-green brocade by the frères Grand.

Beunat in Sarrebourg. Made of a special kind of white plaster, these ornaments could be painted or gilded to the customer's wish. Beunat's advertising stressed that they were far less costly than carved wood or regular plaster ornaments and that any craftsman could apply them easily. Trompe l'oeil imitations of wood or marble were also popular and became even more so as economic difficulties increased.

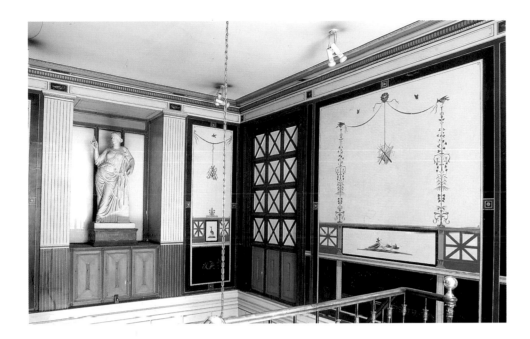

*Directoire stairway in the Hôtel Botterel
Quintin d'Aumont, Paris. Count Botterel
Quintin lived in this hôtel from 1785 to
1817 and had it richly decorated. The decor
of this landing was inspired by the Poet's
House in Pompeii.*

Remarkably large mirrors framed by moldings multiplied these stately decors or enlarged alcoves and boudoirs. Palace ceilings were heavily decorated, often in dark natural wood, sculpted and partly gilded or painted. In private homes simpler designs with a central rosette and a large border framing the whole ceiling were often echoed in the design of the carpet.

Bathrooms were charming, often featuring large mirrors and stuccoed walls decorated with flowers and foliage. Bathrooms, like vestibules, were simply furnished with benches and sheet-metal jardinieres.

Boudoirs had a particularly feminine atmosphere, and the Turkish style of decor was especially fashionable. Sometimes a comfortable divan and a decoration of drapes, stars, and crescents sufficed, as in the Turkish boudoir Berthault made for the princesse de Courlande in 1801, and which Krafft and Ransonnette published. Sometimes, as in the Hôtel de Beauharnais, the decoration was closer to a true Ottoman interior.

Fortunately, the symmetrical and imposing organization of interior decoration advocated by Percier and Fontaine—as manifested in Isabey's various bedrooms—was not often followed in private homes, since it left little leeway for the owner's personal taste or fancy. Even paintings were awkwardly fitted into rooms that looked like a stage; they had to be hung on the drapes as they had been in earlier centuries.[2]

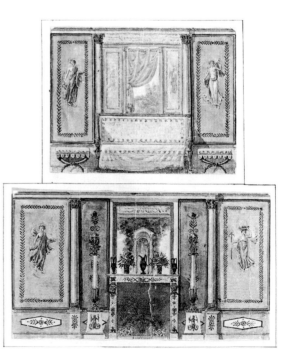

*Two projects for room decoration by
Pierre-Antoine Bellangé (1758–1827). THE
METROPOLITAN MUSEUM OF ART, NEW YORK;
THE ELISHA WHITTELSEY COLLECTION*

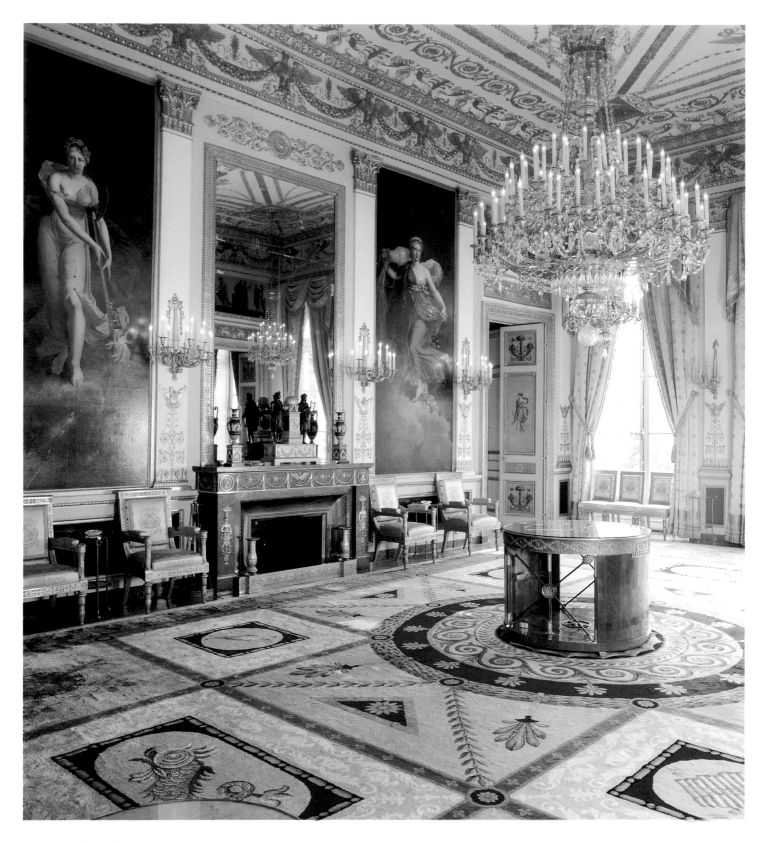

ABOVE: *Salon of the Four Seasons in the Hôtel de Beauharnais, Paris. The windows overlook the Seine and the Tuileries garden beyond.*

OPPOSITE: *The bathroom in the Hôtel de Beauharnais, Paris. Its eighteen columns are painted to imitate marble. The bathtub is lined with copper, and the floor is inlaid with colored marbles.*

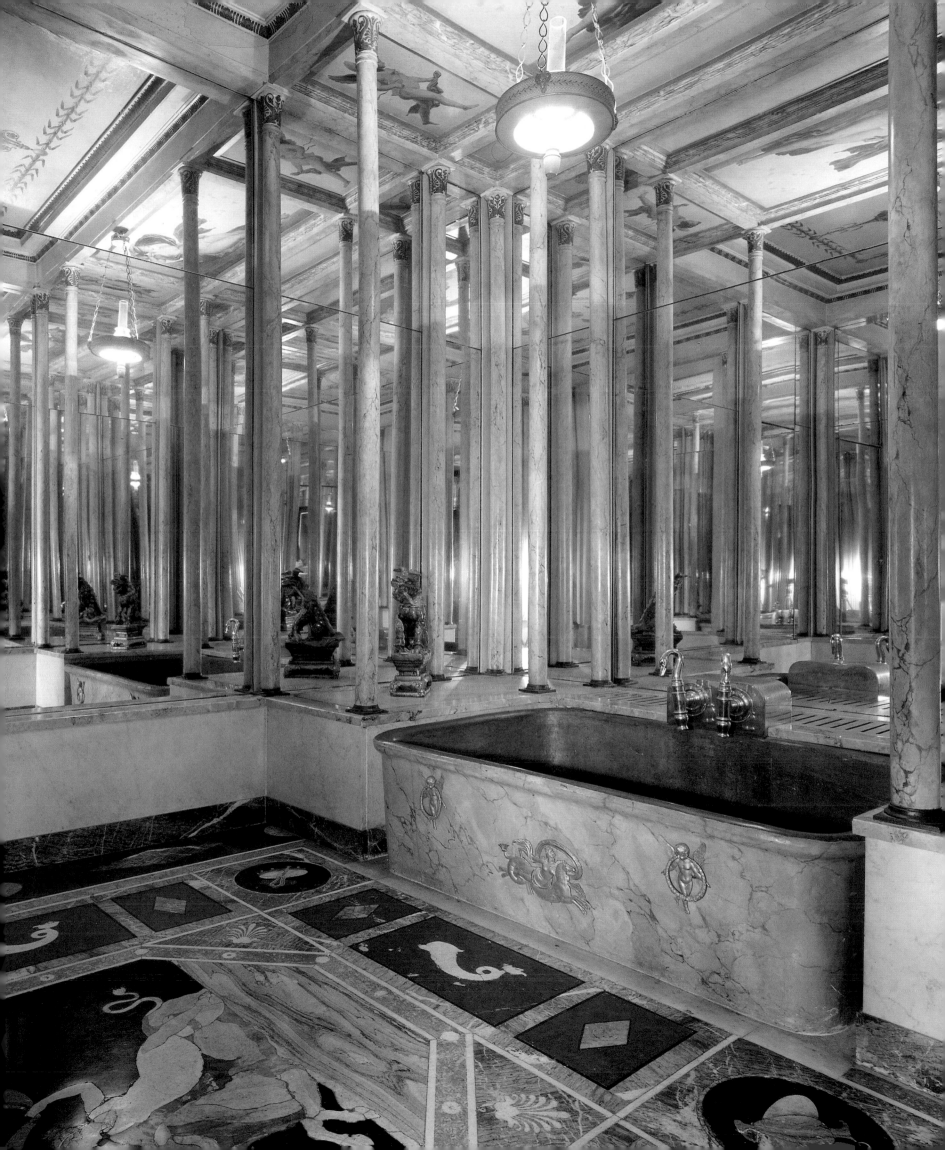

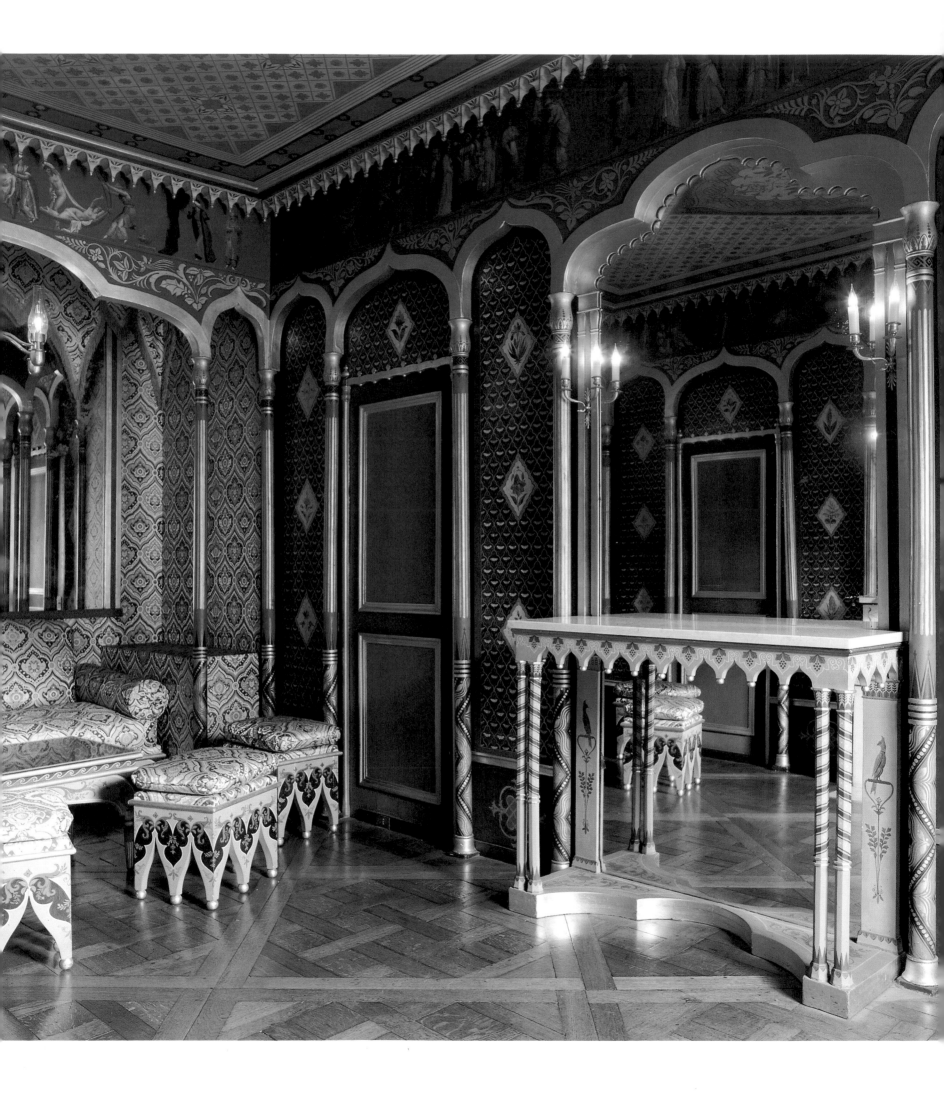

WALLPAPER

Wallpaper was rapidly becoming a convenient and attractive way to decorate an interior. Such excellent manufacturers as Jacquemart et Bénard, Dufour, and Zuber made papers of great artistic and technical quality in lavish colors. Even so, the use of wallpaper was not always considered quite proper: in 1804 the château de Fontainebleau was in serious disrepair and had to be refurbished in great haste for the arrival of the pope, who was coming to coronate Napoleon. But the latter was displeased when the architect in charge wallpapered some of the rooms.

The manufacturing of wallpapers was still a young industry when the Revolution broke out, but it did not suffer long from the upheavals or from the ransacking of the premises of the most important manufacturer, Jean-Baptiste Réveillon. For thirty-five years Réveillon had improved the techniques of printing with woodblocks; he had brought to France the English use of thick distemper colors, and he had commissioned designs from the best decorative artists and specialists in textiles and tapestry—those who worked for Oberkampf and the Gobelins. At the time of the Revolution his successors Pierre Jacquemart and Eugène Bénard continued using Louis XVI arabesques, bouquets, and birds, and they also produced wallpapers for the revolutionary government, with Phrygian caps, wreaths, and patriotic mottoes. Soon, however, they adopted the prevailing neoclassical style, as did the other rising manufacturers, Jean Zuber from Alsace and Joseph Dufour from Mâcon.

These companies were noticed and rewarded at the national expositions. They were successful because their papers were strong; to insure quality they often made their own, and they could now produce longer strips of paper, which were more convenient than the former dominos (small squares placed side by side). Production increased as the manufacturers catered to the many new administrators moving into buildings that needed refurbishing. They also answered the demand of a clientele that could not afford expensive silks for decorating the home and was delighted by the bright patterns available in wallpaper. Furthermore, the extension of the Empire opened the whole of Europe to their production. As with other crafts and industries, the situation deteriorated only later when raw materials could not be obtained and when exports became impossible.

OPPOSITE: The Turkish Boudoir in the Hôtel de Beauharnais. The frieze above the gilded arches and columns depicts the life of women in a harem.

Wallpapers ranged from the luxurious to the inexpensive. Simple repeat patterns of floral or geometric motifs, rosettes, and stripes were the most common. But even then very colorful and dense borders of roses, poppies, lilies, fruit, or foliage were carefully conceived to enhance or match them. Richer borders included golden acanthus leaves, anthemion, and friezes of stylized plants gilded to resemble bronze mounts. There were also putti, medallions, cameos, and scenes inspired by Greece. Most sophisticated were the borders in imitation of drapes, as lush in color and volume as the textiles themselves.

Wallpaper designs followed decorative trends very closely, and favorite patterns of the early nineteenth century were those that reproduced the look of other materials, including marble, wood, and especially silk. For more than a century, flocking (adding powdered wool to the surface) had given a velvety quality to wallpapers. Now, with improved printing techniques, papers could also have the bright colors and delicate shimmering effects of brocades and damasks. Whether in large patterns, in single decorative panels, or in borders, the most lavish draperies, festoons, and tassels were imitated, as if drawn on brass rods or hung like curtains. For the rendering of skies, Zuber developed the remarkable *fondu*, or *irisé*, technique, which produced deep perspectives by gradually diminishing the intensity of the blues. This technique paralleled the rendering of atmosphere in early nineteenth-century painting.

In an industry so heavily dependent on current taste, the designer had a very important role. Yet he usually remained anonymous, working exclusively for the factory and privy to all its technical secrets. Large illustrated panels—closer to painting than to wallpaper—were sometimes created by well-known artists. However large and complex, these papers were printed like woodcuts, using separately carved and inked blocks for each color; the most luxurious ones actually used several hundred blocks. Not until 1826 would Zuber take out a patent

for printing with cylinders. In 1808 Dufour published the "Months of the Year" by Alexandre-Evariste Fragonard, independent panels almost two meters high. In 1814 he produced the "Galerie Mythologique," six large panels that imitated classical reliefs, designed by Xavier Mader, who collaborated with him on many important projects.[3] The painter Louis Lafitte, who decorated the dining room at Malmaison, also produced designs for neoclassical panels.[4]

Top: Wallpaper border design attributed to Dufour. Musée des Arts Décoratifs, Paris

Bottom: Design for a painted wallpaper, 1810–20, artist unknown, gouache. Musée des Arts Décoratifs, Paris

Opposite, left: Detail of a painted wallpaper attributed to Dufour. Musée des Arts Décoratifs, Paris

Opposite, right: Detail of a block-printed wallpaper border. Courtesy of Cooper-Hewitt, National Design Museum, Smithsonian Institution–Art Resource, New York

"Les Sauvages de la Mer du Pacifique,"
panels 13–14, 1804, Jean-Gabriel Charvet,
panoramic wallpaper manufactured by Dufour.
MUSÉE DES URSULINES, MÂCON, FRANCE

The most prized Empire papers were *papiers panoramiques.* Of exceptional quality and dimensions, these spectacular wallpapers were conceived to cover whole walls of sitting rooms or dining rooms. The first ones, presented as *papiers peints paysages* (landscape wallpapers), were greatly admired at the 1806 exposition. Zuber showed "Vues de Suisse" by Pierre-Antoine Mongin, and Dufour presented "Les Sauvages de la Mer du Pacifique" by Jean-Gabriel Charvet. Quite in keeping with their time, they displayed exotic themes and opened windows onto distant worlds, enchanting the public with tales of nature and voyages. Though they evoked ideal and dreamlike worlds, they were highly descriptive and might even come with explanatory pamphlets. Dufour

portrayed "Les Monuments de Paris" (1814) and related the explorations of Captain James Cook in "Les Sauvages de la Mer du Pacifique." Some drew on classical sources, such as "Les Métamorphoses d'Ovide" or the endlessly successful "Psyché et Cupidon," a famous *grisaille panoramique* by Louis Lafitte, first published by Dufour in 1816 but probably designed a year or two earlier.

Nature remained the most poetic and lush subject for wallpaper design. Seas, lakes, and fountains abounded, billowing clouds traversed vast blue skies (a device that also helped hide imperfections in the paper), and luxuriant vegetation enveloped nymphs and savages.

Psyche Bathing, panels 5–8 of the wallpaper "Psyché et Cupidon," 1816, Louis Lafitte, manufactured by Dufour. Musée des Arts Décoratifs, Paris

The place of wallpaper in interiors was to become increasingly important in the nineteenth century, as manufacturing techniques improved and as a larger middle class decorated its homes. However, the role of the *tapissier* remained as crucial as it had been earlier. During the time of Louis XVI the upholsterer ordained the overall appearance of a room, unifying the colors of the wall hangings, silks, and curtains and adding festoons to the furniture wherever possible. This unity could be overwhelming in its profusion, and it would be so again in the second half of the nineteenth century, in the age of Victoria and Napoleon III. During the Empire the presence of textiles in the home softened the stark lines of the architecture and the furniture and added color to the woods, which were often dark.

In the eighteenth century the *marchand-mercier* had been quite important; initially a dealer in loose furnishings, he had become the indispensable intermediary between the manufacturer, the dealer, and the customer. The latter no longer had to deal directly with the craftsman but would instead be visited by a person a little more worldly, who knew what was in fashion and could commission exactly what the client needed from the different craftsmen or dealers in wood, bronze, or porcelain. The *marchand-mercier* even became the link between the craftsmen and the dealers, buying ornamental porcelain plates

Curtain designs by the tapissier *Osmont, plate from d'Hallevent and Osmont's* Cahiers de dessins pour le décor des appartements de Paris. *BIBLIOTHÈQUE HISTORIQUE DE LA VILLE DE PARIS*

from Sèvres and lacquer panels from importers who dealt with the Orient, and then selling them to the *menuisiers* who would include these precious elements in their work.[5]

The *marchands-merciers* were now called *tapissiers*, and the better ones, like Michel-Jacques Boulard and François-Louis Darrac, worked with the Garde-Meuble, supplying it not only with silks and trimmings but also with important pieces of furniture, such as the innumerable seats needed in the palaces. The *ébéniste* and *tapissier* Alexandre Maigret was responsible, together with Jacob-Desmalter, for furnishing the apartments of the royal children in the Pavillon de Marsan in the Tuileries; with Pierre-Antoine Bellangé, he also furnished the château de Meudon.

The Garde-Meuble would give the *tapissiers* a few sketches, would usually let them order the woodwork from whomever they chose, and would entrust them with the upholstering. Some *tapissiers*, such as Pommier and Marcus, even gave their name to varieties of beds and seats. The designs for the fabrics had to be approved by the Garde-Meuble, and strict rules governed the work of the manufacturers: the quality and thickness of the silk, the quantity of gold woven into the brocades and brochés, the width of the patterns, and so on. Napoleon paid special attention to the fastness of the colors and encouraged research on dyes.[6] Two major technical innovations of the time that increased production significantly were the invention of the Jacquard loom for silk weaving and Oberkampf's introduction in France of cylinders for the printing of cotton cloth.

Napoleon was very concerned that the necessary help be given to the textile industry, which had almost come to a halt during the Revolution. His massive commissions revived the silk industry in Lyons and the cotton industry in Normandy and the Ile de France, around Paris.[7] Thus the Lyons manufacturers, the renowned *soyeux*, received huge orders through the Garde-Meuble Impérial. Among the *soyeux* Camille Pernon, who had been supplier to the Garde-Meuble under the ancien régime, and his successors, the frères Grand, were by far the most important, as famous as the Jacob family was in furniture making. From 1802 to 1808 they supplied silks for the Tuileries and for the châteaux of Compiègne, Fontainebleau, Meudon, Saint-Cloud, and Versailles. The manufacturing company of Bissardon, Cousin and Bony was very much in demand too. More

Fabric for a vertical border, 1802–5, by Camille Pernon (1753–1808), laurel-leaf and -flower pattern of lampas broché, *poppy-red damask ground, commissioned for the premier consul's library at Saint-Cloud.* MOBILIER NATIONAL, PARIS

White satin embroidered with flowers and birds, 1811–12, by Bissardon, Cousin and Bony, 10⅞ ft. (3.3 m) high, commissioned for the private salon of Empress Marie-Louise at Versailles. MOBILIER NATIONAL, PARIS

modest materials were also commissioned from lesser-known manufacturers to enable the whole industry to benefit from the imperial purchases.

The production of textiles, however, was not always of the highest quality, even for imperial interiors. After a damask commissioned from Pernon for the library at Saint-Cloud had faded, a long inquiry ordered by Napoleon himself concluded that the problem came from the dyers in Lyons, many of whom were young and inexperienced, without the benefits that guild training had provided for previous generations. The same was true of other products exhibited at the national expositions; for similar reasons, they were often of poor quality.

Furthermore, French "industry" of the time was composed mostly of artisans and not factory workers. The Lyons silk industry, for instance, had not been concentrated in large factories but was traditionally distributed among *chambrelans* who worked at home (in their chambers); this made it more difficult to control quality as new industrial techniques were developing. Cotton manufacturing in the provinces witnessed a similar situation: industrialists would rent out looms to peasant families scattered through the countryside. This, of course, began to change as industrialization spread.

A Drawing Room in Villa Acton, Naples, *artist unknown, watercolor.* SIOLI LEGNANI COLLECTION, BUSSERO, ITALY

The muslin drapery, the athénienne, *and the seats are all in a graceful, late Empire style.*

Other important factors that hampered French industry in general were the incessant wars and the Continental Blockade. On the one hand they ensured that French factories were the main ones supplying the vast French Empire. But on the other they impeded imports of raw materials, such as Brazilian cottons, as well as exports to other parts of the world.

Private residences followed the same fashions as the court. Silks and satins were used to drape walls, often in loose hangings thought to look "antique." This fashion extended through the whole of Europe; Charles IV of Spain, the king of Bavaria, and many other monarchs ordered silks from the Lyons *soyeux.* Napoleon, however, ordered that rooms of lesser importance be hung with simpler and cheaper cloth, such as the so-called *damas économiques.*

A crucial aspect of a room was the way in which materials were draped over and around windows; one could hardly call them curtains, so abundantly were they thrown over the rods. Festooned, decorated with tassels and pelmets, the heavy silks were attractively lined in a contrasting color. These draperies often formed decorative frames for windows and alcoves and were not meant to close. Muslins were used as lighter veils in the windows themselves and

Horizontal daisy-pattern border, 1802–4, by Camille Pernon (1753–1808), silver and gold brocade on a blue ground, one of an ensemble of fabrics made for Josephine Bonaparte's Grand Salon at Saint-Cloud. MOBILIER NATIONAL, PARIS

Blue-and-gold brocade seat fabric featuring Greek-key, star, and wreath motifs, commissioned for Josephine Bonaparte's bedroom at Saint-Cloud. MOBILIER NATIONAL, PARIS

over the bed. Thus three different colors might be conspicuously juxtaposed around a room.

Fabrics were numerous: brocades, velvets, *gros de Tours*, satins, reps, moirés, *gorgorans*, damasks, and *lampas*.[8] Patterns were plentiful too; stylized antique patterns such as anthemion and cornucopias and especially wonderful floral motifs inherited from the eighteenth century were the most frequent. Foliage of oak, ivy, or vine was woven in garlands, scrolls, and wreaths (for Saint-Cloud in 1802 Pernon used Etruscan motifs, oak leaves, and acorns). Many of these materials were embroidered with gold for imperial palaces, as were the muslins used for Josephine's rooms. Borders were also very important.

Several artists were famous for Empire silks. Jean-Démosthène Dugourc designed silks that were woven in Lyons and used in the palaces of France and Spain.[9] François Grognard also designed for Spain.

Colors were very varied and had poetic names: *bois de citron* (lemon wood), *aurore* (dawn), *terre d'Espagne* (earth of Spain), *tabac d'Espagne*, poppy red, hazelnut. Here again Josephine's eighteenth-century taste for lighter materials and colors and her great interest in nature and love of flowers were influential. Colors, however, grew darker between the Directoire and the end of the Empire as decoration became more ponderous and lifestyles more formal. Napoleon's state rooms featured brocades of deep reds, greens, and yellows, with imperial emblems as design motifs—the eagle, the bee, the *N*, and Greek geometric designs.

The cotton industry, too, was encouraged by competitions and prizes, and two major industrialists, Liévin Bauwens and Richard-Lenoir, invested heavily in it. The latter was an interesting example of a man with no family wealth who acquired *biens nationaux* and speculated and invested wisely, first with a partner and then on his own. He settled in the Faubourg Saint-Antoine, the furniture neighborhood, in several former convents that he bought with the help of the premier consul. Little by little he purchased several other convents and factories in Normandy, and by the end of the Empire he was employing more than fifteen thousand workmen. He even manufactured his own machines and exported to most of Europe. Nevertheless he suffered greatly from the 1811 economic crisis and had to receive massive help from the government.

Printed cottons—*toiles peintes* or *indiennes*[10]—were very popular for their figurative and narrative diversity. Cotton cloths were usually printed in three different ways: with woodblocks for color, with copperplates in the typical Jouy

"Psyché et Cupidon," toile de Jouy, c. 1810, after a design by Jean-Baptiste Huet (1745–1811) and inspired by motifs by Pierre-Paul Prud'hon (1758–1823). MUSÉE DES ARTS DÉCORATIFS, PARIS

This theme was very popular in textile and wallpaper design.

"Paul et Virginie," toile de Jouy.
Musée des Arts Décoratifs, Paris

Jacques Bernardin de Saint-Pierre's novel
Paul et Virginie *(1788) contributed to the late-eighteenth-century taste for pastoral and exotic scenery.*

red, or, after 1797, with cylinders. The printed cottons from Oberkampf's factory in Jouy and Petitpierre's in Nantes were the most sought after. History, mythology, and contemporary novels and operas were favorite subjects, especially in the famed toiles de Jouy. They were sometimes designed by well-known artists; Jean-Baptiste Huet, for instance, working for Oberkampf in Jouy, invented delicately striped patterns and created hues of lilac, rust, and "dawn" for backgrounds. Drawing on Jean de La Fontaine's *Fables* and Bernardin de Saint-Pierre's popular novel *Paul et Virginie*, Huet adapted scenes to contemporary tastes. Designs at the end of the eighteenth century were light and airy, but they tended to become more dense during the Empire and Restoration.

C A R P E T S

The long tradition of tapestry weaving that had flourished in France in the time of the kings had gone into decline in the wake of the Revolution. To decorate official buildings or as gifts to foreign sovereigns, tapestries were still woven in the Manufacture des Gobelins, patterned after well-known paintings celebrating the Napoleonic epic, such as works by David or Antoine-Jean Gros's *Les Pestiférés de Jaffa.* But the fashion was no longer to cover entire walls with

the works that had been the pride of Aubusson, Beauvais, or the Gobelins. Their manufacture was exceedingly slow and costly, and state commissions were not sufficient to keep the industry alive and creative. It therefore turned to more lucrative endeavors.

In the most luxurious interiors, chairs might still be covered in Beauvais tapestry[11] and doors hung with an Aubusson. But the most important production after the turmoil of the Revolution was that of carpets, for which the main centers were the Manufacture Impériale de la Savonnerie in Paris, the private workshops in Aubusson in the center of France, and Tournai in Flanders. As a result of Napoleon's keen interest, carpets were particularly beautiful, their

Period replica of the carpet of the Throne Room in the Tuileries Palace, 1807–9, Manufacture Impériale de la Savonnerie, wool, 25½ × 21 ft. (7.8 × 6.4 m). MUSÉE NATIONAL DU CHÂTEAU DE MALMAISON; GIFT OF MRS. HELEN FAHNESTOCK-HUBBARD

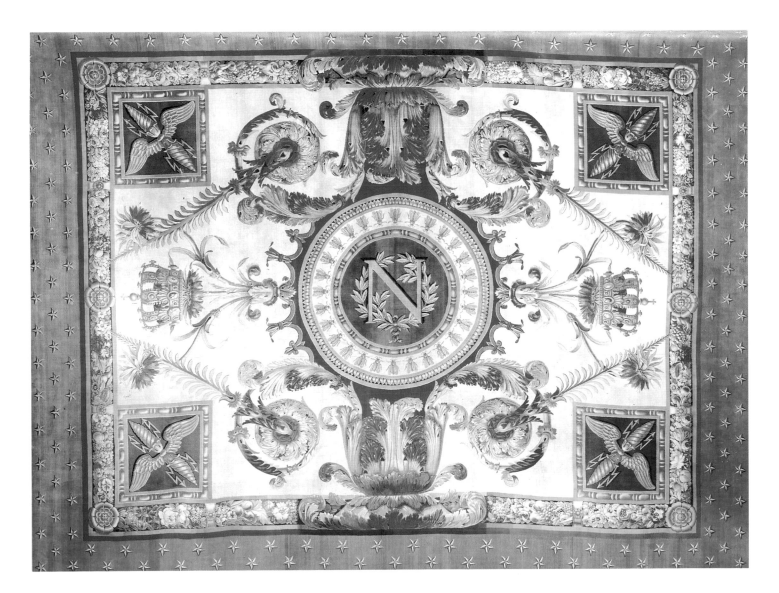

patterns bold and their colors bright with flowers, foliage, swans, peacocks, and military and imperial emblems.

The Manufacture de la Savonnerie, which had originated in the early seventeenth century, was famous for its knotting technique (*au point noué*), which gave Oriental carpets their velvety texture. The firm made huge carpets for the Tuileries, for the châteaux of Saint-Cloud and Compiègne, and for Napoleonic residences throughout the Empire. Designs were provided by Percier and the

Model after a design by Louis de La Hamayde de Saint-Ange (1780–1831) for the carpet representing the cohorts of the Legion of Honor, commissioned in 1808 from the Manufacture Impériale de la Savonnerie for the Tuileries Palace and now in the château de Compiègne.
GALERIE YVES MIKAELOFF, PARIS

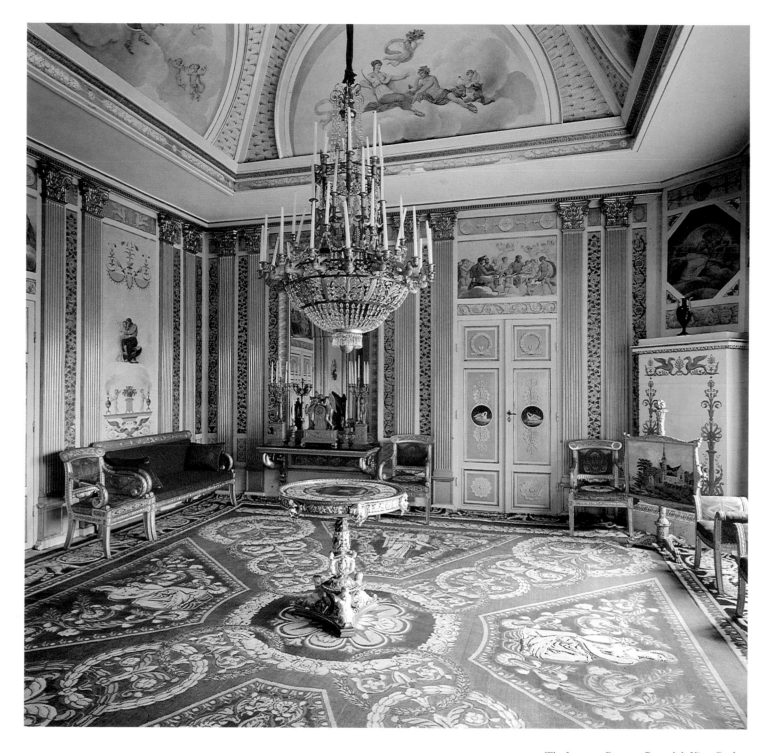

The Lantern Room at Rosendal, King Carl XIV Johan's private residence, is perhaps the most beautiful Empire room in Sweden. It was decorated by Pehr Emanuel Limnell. The carpet was woven about 1815 in Tournai.

Carpet design by Piat Lefebvre. A carpet with a similar design can be seen on page 29. MUSÉE DES ARTS DÉCORATIFS, PARIS

painter Dubois. But La Hamayde de Saint-Ange, who was appointed designer of the Mobilier Impérial in 1810, was the artist who gave a new impetus to designs both for Savonnerie and for Aubusson, cleverly including imperial symbols with arabesques and garlands of flowers around the central motifs and in the all-important borders. His style closely resembled that of the gardens of the period, and his borders were said to look like paths lined with charming beds of flowers.[12] In carpets borders had both a decorative purpose, as they had in wallpapers and curtains, and an economic one, for they could be added or removed to adapt the carpets to rooms of different sizes.

In 1805 in the private factories of Aubusson, about 250 workers made close-pile carpets, hangings, and tapestry work for furniture, while about 50 women wove thick-pile carpets. Among these factories, that of Jean Sallandrouze de La Mornaix was by far the most productive (and is still active today). His Aubusson firm had managed to survive the Revolution, and in 1801 he opened a factory in Paris with the help of two workers from Savonnerie; interestingly, though this new establishment presented competition to the imperial manufacturers, the minister of the interior granted him this favor, considering it "in the best interests of trade to patronize these new ventures."[13] His carpets, designed by Saint-Ange, Berthault, and Dubois, were of excellent quality and very much in demand. He supplied innumerable carpets for the châteaux of Napoleon and his suite; in 1806, for instance, he sold thirteen velvet carpets and eleven *moquette*, or mechanically woven, carpets to Prince and Princesse Murat for their Elysée Palace, and that same year he sent six fine-quality carpets to the Stupinigi Palace in Turin. During those years he also regularly supplied other palaces in Europe, including Napoleon's sister Elisa's residence in Florence's Pitti Palace and the Montecavallo Palace in Rome.

In Tournai the Manufacture Piat Lefebvre was also extremely prosperous, producing carpets both of high quality in the velvety manner of Savonnerie and for more ordinary use, exporting to Germany, Italy, Russia, and the United States.

Moquette carpets were woven in narrow bands that were then assembled. Their repetitive motifs seem to have influenced even Aubusson and Savonnerie designs. These far less expensive carpets were used in the less formal rooms of the imperial palaces and were common in private homes. As in earlier times, they were often stored away during the summer. But carpets were not used in all

Interior of a Kitchen, *1815, Martin Drolling, oil on canvas. LOUVRE, PARIS*

rooms. In good French homes the tradition of beautiful parquetry was still alive, a tradition that remained influential abroad. Entrances were often paved with white-and-black marble to match the columns and trompe l'oeil stucco walls. Dining rooms, too, often had marble floors, as did bathrooms. For small rooms and in middle-class homes, when carpets were not used, the typical small red floor tiles (*tomettes*) were left visible.

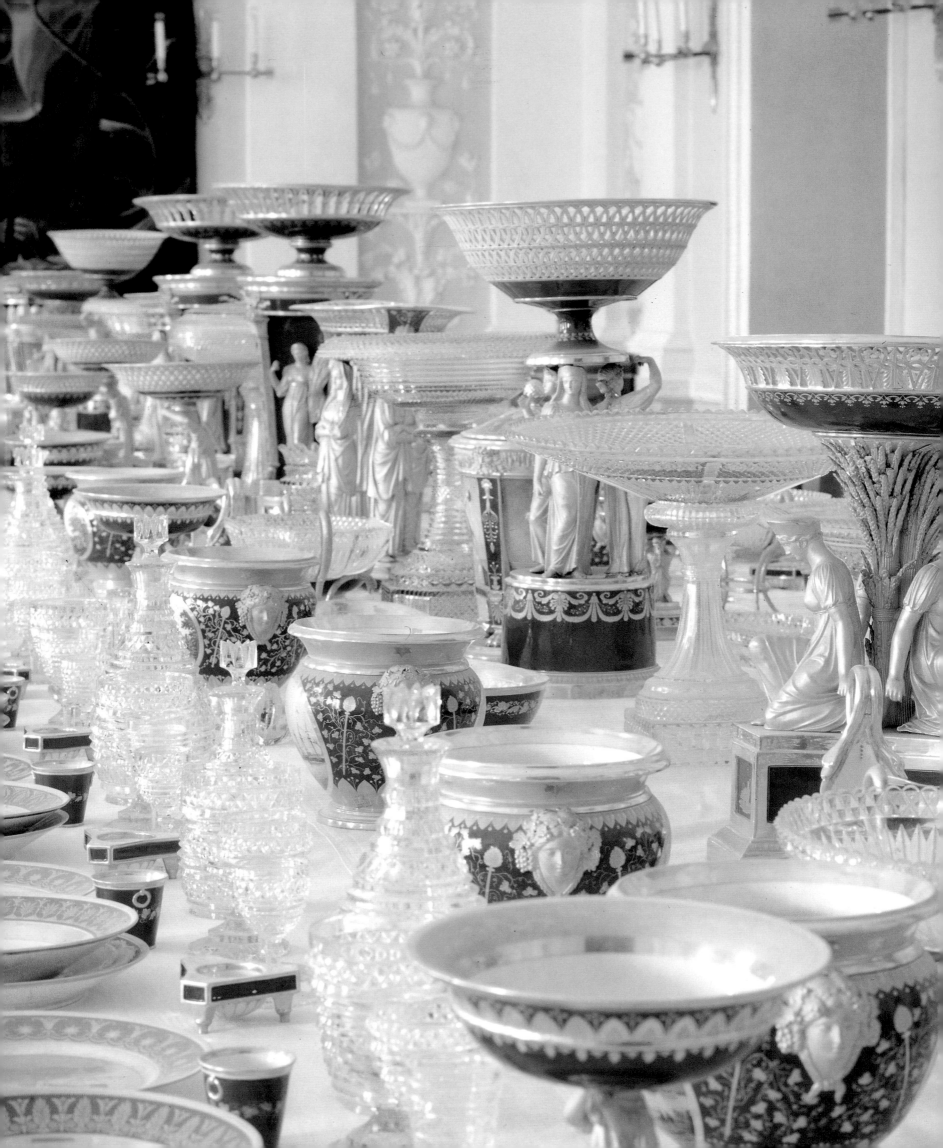

THE ART OF ENTERTAINING

T he production of beautiful objects alone was not what surrounded French arts with prestige for centuries. It was rather a tension, characteristically French, between two poles: an ancestral respect for tradition and fine workmanship, and a constant curiosity for intellectual discovery and formal innovation. This had remained true during the ancien régime, but it was distinctly in danger of vanishing as the nineteenth century began.

A burgeoning capitalism would soon ensure that there was far less time to devote to aesthetic considerations. Workers were no longer as well grounded in the practice and the love of their art. And a gap was appearing between the creative artist who produced the designs and the artisan or workman who had no choice but to execute them. Yet this course was not ineluctable. Through his demanding commissions, precise orders to administrators and directors, and exacting standards, Napoleon instilled a desire for quality in luxury industries that were to bear the colors of the French decorative arts for decades.

Entertaining and gastronomy had always been and would remain arts that the French paid particular attention to, and around which many crafts thrived. Even during the most tragic days of the Terror, imprisoned aristocrats who knew they would be guillotined a few days later had the best *traiteurs* in town bring them delicate meals. As soon as the Revolution was over, the famed restaurants around the Palais Royal and the Terrasse des Feuillants were patronized and talked about by everyone, whether Parisian or foreign: among the most fashionable were Le Café de Chartres (now Le Grand Véfour), Le Boeuf à la Mode, Les Frères Provençaux, and Méot, as well as those run by the restaurateurs Prunier, Robert (who had reigned over the kitchens of the prince de Condé), and Véry. These restaurants were luxuriously decorated and lit, for meals were more than simple fare: they were an aesthetic affair.

A true gastronomic literature developed, and Grimod de La Reynière's *Almanach des Gourmands* delighted many. Charles-Maurice de Talleyrand— prince de Bénévant and minister of foreign affairs—was famous for the dinners

Café Frascati, *c. 1807, Philibert-Louis Debucourt (1755–1832), engraving.* MUSÉE CARNAVALET, PARIS

Founded during the Directoire, this café on the rue de Richelieu was among the most fashionable meeting places during the Empire.

PAGE 154: The table in Mon Plaisir, a banqueting pavilion at Peterhof Palace in Russia, is set with the Guriev Service, commissioned in the early nineteenth century from the St. Petersburg Imperial Porcelain Factory.

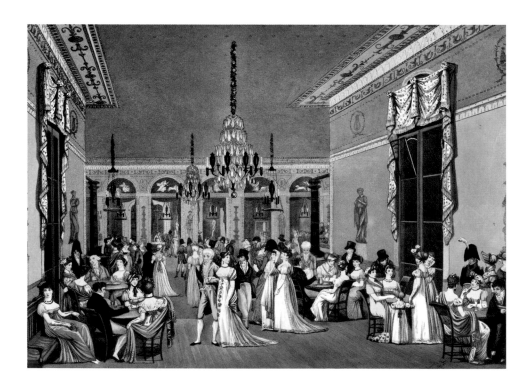

he gave in his residences, the Hôtel Matignon and the Hôtel Saint-Florentin. He employed the most prestigious cooks—Louis Esbrat, Boucher, and especially Antonin Carême. Carême, whose sense of decorum and ornament made gastronomy an art, helped to codify the art of serving and decorating. He was to work for all the courts of Europe, and everyone would later want one of his pupils as a cook.

Talleyrand was known to use the art of dining to entice foreign sovereigns and diplomats. And this was a pleasure virtually all classes of society could enjoy. There were hundreds of cafés in Paris alone; according to the *Almanach*

Le Grand Véfour restaurant, in the gardens of the Palais Royal, Paris.

des Gourmands in 1804, out of every ten new shops that opened in Paris, three were for fashion and four for *la gourmandise* (delicacies).[1]

Around the turn of the century a major change was taking place in the art of the table.[2] *Service à la française*, in which all courses of a meal were laid out at the same time, was being replaced by *service à la russe*, in which the food was prepared in the kitchen and served one course at a time. This method was less pleasing to the eye but more efficient, and one could thus eat the food warm. Concurrently, the decoration of the table was changing. Spectacular centerpieces remained, and the custom of *nefs* was revived for the emperor and empress. Sumptuous silver-gilt pieces in the shape of ships, *nefs* had been used to hold the king and queen's flatware, napkins, and spices in the Middle Ages. And since *service à la russe* left the table free of dishes, table decoration became richer than ever. Ornamental sculpture, flower-filled jardinieres, and beautiful glasses and goblets of cut glass or crystal made by Saint-Louis, Mont-Cenis, and Baccarat— all were symmetrically disposed down the table. Moreover, atmospheric lighting was crucial to the mood one wished to give to a room and to an evening. And the lighting implements themselves, whether simple candlesticks or elaborate multi-branched candelabra, were left on the table after the meal.

"Bonne Double Bierre," 1800–1802, artist unknown, wallpaper, block printed on handmade paper. Courtesy of Cooper-Hewitt, National Design Museum, Smithsonian Institution–Art Resource, New York; Gift of Josephine Howell

This witty wallpaper vignette may have been an advertisement.

The elaborate ceremonies of dining and table decorating naturally had a significant impact on the objects used and displayed, whether of porcelain, silver or gilt metal, or bronze. The art of entertaining helped to develop the tradition of objets d'art to adorn not only the table but the entire house.

PORCELAIN

Founded in Vincennes in 1740, the Manufacture de Porcelaine moved to Sèvres in 1756, close to the château of Madame de Pompadour, who protected it. Until the secret of hard-paste porcelain was discovered and a deposit of kaolin found in the region of Limoges in 1768, soft-paste porcelain was manufactured at Sèvres. After 1804 the very expensive process of making soft-paste porcelain was abandoned.[3]

The Manufacture Royale suffered greatly from the Revolution, which deprived it not only of its royal privileges but of most of its patrons. The private manufacturers of Paris took advantage of these difficult years and became more creative and prosperous during the Empire than they had ever been or would ever be again.

In 1800 Minister of Interior Lucien Bonaparte appointed Alexandre Brongniart director of Sèvres; Brongniart was to remain in charge until his death in 1847—half a century during which he gave Sèvres an outstanding reputation for quality and efficiency. Son of the architect Alexandre-Théodore Brongniart, he was an engineer and a chemist and knew the contemporary arts. In 1806 he was appointed Inspecteur du Mobilier Impérial and proved to be an excellent administrator: he reorganized and improved production and brought Sèvres porcelain to a technical perfection that had no equal in Europe.

Brongniart was also a man of taste and culture. He assembled a large team of craftsmen, sculptors, painters, and gilders who invented new designs. They drew inspiration from the Sèvres collections, which were important in the evolution of porcelain styles. In 1785 the comte d'Angiviller, who was director-general of the king's buildings and responsible for Sèvres, had acquired in the name of Louis XVI the important collection of antique vases that Baron Denon had bought during his stays in Italy. This eclectic collection proved how thorough a collector

Plate from the Service au Marli d'Or (gold-trim service), painted by Gilbert Drouet, Sèvres porcelain. MUSÉE NATIONAL DE CÉRAMIQUE DE SÈVRES

Painted vase depicting a quagga, 1814, Sèvres porcelain. Apsley House, The Wellington Museum, London

Denon was at a time when little was known about vases, all of which were called Etruscan. Angiviller gave this collection to Sèvres to inspire the artists and encourage them to imitate antiquity.[4] Many of the Sèvres vase shapes stemmed from it, such as the *vase étrusque à rouleaux* (with scrolls) designed by Charles Percier and decorated by Antoine Béranger in 1813, which depicted the arrival of works of art (in fact the spoils of war) at the Musée du Louvre.

Percier was not the only architect from whom Brongniart requested designs; his father created a great number of designs both for tableware and for prestigious state commissions, like the Service Olympique of 1803–4. This interesting service illustrated a transition between two periods of Empire style: its decoration demonstrated the eighteenth century's light and graceful view of antiquity, but its shapes were forerunners of the stricter and heavier style to come.

The most spectacular Empire creations of Sèvres were often ponderous and stiff. Napoleon's orders prompted majestic shapes. The influence of architects Percier and Brongniart, added to the taste for archaeology of Denon, who was the main advisor to Sèvres, might also explain why the shapes tended to be

Mahogany and ebony table with a Sèvres porcelain tabletop attributed to Pierre-Etienne Levasseur. BAYERISCHES NATIONALMUSEUM, MUNICH

monumental. Vases were in the form of amphoras, Greek chalices, craters (often called *vases Médicis*), cornets (*vases Jasmin*), and the tall *vases fuseaux*.

At Sèvres *grands services* were officially commissioned with specific themes, either for the emperor's table or as sumptuous state presents. A Service Encyclopédique of 140 pieces was offered in 1805 by Napoleon to his minister Maret and was repeated as a present to the king of Bavaria. The Service Olympique was offered to Tsar Alexander I in 1807. And Napoleon ordered for himself the Service des Quartiers Généraux, the subjects of which were to remind him of the countries he had traveled to during his campaigns. Brongniart and Denon oversaw the execution of this famous service with the greatest care. Napoleon gave some pieces from it as presents, but he retained seventy-two dessert plates for his personal use; he cherished them and took them with him to Saint Helena, where, for fear of breaking them, he did not use them but often took them out and looked at them with wonder.

Among the most splendid services were the many and varied *services* and *cabarets égyptiens* (*cabaret* designated a tea or coffee service) inspired by Denon's

Design for the Oiseaux (Birds) Service,
Alexandre-Théodore Brongniart (1739–
1813). ARCHIVES DE LA MANUFACTURE
NATIONALE DE SÈVRES

Design for the Olympic Service, 1806,
Alexandre-Théodore Brongniart (1739–
1813), watercolor. ARCHIVES DE LA
MANUFACTURE NATIONALE DE SÈVRES

This service was manufactured by Sèvres.

Voyage dans la Basse et la Haute Egypte, a copy of which was at Sèvres and served as a model for the painters and for the gilders who painted the hieroglyphs on the border.[5] In Sèvres porcelain these subjects were treated long after the first wave of the Egyptian fashion had swept the decorative arts during the Consulat. A spectacular *service égyptien*, accompanied by a six-meter-long centerpiece, was a lavish present from Napoleon to Tsar Alexander, first sent from Sèvres to the Tuileries in thirty-two crates and then on to St. Petersburg, where it arrived intact.[6] Others were commissioned for Josephine[7] and for Napoleon and Marie-Louise's wedding.

Thus throughout these years Sèvres received major commissions, and between commissions the Service au Marli d'Or was painted, consisting of a countless number of plates with picturesque views and a gilded edge.

During the Empire painting on porcelain became extremely important; the pieces were entirely decorated, leaving almost no white porcelain visible. Portraits, views of cities and sites of the Empire, and refined imitations of antique

cameos were common subjects. Scenes from the Renaissance and the Middle Ages also became popular as the Romantic spirit spread. The subjects were framed by highly decorative motifs of gold, and great attention was paid to the border. Major pieces such as gueridons were also made in Sèvres, but they were very rare and costly.[8] Among the artists working in Sèvres were the well-known painters Martin Drolling, Jean-Baptiste Isabey, Nicolas-Antoine Lebel, Jean-François Robert, and Jacques-François-Joseph Swebach, as well as minor painters who specialized in animals, like Christophe-Ferdinand Caron, or in flowers and fruit, like Gilbert Drouet.

Besides this remarkable activity in Sèvres, the manufacture of porcelain

Cabaret *with circular tray, c. 1810, by the Dagoty firm, Paris.* MUSÉE NATIONAL DE CÉRAMIQUE DE SÈVRES

Small creamer with gilt ornamentation in relief, by the Nast firm. MUSÉE NATIONAL DE CÉRAMIQUE DE SÈVRES

in Paris was also developing. During the ancien régime strict rules differentiated Sèvres from private Paris manufacturers, which had to be "protected" by members of the royal family. After the Revolution, when the royal privileges of Sèvres were abolished, private manufacturers flourished in Paris, Chantilly, Fontainebleau, and soon Limoges. The most productive were in Paris: Dagoty, Darte, Dihl et Guérhard, Lefebvre, Nast, Pouyat, and Schoelcher. Many more specialized in porcelain cameos to be set in crystal vases, like Duprez, or in decoration on white porcelain, like Legros d'Anisy, who perfected a recently invented method for printing illustrations directly onto ceramics on a massive scale. They also invested in technical research: Nast invented a mechanical means of decorating with a muller; the chemist Nicolas-Louis Vauquelin, who worked for Nast, discovered chrome green, and Morteleque found ultramarine blue.

These private factories were also extremely creative in their decorative patterns. Without the official constraints of Sèvres, they could be more fanciful and thus appeal to a wider public. Parts made of biscuit (unglazed white porcelain) were combined with the brightest colors or with gold. Formerly only the royal manufacturer had the privilege of using gold, but this rule was now ignored, and Nast especially was known for the quality of his gold. The private workshops also had well-known artists working for them, whom they sometimes shared with Sèvres: Drolling and Swebach worked for Sèvres and for Dihl et Guérhard. Nast asked the sculptors Augustin Pajou and Louis-Simon Boizot to work for him.

These manufacturers produced for a private clientele, but their commissions could be considerable, and a large part of their production was exported. For instance, in 1806 Marc Schoelcher, who had bought the manufacture formerly protected by the comte d'Artois, made a service of 600 plates and 82 pieces for Bernadotte. Nast sold a large service to President James Madison. And, though very high, their prices were quite attractive: the service in the White House was 40 percent less expensive from Nast than it would have been from Sèvres. This nevertheless did not prevent Nast from being listed, in 1812, as one of the most highly taxed persons in Paris. These factories were also freer than Sèvres to produce small popular pieces: inkstands or eggcups in the shape of dainty statuettes, angels, swans, and shells, for instance. They worked for the

trade too, manufacturing ornamental plates for cabinetmakers, clock makers, and perfumers. Nast even tendered a bid to the City of Paris when the latter decided to affix numbered plates on houses.

The influence of the goldsmith's work on porcelain was often evident: vases were mounted on bronze stands; handles either were designed to imitate those of tureens or were made of bronze and applied to cups or vases.

As in earlier times, porcelain took the place of silver and gold in many bourgeois homes. It was of course cheaper and more convenient, and the extraordinary development of its designs and techniques was slowly bringing it to tables and homes where, for centuries, gold and silver had been the mainstay of elegance and luxury.

Ewer and basin, attributed to the Creusot firm, engraved glass. MUSÉE DES ARTS DÉCORATIFS, DÉPOT MOBILIER NATIONAL, PARIS

The emperor's athénienne, *1800–1804, by Martin-Guillaume Biennais (1764–1843) and Joseph-Gabriel Genu after a design by Charles Percier (1764–1838), yew, gilt bronze, silver, 35⅜ × 18½ in. (90 × 47 cm).* Louvre, Paris

Napoleon prized this washstand. He used it in the Tuileries Palace and took it with him to Saint Helena.

ORFÈVRERIE

The Parisian *orfèvres* of the time drew their inspiration from the same sources as other craftsmen and often worked from the same pattern books. Martin-Guillaume Biennais, for instance, appears to have had in his workshop a copy of Percier and Fontaine's *Recueil.* Gold and silver work was naturally influenced by the bronze works found in excavations, and even early documents were still abundantly used: many motifs were borrowed from the *Voyage pittoresque ou description des royaumes de Naples et de Sicile*, 1781–86, published by Abbé de Saint-Non, a friend of Alexandre-Evariste Fragonard and Hubert Robert. A bronze *athénienne* (tripod) discovered at Herculaneum and engraved by Saint-Non was transposed by Jean-Baptiste-Claude Odiot, who presented it at the 1806 exposition; it was also the inspiration for the *athénienne* that Napoleon commissioned from Biennais and had a particular liking for, taking it with him from the Tuileries to Saint Helena. In England, the firm Rundell, Bridge and Rundell drew from the same antique sources.

The *orfèvres* used new techniques, such as cold mounting to assemble pieces with rivets, and they also benefited from the bronze makers' perfected chasing methods.

During the Empire the work of gold- and silversmiths was once again greatly encouraged by Napoleon's direct support and by the huge commissions that he, Josephine, and the City of Paris gave them. French gold and silver work had always been famed and sought after by European courts, even during the difficult years of the Revolution, when no orders came in, or after the venerable goldsmiths' guild was modified in 1791 and abolished in 1797. These circumstances had favored an increase in English production, but the competition did not long affect the French workshops. Even during the Directoire work was abundant: the society that was reaching a new affluence needed this traditional mark of wealth, and its requests could be satisfied by artisans who had worked for the king, as had Auguste, or for wealthy clients, as had Chéret, Dany, and Odiot.

Unlike the furniture makers, most of whom worked in the Faubourg Saint-Antoine just on the fringe of the city, these craftsmen had their workshops in the

center of Paris, near the Tuileries (Auguste was right on the place du Carrousel), or in the affluent districts (Biennais, Cahier, and Odiot were on the rue Saint-Honoré). They evidently believed their status and position vis-à-vis their clients justified more prestigious addresses.

Napoleon's commissions for *orfèvrerie* stemmed from the same desire as his commissions for furniture and textiles: he wished to give a regal splendor to his reign, to increase French production in the luxury industries, and to restore the national heritage. This was all the more necessary since many major historical services and pieces had been melted down by one king after another to finance the wars, and little was left that Napoleon could use. He ordered a few services for his personal use, such as various *nécessaires de voyage*,[9] and numerous objects and services that he gave as presents. But his main orders were spectacular ensembles, such as the large vermeil (silver-gilt) tea service delivered by Biennais just before Napoleon's marriage to Marie-Louise. Increasingly large orders were subsequently given to the same Biennais. In 1811, for instance, he made nine important deliveries of silver and gilt silverware for the imperial table, as well as works destined for the newborn king of Rome, including over

ABOVE: Silver-gilt ewer with wood handle, 1798–1809, by Henri Auguste. CHRISTIE'S, NEW YORK

LEFT: Covered cup by Jean-Baptiste-Claude Odiot, gilded silver, 11 in. (28 cm) high. MUSÉE DES ARTS DÉCORATIFS, PARIS

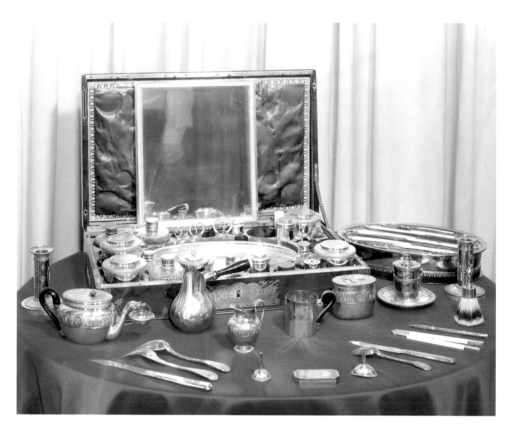

The emperor's campaign toilet set, by
Martin-Guillaume Biennais (1764–1843).
<small>LOUVRE, PARIS</small>

a hundred large pieces and several hundred plates. In the Tuileries there was a
"*vermeil ordinaire*" for current use that was kept in twenty-eight trunks! The
huge vermeil service made by Biennais in 1807 after designs by Percier for
Napoleon's palace in Milan comprised 950 pieces. It was recently discovered that
after Napoleon's fall this service became the Grand Vermeil of the Habsburg
court in Vienna, thus escaping being melted down under Napoleon III, the fate
of so many prestigious services.

Napoleon was lavish where the prestige of the state was concerned but
thrifty in his private life and in state finances; he therefore paid great attention
to what happened to the objects he ordered and was constantly having them
repaired by his silversmiths.

Josephine also commissioned important pieces from the best Parisian work-
shops for her table and personal use, for traveling, and for sewing. She owned a
beautiful *toilette* that Odiot made in 1812. Another major commissioner was the
City of Paris; on the occasion of Napoleon's coronation it presented the emperor
and empress with a *grand service* by Auguste that included the large vermeil *nefs*.[10]

The City of Paris also offered a luxurious *toilette* to young Empress Marie-Louise in 1810: a monumental cheval glass, a washstand and ewer, a dressing table with mirror and candelabra, a chair, and a jewel casket. Three of the great names of the time collaborated on this exceptional vermeil and mother-of-pearl ensemble: Prud'hon designed it, Odiot cast it, and Thomire worked on the chasing.[11] The three of them collaborated again on the cradle of the king of Rome in 1811, another exceptional piece of silver-gilt and mother-of-pearl, which was also a gift from the City of Paris (a lovely and less imposing cradle of elmwood was made to similar designs by Thomire and Duterme).[12]

Napoleon bestowed lavish pensions on the members of his family to whom he had given duchies and kingdoms. But he expected them to furnish their palaces accordingly and be the ambassadors of the French arts and industries in Europe. They too gave very large commissions to the famous *orfèvres*: Prince Borghese, Pauline's husband, had almost 1,600 pieces of gilt silver made by Biennais and Odiot. The latter was also protected by Napoleon's mother, Maria Letizia. Elisa, grand duchess of Tuscany, had a large silver-gilt table service delivered by Biennais to her residence in the Pitti Palace, Florence, in 1809. Jérôme Bonaparte, king of Westphalia, commissioned a hundred pieces of chased silver.

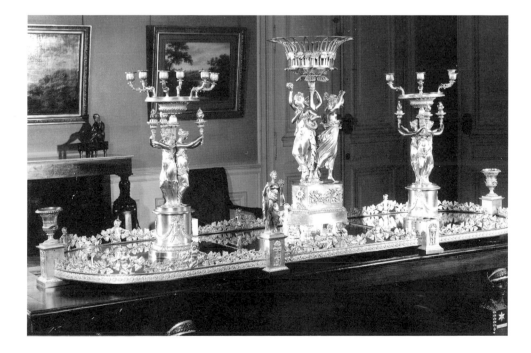

Centerpiece, by Pierre-Philippe Thomire (1751–1843), gilt bronze, 1810–1814, 30¾ 2 84⅝ in. (78 2 215 cm). MUSÉE MARMOTTAN, PARIS
The candleholders of this large surtout are after a design by Pierre-Paul Prud'hon (1758–1823), and the three graces of the center cup are after Antonio Canova (1757–1822), whose originals were made between 1808 and 1811.

Many members of the royal courts of Europe were also clients of the French goldsmiths, including Maria Fedorovna (mother of Tsar Alexander I), who commissioned from Biennais one of the largest ensembles of the Napoleonic period. In 1806 Odiot sold a silver-gilt ensemble to the king of Bavaria. These commissions explain the remarkable prosperity of these workshops until the crisis of 1807; Biennais, for instance, employed up to six hundred workmen.

Martin-Guillaume Biennais was Napoleon's favorite *orfèvre*, and his work offered all the characteristics of the best Empire silver work. It was of great richness and splendor for official commissions, but it could be beautifully simple when destined for Napoleon's private use. Biennais was a master of what was probably the outstanding accomplishment of both the goldsmiths and the bronze makers of the time: the contrasting effect of matte and shiny parts, of smooth and sculpted surfaces that accentuated the relief, the light, and the silky texture of the metal.

Covered silver cup with tray surmounted by a pine cone, 1798–1809, by Master A. P. MUSÉE DES ARTS DÉCORATIFS, PARIS

Biennais began as a *tabletier*[13] and was known for his *nécessaires*, dressing cases and boxes of all kinds that were neatly fitted with precious objects and silver for table or toilet purposes. He soon turned to making table silver, which he sold in his famous shop Au Singe Violet (The Purple Monkey). He also wrought many Legion of Honor medals and ceremonial swords and sabers.

For their bourgeois clientele, these *orfèvres* made many simpler tableware pieces, as well as toilet items and precious little objects that were very fashionable as presents, such as gold boxes or snuff boxes. Even a silversmith like Jean-Charles Cahier, known for his work for the church, did not refrain from making such objects.

Silver-gilt tureen with plateau, by Martin-Guillaume Biennais (1764–1843) after a design by Charles Percier (1764–1838) and Pierre-François-Léonard Fontaine (1762–1853). THE METROPOLITAN MUSEUM OF ART, NEW YORK; BEQUEST OF JOSEPH PULITZER, 1934

L I G H T I N G A N D D E C O R A T I V E O B J E C T S

During the Empire chandeliers were objects of luxury, as they had always been. In the first years their heavy crystals hung in garlands off branches stemming from a central column, as in the earlier manner. About 1810 their form became more sculptural: the candlesticks were set around a bronze circle, and the crystals hung in long chains, giving the chandelier a light and graceful pear shape. Among the suppliers were Ladouèpe de Fougerais, who owned the Cristaux du Mont-Cenis, Claude Galle (well known for his bronzes), and the firms Chaumont, Duverger, and Valentin. Chandeliers were also made to imitate oil lamps found in excavations (Thomas Hope was one of the first to hang such a lamp in his house on Duchess Street), and the Russian architect Andrei Voronikhin commissioned some for the palace of Pavlovsk in 1804. Many beautiful chandeliers of both types were exported to Spain, Germany, and Russia. Many others were made abroad, sometimes after French models, as in St. Petersburg, where French bronze makers had settled and where Karl Rossi installed some in the Mikhailovsky Palace. In Sweden, too, the local production was very fine.

Lanterns were equally decorative. Most often they were cylindrical in shape and surrounded with glass as in the eighteenth century. Large lanterns were usually placed in vestibules and dining rooms, while smaller ones made of

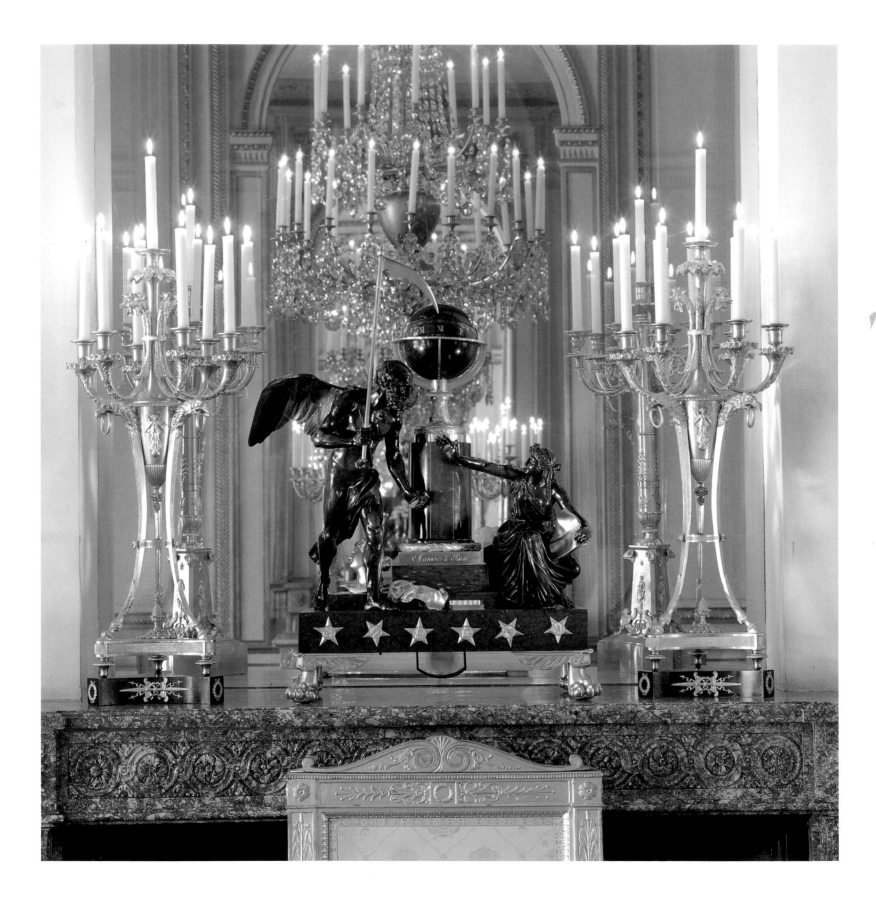

opaline glass or alabaster were appreciated for boudoirs (as in Hortense's boudoir) and other more intimate rooms.[14]

In stately and luxurious rooms the candelabra (*torchères, girandoles*) were tall and imposing, imitating antique models. The most graceful were certainly the ones supported by dark bronze figures of dancers or bacchantes, which Thomire and Galle designed and which were so often copied. The bronze factory of Claude-François Rabiat worked for these designers as well as for the well-known Delafontaines, Lucien-François Feuchère, and a prestigious clientele. The majority of these candelabra, brackets, and candlesticks were made of gilt bronze, which remained a Parisian specialty for a long time and was exported to all parts of Europe.

The most important change in lighting was the gradual replacement of expensive and inconvenient candles with more sophisticated oil lamps. But these were not considered proper, and the more traditional Parisian houses continued using candles in chandeliers, in splendid silver candlesticks, and in silver or bronze candelabra. The duchesse d'Abrantès described how, for an official reception in the Pavillon de Flore in the Tuileries, the vast room was lit by many candles placed on the mantelpiece and surrounded with gauze to soften the effect.

But the new Argand lamp, invented in the 1780s, was so much brighter and more practical with its glass funnel and its oil reservoir that it could only gain in popularity, as did a French version of it, the *lampe à la Quinquet*, or simply *quinquet*,[15] made of painted and varnished sheet metal or tin. Two more elaborate developments of these lamps were the *lampe Carcel* (but its mechanism was too complicated for widespread use) and especially the *lampe astrale*: invented in France about 1809, it had a reservoir in the shape of a ring that supported a glass lamp shade, thus avoiding the shadows projected by the reservoirs of its predecessors. Many of these lamps were made of japanned metal, which could imitate all textures and colors, whether Oriental lacquers, porcelain, marble, or rare stones, and was of course much cheaper for vases, toilet items, and everyday objects of all sorts.[16] Lighting for many other purposes was also made, such as carriage lamps.[17]

Objets d'art were important in decoration and served as models for many artists and craftsmen outside France. Andirons and such prestigious objects as bronze

Design for a Japanned-Tin Lamp Base, Philippe Girard. GALERIE DIDIER AARON, PARIS

The frères Girard founded one of the main firms for this sort of lamp and won a silver medal for their work at the 1806 Exposition. The lamps they manufactured for Princess Murat attracted the attention of Napoleon and Josephine, who asked them to make a pair quite similar to this one for the château de Fontainebleau. The firm exported to the whole of Europe.

Queen Hortense's Drawing Room
in Augsburg, *artist unknown, drawing,*
4³/₄ × 7⁷/₈ in. (12 × 20 cm). FONDATION
THIERS, PARIS

athéniennes were remarkably sculpted, chased, and gilded. The work of the
Delafontaines, Lucien-François Feuchère, Claude Galle, André-Antoine Ravrio,
and Pierre-Philippe Thomire was mostly inspired by antique models. Bronze
making was a true industry,[18] and the objects made by the different ateliers were
often quite similar, with many craftsmen working for one another. Several of
these *bronziers* were not only successful businessmen but also painters, sculptors,
poets, and collectors.

Thomire had studied with the sculptors Augustin Pajou and Jean-Antoine
Houdon, as well as with Pierre Gouthière, the most famous bronze maker of
the time of Louis XV and Louis XVI. He worked for Louis XVI, Napoleon, the
Bourbons during the Restoration, and all the major courts of Europe, and
his workshop was among the most prosperous of the period. He also collabo-
rated with the greatest cabinetmakers of his day and with the Manufacture
de Sèvres, making mounts for porcelain vases and for table objects. As for
Galle, he received innumerable commissions from the Garde-Meuble and

from dignitaries such as Louis-Alexandre Berthier, prince de Wagram, for his château de Grosbois.

Clocks decorated with mythological subjects were often found in interiors during the reign of Louis XVI; thereafter, though they continued to be splendidly crafted, they began to lose their grace. Sculptors such as Pierre Cartellier and Denis-Antoine Chaudet made the statuettes, while the mechanisms were made by Bréguet, Janvier, Lenoir, Moinet, and Ridel. Bailly and Lepaute's famous company (still in existence) delivered many clocks to the imperial palaces. These craftsmen were famous abroad for the quality of both the clockwork and the sculpture, which married dark bronze and ormolu figures to bronze or marble pedestals.

These clocks were rarely signed (often only the mechanisms were) though they came from well-known bronze makers like Thomire, Galle, Ravrio, and Feuchère. During the Consulat their subjects were full of imagination; *pendules au Nègre* or *aux Indiens* followed the fashion for exotic themes. But during the Empire their mythological content tended to become awkwardly heroic and moralistic. The bases of some included porcelain plates made in Sèvres after a

Six-candle chandelier, c. 1800, Swedish, patinated, chiseled, and gilt bronze, 37³⁄₈ × 21⁵⁄₈ in. (95 × 55 cm). GALERIE CAMOIN, PARIS

Lamp in the Billiard Room at the Hôtel Gouthière, Paris. This hôtel was built in the 1770s for Pierre Gouthière (1732–1813/14), the best bronze maker of the late eighteenth century. Its decoration has Directoire and Empire features.

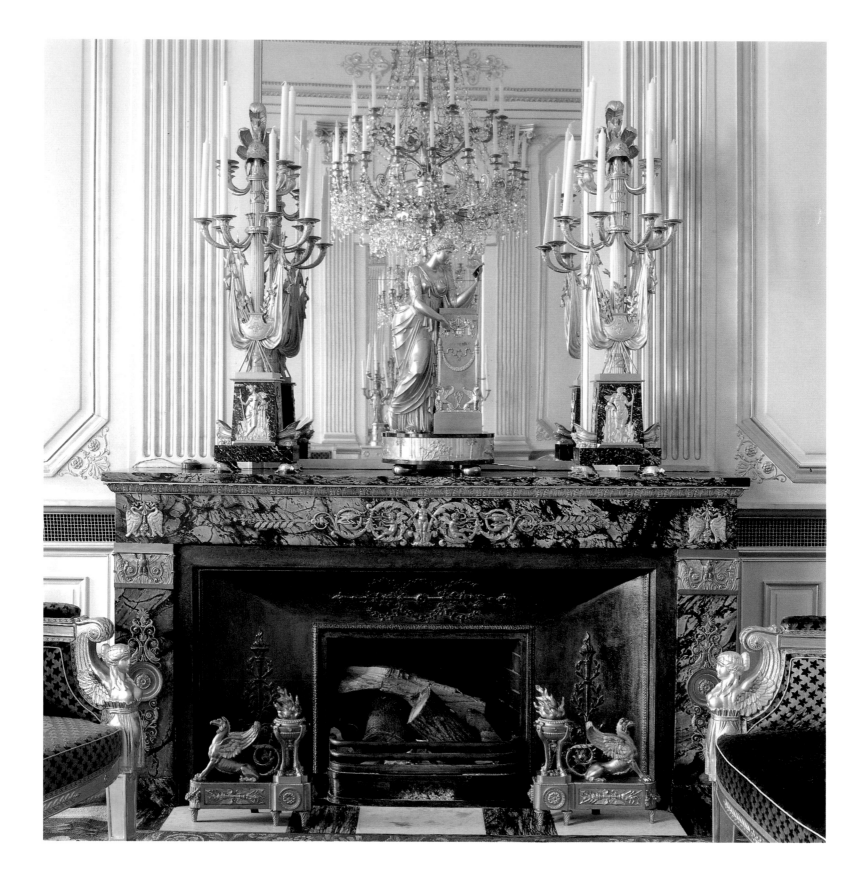

"Allegory of America" clock, bronze, 18⅞ × 15 × 6¾ in. (48 × 38 × 17 cm). MUSÉE DU NOUVEAU MONDE, LA ROCHELLE, FRANCE

design by Percier. Clocks were also made of mahogany, their simple, handsome cases decorated with bronze mounts.

Some shrewd bronze makers worked specifically for foreign markets. Dubuc, for instance, produced objects designed for America, such as a clock featuring a statue of George Washington; the pose was copied from a painting by John Trumbull, whose work was known in Europe through engravings.

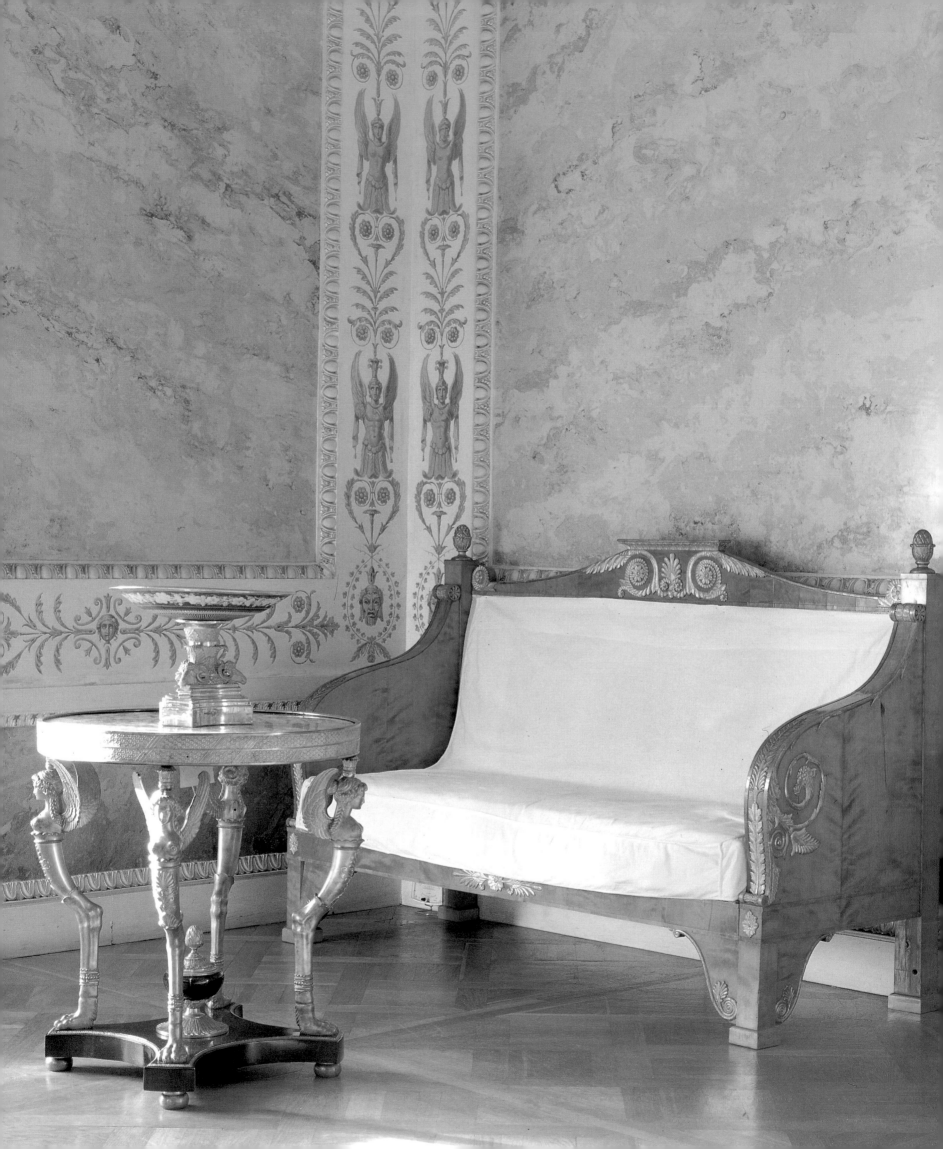

E U R O P E A N D A M E R I C A

*F*or over a century French architects and craftsmen had
been called to all European courts. French leadership in architecture, which had
been established under Louis XIV, was renewed under Napoleon, even though
the classical doctrine that flowed from Paris at the beginning of the nineteenth
century was still inspired by prerevolutionary ideals and models. As the Empire
grew, French architects went abroad and foreign architects worked in the
Empire style.

The members of his family whom Napoleon put at the head of kingdoms and
duchies took their task to heart, and all of them sided with the people over whom
they reigned. They often angered Napoleon by not following his instructions
closely enough or not applying the Continental Blockade too strictly because it
harmed the local economy. They also understood long before Napoleon did that
dreams born with the French Revolution, and then smothered, were developing
again under their rule. Murat saw how Napoleon had given the Italians a new
sense of unity by being their sole ruler, but the emperor would not acknowledge
what Murat also saw: the patriotic feelings that his rule was nurturing and that

Germaine de Staël had outlined in *Corinne ou l'Italie* in 1807. A ferment of liberty was spreading, even though Murat was careful to have no one French in his government and Elisa in Italy and Louis in Holland were very respectful of national pride. Napoleon's censorship in all fields could not long be tolerated by these conquered nations.

In the arts the influence of Paris became paramount during the Napoleonic Empire: "The French became the educators of the world in architecture and codifiers of taste once a new post-Baroque style had been created."[1] Most influential were the teachings of Jean-Nicolas-Louis Durand, a pupil of Boullée, at the Ecole Polytechnique.

Many urbanistic and architectural projects could not be carried out for various reasons. The life of these states was too short, some projects were too ambitious or too costly, and the very centralized Napoleonic administration was slow. But even critics of Napoleon's presence acknowledged that the innumerable and important projects discussed initiated an extraordinary exchange of ideas in all domains and were the origin of a new way of thinking about the land and the city for modern times.

Palaces were often furnished from Paris through the Garde-Meuble Impérial, as during the crisis of 1810–11, when very large orders were placed with the struggling *ébénistes* and furniture was dispatched to palaces throughout Europe. Some decorative items, such as silks, carpets, and *orfèvrerie*, were also commissioned from France. But the Napoleonides (Napoleon's relatives) promoted local crafts and gave new life to arts that were sometimes still hovering on the edge of the eighteenth century. They worked with existing institutions and schools, which they developed, and if they did call in French architects and occasionally craftsmen, these always collaborated with nationals.

Interestingly, the furniture that was sent as presents by the French state to foreign sovereigns seemed to differ slightly from contemporary French pieces. It was more ornate and often followed fashions a few years old. This was perhaps because prestigious pieces were made more slowly and were not immediately given away as presents, or because the pieces used ornaments from stock that had been abandoned when France was less prosperous. But it also could be that these presents were adapted to suit national tastes. Pieces given to the prince of Bavaria and to Spanish prime minister Manuel de Godoy or pieces made for the

PAGE 178: Settee in Pavlovsk Palace, 1817, from the workshop of J. Baumann after a design by Karl Rossi, Karelian birch, partially carved and gilded, upholstered in silk-embroidered canvas.

queen of Spain were more elaborate than those made in France during the time of their delivery.

Furthermore, many European architects and designers active in the first part of the nineteenth century had studied in France before or shortly after the Revolution, and their architecture remained, even more than in France, marked by the visionary art of Ledoux and Boullée and by early Greek temples. Finally, Percier and Fontaine's *Recueil* was sometimes translated with some delay; this did not prevent the more informed architects from knowing their work, but their influence reached the more distant provinces many years after the *Recueil* first appeared.

ENGLAND

Exchanges between France and England were frequent at the end of the eighteenth century. The French readily adopted English fashions in clothing, as they did the use of mahogany and the Sheraton style of chairs, especially for dining room chairs. Conversely, through the Revolution, the blockade, and the wars the English remained very attracted to the intellectual and artistic life of France. The Prince Regent, later George IV, had accumulated an extremely rich collection of French eighteenth-century furniture and objets d'art for Carlton House, with the help of the famous *marchand-mercier* Dominique Daguerre. And so fond was he of French arts that he regretted that the hostilities prevented him from furnishing his Brighton Pavilion in the French style in 1806. By the time he became king in 1820, Napoleon was no longer a hindrance, and George IV was able to employ various French craftsmen, including Jean-Jacques Boileau and Jacob-Desmalter. He sent the furnisher Nicholas Morel to France in 1826 to seek out designs and patterns. The decor and furnishings of Windsor Castle had many Empire features.

Neoclassicism pervaded Europe, and through the Adam brothers and John Flaxman, England had acquired a great taste for antiquity. Since France and England drew inspiration from the same sources between 1800 and 1815, it seems unlikely, as some writers have asserted, that France had a direct influence on England and that Thomas Hope and Sir John Soane were exponents of the French Empire style.

Secrétaire-cabinet, *plate from Rudolph Ackermann's (1764–1834)* Repository of Arts, *April 1822, after a design by Percier and Fontaine. When illustrating this piece, Ackermann remarked that "the English style for such furniture is more simply chaste, and thence perhaps less liable to be affected by changes of fashion."* COURTESY OF COOPER-HEWITT, NATIONAL DESIGN MUSEUM, SMITHSONIAN INSTITUTION LIBRARIES–ART RESOURCE, NEW YORK

Nevertheless, during the short peace that followed the Amiens treaty in 1802, thousands upon thousands of Englishmen came to Paris to discover its new trends in the arts. Interest in French styles and designs did not wane during the Napoleonic wars, and anglicized versions of Empire did indeed become frequent. French models published in the popular pattern books and magazines often inspired cabinetmakers such as William and Edward Snell, who specialized in Empire and copied and simplified a Percier and Fontaine *secrétaire-cabinet* of the beginning of the century (reproduced in Ackermann's famous *Repository of Arts* in 1822). Another model by the French architects—a plush armchair with winged sphinxes and neoclassical silk upholstery—was made with slight differences and added tassels by Morel and Hughes for the duke of Northumberland; it was reproduced in Ackermann's *Repository* in 1825, as were chairs that might have been inspired by La Mésangère. A *fauteuil gondole* designed by Percier and Fontaine for their client Citoyen V. in Paris, probably before 1802, and made by the frères Jacob, became a highly sculptural chair in the workshop of Morel and Hughes almost twenty years later. The chaise longue was also quite popular in English decor. And George Bullock provided all the furniture and functional and decorative objects for Napoleon and his entourage in Longwood when the emperor was banished to Saint Helena.[2]

Throughout the nineteenth century English collectors showed interest in Empire and its later copies, and painters James McNeill Whistler and John Singer Sargent owned some pieces. English ambassadors to Paris brought back important objects; Lord Stuart de Rothesay collected significant works and may have bought the collection belonging to Cardinal Fesch, Napoleon's uncle, which included some exceptional pieces by the frères Jacob. And the duke of Wellington furnished Apsley House with Empire pieces.

Thomas Hope, probably the closest in spirit to Empire taste, was convinced that France was the center of European civilization; he visited France regularly and was no doubt influenced by Percier and Fontaine, whom he knew.[3] Some of his designs are copied from theirs or from Berthault's.[4] And Bonaparte's Egyptian campaign and especially Denon's *Voyage dans la Basse et la Haute Egypte* heightened his curiosity about Egypt. Hope was a banker, collector, theorist, and designer who shared with Percier and Fontaine eclectic cultural tastes and a passion for archaeology. His penchant for ostentatious settings was not foreign to

The Egyptian Hall, *plate from Thomas Hope's (1769–1831)* Household Furniture and Interior Decoration. *BIBLIOTHÈQUE DES ARTS DÉCORATIFS, PARIS*

their own tendency toward majesty, but differences were evident. Hope's *Household Furniture and Interior Decoration*, published in 1807, illustrated the neoclassical interiors he had created for his home on Duchess Street. This house was planned to show off his remarkable collections of classical objects and was much more museumlike than Percier and Fontaine's interiors. Furthermore, his decoration did not include the elaborate detailing, floral arabesques, or sumptuous upholstery of the French, nor was it "suited for practical use," as his son wrote.[5]

There were other differences between Hope's style and Percier and Fontaine's. Hope's references to antiquity, as austerely accurate as Percier and Fontaine's, were in a way more realistic. His caryatids were willful-looking ladies with crossed arms; his winged sphinxes were large-bosomed women; his monopod lions with neat little ears jutted out of bulbous acanthus leaves. But some strange coincidences occurred too. For a couch at Duchess Street dating to about 1800 he designed a sleeping greyhound, which he likened to those on Gothic sarcophagi. A very similar one in the form of a bronze mount was made by the frères Jacob in 1801 or 1802 after a design by Percier and Fontaine; it adorned Madame Moreau's night table.

Small Drawing Room at Deepdene, *1818,*
Penry Williams. LONDON BOROUGH OF
LAMBETH, ARCHIVES DEPARTMENT

The decor of Thomas Hope's (1769–1831)
small drawing room was influenced by Charles
Percier, whom Hope admired. The marble of
the chimneypiece came from Anglesey, Wales,
where the decorator and cabinetmaker George
Bullock owned a quarry.

While the English were partial to French formal and decorative inventions, the French were open to the English way of life, to the privacy of smaller rooms or to the comfortable dining room. And they enthusiastically adopted the flowing lines and lyrical atmosphere of English gardens, which were natural landscapes rather than rigorous designs.

ITALY

Napoleon was always attracted to Italy, not only to the legacy of the Roman Empire but also to contemporary Italy. Only three months after he became emperor he declared himself king of Italy in Milan, and when his son was born in 1811 he named him king of Rome. The history of Italy was complicated, and

many states shared the peninsula. Under Napoleon's authority it came as close to unity as it had been for a long time: Napoleon organized it into the Kingdom of Italy, the Kingdom of Naples, and states joined directly to the Grand Empire.

After the French Directoire army entered Milan victoriously in 1796, progressive groups of patriots had given a number of Italian states republican governments modeled on the French revolutionary government. Fashion, as always, followed these political upheavals: men then thought, dressed, and combed their hair *alla Bruto* and performed Voltaire's *La Morte di Cesare* in Italian translation. Similar republican governments appeared in several European countries that came under French influence, but they were short-lived. With the advent of the Napoleonic Empire, the central authority soon took over.

Josephine's son Eugène de Beauharnais, for whom Napoleon had great affection and who was totally faithful to him, became viceroy of Italy. The majority of Italian states became satellites of the Empire. Napoleon's sister Elisa was named princess of Piombino in 1805, of Lucca in 1806, and grand duchess of Tuscany in 1809. Joseph was made king of Naples in 1806, and when he left for Spain in 1808 he was replaced by Joachim Murat, Caroline's husband. Pauline became duchess of Guastalla in 1806, and her husband, Camille Borghese, was made governor in Torino of the departments of Piedmont in 1808.

These states were for the most part administered in a modern, efficient manner and were given legal and commercial codes modeled on the Napoleonic codes. Here again Napoleon commissioned plans for major works of public utility, redesigning the city centers according to the spirit that had fostered French revolutionary urbanism and architecture. These projects were not always carried out, but they triggered a new way of thinking. Napoleon planned aqueducts and canals, opened engineering schools, increased the power of such existing institutions as local art academies, developed museums, and greatly encouraged and financed the pursuit of archaeological digs and publications.

For Milan, Napoleon's first capital in Italy, Giovanni Antolini designed a vast urban plan, geometric and rigorous. It was not carried out but was replaced with a plan by Luigi Canonica, and the Ornato Commission's plan of 1807 modernized the city. Eugène de Beauharnais encouraged the arts and created a court. Andrea Appiani became the official painter and decorated the Sala delle Cariatidi in the royal palace with twenty-five large monochrome paintings.

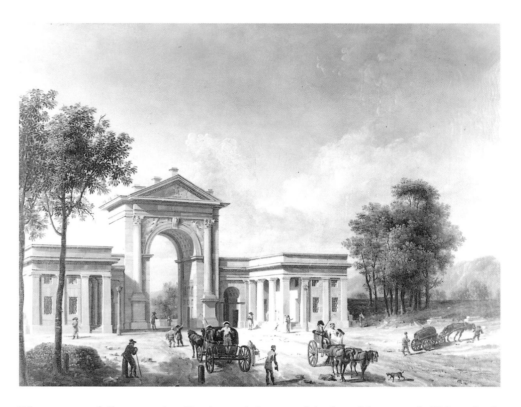

La Porta Nuova, Milano, *G. Migliara, painting. MUSEO DI MILANO*

These powerfully narrative Fasti, reminiscent of Andrea Mantegna's *Triumph of Caesar*, were the only example in Italy of a celebration of the Napoleonic epic.

Rome, which he had taken from the pope, was Napoleon's second capital. After a long period of severe neglect, Rome during the Empire years became the embodiment of a completely new concept for a city that had to be a modern administrative capital. This occurred under the direction of the architect Giuseppe Valadier (an Italian despite his French name and ancestry). His decisive plan for the Piazza del Popolo was altered by additional designs for fountains, gardens, and woods from Alexandre-Jean-Baptiste Guy de Gisors and Berthault. This ensemble, which successfully dealt with the delicate problem of preserving Rome's historical monuments, was considered a fine example of neoclassical urbanism, creating a successful unity between the antique and modern ideals, between architecture and nature.

Napoleon had the palace of Montecavallo in the Quirinal redecorated by Raffaello Stern. He personally chose the subjects of the paintings, which were executed by a number of French and Belgian artists, including Ingres. And he commissioned the furniture, which was sent from France. The sculptural decoration of the Quirinal imperial apartments was especially sumptuous, and greater

attention was paid to it than in any of the French palaces. Italians were famous throughout Europe for their work with stone, marble, and mosaics, and their talent was encouraged by the Bonapartes. Roman artists and craftsmen sculpted priceless Italian marble, granite, and porphyry. The most important rooms were decorated with figurative friezes; every room had its own chimneypiece of varied marbles and panels with classical scenes in low relief from the workshop of Carlo Albacini.

Drawings were produced for urbanistic and architectural projects in smaller cities, as in Faenza under the direction of Giovanni Antolini and Giuseppe Pistocchi. Venice was given a cadastre, and buildings were restored throughout the city. Giuseppe Jappelli and Antonio Gradenigo designed the classical Caffè Pedrocchi in Padua. Majestic arches were erected in many cities. And, as public health became a concern, large cemeteries with imposing entrances were constructed on the edge of town, as in Verona and Brescia.

Local craftsmen, such as Luigi Manfredini in Milan, produced very interesting work, even though it was often supervised from Paris. But Napoleon could spend almost no time in these cities and was not able to acknowledge local arts as much as the members of his family could.

Elisa, the eldest Bonaparte sister, was intelligent, willful, and well-informed. She had married Felix Bacciochi, a Corsican officer, and was twenty-nine when Napoleon made her princess of Lucca. She became grand duchess of Tuscany three years later and showed much interest in the economic development of both these states, energetically improving the legislation and administration as well as the hospital system. She developed mines, quarries, and forests, and restored bridges, city walls, streets, and churches. Through exhibitions, prizes, and important commissions to the silk industry and to the alabaster workshops in Volterra,

Over the Great Saint Bernard Pass, *G. Rosaspina, engraving after a painting (destroyed) by Andrea Appiani (1754–1817) for the royal palace in Milan.* RACCOLTE DELLE STAMPE ACHILLE BERTARELLI, MILAN

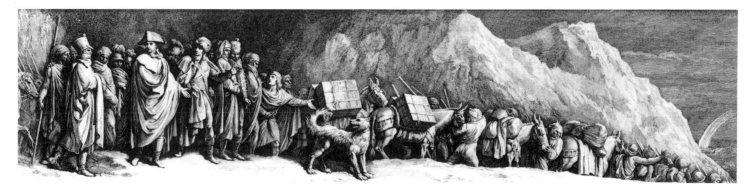

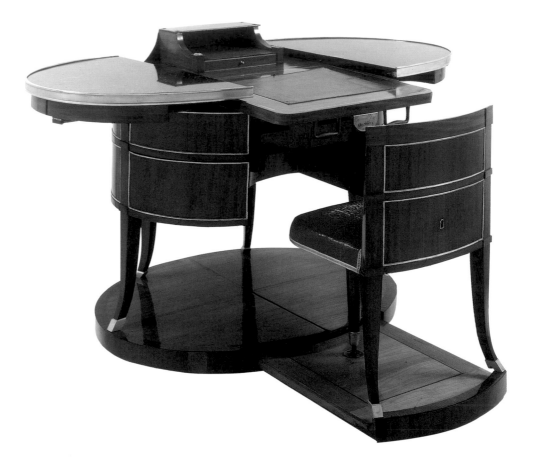

Bureau mécanique, *1807, by Giovanni Socci, mahogany, bronze mounts, and marble.*
Mobilier National, dépôt
Musée Napoléon, Fontainebleau

When the desk is closed, the chair fits under the desktop and the whole piece resembles an oval commode. Socci is known to have made three or four such desks, two of which are in the Pitti Palace, Florence. Napoleon's sister Elisa bought this one.

she promoted local industries. She invited Parisian *ébéniste* Jean-Baptiste Youf to produce new designs for the traditional local furniture manufacturers. She held a brilliant court and encouraged intellectual life, creating schools, reforming academies, and giving artworks to museums. The academy in Carrara became the reference point for marble sculpture, producing, among other things, many portraits of the imperial family and copies of antique reliefs.

In Lucca Elisa had the palace and the country villa Marlia decorated by the architect Bienaimé, a student of Durand and Thibault whose work at the Théâtre Favart in Paris had attracted her attention, and by the painter Tofanelli. The gardens were designed by J. M. Morel. The furniture came from local cabinetmakers and from the workshop Youf set up, so huge were the Italian commissions he was receiving. In Florence, she had entire apartments in the Pitti Palace elegantly redecorated. The columned Sala dei Tamburi—a music room— and the two exquisite bathrooms designed by Giuseppe Cacialli are masterpieces of Empire interior architecture and decoration.[6] The furniture was made by

Youf and by local cabinetmakers Giuseppe Benvenuti, Jacopo and Giuseppe Ciacchi, and Giovanni Socci. By order of the Mobilier Impérial, which wanted French manufacturers to benefit from this refurbishing, the silks were commissioned from Lyons and the carpets from Savonnerie and Tournai, while clocks came from Lepaute and bronze objects from Thomire and Feuchère.

Besides the work done under Elisa's administration, the most interesting Empire creations were Neapolitan. Joseph Bonaparte initiated projects that were carried out by his successor; he had little impact on the arts during his two years as king. When he left to be king of Spain in 1808, Joachim Murat, who had been grand duke of Berg and Clèves, became king of Naples. Though he would relinquish none of his power to Caroline, her presence was nevertheless strongly felt during some difficult periods and while her husband was away on the Russian campaign. She personally financed excavations in Pompeii, and she commissioned a number of works from Ingres, including the superb *Grande Odalisque* of 1814.

Murat undertook important reforms in the fields of education and health and in works of public utility. Under his administration Naples was also a major center for the development and diffusion of the Empire style. When he was living in the Elysée, Murat had asked the architect Etienne-Chérubin Leconte to work

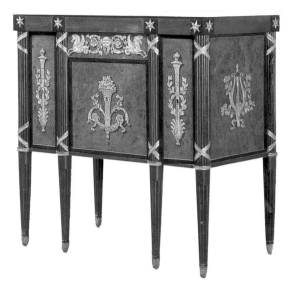

Commode for Marie-Louise de Bourbon, 1820, by Jacopo Ciacchi, various woods and gilt-bronze mounts. PITTI PALACE, FLORENCE

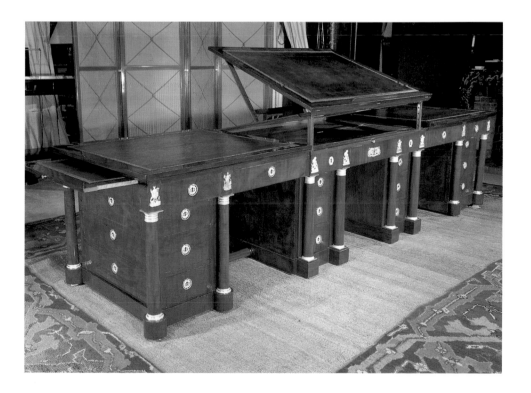

Architect's desk, by Jean-Baptiste Youf (1762–1838), mahogany. GALERIE CAMOIN, PARIS

This desk opens on both sides and incorporates a twenty-one-drawer seventeenth-century cabinet. It was probably made in the prominent workshop opened by Youf in Lucca, at Princess Elisa's request.

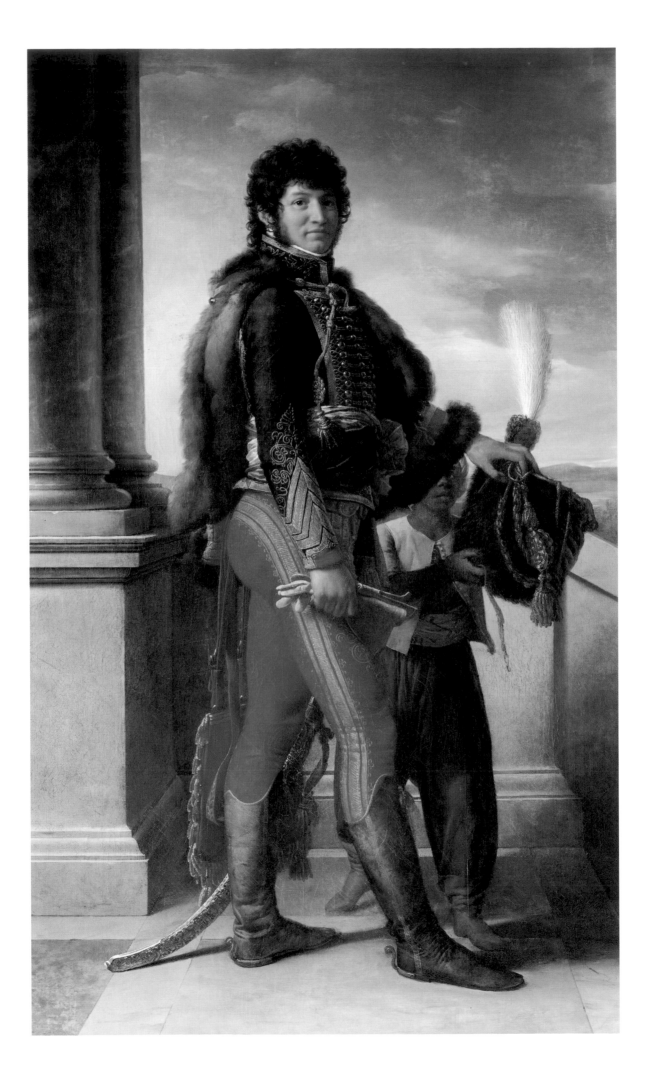

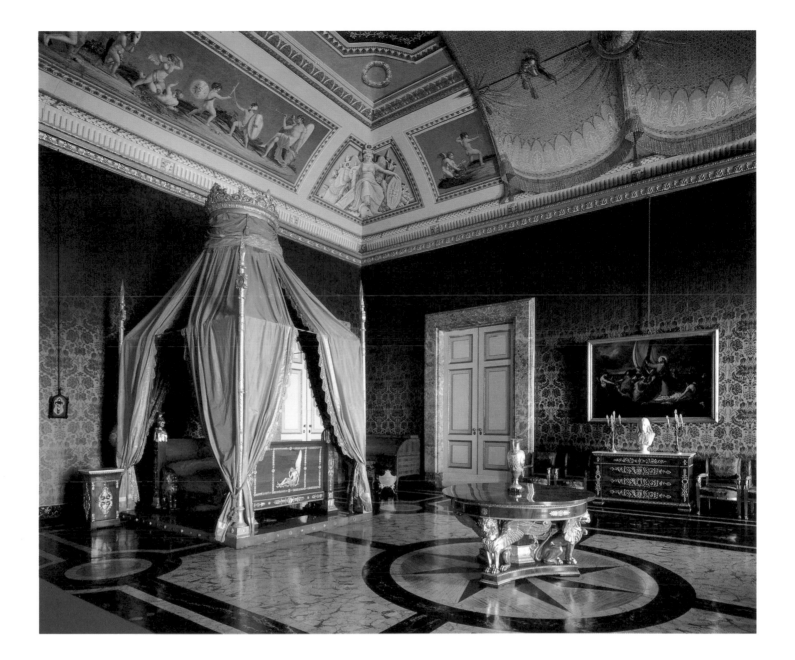

for him and had later commissioned from him projects for Düsseldorf that could not be carried out because of the war. In Naples Leconte remodeled the San Carlo Theater and, with Antonio de Simone, redecorated the palace of Capodimonte, the royal palace of Naples, and the Reggia di Caserta. In the grandiose Reggia di Caserta, de Simone alone continued the beautiful interior decoration of the Sala di Astrea and the Sala di Marte he had begun for Joseph Bonaparte.[7]

Murat and Caroline had brought with them and imported furniture from France, but they also commissioned many pieces from local craftsmen whose work was of excellent quality. Jacob-Desmalter and Percier and Fontaine remained the chief design reference. The renowned porcelain factory of Naples produced many neoclassical pieces, including tall *vases fuseaux* bearing portraits

Ferdinand II's bedroom in Reggia di Caserta, near Naples, 1814–22.

OPPOSITE: Joachim Murat, Marshal of the Empire, *François, baron Gérard (1770 1837), oil on canvas, 84⅝ × 52⅜ in. (215 × 133 cm). MUSÉE NATIONAL DU CHÂTEAU DE VERSAILLES*

A flamboyant and fearless cavalier, Murat was named king of Naples in 1808.

The ballroom in the palace of Capodimonte, Naples, decorated by Salvatore Giusti with Empire furniture and chandeliers, 1835–38.

The Sala di Marte, Reggia di Caserta, near Naples, 1807–15.

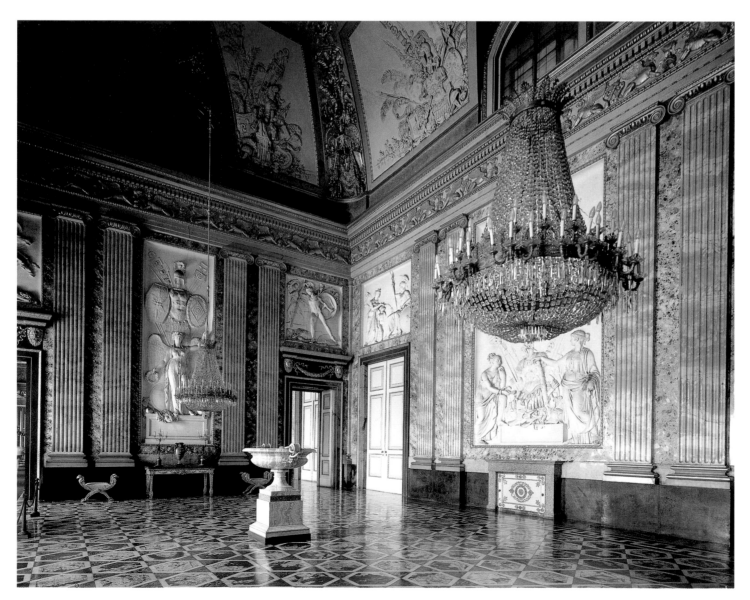

of Murat's family, which were probably copied from Sèvres vases. So sumptuous were the Empire ensembles left by Murat and Caroline that when Ferdinand II won back his throne he is said to have exclaimed, "What a pity they didn't stay another ten years!" thus proclaiming the long influence that Empire was to have in the following decades, not only on the work of de Simone and Niccolini but on the whole of Italy. Even in 1836–38, after historical revivals began invading the decorative arts and after the traditional Italian love of baroque shapes had reappeared, Pelagio Palagi was still producing seats inspired by Empire for the Palazzo Reale in Torino.

S P A I N A N D P O R T U G A L

The Spanish political situation was very unstable. The weakness of King Charles IV's government, the power of his detested prime minister Manuel de Godoy, and the plotting of Crown Prince Fernando, who called for Napoleon's help, all encouraged Napoleon to interfere. He justified his presence in Spain by the need to abolish the feudal system and the Inquisition. But he also wanted to halt the profitable trade of English and exotic goods that Portugal brought in from London and then redistributed, through Spain, to the whole of Europe. The need to enforce the blockade upon Portugal meant going through, and soon dominating, Spain. Furthermore, beyond Spain lay America and its limitless commercial possibilities. So Napoleon toppled the weak Spanish monarchy and installed his brother Joseph on the throne, despite the strong patriotic reaction of the people of Madrid on May 2 and 3, 1808, so dramatically depicted by Goya. Napoleon's action was unfortunate—Joseph was never able to find a consensus among the Spaniards despite the court he surrounded himself with, some interesting urban projects he commissioned from the architect Silvestre Perez, and other endeavors. This was also an indication of Napoleon's total lack of understanding of the people he oppressed. And the terrible Spanish War that followed was the first sign of his downfall.

Charles IV had long been a francophile. He admired French art and had several casitas built near the Pardo and Escorial palaces in imitation of the French *folies*.

View of a Study for the King of Spain, *plate from Charles Percier (1764–1838) and Pierre-François-Léonard Fontaine's (1762–1853)* Recueil de décorations intérieures. . . . *BIBLIOTHÈQUE DES ARTS DÉCORATIFS, PARIS*

The entire study was made in Paris and brought to Aranjuez, Spain, where it was installed in the Casa del Labrador.

In the exquisite Casa del Labrador, the Farmer's House in the park of Aranjuez, he had a little room, the Gabinete de Platino, or Platinum Study, executed entirely in Paris after drawings by Percier and Fontaine and brought to Spain. The mahogany panels were inlaid with platinum and decorated with Pompeian arabesques and figures; the floor, as in most of the rooms, was a pattern of bright marble and colored stones, many from Granada; paintings of the four seasons by Anne-Louis Girodet and small landscapes were fitted into the paneling; and a superb gilt-bronze chandelier hung from the vaulted and painted ceiling. It is also possible that, in those early years of the century, furniture by the frères Jacob was brought to Spain.

Charles IV also called to his service the French designer Jean-Démosthène Dugourc.[8] In Spain Dugourc had first worked for the duchess of Alba and collaborated with Spanish *marchand-mercier* Godon, apparently designing furniture and bronzes for them. He also imported furniture and objects sold in the Revolutionary sales.[9] Charles IV asked him to decorate two rooms in the palace of La Moncloa, and in the Casa del Labrador several rooms were lined with Lyons silks made to his designs: in the billiard room, dining room, and ballroom the most delightful landscapes, dancing fauns, and neoclassical motifs formed a graceful background.

In the first years of the nineteenth century some furniture was quite French in style. Beds were *lits droits*, with delicate bronze mounts that were also applied to desks, such as those in the royal palaces of Madrid, Aranjuez, and El Escorial. Consoles featured Egyptian caryatids. Armchairs had handsome Consulat or early Empire backs, slightly scrolled, with fine griffins as armrests, as in Aranjuez. But the white-and-gold furniture, a lighter version of Empire that still had eighteenth-century detailing and dainty columns, was quite Spanish, as were the pretty chairs *tipo peinata*, the backs of which were curved in the shape of the graceful combs worn by Spanish women.

The influence of the Empire style on Spanish artisans—if not on collectors—was brief. If in the time of Charles IV Empire furniture retained Spanish traits, even more typically Spanish was the furniture made after the return of the Bourbons: the Fernandino style was Empire but tended toward the more ample, baroque shapes that were a component of Spanish and Italian tastes. Through Garretta, his agent in Paris, King Fernando VII commissioned numerous pieces

OPPOSITE: A neoclassical and Empire room in the Casita del Principe, El Escorial, Spain.

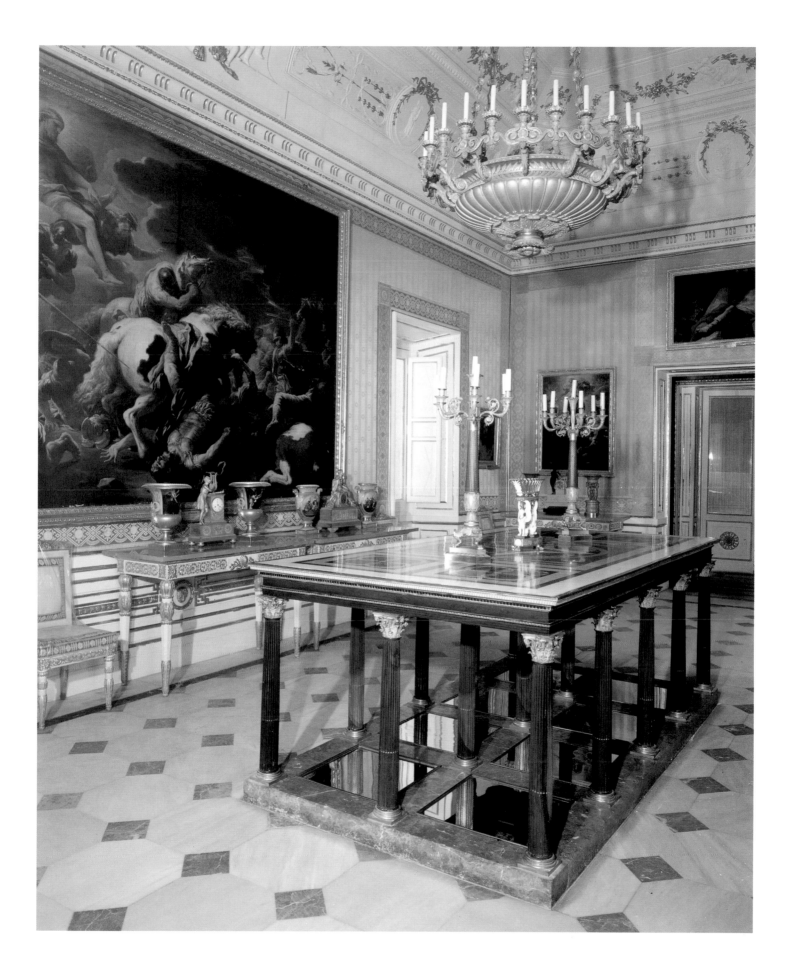

from the Jacob family, and during his reign many lights, clocks, and porcelains were still imported from the workshops of Biennais, Chaumont, Ravrio, and Thomire (Charles IV was fascinated with clocks, and there were more than fifty in the Palacio Real in Madrid). But many objects were still made by Spanish manufacturers. Crystal chandeliers from La Granja were especially in demand, as were silks from Talavera and carpets from Santa Barbara. Thus Spanish interiors of the early nineteenth century were just as ornate as the French, but were perhaps more fanciful and more brightly colored.

In Portugal the French presence was brief, but the influence of the Empire style amplified a preexisting taste for neoclassicism and lasted well into the nineteenth century. Only a small amount of French furniture was imported, but Portuguese works did become simpler under the influence of Empire, and they followed French models, as evidenced by the national palace of Ajuda in Lisbon. Yet as in Spain, Portuguese Empire was less majestic and formal, bronzes and brass mounts looked more fragile, and gilt wood carving remained faithful to the Portuguese tradition. Spaces were more stiffly organized, and furniture was more strictly unified, though interiors were enlivened by plush curtains, draperies, and pelmets enriched with gold lace, fringes, and tassels.

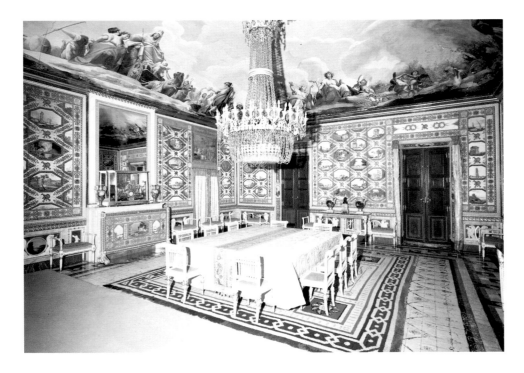

Dining room in the Casa del Labrador, Aranjuez, Spain. The textiles lining the walls—and, most likely, those covering the seats—were woven in 1797 in Lyons by Camille Pernon's firm after designs by Jean-Démosthène Dugourc. The chairs were inspired by French models, one of which was shown in Krafft and Ransonnette's book.

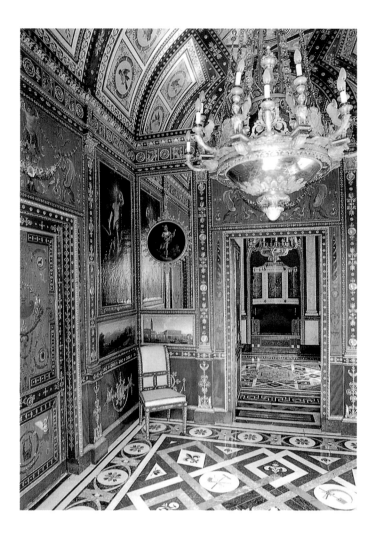

Interestingly, Empire architecture reached even South America through Auguste Grandjean de Montigny. He had studied with Percier and Fontaine; worked in Tuscany, where he wrote his influential *L'Architecture toscane*, sponsored by Elisa; and also worked for Jérôme Bonaparte in Germany. In 1816 he settled in Rio de Janeiro and initiated the Ecole des Beaux-Arts curriculum in the imperial academy, which he designed. He also received many commissions for public buildings and private houses.

GERMANY

All through the eighteenth century German princes had asked French architects to build their palaces and public buildings. At the turn of the century, despite the turmoil of the Napoleonic wars, major architects emerged whose work was strongly marked by Ledoux and Boullée. And around 1810 Durand's influence in Germany inspired even finer monuments than in France.

Design for the Monument to Frederick the Great, *Friedrich Gilly (1772–1800).*
BILDARCHIV FOTO MARBURG, GERMANY

David Gilly was among the most energetic exponents of the neoclassical style in Berlin. He and his son Friedrich admired the French revolutionary architects, but they also drew their models from the solemn early Doric temples set in vast empty spaces. Friedrich, who died at the age of twenty-nine in 1800, remained a legendary figure among architects, and his design for the monument to Frederick the Great was extremely influential. He also collaborated with Heinrich Gentz, the architect of the uncompromisingly stark Berlin mint. Gentz's mint owed much to monuments erected in Paris on the eve of the revolution, such as Ledoux's *barrières* (tollhouses) and Bélanger's houses. Also influenced by French architecture were Friedrich Weinbrenner, who transformed Karlsruhe into an exemplary neoclassical city, and Karl Friedrich Schinkel, whom Gilly considered his heir. Schinkel designed a museum in Berlin that strongly recalled a design published by Durand, and when he decorated Queen Luise's bedroom in Charlottenburg Castle in 1810 he obviously remembered Percier and Fontaine in his *lit bateau* and muslin-draped walls.

Altes Museum, Berlin, *1823, C. F. Thiele, engraving after a design by architect Karl Friedrich Schinkel (1781–1841). BILDARCHIV FOTO MARBURG, GERMANY*

The Schinkel Pavilion at Charlottenburg Castle, Berlin, 1824–25, by Karl Friedrich Schinkel (1781–1841).

Leo van Klenze, who worked in Paris with Percier and Fontaine and admired Durand, worked on the castle of Wilhelmshöhe for Jérôme and especially in Munich. All these architects, however, developed far beyond the initial French influence.

In the course of the eighteenth century, German decorative arts had been powerfully baroque. A number of cabinetmakers, including Beneman, Molitor, Papst, Riesener, and Weisweiler, had emigrated to Paris and set up workshops that were among the most famous of the century; David Roentgen even kept semi-industrial workshops in both countries. At the end of the century German craftsmen looked toward France and England for the new neoclassical trends. Northern cities trading with England were open to fashions from London, whereas western and southern states were more receptive to France, especially after the French Revolution and Napoleon's conquests. F. J. Bertuch's widely read *Journal des Luxus und der Moden*, which started appearing in Weimar in 1786, mirrored this change from English to French tastes.[10]

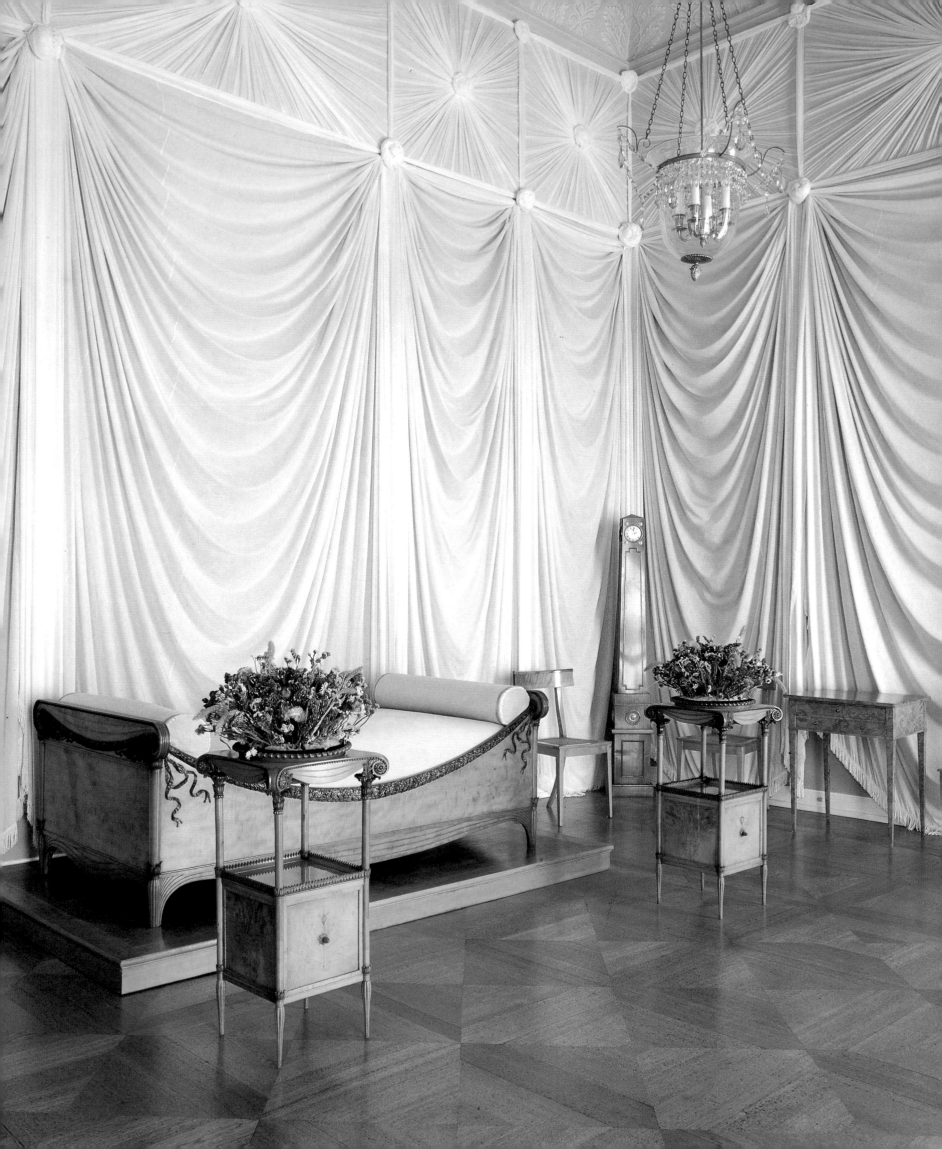

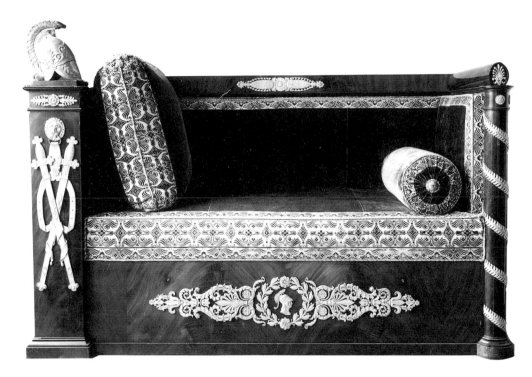

Small sofa, mahogany and gilt bronze, at Wilhelmshöhe Castle, Kassel. The military ornamentation of this sofa, including the bronze mounts of a victory and a warrior, the crossed swords, and the sculpted and gilt wood helmet, suggests that it was commissioned by an officer. VERWALTUNG DER STAATLICHEN SCHLÖSSER UND GARTEN, GERMANY

Germany, like Italy, was composed of many territories, some of them part of the Grand Empire and others members of the different coalitions that formed against it. In 1806 Napoleon made Frederick II, duke of Württemberg, king, but even before that Hohenheim Castle in Stuttgart and the castle in Ludwigsburg were beautifully decorated and furnished by Nicolas Thouret. Trained in Paris, this German architect and painter was a proponent of Empire style, and his furniture was manufactured by a good court cabinetmaker, Johannes Klinkerfuss, who had collaborated with Roentgen. For these two residences Thouret designed case furniture, gueridons, consoles, and seats heavily sculpted with Egyptian caryatids and capitals, winged lions, and animal claw feet, and richly adorned with elaborate bronze mounts.[11]

Ferdinand III, who ruled in Würzburg and Frankfurt, was formerly grand duke of Tuscany but had lost his Italian states to Napoleon. This did not dampen his enthusiasm for French arts, however, and he named Nicolas Salins de Montfort court architect of the grand duchy of Würzburg, which Napoleon gave him. The French Salins had been living in Frankfurt since 1797, building villas such as the Villa Gontard in a subdued Empire style for the affluent middle class. In the Würzburg royal residence Salins hung many rooms with silks in the Empire mode, with the collaboration of a Frankfurt upholsterer, Ludwig Rumpf;

OPPOSITE: Queen Luise's bedroom in Charlottenburg Castle, Berlin, 1809, designed by Karl Friedrich Schinkel (1781–1841).

Secrétaire-cabinet, *early nineteenth century, attributed to Johannes Klinckerfuss, mahogany, bronze and gilt-lead mounts.* PRIVATE COLLECTION

some pieces of furniture were ordered from France, while others were made to Salins's designs by Frankfurt cabinetmaker Johann Valentin Raab and probably by Philipp Carl Hildebrandt as well. These sumptuously decorated rooms were among the finest Empire interiors in Germany.[12]

In 1807 France dominated the whole continent, and Napoleon wanted to create a state that would serve as a modern and enlightened model for eastern Europe. Westphalia did indeed contribute to the modernization of Prussia, but the aim was far from fully reached, for at its head Napoleon put his youngest brother, Jérôme, a hedonist who was mainly concerned with entertaining a lavish court in Kassel. Arriving at an empty castle, he ordered a great deal of furniture both from Paris and from local craftsmen, including Friedrich Wichmann, a sculptor who owned a workshop in Kassel, and Carl Lauckhardt, who seems to have been influenced by French models but also made heavier pieces and highly sculpted armchairs. Architects Auguste Grandjean de Montigny and Leo von Klenze also worked for Jérôme.

The court of Bavaria was also attracted to French styles. Napoleon had sent the royal family delicate pieces of furniture and porcelain as presents, and on a journey to Paris King Maximilian-Joseph and Queen Caroline had bought many works from Sèvres and the best workshops in town. The castle of Nymphenburg

RIGHT: Interior of Queen Elizabeth of Prussia's Residence in Togernsee, *artist unknown.* COURTESY OF COOPER-HEWITT, NATIONAL DESIGN MUSEUM, SMITHSONIAN INSTITUTION LIBRARIES–ART RESOURCE, NEW YORK

OPPOSITE: Dining room in Charlottenhof Castle, Potsdam. The table and fine gilt-bronze oil chandelier are both by Karl Friedrich Schinkel (1781–1841). The stars in the niche are reminiscent of those in Schinkel's set designs for The Magic Flute, *1815–16, and were in fashion in palaces all over Germany between 1815 and 1830.*

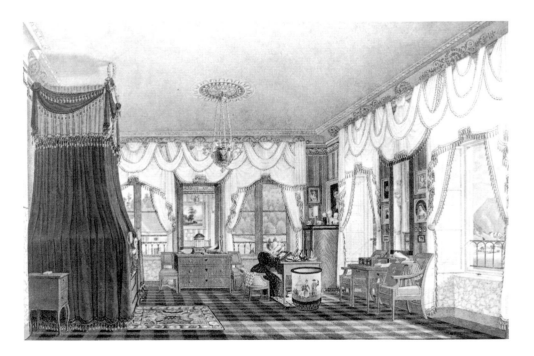

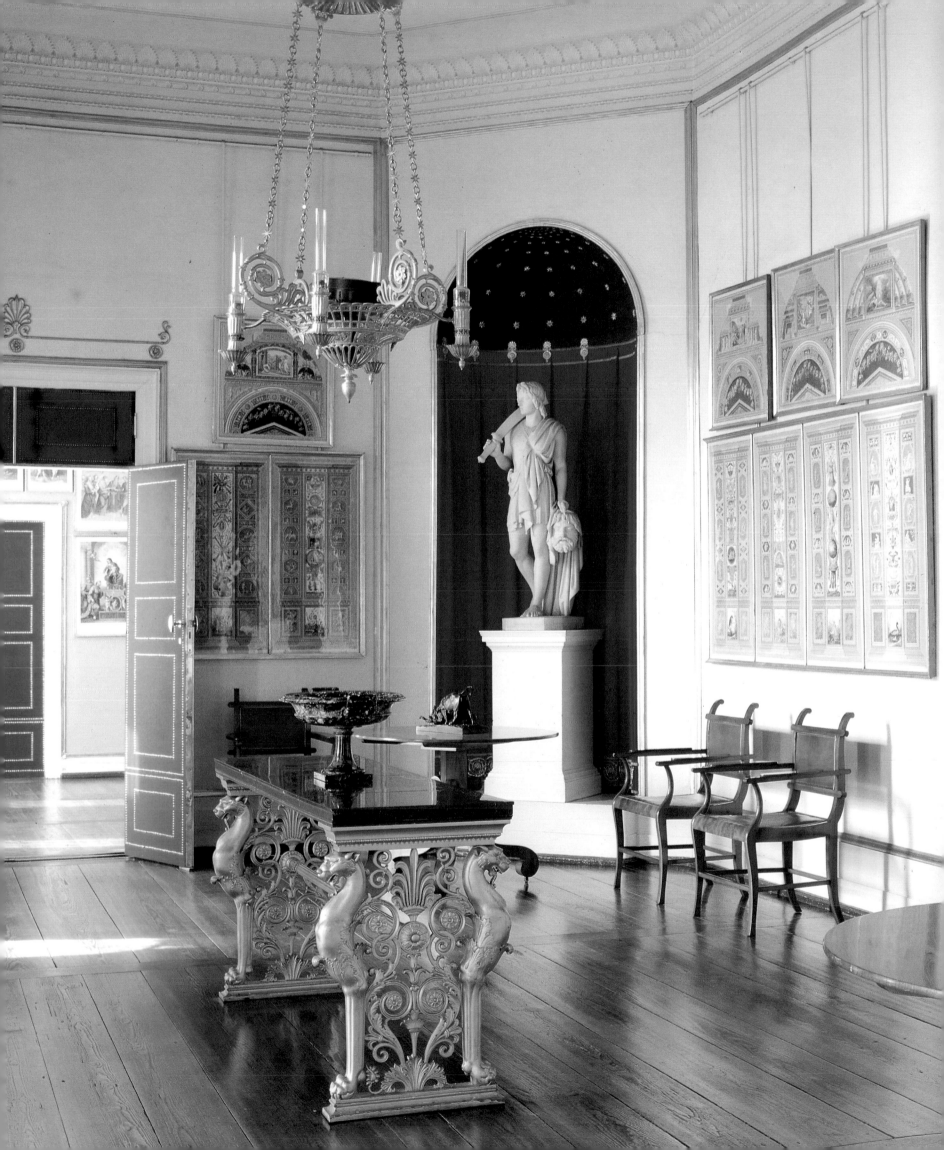

Charlottenhof Castle, Potsdam. View from a tented bedroom toward the living room, which features a mahogany desk designed by Karl Friedrich Schinkel (1781–1841).

and the royal residence in Munich were beautifully furnished in an early Empire style; some of the furniture was by the French-trained architects Klenze and Andreas Gârtner.

An original Empire style also developed in Vienna, Austria, where cabinetmakers such as Franz Dettler and Johann Härle produced furniture that was luxurious and full of fantasy in its picturesque shapes and use of local woods. Empire style was very influential in the formation of the Biedermeier style, inspiring a number of its basic shapes. But the spirit of this new bourgeois style was fundamentally different, fostering a far simpler, lighter, and more graceful type of furniture.[13]

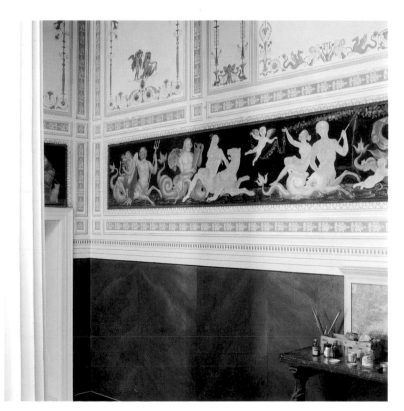

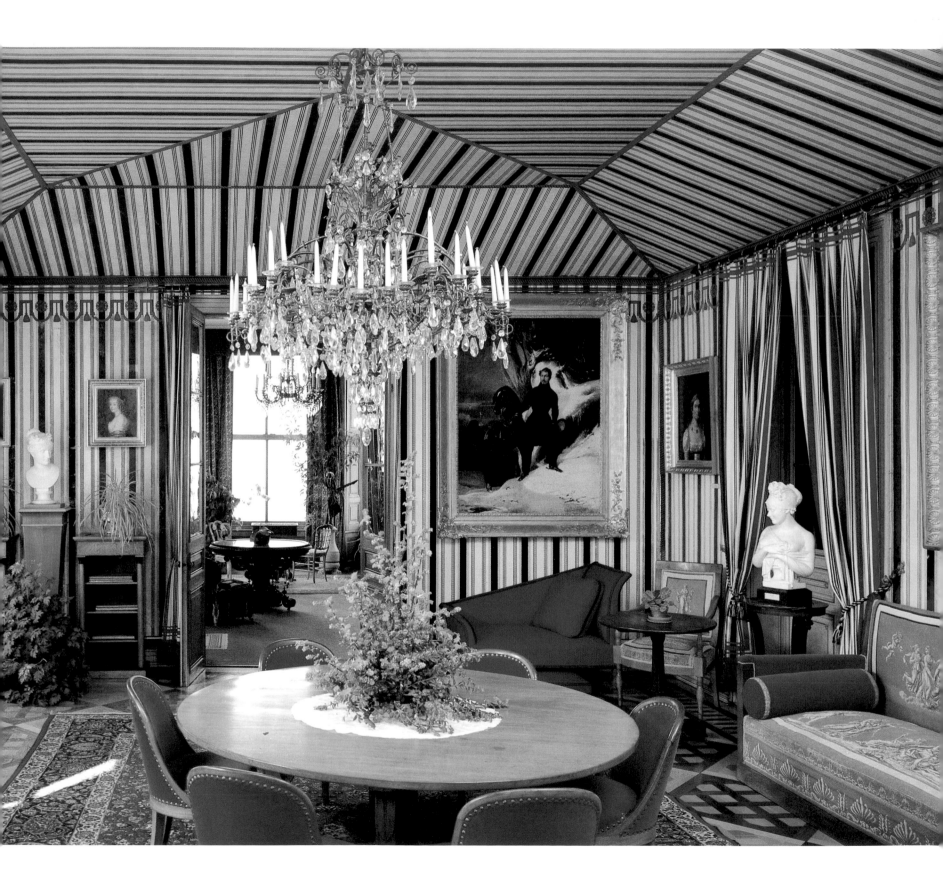

HOLLAND

In 1806 Napoleon's brother Louis was proclaimed king of Holland. For centuries the wealth of this country had been based on trade, and the Continental Blockade had disastrous effects on its economy. Louis Napoleon's efforts to gain autonomy from his brother's power were in vain, and he could do little to defend Holland from the draft. In 1810 Napoleon deposed him and annexed Holland to France. The Dutch, however, long remembered Louis's brief administration and his great support of the arts. Respectful of cultural traditions, he founded, enlarged, and protected art and science institutions and museums, launched competitions, and encouraged theater. Also, at a time when French was still very much in use in Holland, as in most of the European ruling classes, he decreed that all official documents should be in Dutch.

In 1802 Louis and Hortense de Beauharnais had been forced to marry by Josephine, who thought this would bring the two families closer. The unhappy marriage ended in a separation. But the couple did have three sons, the youngest of whom was to become Napoleon III. Queen Hortense's role seems to have been minor during her short time in Holland.

Louis gave great impetus to architecture and the decorative arts. The French architect Jean-Thomas Thibault, who had studied under Boullée and had spent a number of years in Rome, had worked for Louis on his château de Saint-Leu. Now, as royal architect, he directed Dutch architects J. D. Zocher the elder, Philip Posth, and P.H.W. Ziesenis in the transformation and refurbishment of the royal palaces. The castle of Soestdijk was renovated and furnished in the Empire style. The Huis ten Bosch (Palais Royal du Bois) in The Hague was also completely redecorated. Much of the furniture was brought from France, such as the king's bed by Jacob-Desmalter, objets d'art by Biennais and Ravrio, and paintings by Gérard. But Louis Napoleon was intent upon promoting Dutch crafts and industries, commissioning furniture makers such as A. Eeltjes and Horrix, Carel Breytspraak, and Jean Joseph Chapuis and upholsterer Joseph Cuel, who provided many seats. Rooms were hung with silk or papered with flocked wallpaper sent by the Paris firm Simon. The ceilings in the Huis ten Bosch were molded by Beretta. Percier and Fontaine and La Mésangère were, as always, major

Chair, by Chapuis (probably Jean-Joseph Chapuis [1765–1864] of Brussels), cherry wood. INSTITUT ROYAL DU PATRIMOINE ARTISTIQUE, BRUSSELS

The château de Laeken was bought at Napoleon's request and restored by Ghislain Henry, following instructions by Percier and Fontaine.

OPPOSITE: Queen Hortense's drawing room in Arenenberg Castle, Switzerland. In 1817, after the fall of the Empire, Hortense spent long periods in Arenenberg and had this little castle refurbished. The tented drawing room recalls the boudoir she had decorated in 1811 (see page 74). Hortense died in Arenenberg in 1837. NAPOLEON MUSEUM, ARENENBERG, SWITZERLAND

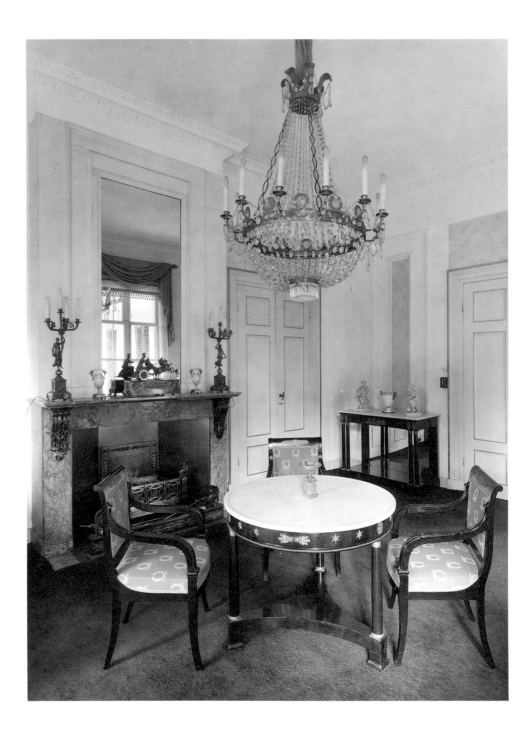

Empire room at Soestdijk Castle, near Utrecht. Louis Napoleon commissioned French architect Jean-Thomas Thibault to restore this castle and decorate it in the latest French style.
RIJKSVOORLICHTINGSDIENST, NETHERLANDS

sources of inspiration. Gardens were redesigned by Alexandre Dufour, who had worked at Saint-Leu, and by Zocher.

When French rule ended, King William I continued to furnish the state apartments in The Hague in Empire style, a fashion that was to endure for many more years.

SWEDEN

Scandinavia—Sweden in particular—was inspired by French neoclassicism in the 1770s and 1780s. Then, in the wake of the excavations and publications, it became fascinated with classical antiquity. This interest was enhanced by Gustave III, who visited Italy in 1783. Traveling back through France, he was impressed by the new French styles and immediately wrote to Stockholm, asking the decorator Jean-Baptiste Masreliez, the son of a French émigré, to join him in Paris to study the new fashions.[14] Gustave then returned to Sweden with French architect and painter Louis-Jean Desprez, whom he had met and hired in Rome and who strongly influenced Swedish art.

Late Gustavian style was rather frail and dainty, often painted white, and chairs had Directoire features. The Melchior Lundberg workshop added a few Empire motifs. In 1809 C. C. Gjörwell, who had studied with Desprez and whose main source of inspiration was Percier and Fontaine's *Recueil*, designed the castle of Rosersberg. Rosersberg was given a remarkable Empire interior and was decorated in the 1820s with many locally manufactured objects.

After Gustave III was assassinated in 1792, Sweden endured a period of political turbulence, aggravated by the Napoleonic wars. Jean-Baptiste Bernadotte, a former marshal of Napoleon's Empire, was elected crown prince in 1810, becoming king of Sweden in 1818 under the name of Carl XIV Johan. This was a surprising destiny; Bernadotte became a very popular king and gave new life to a country that had been torn for twenty years.[15] Though a declared enemy of Napoleon, he introduced the Empire style into Sweden but insisted on working with local craftsmen. The arts flourished during the prosperous years following his accession to the throne. The elegant bronze and crystal chandeliers made in Sweden during this period were among the best in Europe.

The castle of Rosendal became Bernadotte's private residence; it was partially rebuilt and entirely redecorated in the 1820s. The Rosendal Summer Palace—which employed architect and officer Fredric Blom's technique of assembling boards to allow insulation between the outside vertical boards and the inside horizontal ones—was modeled on Paris houses of the Consulat or

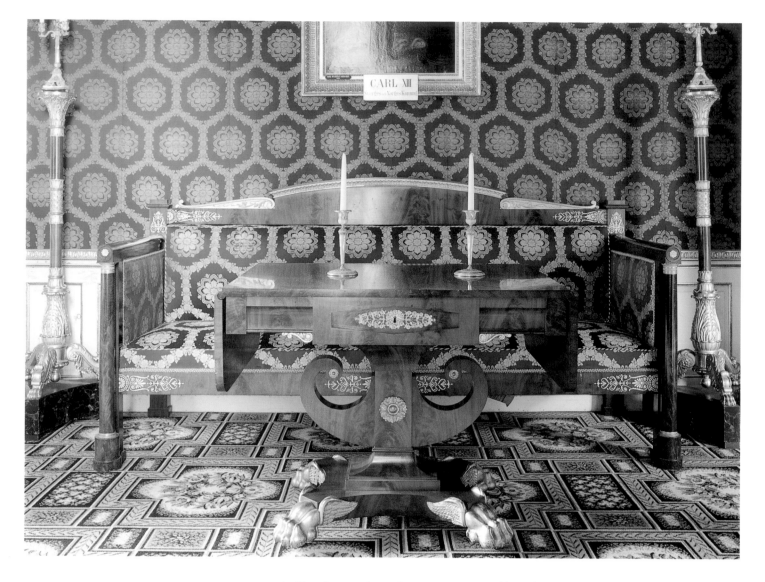

The Blue and Yellow Study at Rosendal, King Carl XIV Johan's private residence. The silks were woven in Sweden, 1830. The table is by Johan Öman. The candelabra, made of pinchbeck and mother-of-pearl, are French.

OPPOSITE: *The King's Red Salon, Rosendal. The mahogany furniture, 1827, is attributed to Lorenz Wilhelm Lundelius. Hanging above the sofa is Olof Södermark's portrait of King Carl XIV Johan (1763–1844), who liked to be considered the liberator of Sweden, a modern Odin.*

early Empire, such as those seen in Krafft and Ransonnette's publication. The most spectacular ensemble of Swedish Empire style, Rosendal housed furniture, silks, and chandeliers that were almost entirely designed and made by local artists and craftsmen: the painter Pehr Emanuel Limnell, the cabinetmaker Lorenz Wilhelm Lundelius, and the upholsterer J. A. Jäger. Most of the candelabra and clocks, however, were imported from France, and the carpets were woven by Piat Lefebvre.

Another beautiful Empire ensemble was commissioned by Peter Möller for his Skottorp mansion. This merchant, who had made his fortune thanks to the blockade, had his house entirely refurbished in Empire style by Carl Fredrik Sundwall. Sundwall designed interesting wall paintings that recalled the French wallpapers of the time: Etruscan motifs inspired by Greek vases; trompe l'oeil draperies, either red and gold or blue studded with gold stars; and a monumental frieze imitating marble reliefs. Sundwall also designed the furniture.

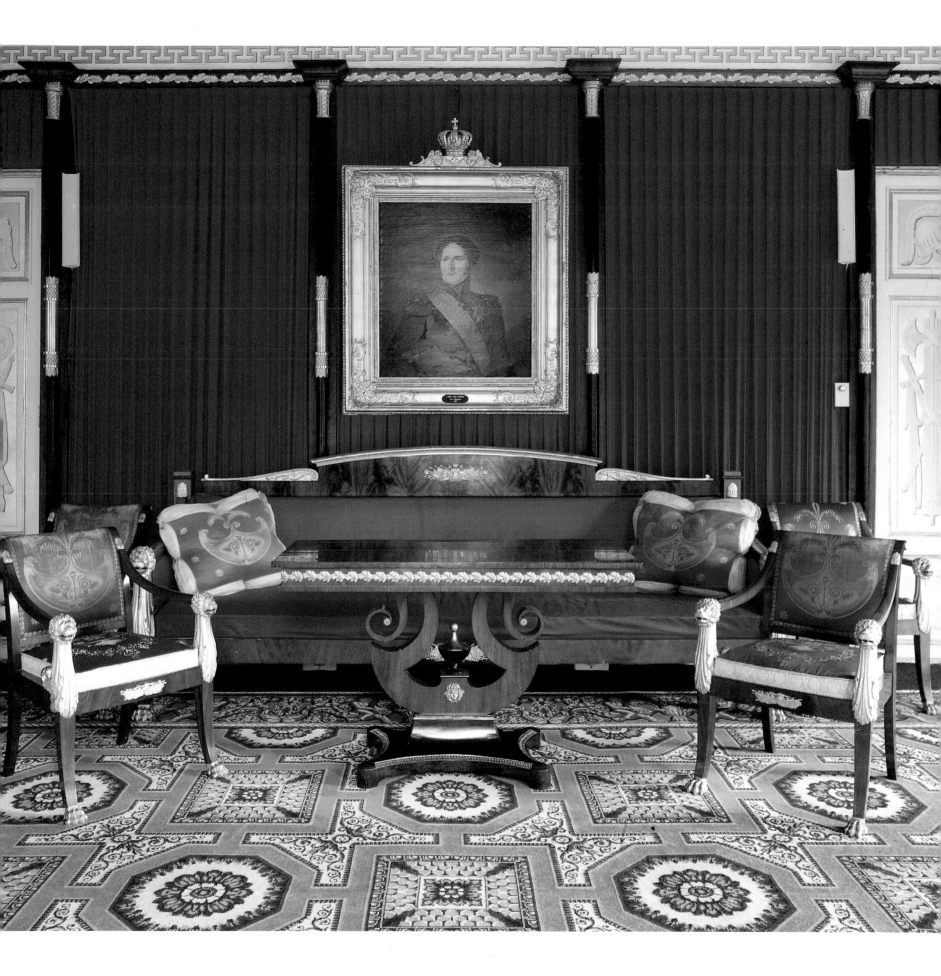

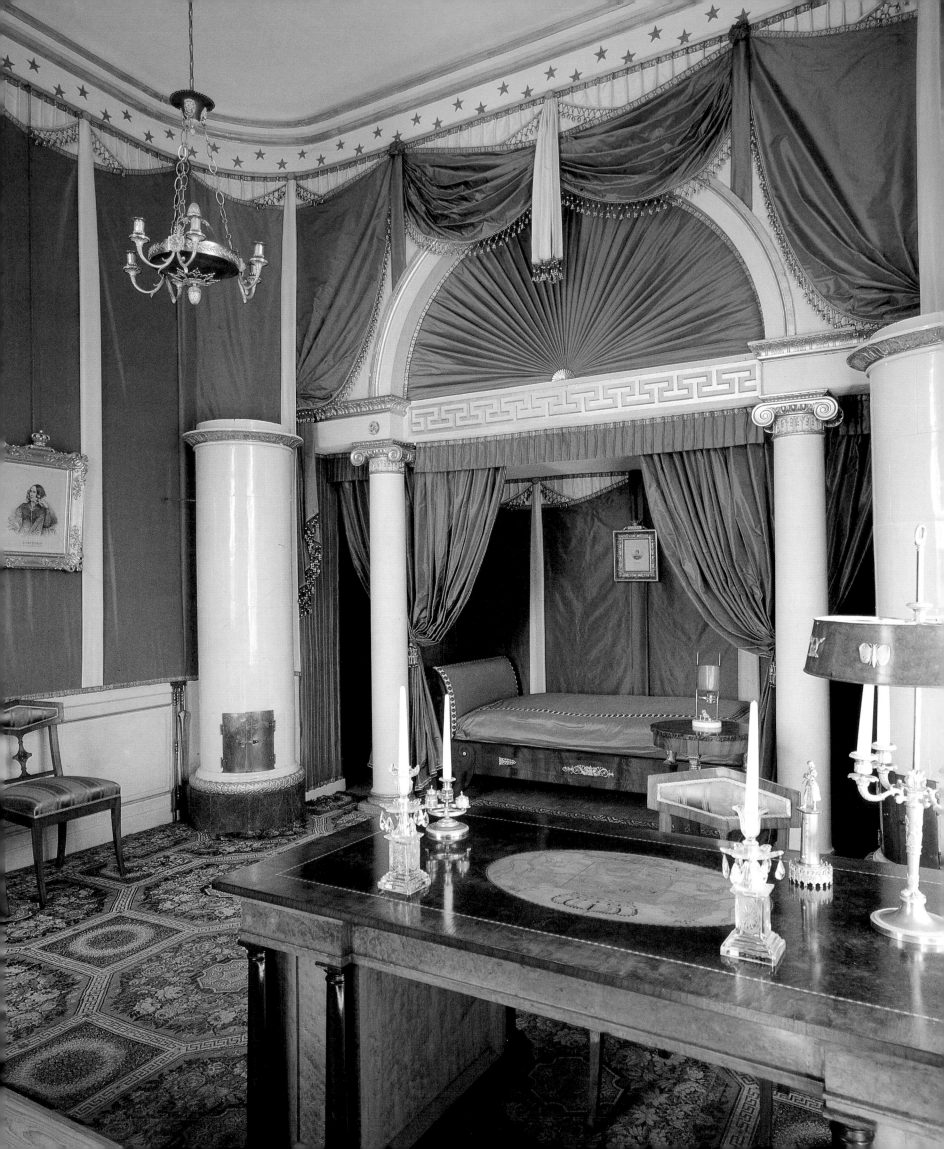

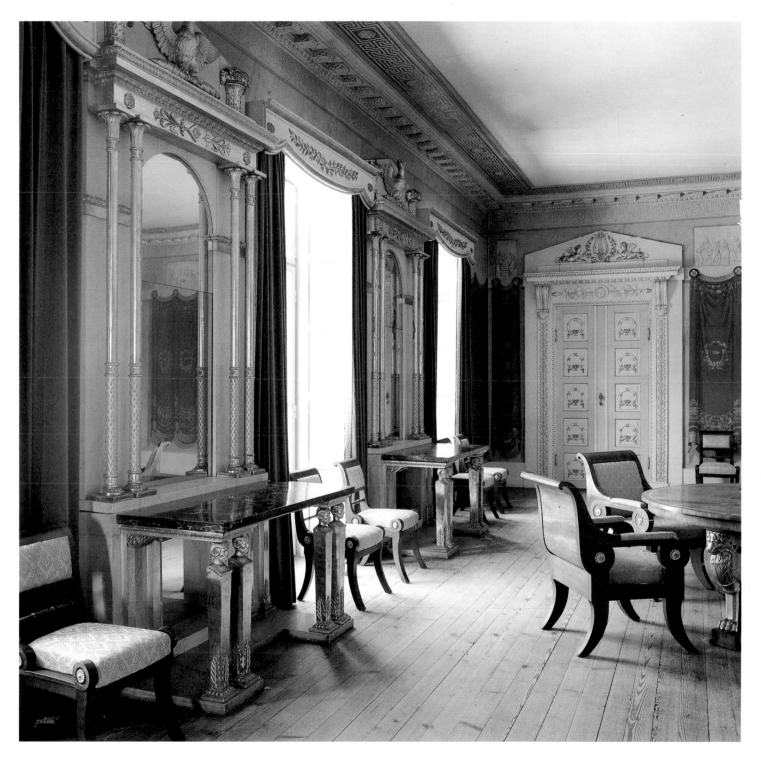

OPPOSITE: *King Carl XIV Johan's bedroom in Rosersberg Palace, Sweden. The decor, by Fredric Blom, 1823, was inspired by Percier and Fontaine. The desk is probably by J. H. Dumrath; the lamp is Swedish, c. 1820.*

ABOVE: *Drawing room in Peter Möller's Skottorp mansion, decorated between 1816 and 1828 by Carl Fredrik Sundvall (1754–1831), who also designed the mirrors, mahogany furniture, and pier tables. Note the red and gold trompe l'oeil drapes.*

Russian tsars had long employed Italian and French architects. Giacomo Quarenghi worked for Catherine the Great and her successors. Paul I had asked Vicenzo Brenna to decorate his palace in Pavlovsk. And Alexander I's love of French art was not marred by Napoleon's bellicose behavior. In 1816 he appointed a commission to coordinate all public and private buildings in the capital, St. Petersburg, and put at its head a French military engineer, General Béthencourt. Claude-Nicolas Ledoux dedicated his book on architecture to this monarch, for whom neoclassical architecture was, as for many, symbolic of enlightened progress and civic pride.

By 1800 monuments and constructions of public utility were a priority, as in all European countries. Soon after his accession in 1801 Alexander asked the French architect Thomas de Thomon to design the St. Petersburg stock exchange (1804–16). With its colonnade, pediment, and grand segmental lunette lighting the interior (clearly inspired by Ledoux and Boullée), it was one of the most perfect examples of neoclassicism. The whole city of St. Petersburg became splendidly neoclassical, its monumental buildings surrounded by vast open spaces. Andrei Voronikhin, who had trained as an architect while still a serf and had then traveled extensively and studied with French architect Charles de Wailly, built the Academy of Mines and also redecorated and furnished many rooms in Pavlovsk. Most striking was the Admiralty by Adrian Dmitrievich Zakharov, a student of Antoine-François Chalgrin: its monumental scale (the façade is four hundred meters long) and the quality of its construction were exceptional. A few years later, Auguste Ricard de Montferrand, a French pupil of Percier's who had worked on the Madeleine under Vignon, built the huge St. Isaac's Cathedral and erected the Alexander Column in Palace Square.

After the Napoleonic Empire, however, a younger generation abandoned this sublime classicism. In the 1820s Karl Rossi, a Russian educated by Vincenzo Brenna, created the magnificent white-and-gold decoration of the Mikhailovsky Palace in a style more Italian than French. He also designed much of the heavily sculpted and gilded furniture in the Winter Palace, the Mikhailovsky Palace, and Pavlovsk. Vasili Stasov decorated rooms in the palace at Tsarskoe Selo and the

OPPOSITE: The Malachite Room in the Winter Palace, St. Petersburg, designed by Auguste Ricard de Montferrand, a French pupil of Charles Percier's, in 1830; redesigned by Alexander Bryulov (1798–1877) in 1839. Bryulov had traveled extensively; the ceiling and doors are inspired by Italian decoration, whereas the harmony of colors recalls the Malachite Salon in the Grand Trianon at Versailles.

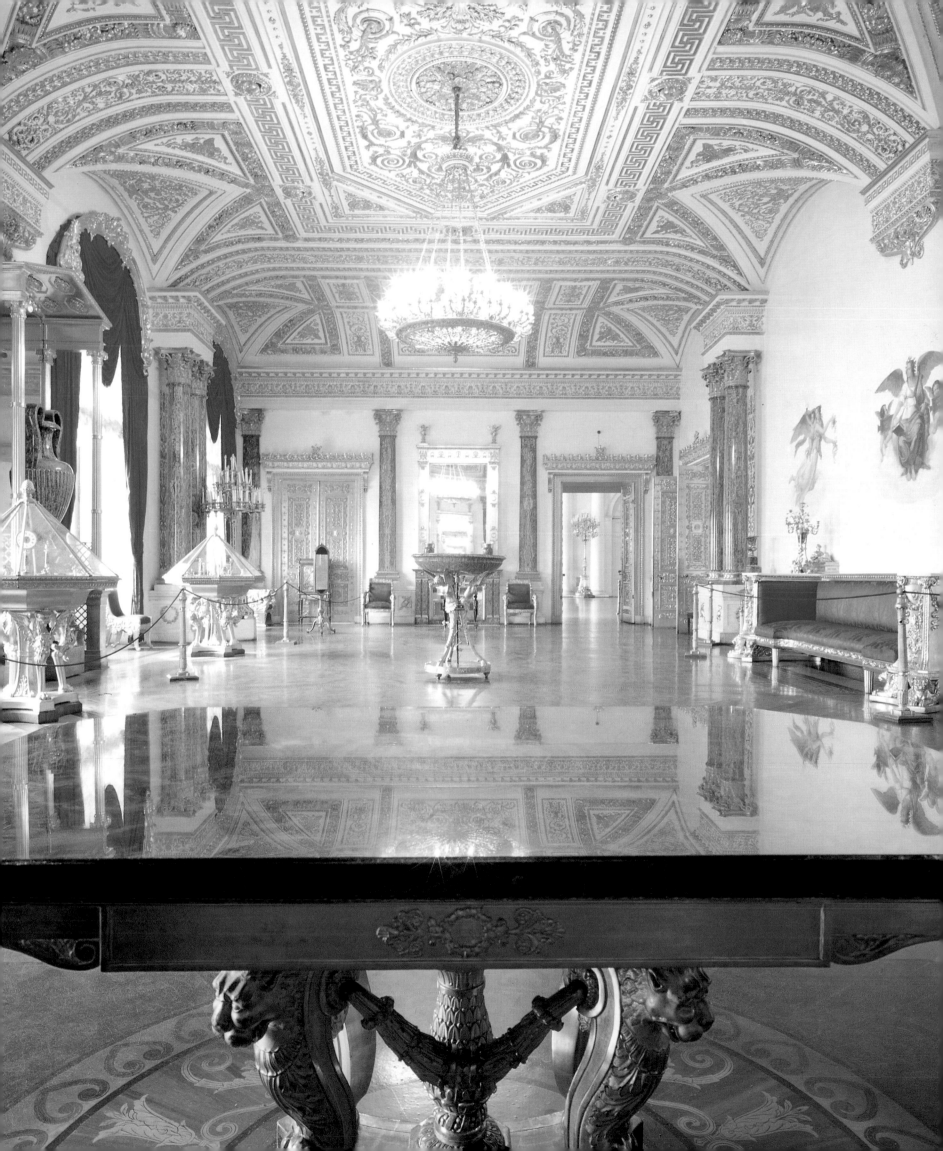

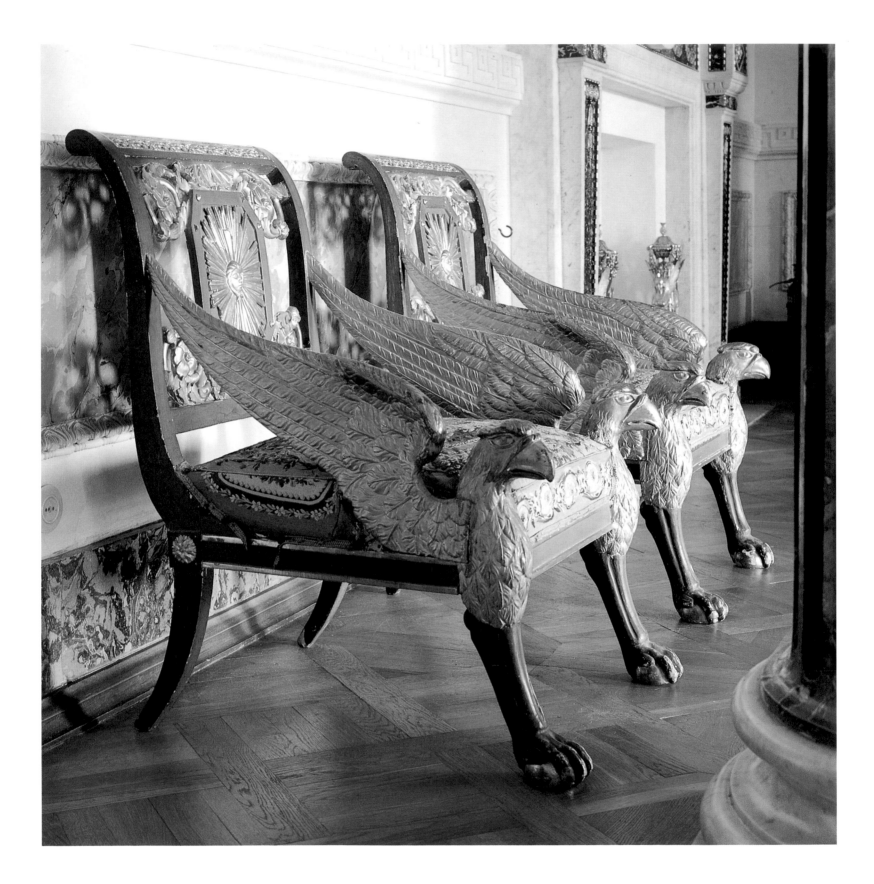

Winter Palace. The typical Russian interior was one of vivid contrasts: white stuccoed walls decorated with gilt ornaments provided a spectacular setting for the many colored stones, such as green malachite or red porphyry, used in the columns and the furniture.

The early nineteenth century was a rich period for Russian decorative arts. Russian Empire was shaped mainly by the outstanding architects who designed whole ensembles—wall decorations, furniture, and objects—and who worked with proficient sculptors and painters. Majestic St. Petersburg palaces and private Moscow mansions were decorated in this mode, but with a few years' delay Empire also reached into the provinces. Decorative compositions and furniture displayed victories, sphinxes, caryatids, and the stylized floral motifs found in Percier and Fontaine's designs, but in a more supple and less strict manner. Drawing rooms were draped with brightly colored silks or wallpapered.

Russian decorative arts are often characterized by a beautiful use of woods. As in other Continental countries, light-colored woods such as Karelian birch and walnut were used in veneers, while the carved elements were painted green, gold, or black to enhance the light color of the wood. Mahogany was reserved for luxurious pieces, and wood was often gilded; few bronze mounts were applied. Furniture by Jacob-Desmalter was bought for the imperial residences, especially for Tsarskoe Selo, but many pieces were also made by local German and Russian craftsmen Heinrich Gambs, J. Baumann, B. Bobkov, and A. Tour. In Moscow and even in the countryside, serf-artisans produced a great deal of furniture according to the nobility's personal tastes, making private interiors more charming and fanciful.

Sculptors adorned tables, consoles, and arm stumps with figures in solid wood and in high relief: eagles, lions, griffins, and swans. The sides and pediments of seats were also abundantly carved in low relief; front and back legs alike were of a saber type. Around 1810 the gondole armchair was made in many different and graceful shapes, its wide back displaying fine figured woods. In reception rooms seats were often painted white, and their sculpted parts were gilded. Sometimes inlays of ebony and ebonized wood were set in the birch and mahogany.

With its highly sculpted armrests and table legs Russian Empire furniture

OPPOSITE: Armchairs, 1804, part of a set in the Grecian Hall, Pavlovsk Palace. Designed by Andrei Voronikhin, the chairs were carved in the workshop of Karl Schreibe and gilded in the workshop of F. Koelner. The upholstery is a Beauvais tapestry, 1803–4.

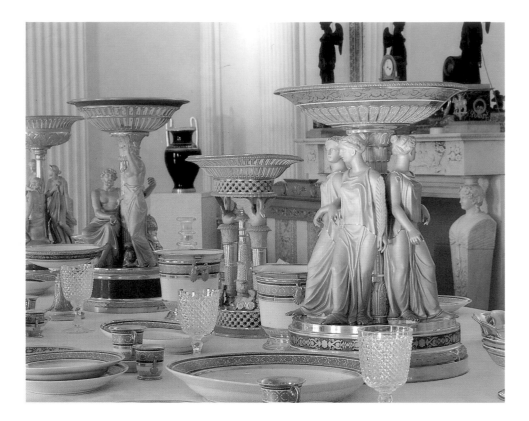

The Golden Service, made in the St. Petersburg Imperial Porcelain Factory, 1807–20, graces the dining room at Pavlovsk.

Plate from the Guriev Service depicting a Black Sea Cossack, c. 1817, painted by Simeon Chiflar, made in the St. Petersburg Imperial Porcelain Factory, porcelain with gilt and brick-red border. COURTESY OF A LA VIEILLE RUSSIE, NEW YORK

could be heavy, but it was not stiff: saber legs on seats and legs of gueridons and tripods were strongly curved, and case furniture and sofas rested on tapered or claw feet, which made them lighter, rather than on base plinths as in France.

As in many other European countries, candelabra and clocks were usually imported from France. But Russian manufacturers produced beautiful chandeliers; made of bronze, with or without crystals, they were designed by the best architects, including Auguste Ricard de Montferrand, Vasili Stasov, and Alexander Bryulov. The Imperial Porcelain Factory in St. Petersburg and workshops like that of Alexis Popov in Moscow made *vases Médicis* and *vases fuseaux* very close to the French style, but more supple. Indeed, until 1806 the main sculptor in the Imperial Porcelain Factory was the Frenchman Antoine-Jacques Rachette, who was also a professor of decorative sculpture at the Imperial Academy of Fine Arts. The French painter G. Adam worked at the imperial factory from 1808 on, and Jacques-François-Joseph Swebach, the "*premier peintre*" of Sèvres, was director of the factory. The imperial crystal and glass works made white crystal vases, sometimes after designs by Rossi, but more popular were pieces in colored glass typical of the Russian taste for bright colors. Many decorative objects were still traditionally in silver, and the Tula armorers made furniture of polished steel inlaid with bronze and silver, also a typically Russian style.

UNITED STATES

America's natural ties with England were severed when the colonies gained their independence and new cultural ties were established with France, whose help had been so precious during the Revolutionary War. Several factors opened America to French influence: Thomas Jefferson's love of France and his friendship with Charles-Louis Clérisseau, who was of great assistance in the conception of the Virginia State Capitol; Pierre Charles L'Enfant's designs for the city of Washington; and Maximilien Godefroy's work in Baltimore. But the English-born Benjamin Latrobe was the architect who made classicism the official style of the United States, and his pupils Robert Mills and William Strickland erected the temples of democracy that declared to the world the meaning of America's independence.

The United States was a country with no remote and legendary origins, yet it had given itself a mission felt as universal. Thus, linking its new institutions to the Roman Republic gave it dignity and confidence,[16] and builders readily adopted the classical mode.

Apart from the civic ideology this new architecture embodied, however, America was not ready for the abstract symbolism of neoclassicism. When the painters John Singleton Copley and Benjamin West went to Rome, they would not bend to neoclassical rules; they were too interested in contemporary events to adopt antique attitudes and dress. When John Vanderlyn, who had studied in Paris, exhibited in America works such as *Ariadne Asleep on the Island of Naxos* (1814), or when Samuel Morse tried to interest collectors in historical painting, no one understood them. Nor did anyone appreciate the intentions of Washington Allston, who had traveled to Italy with Samuel Coleridge and Washington Irving.

Yet in the more concrete field of the decorative arts, French neoclassicism was of consequence. It contributed to a style the new middle class needed: American Empire. In Baltimore, Philadelphia, New York, and Boston, wealthy businessmen, bankers, leading citizens, and congressmen wanted not only to assert their position but also to distinguish their taste from that of the former rulers. They furnished their homes in a style that was quite distinct—even if

The Tea Party, *1820, Henry Sargent (1770–1845), oil on canvas, 64¼ × 52¼ in. (163.2 × 132.7 cm). Museum of Fine Arts, Boston; Gift of Mrs. Horatio A. Lamb in memory of Mr. and Mrs. Winthrop Sargent*

still influenced by England through recent publications—and very close to French Empire.[17]

The Federal period, which lasted from about 1790 to 1810, was partial to a neoclassical detailing that was not of archaeological precision or even origin but clearly drew on Robert Adam and the publications of George Hepplewhite and Thomas Sheraton.[18] The Federal style was particularly fine in Philadelphia. In New York the Scotsman Duncan Phyfe maintained the most fashionable cabinet-making shop around the turn of the century, when his work was in the Sheraton manner. His seating was especially graceful, with square scrolled backs, slender legs, scrolled and reeded armrests, and carved bow knots and floral motifs in the crest rails, as seen in the seats he made for William Bayard, a wealthy New Yorker, in 1807. Phyfe soon became interested in French styles and was one

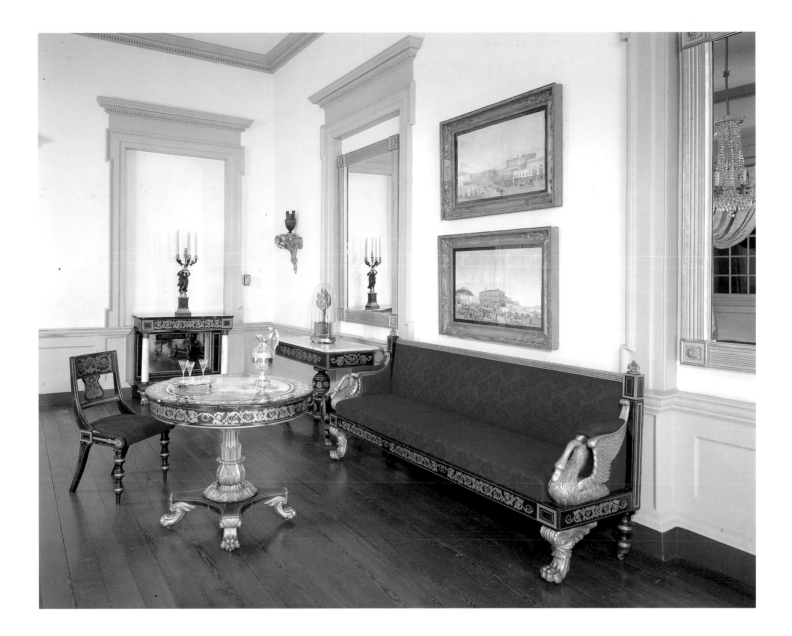

of the main creators of American Empire. He made handsome armchairs and settees with curule legs, and lovely versions of the chaise longue. His restrained and elegant pieces contributed greatly to the fame of the New York furniture industry, as did the work of such fine cabinetmakers as Michael Allison, the Seymours, and later the Meeks.

American Empire, which was very much in favor from about 1810 to 1825, was a style in its own right. It was not—as was sometimes the case with the Empire arts in Europe—an adaptation, however inventive, of French Empire. There were no Napoleonic courts to impose their style and expand the influence of French arts and industries. And far fewer were the craftsmen who had traveled to Paris. Nevertheless, Percier and Fontaine's publications and various pattern books were familiar to many. Furniture and objets d'art were imported from

The Drawing Room of Hampton House. This suite of furniture, 1832, was ordered by John and Eliza Ridgeley of Hampton from Baltimore cabinetmaker John Finlay. The sofa features gilt swan arm stumps and chimera feet. HAMPTON NATIONAL HISTORIC SITE, NATIONAL PARK SERVICE, BALTIMORE

Scroll-back chair with eagle splat, 1810–30, mahogany and silk. COURTESY, THE HENRY FRANCIS DU PONT WINTERTHUR MUSEUM

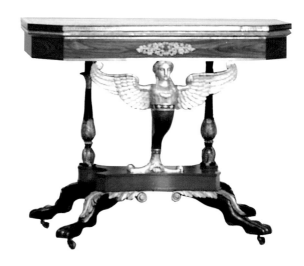

Card table, c. 1815, Charles-Honoré Lannuier (1779–1819), mahogany veneer, mahogany, rosewood, satinwood, poplar, ormolu, brass. VALENTINE MUSEUM, RICHMOND, VIRGINIA; BEQUEST OF CAPTAIN WILLIAMS CARTER WICKHAM

France in significant quantities between 1810 and 1820, proudly advertised in the press by local upholsterers and decorators. And a number of French *ébénistes* who settled in America were extremely successful in affluent society.

The first French craftsmen to arrive in the early nineteenth century brought with them a skill dating from before the Empire period. When Charles-Honoré Lannuier came to New York about 1800, his early work, with its fluted columns and fine detailing, was still rather Directoire and even Louis XVI in style. But these *ébénistes* did bring a new sensibility to simple and geometric volumes, as well as new shapes: the console and the gueridon. They obviously remained in contact with France and kept abreast of the latest fashions, which they introduced as the country enjoyed the prosperity and security that followed the War of 1812.

Lannuier was New York's leading cabinetmaker in the Empire style, and his work was found in the homes of the mayor, successful merchants, and influential citizens. In New York newspapers he advertised his "new fourniture," which obviously kept its French accent. But his highly sculptural pieces had quite an American flavor, even more so than those of Duncan Phyfe. The eagles, swans, and winged female figures that supported his consoles and tables were bold, almost sculptures in themselves. Columns were solid and thickly carved; legs rested on strong animal paws with leafy hocks, often ebonized. He applied gilt-bronze mounts that he imported from France and used as models for later works. His rich, lavish style was imitated by many craftsmen. French *ébénistes* Alexandre Roux, Emmanuel Leprince-Ringuet, and Joseph Brauwers also settled in New York, which became the style leader of the country and exported pieces in large quantities.

Two other burgeoning commercial centers had vigorous furniture industries: Boston, where the Frenchman Auguste Eliaers worked, and Philadelphia, which boasted two French *ébénistes*, Michel Bouvier and Antoine Quervelle. Bouvier had among his clients Stephen Girard, a wealthy banker, and Joseph Bonaparte, who had come to Philadelphia after the fall of the Empire and lived in Point Breeze. Quervelle received important commissions from fashionable Philadelphia society and from the White House. Both cabinetmakers used the proportions typical of Empire, but their ornamental vocabulary became quite massive as years went by.

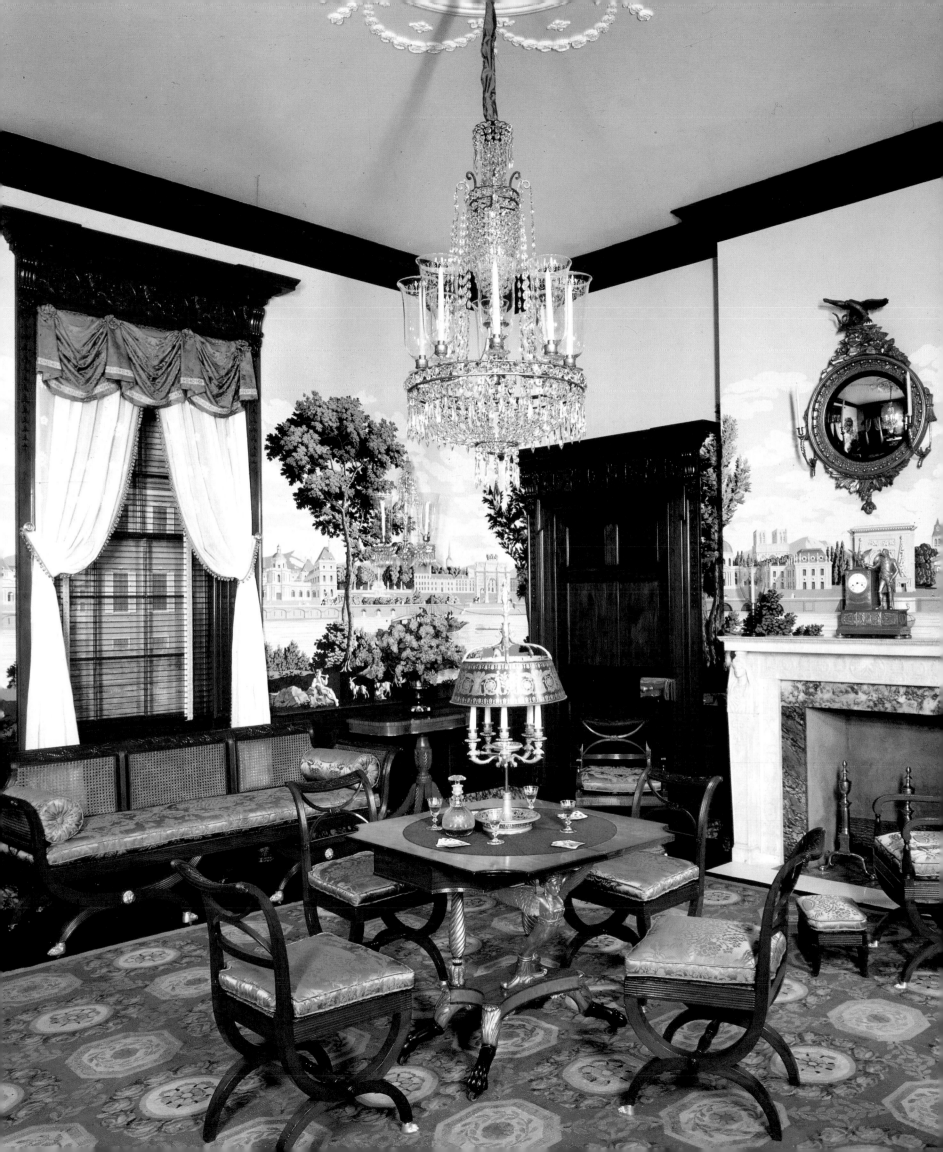

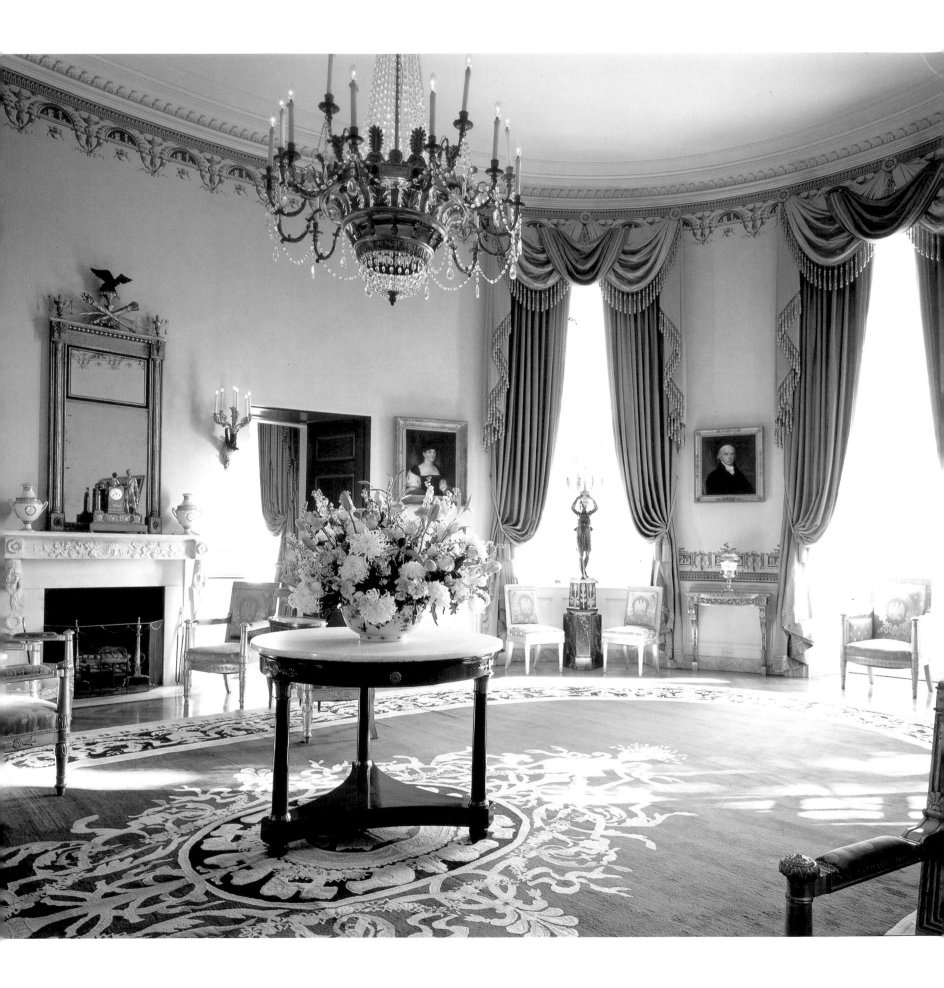

As techniques and trading improved, more varied woods were used. Mahogany had been appreciated during the Federal period and it remained the most prized. But many other woods were chosen for their color and patterns, such as rosewood and tulipwood, while simpler woods like poplar, maple, and pine were often painted or grained to resemble the better ones. An original feature of American Empire was painted furniture, which was popular in city as well as country homes.

Painted chairs imitating Greek *klismos* (seats with four saber legs) or Egyptian pieces were probably inherited from England and were still being made in the 1820s. But the most widespread painting technique was stenciling. A very popular style at the time was the chair with a light frame and a rush or caned seat painted or stenciled in a manner for which Lambert Hitchcock of Connecticut was famous. Hitchcock-type fruit and foliage stenciling also decorated Empire couches, consoles, and card tables. Bronze powders had already been substituting for gold leaf in ornaments, but when stencils appeared about 1815 they were adopted by the majority of the furniture makers, since they were much easier and cheaper to use than gilt-bronze mounts. Baltimore decorative painters freely adapted foliage and rosettes from Percier and Fontaine's *Recueil* and fashioned them into a true ornamental repertoire, quite suited to the neoclassical furniture of both private homes and public buildings. Such stenciling was especially attractive on Grecian couches.

American Empire was thus directly influenced by French *ébénistes*. Certainly influential too were the important French Empire pieces President James Monroe bought for the White House in 1817: chairs were commissioned from Pierre-Antoine Bellangé in Paris; decorative objects, porcelain vases from Sèvres, bronzes, and clocks decorated many of the rooms and were greatly admired.[19]

But American Empire differed from the French style in a number of ways. Some pieces were visually lighter than the French: side chairs remained quite close to the Sheraton type and armchairs had high, thin armrests in the Regency manner. Elegant scroll-back chairs with eagle splats were typically American (the Roman eagle had been adopted as an American emblem when the colonies fought the British; a frequent motif in Federal decoration, it recurred throughout the Empire period). These chairs displayed smooth, harmonious shapes, one

Card table, 1815, by Joseph Brauwers, mahogany, tulip, pine. COURTESY, THE HENRY FRANCIS DU PONT WINTERTHUR MUSEUM; GIFT OF MR. DAVID H. STOCKWELL

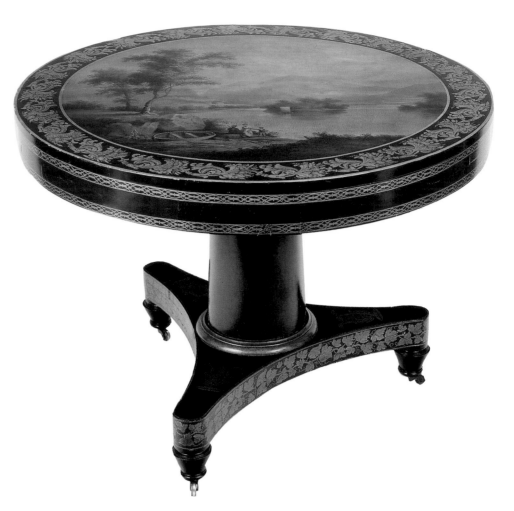

Center table with painted top, 1820–40,
artist unknown, pine with rosewood veneer.
THE MUSEUM OF FINE ARTS, HOUSTON;
THE BAYOU BEND COLLECTION, GIFT OF
MISS IMA HOGG

single line flowing up the saber front leg, over the typical protruding knee, up the slightly scrolled back, and down the saber back leg.

Many pieces of furniture featured more architectural elements than the French: tall secretaires and imposing sideboards offered arched and recessed front panels, detached columns, and prominent cornices and capitals. America, in general, used more decorative devices than did France. Most charming was the way in which quintessentially French gueridons were sometimes decorated: their tops were plastered and painted with delightful landscapes much in the style of the delicate views of Thomas Doughty, a painter of the Hudson River school.

American Empire displayed more movement and curves than the French style. But these opulent shapes could also be quite massive, such as the highly sculpted Grecian couches influenced by the sinuous lines and scrolled cyma ends of George Smith and by the sofas of the Gillow workshop in England. Sculpture in high relief was a distinctive trait. In France it had been used mainly for arm stumps and was otherwise made of bronze when supporting a gueridon or a tripod. In American Empire, however, animal shapes in sofas, legs in the form of lion hocks, and paws carved with wings or acanthus leaves were prominent

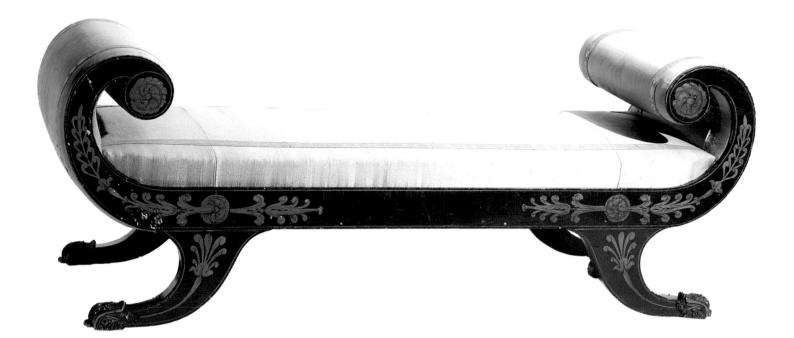

features. Some armchairs with large, voluted arms and prominent animal-hock legs also retained an English flavor. Very American too were the bright silks radiating in small pleats from a central flower that adorned cabinets and some of the highly decorated musical instruments found in so many American interiors.

By the mid-1820s American Empire became heavier and more contrived, as it had some years earlier in other countries. It was no longer dignified but ponderous, and the delight in decoration became ostentation. Scrolled cyma ends and crests were dramatically carved, shapes were more complicated, and cornucopias, winged hocks, and dolphin feet, very popular in American pieces, grew thicker. Yet American Empire remained in fashion well into the 1830s and even later, as the influence of the Gothic style began to dominate.

Stenciled window seat or bench, 1810–25, tulipwood, maple, and magnolia.
Courtesy, The Henry Francis du Pont Winterthur Museum

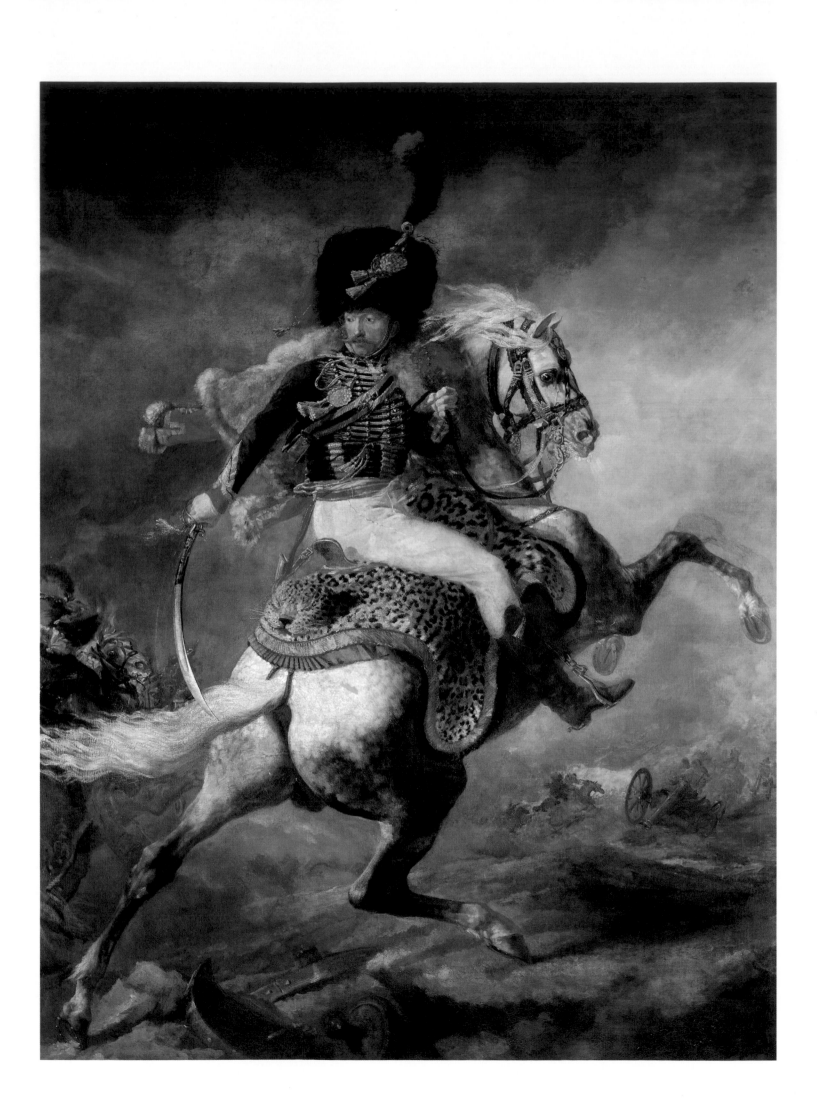

R O M A N T I C I S M

N apoleon sincerely wanted to promote the fine arts and paid great attention to state commissions and purchases, to museums and exhibitions. But the fine arts demanded more freedom than the decorative arts, and although they were given generous exposure they were hampered in their expression by the increasingly harsh censorship Napoleon imposed on all intellectual and artistic life.

Sculpture during the Empire remained very classical. Napoleon had a true interest in it—he liked to visit the Louvre at night, by torchlight—and he launched many projects, most of which were collective works supervised by Denon to give them unity.[1] On the place Vendôme the Colonne de la Grande Armée was erected, a structure sheathed with plates cast from the bronze of captured enemy cannons. Innumerable friezes, statues, and busts of generals decorated buildings, bridges, and city squares, both in Paris and in the provinces. Abroad, sculptural projects spread the Empire style of historical reliefs and portraits. The Dane Berthel Thorvaldsen, who lived in Rome, sculpted a thirty-five-meter-long frieze in the Quirinal Palace representing the conquests of

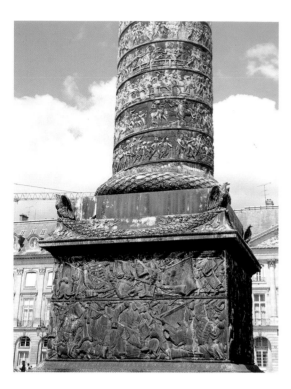

Colonne de la Grande Armée, place Vendôme, Paris, 1806–10. Probably inspired by Baron Denon, this column was made from the bronze of 1,200 Austrian cannons and reproduces trophies taken from the enemy. François-Joseph Bosio was among the sculptors who worked on it.

PAGE 228: Light Cavalry Officer Charging, *1812, Théodore Géricault (1791–1824), oil on canvas, 137 3/8 × 104 3/4 in. (349 × 266 cm). LOUVRE, PARIS*

Alexander the Great. Joseph Chinard, Charles-Louis Corbet, and François-Joseph Bosio made numerous portraits of the imperial family.

Napoleon's favorite sculptor was the neoclassical artist Antonio Canova, and he contributed significantly to his success. He and the members of his family had many portraits done by Canova, and he offered the sculptor prestigious positions, which Canova, who did not wish to bow to Napoleon's authority, refused. Josephine commissioned replicas of *Cupid and Psyche* and *Hebe*, as well as a *Danseuse*, a *Paris*, and the well-known *Three Graces*. Napoleon also commissioned a statue of himself, but the three-and-a-half-meter-high heroic nude did not please the emperor, who stored it away in the Louvre.[2] However, Canova's famous nude statue of Pauline Borghese as Venus had a far different reception when it was seen in 1808.

Painters also commemorated military victories and portrayed high-ranking dignitaries. But in its many forms, painting was much more sensitive to the social and aesthetic changes taking place at the time.

The main event of the art scene was the Salon, an exhibition that originated in 1667 and that, during the Empire, was organized every other year and was open to almost everyone. Held in the Salon Carré of the Louvre (hence its name), it was widely discussed and immensely popular: in 1810 it attracted some 100,000 visitors. The Salon exhibited works recently commissioned or bought by the state or by private collectors, giving a vivid picture of contemporary art; in 1812 nearly 1,300 works were shown. Collectors, among whom Josephine was assiduous, came to buy, and Napoleon visited it regularly, occasionally awarding the highly prized Legion of Honor. Baron Denon, the emperor's main counselor for the arts and director of the Musée Napoléon (as the Louvre was called from 1803 until the fall of the Empire), gave the emperor detailed reports on the exhibition.

The Salon was all the more influential because intellectual and cultural life became centralized in Paris, as did much of public life, under Napoleon's aegis. Sculpture, architecture, and engraving were represented, but the public was especially drawn to painting. Among the great variety of works exhibited, the most prestigious were the great paintings of contemporary history, such as Anne-Louis Girodet's *Apothéose des héros français* (1802) and Antoine-Jean Gros's *Bataille d'Aboukir* (1806), which Delacroix would so admire. In 1808, when the imperial eagle was spreading its wings over most of Europe, the highlights of

the Salon were David's *Sacre* (Coronation), Gros's *Champ de bataille d'Eylau*, Carle Vernet's *Napoléon donnant ses ordres avant la bataille d'Austerlitz* and *Napoléon devant Madrid*, and Pierre-Paul Prud'hon's *La Justice et la Vengeance divine poursuivant le Crime*. In 1810, among the many works magnifying the Napoleonic legend were Gros's *Bataille des Pyramides* and Gérard's *Bataille d'Austerlitz*.

These epic paintings told of Napoleonic conquests on vast battlefields, of victories in the midst of the interminable and tragic wars that extended from the Revolution to the Battle of Waterloo—long years during which the Grande Armée was heroic, despite the terrible suffering endured by very young men who could not avoid the draft, as well as by the old Grognards (grumblers), whose respect and love for Napoleon was legendary. The artists who depicted these dramatic episodes had impeccable training (Girodet and Gros were students of David[3]).

Jacques-Louis David's consciously austere manner had given a new grandeur to mythology and Roman history. Classical scenes were frequent subjects in the last years of the eighteenth century, such as Girodet's *Sommeil d'Endymion* (1792), Gérard's *Psyché et l'Amour* (1798), and Pierre-Narcisse Guérin's *Retour de*

Pauline Borghese as Venus Victorious, *1808, Antonio Canova (1757–1822), marble, 78⅝ in. (199.7 cm) long.* GALLERIA BORGHESE, ROME

The Funeral of Atala, *1808, Anne-Louis Girodet (1767–1824), oil on canvas, 78¾ × 105⅛ in. (200 × 267 cm).* LOUVRE, PARIS

François-René de Chateaubriand's (1768–1848) remarkably successful novel Atala, *1801, is set in North America, where the writer had traveled. Atala was a Christian squaw.*

Marcus Sextus (1799). David was among the first to apply this grand classical style to contemporary events when, in 1800, he depicted Bonaparte riding over the Saint-Bernard pass, leading his army into Italy. Four years earlier, however, his student Gros had presented a far more dynamic and convincing *Bonaparte au Pont d'Arcole*, which took an opposite course from David's cold solemnity.

Gros's *Les Pestiférés de Jaffa*, depicting Napoleon's visit to plague-stricken soldiers during the Syrian campaign, was one of the highlights of the 1804 Salon. Splendidly composed and lit, this work was one of the first to treat the Orient not as the fanciful "China" that had played merely a decorative role in eighteenth-century tapestries and gardens but as a powerful and mysterious land. The naked figures show a neoclassical influence, but the Arabs have a

Les Pestiférés de Jaffa, *1799, Antoine-Jean, baron Gros (1771–1835), oil on canvas, 17⅛ × 23½ ft. (5.2 × 7.2 m).* LOUVRE, PARIS

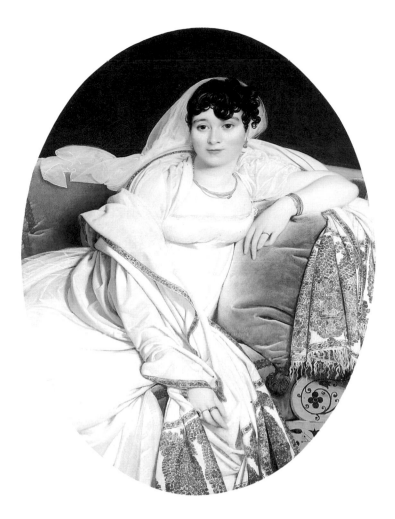

Portrait of Madame Rivière, *1805, Jean-Auguste-Dominique Ingres (1780–1867), exhibited at the 1806 Salon, oil on canvas, 46 1/8 × 35 1/2 in. (117 × 90 cm). LOUVRE, PARIS*

solemn, statuesque presence. Napoleon's gesture, extending his arm toward a sick soldier, is perhaps too theatrical, but this is nevertheless a masterful work that announced a Romantic feeling as yet unknown to French painting.

Countless portraits were commissioned in those years from the best painters.[4] Most official portraits were stilted, and even Gérard and Isabey were conventional in their grand compositions. But their smaller works and their portraits of the women of Napoleon's family could be quite sensitive. David, too, before he became Napoleon's official painter, was a wonderful portraitist, as his *Monsieur Sériziat* and *Madame Sériziat* (1795) attest. Jean-Auguste-Dominique Ingres was impenetrable and frozen in mythological works such as *Oedipus and the Sphinx* (1808) or *Jupiter and Thetis* (1811). But he was an insightful and keen portraitist of the bourgeoisie, as his remarkable portraits of Monsieur, Madame, and Mademoiselle Rivière or Louis-François Bertin show.

French landscape painting had not reached the status it had in Dutch, or more recently English, painting. The historic landscape, inherited from Poussin, was only slowly freeing itself from mythological themes, and the nascent neo-classical landscape was still close in spirit to the eighteenth century: in quiet

The Empress's Lunch at Cervos, *from Album de Voyage de l'Impératrice, 1810, Turpin de Crissé (1782–1859), drawing and sepia. CHÂTEAU DE MALMAISON*

valleys framed by well-planted trees, small classical figures gathered among ruins often reminiscent of Hubert Robert and Charles-Louis Clérisseau.[5] The landscapes of Jacques-François-Joseph Swebach and especially of Jean-Victor Bertin were enchanting and full of peaceful light.

Romanticism did not come from nature in the early nineteenth century; it came from the new sensibility and the new sense of history that literature was revealing. The Age of Enlightenment was being overcome by tempests and desires, the Sturm und Drang that had already filled young Germans with Werther's desperation. In the first decade of the century, the neoclassical subjects of Gérard, Girodet, Isabey, or Prud'hon became enveloped in a nebulous atmosphere, their legends bathed in strange moonlight that contradicted the classical purity of their lines and the clarity of their shapes. Girodet's *Atala* was a moving evocation of François-René de Chateaubriand's novel. Prud'hon's sfumato effects and the chiaroscuro surrounding his allegories successfully translated the melancholy of the times. His fine portrait of Josephine in the gardens of Malmaison was almost Romantic.

This new sensibility was induced by literary themes, particularly the legend

of the Scottish bard Ossian, popularized by the poet James Macpherson. Ossian became the ancestor of nations delving into their past. Surprisingly, the eminently rational Napoleon was fascinated by this myth and had several artists depict it. Gérard and Girodet (Napoleon's favorite painter) painted large works on this theme for Malmaison.[6] Ingres painted a *Songe d'Ossian* (Ossian's Dream) for the Quirinal, and Napoleon even asked Isabey to reproduce in watercolor Gérard's *Ossian* in his own copy of the bard's poems, one of his favorite books. On stage, the mists of Jean-François Le Sueur's opera *Ossian* were a tremendous success.

The early nineteenth century was in search of origins other than those imposed upon it by "enlightened" governments and their followers. Chateaubriand's *Génie du Christianisme* (1802) proposed a vast religious and cultural vision that was immensely influential in a time that was rejecting the secular

ideals of the Revolution. The Christian Middle Ages became an alternative to the rationality of ancient Rome: in 1808 David predicted that knights would triumph over the heroes of antiquity. A taste for the Gothic and for Sir Walter Scott was coming from England, at the same time as many medieval subjects inspired troubador artists like J. A. Laurent, Henriette Lorimier, Jean-Baptiste Mallet, Pierre-Henri Revoil, and François Fleury Richard. The passion of Héloïse and Abelard and the feats of Chevalier Bayard, Mary Stuart, and Henry IV were favorite subjects, encouraged by the Musée des Monuments Français, in which Alexandre Lenoir exhibited many medieval works.

French medieval poems and fables were republished, Josephine subscribed to the *Journal des troubadours*, which published medieval music, and medieval romances were sung in salons as well as in the most modest homes. Josephine and her daughter Hortense collected troubador painting and played an important role in spreading the new taste. They also encouraged a new sense of fantasy in the decorative arts: the stiffness of the late Empire slowly gave way as Gothic motifs were integrated into architecture, furniture, and textiles.[7] But only after

La Grande Odalisque, *1814, Jean-Auguste-Dominique Ingres (1780–1867), oil on canvas, 35 ¾ × 63 ¾ in. (91 × 162 cm).* LOUVRE, PARIS

This painting was commissioned by Caroline Murat and shows the artist's interest in both the Renaissance and Oriental themes.

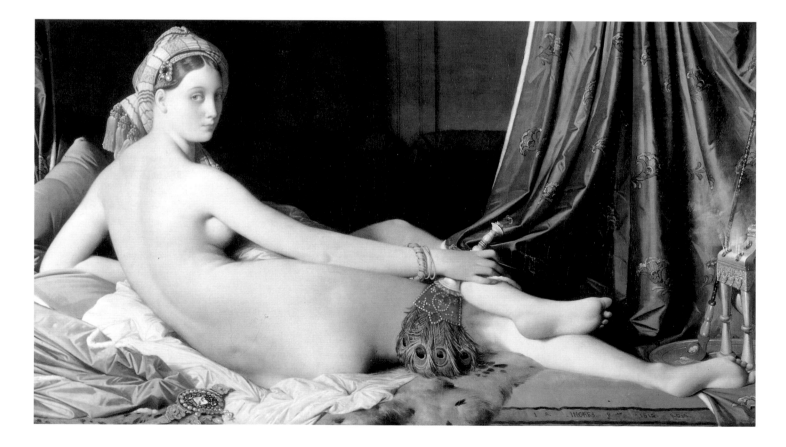

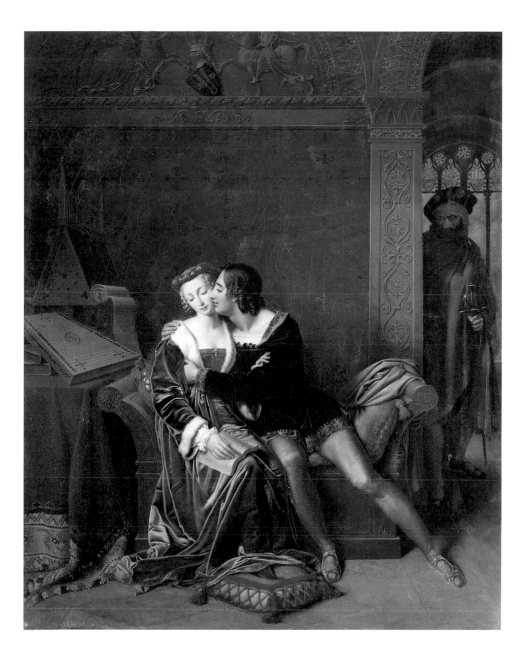

The Tragic Love of Paolo Malatesta
and Francesca da Rimini, *1812,*
Marie-Philippe Coupin de la Couperie
(1773–1851), oil on canvas, 39 ⅜ × 32 ¼ in.
(100 × 82 cm). NAPOLEON MUSEUM,
ARENENBERG, SWITZERLAND

the fall of the Empire did the *style troubadour,* or *à la cathédrale,* really blossom in decoration. Under the influence of the duchesse de Berry and Queen Marie-Amélie, the wife of Louis-Philippe, these motifs seemed quite pertinent to the return of a monarchy that had its origins in the Middle Ages.

Romanticism was a quest for a sublime destiny. A Romantic yearning sprang from the dreams Napoleon had inspired. The exalted generation that came of age after the fall of the Empire had been raised on tales of glory and conquest, and it would be confronted with an eminently bourgeois society. The Romantic movement in France developed after Napoleon's death, but many of its traits already belonged to the Empire. And no one expressed this better than Géricault.

Théodore Géricault was barely twenty-one when he exhibited a masterpiece

Plate from a service belonging to Josephine,
1811–12, by the Dihl and Ghérard firm.
A painting by Nicolaes Berchem (1620–1683)
in her collection at Malmaison is reproduced
on it. Château de Malmaison

in the Salon of 1812: *Light Cavalry Officer Charging.* That summer Napoleon, still dominating the whole of Europe, had begun his tremendous assault upon Russia and had penetrated as far as Moscow. But in December the Grande Armée, chased by the Cossacks and trapped by the brutal Continental winter, was decimated. The officer Géricault had portrayed was one of the three hundred thousand troops who would fall in the terrible retreat on the plains of Russia. Géricault's picture—exhibited the preceding autumn—was not only premonitory, it was also a very strange image of combat. In the heat of the action the horseman turns and, with absent gaze, seems to reflect on his fate.

This painting is remarkably modern. The strong and contradictory movement of the horse, which is both climbing a hillock and rearing, thus remaining immobile; the crepuscular light; the rich color of the officer's bedecked uniform; the elevated position of the horseman; Géricault's very personal brushstroke—everything speaks at once of glory, of death, and of the end of an era. Two years later, when Napoleon was in exile on the island of Elba, and Josephine had just died at Malmaison, Géricault exhibited in the Salon his magnificent *Wounded*

Cuirassier Leaving the Battlefield. His combat over, the cuirassier has left the army behind and stands alone, holding back his frightened horse, on the brink of a precipice. His head wound is barely visible as he questions the skies, and darkness lifts over the horizon.

Light Cavalry Officer Charging epitomized the last years of the Empire, its sky on fire, laden with smoke. As the Empire extended, and especially after 1810, Napoleon became increasingly adamant in his convictions and his sense of almightiness. He would accept no criticism; he disregarded warnings not to

Wounded Cuirassier Leaving the Battlefield, *1814, Théodore Géricault (1791–1824), oil on canvas, 141 × 115¾ in. (358 × 294 cm).* LOUVRE, PARIS

venture into Spain and Russia; he was more and more suspicious of writers, journalists, and of any creation that appeared beyond his control, enforcing censorship in all domains.[8] And his marriage to an archduchess from one of the oldest dynasties in Europe seemed to have convinced him that no one could resist his will. But he was vanquished, and after his empire was dismantled by the Congress of Vienna in 1815, he spent the last six years of his life on a forlorn island in the South Atlantic.

Napoleon was prompted by unbounded and contradictory ambitions. He was a man of the eighteenth century in his wish to organize Europe in a modern, rational manner and to be the founder of modern society. Yet he was a Romantic in his vision. Chateaubriand, his longtime opponent, perhaps judged him best: "A prodigious imagination drove this cold politician. He would not have been the man he was if he had not been inspired by the Muse. Reason accomplished the ideas of the poet."[9] His fondness for Ossian, for Girodet, for Gros, for Benjamin West's *Death on a Pale Horse*, revealed a Romantic spirit.

The Revolution had wanted to be the victory of light over ignorance and injustice. Of mythic dimension, it shook the imagination of the whole of Europe. The goal of the Empire was to spread this light and order, but Napoleon's conquests led to a destructive and impossible hegemony, a fact he would never admit. By the time the Empire came to an end, the luminous grandeur of antiquity had evolved into the sensuous torment of Romanticism. Reason was no longer guarded by deities, and never again would nymphs and satyrs frolic among arabesques. Wild winds were exalting the imagination. David had predicted the triumph of medieval knights, and Delacroix saw the heroes and horses of the West storming the pashas and steeds of the East. Vast lands were opening beyond the seas, giving a new sense of time and space to Western cultures.

OPPOSITE: Nymph and Satyr, *1817, Théodore Géricault (1791–1824), black chalk, brown wash, white gouache on brown prepared paper, 8¾ × 7⅛ in. (22.2 × 18.2 cm). PRINCETON UNIVERSITY ART MUSEUM; GIFT OF MRS. GEORGE L. CRAIG, JR., IN MEMORY OF HER HUSBAND*

NOTES

CHAPTER 1
From Revolution to Empire

1. The term *Revolution* covers the events of 1789 but also the years of upheavals that ended the ancien régime and extended from 1789 to the beginning of the Directoire in 1795.
2. See pp. 29–37.
3. The Englishman Yorke and the Germans Heinzmann, Kotzebue, Reichardt, and Schopenhauer.
4. The origin of the term *Muscadin* is uncertain. It might come from the musk-scented sweets that the young counterrevolutionaries ate, or from the smell of nutmeg (*noix muscade*) of apprentices working in the spice business. *Incroyable* literally means incredible. As for *Merveilleuse*, it is just marvelous!
5. *Recueil d'antiquités égyptiennes, étrusques, grecques, romaines et gauloises*, 1752–57.
6. The records of the Ecole des Beaux-Arts show that all the subjects submitted for the main competitions were of Greek and especially Roman history and mythology.
7. Among the numerous publications that appeared in the second half of the century, several were influential for decades: *Antichità di Ercolano*, published from 1758 to 1792; the fundamental writings of Johann Joachim Winckelmann; those of Caylus; and the important *Essai sur l'architecture*, 1752, by Father Laugier.
8. The *voyage d'Italie* was not new to the French. Jean-Baptiste Colbert, Louis XIV's minister, had instituted a remarkable educational system and founded the Académie de France in Rome and a competition that was to have an extraordinary impact on the arts in France, the Grand Prix de Rome. Winners could spend a few years living in Rome, where, from the Empire onward, they could stay at the beautiful Villa Medici.
9. Georges Jacob created some of the most beautiful furniture during the reign of Louis XVI and shortly after. In 1796 he left his workshop to his sons, Georges II and François-Honoré-Georges, who stamped their works Jacob Frères, rue Meslée, the address of their workshop. In 1803 the elder son died, and François-Honoré-Georges took over with his father's help and developed his workshop in the most proficient manner, signing his work Jacob-Desmalter (Desmalter was the name of a family land). In 1825 François-Honoré-Georges Jacob-Desmalter left his workshop to his

son Georges-Alphonse, who was active until 1847 and mostly signed the works A. Jacob fils et Cie. The company was then taken over by Jeanselme. One Henri Jacob, unrelated to this family, worked before and after the Revolution.
10. For the English publications of the time that most influenced architects and decorators see chapter 6, note 18.
11. The copies are probably the ones held in the Musée Marmottan, Paris.
12. In 1777 the trendsetting comte d'Artois, the future Charles X, had the *folie* of Bagatelle built by Bélanger within nine weeks, thus winning a bet he had made with his sister-in-law Marie-Antoinette. He also launched a new fashion, *le goût turc*, which was especially suitable for boudoirs.
13. A very large biscuit *surtout* is part of the *service égyptien* in the collections of the Wellington Museum in Apsley House, London. For more on these Egyptian services, see the section on porcelain, pp. 159–65.
14. The tradition still continues, and presidents of the Republic often give Sèvres porcelain as presents of prestige.
15. The term *hôtel* designated the mansion of a lord or a prominent bourgeois. The most beautiful hôtels began to be built in the seventeenth century, both in Paris and in the provinces.
16. The Hôtel Récamier, which was on the present rue de la Chaussée d'Antin, no longer exists.
17. Louis Berthault (1767–1823). In their article "La Décoration et l'ameublement de la chambre de Madame Récamier sous le Consulat," *Gazette des Beaux Arts*, October 1952, R., G., and D. Ledoux Lebard explain that although there is no proof of Percier's participation in this project, his contemporaries were unanimous in attributing the decoration of the Hôtel Récamier to him. Percier, better known, may have been discreet in not wanting his suggestions to his former student to appear in the documents.
18. This chaise longue has been the subject of some confusion: Madame Récamier's own chaise longue had eight feet and lion heads where the sides begin, whereas the one on which she is depicted in David's painting belonged to the artist and has four feet.

CHAPTER 2
The Napoleonic Empire

1. When the French officers returned from Egypt, they brought back ex-

ceptional Oriental shawls. But after the Continental Blockade stopped imports from the Orient, shawls were made in France, the most famous manufacturer being Guillaume Ternaux, who even attempted, unsuccessfully, to acclimate Tibetan goats to France. Some shawls were designed by well-known artists, such as Jean-Baptiste Isabey. When Napoleon married Marie-Louise, he gave her seventeen sumptuous French shawls.
2. "Les hommes ne sont grands que par les monuments qu'ils laissent." Quoted in Louis Hautecoeur, *Histoire de l'architecture classique en France*, vol. 5, p. 148.
3. Quoted in Hautecoeur, *Histoire*, p. 149.
4. In 1808, from Bayonne, he wrote to the minister of the interior, "Monsieur Cretet, send me a little report on the works I ordered. How is the Bourse coming along? Has the convent of the Filles Saint Thomas been demolished? Is the new building going up? What has been done about the Arc de Triomphe? How is the work on the wine market? What about the large stores? And La Madeleine? Is all that progressing? Shall I pass over the Pont d'Iéna when I return?" Quoted in Hautecoeur, *Histoire*, p. 151.
5. Quoted in Hautecoeur, *Histoire*, p. 149.
6. Napoleon never saw the Arc de Triomphe de l'Etoile, for it was only six meters above ground in 1814. But a mockup of wood and cloth was built in full scale for Napoleon and Marie-Louise's wedding.
7. Built about 1792, rue des Colonnes has been attributed in turn to Bernard Poyet and N.A.J. Vestier.
8. Charles Percier (1764–1838) and Pierre-François-Léonard Fontaine (1762–1853).
9. Innumerable palaces were transformed in all parts of the Empire—throughout Italy and in Belgium, Holland, and Germany.
10. Charles Percier and Pierre-François-Léonard Fontaine, *Palais, maisons et autres édifices modernes dessinés à Rome*, 1798, and *Choix des plus célèbres maisons de plaisance de Rome et de ses environs*, 1809.
11. The influence of Percier and Fontaine in these fields is examined in the chapters on furniture and decorative objects.
12. Percier and Fontaine were conscious of their role as tastemakers and pedagogues; they were also curious about Egypt and insisted that students be allowed to study Renaissance models.

13. See p. 95.
14. The renovation of Malmaison was, however, extremely costly. In Saint Helena, Napoleon still recalled the huge bills he had had to pay on his return from Egypt.
15. It is now the residence of the German ambassador.
16. Napoleon thought it unwise to let Josephine live in the Elysée after he married Marie-Louise; he then gave her the château de Navarre, in Normandy. This château was demolished in 1834.
17. The architects Vignon and Thibault, who redid the Elysée, also worked for Louis and Hortense Bonaparte on their hôtel on the rue Cerutti and on their château de Saint-Leu.
18. Pierre Fontaine journal, March 3, 1813. Quoted in *Histoire des jardins de la Renaissance à nos jours*, ed. Monique Mosser and Georges Teyssot (Paris: Flammarion, 1991).
19. Among many other projects, Berthault worked for Louis and Hortense Bonaparte on their château de Saint-Leu, and for Prince Aldobrandini Borghese on Beauregard.
20. Quoted in Marie Blanche d'Arneville, *Parcs et jardins sous le Premier Empire* (Paris: Librairie Jules Tallandier, 1981), p. 139.
21. Krafft and Ransonnette: *Plans, coupes et élévations des plus belles maisons et des hôtels construits à Paris et dans les environs*, 1801–2.

CHAPTER 3
Furniture

1. In 1806 the British cabinet declared that European coasts from the Elbe to Brittany were in a state of blockade. Napoleon's reaction was to declare a blockade on England, and later to forbid trade with England from all European ports.
2. *Les Toulousains dans l'histoire*, ed. by Philippe Wolff (Toulouse: Editions Privat, 1984).
3. Jean Tulard, "La France napoléonienne," in *Revue d'histoire moderne et contemporaine*, 1970, p. 640.
4. For the Jacob family, see chapter 1, note 9.
5. See p. 13.
6. See pp. 21–22.
7. See p. 169.
8. Denise Ledoux Lebard, "Empire Furniture in 'bois indigènes,'" *Connoisseur*, December 1976.
9. The frères Jacob made especially pretty inlaid pieces.
10. Madame Campan was a famous educator whose institution had been attended by many daughters of the ruling class and several young women of the imperial family. In 1807 she became director of

the Maison d'Education de la Légion d'Honneur, which Napoleon had created.

11. The Abbaye-aux-Bois was a residence in a former Bernardines convent and was situated on the present rue Récamier, not far from Saint-Germain-des-Prés.

12. Much later in the century, the atmosphere of the Faubourg Saint-Germain was wonderfully evoked by Henry James in *The American*.

13. In her simple and touching *Memoirs*, Madame de Lamartine, the mother of the poet, appeared endlessly preoccupied with the health of her numerous children, four of whom died—ordeals she lived through without complaint, helped by her faith in God. *Memoirs* was written in the early nineteenth century but not published until 1983.

14. Those belonging to Madame Morceau are also attributed to the frères Jacob, and Jacob-Desmalter made some for Josephine's boudoir in Fontainebleau.

15. See the portrait of Boieldieu by Louis Boilly on p. 28.

16. It has also been said that David refused to finish the portrait.

17. Many of the names of furniture pieces lacked precision, as did their spelling, and could be used differently by makers or writers.

18. Such beds can be seen in the château de Villepreux.

19. See pp. 42–43.

20. See pp. 142–43.

21. Now in the Louvre and the château de Fontainebleau.

22. An interesting bookcase decorated with motifs from the Temple of Dendur belongs to New York antiques dealer Roger Prigent.

23. An exhibition of precious books belonging to the imperial libraries was organized at Malmaison in the summer of 1992.

24. Some tables were made to resemble two consoles back to back, covered by one large slab of marble, such as the one on four severe Egyptian caryatids in the Grand Trianon by Jacob-Desmalter.

25. See illustration on p. 234.

26. The name of this table is slightly erroneous, for several of Napoleon's lieutenants were not yet marshals when it was made.

27. The latter was in the private collection of Paul Getty. These precious Sèvres tables were also very appreciated abroad: dainty little *tables à thé* can be found in the Museo de Artes Decorativas in Madrid and in several other European collections.

28. Percier and Fontaine did, however, design an impressive model that was imitated in England and reproduced in Rudolph Ackermann's *Repository of Arts* as late as 1822. The roll-top desk became fashionable again during the French Restoration.

29. It is part of the collection of the Musée Marmottan, Paris.

30. A beautiful *bureau mécanique* can be seen in the Conseil Constitutionnel in Paris.

31. Now located in the Grand Trianon; see illustration on p. 29.

CHAPTER 4
Interior Decoration

1. *Journal de l'Empire*, February 7, 1807. Quoted in Jean Tulard, *Nouvelle histoire de Paris, le Consulat et l'Empire* (Paris: Hachette, 1970), p. 30.

2. In the seventeenth century lights were stuck into the walls straight through the valuable tapestries that covered them.

3. Xavier Mader had first worked for the *toiles peintes* factory of Favre, Petitpierre et Cie in Nantes.

4. An interesting article by Clare Crick provides information on this subject: "Wallpapers by Dufour et Cie," *Connoisseur*, December 1976.

5. In England, too, the upholsterer could also be a cabinetmaker who provided his clients with all necessary items.

6. In 1808 a course in industrial chemistry and dyes was started in Lyons. In 1810 Napoleon offered a prize to the first person who discovered a blue dye that could be made without indigo, the importation of which had become too expensive because of the blockade. A dye was developed from a woad plant. See Jean Coural, *Silks from the Palaces of Napoleon* (New York: Fashion Institute of Technology, 1983).

7. Some silks had been commissioned or bought by Louis XVI at the end of his reign: they were now used in the Napoleonic projects. For instance, a beautiful satin brocade ordered by the Garde-Meuble Royal was used for Josephine's bedroom in Fontainebleau in 1805.

8. See Coural, *Silks from the Palaces of Napoleon*.

9. See p. 194.

10. They had been fashionable for over a century and initially came from India, but now Napoleon ordered that they be manufactured in France.

11. Jean-Baptiste Huet was named director of the Manufacture de Beauvais in 1800. The same artist reviewed the designs of the toiles de Jouy for Oberkampf.

12. Madeleine Jarry, "La Manufacture impériale de la Savonnerie," *Connoisseur*, December 1976.

13. Quoted in Madeleine Jarry, *The Carpets of Aubusson* (England: Leigh-on-Sea, 1969).

CHAPTER 5
The Art of Entertaining

1. Quoted in Jean Tulard, *Nouvelle Histoire de Paris, le Consulat et l'Empire* (Paris: Hachette, 1970).

2. See the interesting study by Catherine Arminjon, "The Art of Dining," in *L'Art de Vivre* (New York: Cooper-Hewitt Museum/Vendome Press, 1989).

3. Soft-paste porcelain is made through a very complex process and contains no kaolin. Hard-paste porcelain is essentially composed of quartz, feldspar, and kaolin.

4. For a study of this influence, see Frédérique Citéra, "Aux origines du néo-classicisme à Sèvres," *L'Estampille l'Objet d'art*, December 1991.

5. See the section *Voyage dans la Basse et la Haute Egypte*, pages 29–37.

6. See pp. 36–37.

7. Josephine commissioned a first *cabaret égyptien* of twelve cups and saucers and six larger pieces in 1808. Another very large *service égyptien* was presented to her by Napoleon after their divorce, its sepia views painted by Swebach, framed by beautiful dark blue borders decorated with gold hieroglyphs. Josephine refused this service, which was returned to the manufacturer. In 1818, after the fall of the Empire, it was given by Louis XVIII to the duke of Wellington, who was then ambassador to Paris. It is now exhibited in Apsley House, Wellington's mansion in London.

8. See section on tables and desks, pp. 123–27.

9. See p. 171.

10. See p. 158.

11. Nothing is left of this very famous *toilette* because when Marie-Louise lived in Parma after the fall of the Empire, she had it melted down to help the victims of the 1832 cholera epidemic.

12. The vermeil cradle is in the Treasury of Schweizerhof, Vienna. The elm cradle is in the musée Napoleon in the château de Fontainebleau.

13. See p. 25.

14. An interesting lantern in the form of a pagoda was made for Napoleon, probably by a Chinese craftsman on Saint Helena. It now belongs to the Galerie Camoin in Paris.

15. Aimé Argand was Swiss, and he patented his invention in 1783 or 1784, but his idea was stolen by Quinquet, who later admitted to copying it.

16. The Parisian specialists in these lamps were the Girard family, who won a medal at the 1806 exposition and supplied the château de Fontainebleau; the frères Duverger, who supplied the Tuileries Palace; and the firm Chopin. See Catherine Arminjon, "Baisse un peu l'abat-jour," *L'Objet d'art*, 1988.

17. An interesting pair in the shape of helmets belongs to the Hermès museum in Paris.

18. See p. 96.

CHAPTER 6
Europe and America

1. Henry Russell Hitchcock, *Architecture: Nineteenth and Twentieth Century* (London: Penguin, 1990), pp. 45–46.

2. See Martin Levy, "Napoleon's fauteuil de malade," *Apollo*, May 1991.

3. See Frances Collard, *Regency Furniture* (Ithaca, N.Y.: Antique Collectors' Club, 1985).

4. A bed published in *Household Furniture* in 1807 has victories from Berthault's bed for Madame Récamier in 1798, and elements from the bed Percier and Fontaine made for their client Citoyen V. before 1802.

5. Quoted in David Watkin, *Thomas Hope and the Neo-Classical Idea* (London: William Clowes and Sons, 1968), p. 213.

6. Derrick Worsdale, "The State Apartments," *Apollo*, September 1977.

7. The decoration of the palaces in Naples was finished not during the Bonapartes' rule but after the restoration of the Bourbons, under the direction of the architects Giordano and Niccolini. In the city of Naples, French architects Louis and Etienne Gasse built the stock exchange, the city hall, the observatory, and the promenade of Villa Reale.

8. See p. 146.

9. See pp. 13 and 95.

10. It is interesting to see how late French influence was perceptible. For instance, in 1834–44 C. E. von Bötticher's *Ornamenten-Buch* published an exact reproduction of Percier and Fontaine's project for the Throne Room in the Tuileries Palace.

11. The palace in Stuttgart was destroyed during World War II, but some of its furniture was transferred to Ludwigsburg.

12. Interesting information on this period is given by Léon de Groer, *Les arts décoratifs de 1790 à 1850*.

13. Angus Wilkie, *Biedermeier* (New York: Abbeville Press, 1987).

14. Jean-Baptiste's brother, Louis Masreliez, was also an important decorator, who introduced the Pompeian style to Sweden.

15. This period is studied in the interesting *Neoclassicism in the North* by Håkan Groth (London: Thames and Hudson, 1990).

16. When George Washington died in 1799, some four hundred orations

and elegies were given across the country, most of them likening this first hero of the nation to Caesar or Cincinnatus.

17. American Empire was a style in its own right, quite national in its character. It deserves far more attention than can be devoted to it in this volume; hence only its relation to French Empire is considered here.

18. George Hepplewhite, *The Cabinet-Maker and Upholsterer's Guide*, 1788. Thomas Sheraton, *The Cabinet-Maker and Upholsterer's Drawing Book*, 1793. George Smith, *A Collection of Designs for Household Furniture and Interior Decoration*, 1808, and *A Collection of Ornamental Designs after the Antique*, 1812.

19. Benjamin Latrobe had remodeled the interior of the White House and designed furniture for President James Madison in 1809.

Chapter 7
Romanticism

1. The exterior decoration of the Louvre was completed in harmony with the part of the palace that had been designed during the Renaissance. Two of the sculptors who worked on this ambitious project were Pierre Cartellier and Denis-Antoine Chaudet. They were among the artists who received the greatest number of official commissions from the state. Some sculptors worked on both the Louvre and the Arc de Triomphe de Carrousel. Contributors to the latter included the well-known Chinard, Clodion, and Corbet.

2. Canova sculpted this statue from the plaster model he had made in 1802 after a Hellenistic athlete in the Uffizi Gallery in Florence. It was bought by the British Government in 1816 and presented by

King George IV, then Regent, to the duke of Wellington. It is now in Apsley House in London.

3. David was known to be a liberal teacher who refused to be imitated. Among his many students were Drolling, Epinat, Fabre, E. Fragonard, Garneray, Gérard, Girodet, Granet, Gros, Guérin, Ingres, Isabey, and Michallon.

4. Numerous other painters, such as Robert Lefèvre, made portraits of the imperial family and of private patrons.

5. The earliest representatives of this neoclassical landscape tradition had all spent long periods in Italy from the 1770s and 1780s onward: Nicolas-Didier Boguet, a friend of Chateaubriand, who painted frescoes in the Quirinal in 1812; Fleury Epinat, François-Xavier Fabre, and Louis Gauffier, who all lived in Florence, where the latter

worked for Elisa; Achille-Etna Michallon; Turpin de Crissé, who was Josephine's protégé; and Pierre-Henri de Valenciennes. For a study of their drawings, see Mylène Piron, "Les Dessins de paysages néo-classiques," *L'Estampille l'Objet d'art*, March 1992.

6. Girodet, *L'Apothéose des héros français morts pour la patrie pendant la guerre de la liberté*, 1802. Gérard, *Ossian évoque les fantômes sur les bords du Lora*, 1801. Several copies were made of this painting.

7. A few very early examples were visible on the place du Caire and in Krafft and Ransonnette's book.

8. Only four severely controlled newspapers were allowed in Paris, and only eight theaters remained open.

9. Chateaubriand, *Les Mémoires d'outre-tombe*, part 2, book 14, chapter 4.

SELECTED BIBLIOGRAPHY

Abrantès, duchesse d' (Laure Junot). *Mémoires*. Paris: Plon, 1937.

Arminjon, Catherine. "The Art of the Table." In *L'art de Vivre: Decorative Arts and Design in France, 1789–1989*. New York: Cooper-Hewitt Museum/Vendome Press, 1989.

Arneville, Marie-Blanche d'. *Parcs et Jardins sous le Premier Empire*. Paris: Librairie Jules Tallandier, 1981.

Aron, Jean-Paul. *Le Mangeur du XIXᵉ siècle*. Paris: Editions Robert Laffont, 1973.

Beurdeley, Michel. *La France à l'encan, 1789–1799*. Paris: Librairie Jules Tallandier, 1981.

Boigne, comtesse de (Louise d'Osmond). *Mémoires, de Louis XVI à 1820*. Paris: Mercure de France, 1986.

Chevallier, Bernard. *Napoleon*. Memphis, Tennessee: Wonders, 1993.
———. *Malmaison, Château et domaine des origines à 1904*. Paris: Réunion des Musées Nationaux, 1989.

Chevallier, Bernard and Christophe Pincernaille. *L'Impératrice Joséphine*. Paris: Presses de la Renaissance, 1988.

Coural, Jean. *Silks from the Palaces of Napoleon*. New York: Fashion Institute of Technology, 1983. (Exhibition catalog).

Deschamps, Madeleine. "Domestic Elegance: The French at Home." In *L'art de Vivre: Decorative Arts and Design in France, 1789–1989*. New York: Cooper-Hewitt Museum/Vendome Press, 1989.

Fay-Hallé, Antoinette and Barbara Mundt. *La Porcelaine européenne au XIXᵉ siècle*. Fribourg, Switzerland: Office du Livre, 1983.

Fontaine, Pierre-François-Léonard. *Journal 1799–1853*. Paris: Ecole Nationale Supérieure des Beaux-Arts, 1987.

Ford, Franklin L. *Europe, 1780–1830*. London: Longman, 1989.

Godechot, Jacques. *L'Europe et l'Amérique à l'époque napoléonienne (1800–1815)*. Paris: Presses universitaires de France, 1967.
———. *La Vie quotidienne en France sous le Directoire*. Paris: Hachette, 1977.

Grandjean, Serge. *L'Orfèvrerie du XIXᵉ siècle en Europe*. Paris: Presses universitaires de France, 1962.
———. "L'Orfèvrerie napoléonienne." *Jardin des Arts*, November 1955.

Groër, Léon de. *Les Arts décoratifs de 1790 à 1850*. Fribourg, Switzerland: Office du Livre, 1985. (This book is particularly informative.)

Hautecoeur, Louis. *L'Art sous la Révolution et l'Empire*. Paris: Guy Le Prat Editions, 1953.
———. *Histoire de l'architecture classique en France*. Paris: Editions A. et J. Picard, 1953.

Hitchcock, Henry-Russell. *Architecture: Nineteenth and Twentieth Centuries*. London: Penguin Books, 1990.

Humbert, Jean-Marcel. *L'Egyptomanie dans l'art occidental*. Paris: ACR Edition Internationale, 1989.

Jones, Proctor Patterson. *Napoleon: An Intimate Account of the Years of Supremacy, 1800–1814*. San Francisco: Proctor Jones Publishing Company, 1992.

Kain, Roger. "Napoleon and Urban Planning in Paris." *Connoisseur*, January 1978.

Krafft et Ransonnette. *Plans, coupes et élévations des plus belles maisons et des hôtels construits à Paris et dans les environs*. Paris: 1801–1802.

Krafft, J. Ch. *Plans des plus beaux jardins pittoresques de France, d'Angleterre et d'Allemagne*. Paris, Imprimerie de Levrault, 1809.

Las Cases, Emmanuel, comte de. *Mémorial de Saint Hélène (1823)*. Paris: Editions du Seuil, 1968.

La Mésangère, Pierre de. *Collection de meubles et objets de goût*. Paris, 1796–1830.

le Bourhis, Katell, ed. *The Age of Napoleon: Costume from Revolution to Empire, 1789–1815*. New York: The Metropolitan Museum of Art/Harry N. Abrams, 1989.

Ledoux-Lebard, Denise. *Le Mobilier français du XIXᵉ siècle*. Paris: les Editions de l'Amateur, 1989.

Leben, Ulrich. *Molitor, Ebéniste de Louis XVI à Louis XVIII*. Paris: Editions d'Art Monelle Hayot, 1992.

Loyer, François. *Le Siècle de l'Industrie*. Paris: Skira, 1983.

Madelin, Louis. *Le Consulat et l'Empire*. Paris: Hachette, 1933.

Marmottan, Paul. *Le Style Empire*. Paris: Contet, 1925–1930.

Masson, Frédéric. *Napoléon chez lui*. Paris: Editions Tallandier, 1977.

Maurois, André. *Napoléon*. Paris: Hachette, 1964.

Mignot, Claude. *L'Architecture au XIXᵉ siècle*. Fribourg, Switzerland: Office du Livre, le Moniteur, 1983.

Moulin, Jean-Marie. *Guide du musée national du château de Compiègne*. Paris: Réunion des Musées Nationaux, 1992.

Nouvel-Kammarer, Odile. *Papiers peints panoramiques*. Paris: Union des Arts Décoratifs/Flammarion, 1990.

Penot, Philippe. *Les Dessus et les dessous de la bourgeoisie, une histoire du vêtement au XIXᵉ siècle*. Paris: Fayard, 1981.

Percier, Charles and Pierre-François-Léonard Fontaine. *Recueil de décorations intérieures comprenant tout ce qui a rapport à l'ameublement*. Paris: Didot Aîné, Imprimeur du Roi, 1827.

Plinval de Guillebon, Régine de. *Porcelaines de Paris, 1770–1850*. Fribourg, Switzerland: Office du Livre, 1983.

Praz, Mario. *On Neoclassicism*. London: Thames and Hudson, 1969.

Rasponi, comtesse (daughter of Joachim Murat). *Souvenirs d'enfance, 1805–1815*. Paris: Librairie Académique Perrin, 1929.

Samoyault, Jean-Pierre. *Château de Fontainebleau: Pendules et bronzes d'ameublement entrés sous le Premier Empire*. Paris: Réunion des Musées Nationaux, 1989.

Samoyault, Jean-Pierre and Colombe Samoyault-Verlet. *Château de Fontainebleau, Musée Napoléon 1ᵉʳ*.

Paris: Réunion des Musées Nationaux, 1986.

Santi, M. and Madame Soyer. *Modèles de meubles et décorations intérieures pour l'ameublement*. Paris, 1828.

Séguy, Philippe. "Costume in the Age of Napoleon." In Katell le Bourhis (ed.), *The Age of Napoleon: Costume from Revolution to Empire, 1789–1815*. New York: The Metropolitan Museum of Art/Harry N. Abrams, 1989.

Starobinski, Jean. *1789, Les emblèmes de la raison*. Paris: Flammarion, 1979.

Thornton, Peter. *Authentic Decor: The Domestic Interior 1620–1920*. London: George Weidenfeld & Nicolson, 1984.

Tulard, Jean. *Nouvelle Histoire de Paris, le Consulat et l'Empire*. Paris: Hachette, 1970.

——. *La Vie quotidienne en France sous Napoléon*. Paris: Hachette, 1978.

——. *Murat*. Paris: Hachette, 1983.

——. *Napoléon et la noblesse d'Empire*. Paris: Editions Tallandier, 1986.

——. *Dictionnaire Napoléon*. Paris: Librairie Arthème Fayard, 1987.

——. *L'Histoire de Napoléon par la peinture*. Paris: Belfond, 1991.

——. *Le Premier Empire*. Paris: Presses universitaires de France, 1992.

Verlet, Pierre. *Styles, meubles, décors*, vol. 2. Paris: Larousse, 1972.

Viennet, Odette. *Napoléon et l'industrie française. La Crise de 1810–1811*. Paris: Plon, 1947.

Wagener, Françoise. *Madame Récamier*. Paris: Jean-Claude Lattès, 1988.

——. *La Reine Hortense*. Paris: Jean-Claude Lattès, 1992.

ENGLAND

Ackermann, Rudolph. *The Repository of Arts, Literature, Commerce, Manufacture, Fashions and Politics*. London: R. Ackermann, 1809–1828.

Collard, Frances. *Regency Furniture*. Woodbridge, England : Antique Collectors' Club, 1985.

Gere, Charlotte. *Nineteenth Century Decoration: The Art of the Interior*. London: Weidenfeld; New York: Harry N. Abrams, 1989.

Hope, Thomas. *Household Furniture and Interior Decoration*. London: T. Bensley, 1807.

Levy, Martin. "Napoleon's *fauteuil de malade*." Apollo, May 1991.

Watkin, David. *Thomas Hope and the Neo-Classical Idea*. London: William Clowes and Sons, 1968.

GERMANY

Himmelheber, Georg. *Die Kunst des deutschen Mobels*, vol. 3. Munich: Verlag C. H. Beck, 1973.

Karl Friedrich Schinkel. Berlin: Staatliche Museen zu Berlin, 1982.

Watkin, David, and Tilman Mellinghoff. *German Architecture and the*

Classical Ideal, 1740–1840. London: Thames and Hudson, 1987.

ITALY

Bairati, Eleonora and Anna Finocchi. *Arte in Italia*, vol. 3. Turin, Italy: Loescher Editore, 1984.

Bertelli, Carlo, Giuliano Briganti and Antonio Giuliano. *Storia dell'Arte Italiana*, vol. 4. Milan: Electa/ Bruno Mondadori, 1986.

Celona, Toti, and Elisa and Leonardo Mariani Travi. *Scrittori e architetti nella Milano napoleonica*. Milan: Provincia di Milano, 1983.

Fanelli, Giovanni. *Firenze, architettura e città*. Florence: Vallecchi, 1973.

Villes et territoire pendant la période napoléonienne. Rome: Ecole Française de Rome, 1987.

Worsdale, Derrick. "Palazzo Pitti, The State Apartments." *Apollo*, September 1977.

RUSSIA

Chenevière, Antoine. *Splendeurs du mobilier russe 1780–1840*. Paris: Flammarion, 1989.

SPAIN AND PORTUGAL

Barreira, Joao. *Arte portuguesa: As artes decorativas*. Lisbon: Ediçoes Excelsior, n.d.

Fugier, André. *Napoléon et l'Espagne, 1799–1808*. Paris: Librairie Félix Alcan, 1930.

Gaya Nuno, Juan Antonio. *Ars his-*

paniae, vol. 19. Madrid: Editorial Plus Ultra, 1966.

SWEDEN

Groth, Håkan. *Neoclassicism in the North: Swedish Furniture and Interiors 1770–1850*. London: Thames and Hudson, 1990.

UNITED STATES

Cooper, Wendy A. *Classical Taste in America, 1800–1840*. Baltimore: The Baltimore Museum of Art; New York: Abbeville Press, 1993.

Davidson, Marshall B., and Elizabeth Stillinger. *The American Wing at The Metropolitan Museum of Art*. New York: Alfred A. Knopf, 1985.

Fairbanks, Jonathan L., and Elizabeth Bidwell Bates. *American Furniture, 1620 to the Present*. New York: Richard Marek Publishers, 1981.

Fales, Dean A., Jr. *American Painted Furniture 1660–1880*. New York: E. P. Dutton & Company, 1972.

Montgomery, Charles F. *American Furniture: The Federal Period, in The Henry Francis du Pont Winterthur Museum*. New York: Viking Press, 1966.

Otto, Celia Jackson. *American Furniture of the Nineteenth Century*. New York: Viking Press, 1965.

The White House: An Historic Guide. Washington, D.C.: The White House Historical Association, 1962.

ACKNOWLEDGMENTS

I first wish to express my gratitude to Mark Magowan and David Revere McFadden for the faith they showed in this project. I would like to extend special thanks to Bernard Chevallier of the château de Malmaison, and I thank the German Embassy in Paris, the British Embassy in Paris, and the curators of the château de Compiègne for their very courteous collaboration. I am equally thankful to the collectors Olivier Le Fuel, Michel Fleury, Robert Carlhian, and to Hermès, who gave us permission to photograph their holdings, as well as to the administrators of the Hôtel Botterel Quintin, the Hôtel Gouthière, the château de Serrant, and the château de Valençay. I am sincerely grateful for the help I received from the Didier Aaron, Camoin, and Golovanoff galleries in Paris, and from Robert Trent at the Winterthur Museum in Delaware. I also wish to thank Souvenir Napoléonien, and the Yves Mikaeloff, Dragesco Cramoisan, Jean Cailleux, Bernard Steinitz, Ariane Dandois, and Rive Droite galleries in Paris, and the Malmaison Antiques and A La Vielle Russie galleries in New York. I particularly want to thank Marike Gauthier for her warm assistance, and Jackie Decter, my discerning editor. The help of Xavier Carrère and Francine Sanllorente of Editions Abbeville in Paris and of Karen Howes in London was most efficient. I very much appreciated the remarks Myrna Myers and Caroline Boyle-Turner made. Finally, I would like Jacques and Pilar Deschamps to know how I value their unfailing support.

INDEX

PHOTOGRAPHY CREDITS

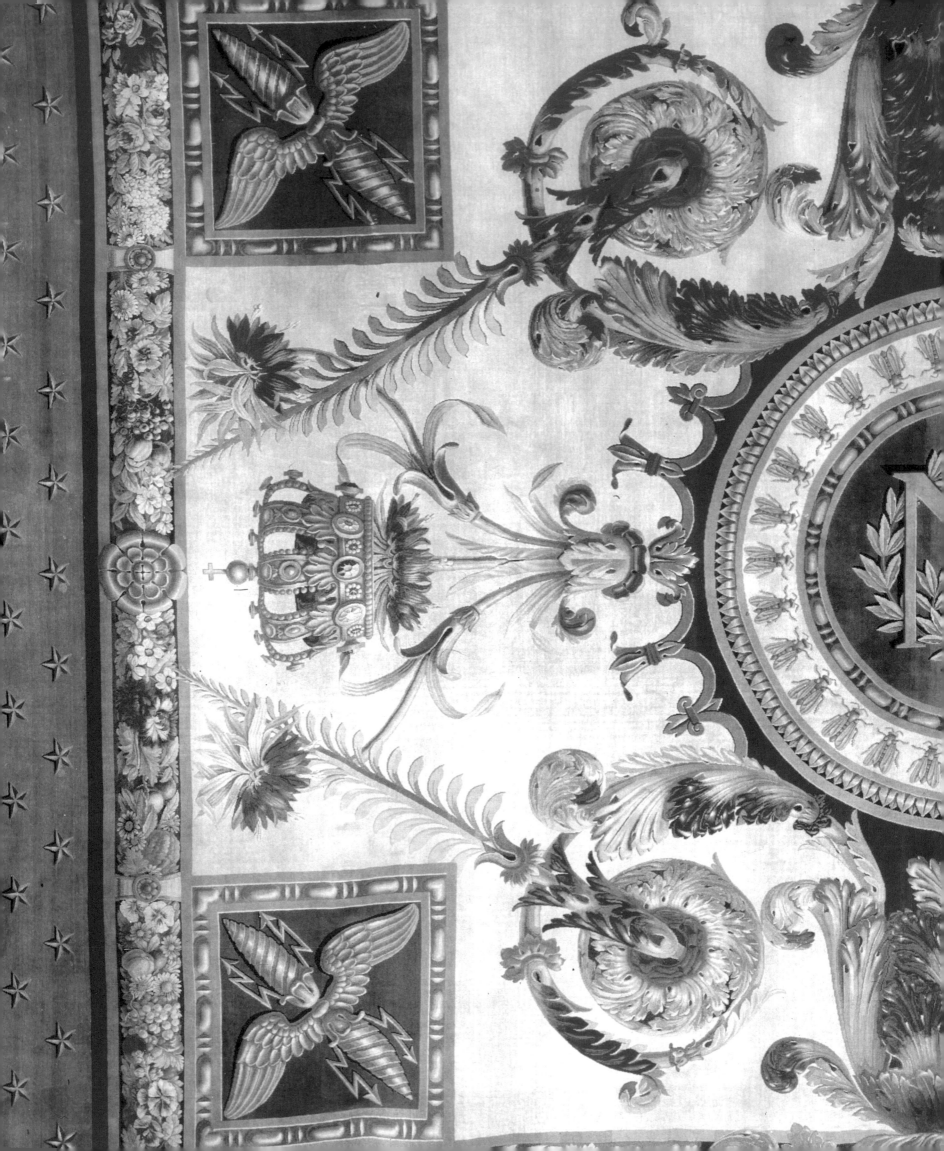